Outdoor Photographer Landscape and Nature Photography with Photoshop® CS2

Rob Sheppard

John Wiley & Sons, Inc.

Outdoor Photographer Landscape and Nature Photography with Photoshop® cs2

Published by
Wiley Publishing, Inc.
111 River Street
Hoboken, N.J. 07030
www.wiley.com

Copyright © 2006 by Wiley Publishing, Inc., Indianapolis, Indiana

Published by Wiley Publishing, Inc., Indianapolis, Indiana

Published simultaneously in Canada

ISBN-13: 978-0-471-78619-1

ISBN-10: 0-471-78619-5

Manufactured in the United States of America

10 9 8 7 6 5 4 3 2 1

1K/RX/QU/QW/IN

For general information on our other products and services or to obtain technical support, please contact our Customer Care Department within the U.S. at (800) 762-2974, outside the U.S. at (317) 572-3993 or fax (317) 572-4002.

Wiley also publishes its books in a variety of electronic formats. Some content that appears in print may not be available in electronic books.

Library of Congress Catalog Control Number: 2006920616

about the author

Rob Sheppard has had a long-time and nationally recognized commitment to helping photographers connect with digital imaging technology. He was one of the small group of people who started *PCPhoto* magazine nearly eight years ago to bring the digital world to photographers on their terms. He is the editor of *PCPhoto* as well as *Outdoor Photographer* magazines (second only to *Popular Photography* in circulation), group editorial director of all Werner Publication photo magazines (*PCPhoto, Outdoor Photographer* and *Digital Photo Pro*) and is the author/photographer of over a dozen photo books, including *Adobe® Camera Raw for Digital Photographers Only.*

He also writes a column in *Outdoor Photographer* called Digital Horizons and teaches around the country, including workshops for the Palm Beach Photographic Centre, Santa Fe Photography and Digital Workshops, Digital Landscape Workshop Series, and the Great American Photography Workshop group. His Web site for workshops, books and photo tips is at www.robsheppardphoto.com.

As a photographer, Rob worked for many years in Minnesota (before moving to Los Angeles), including doing work for the Minnesota Department of Transportation, Norwest Banks (now Wells Fargo), Pillsbury, 3M, General Mills, Lutheran Brotherhood, Ciba-Geigy, Anderson Windows, and others. His photography has been published in many magazines, ranging from *National Geographic* to *The Farmer* to, of course, *Outdoor Photographer* and *PCPhoto.*

credits

Acquisitions Editor
Tom Heine

Project Editor
Cricket Krengel

Technical Editor
Michael Guncheon

Copy Editor
Kim Heusel

Editorial Manager
Robyn Siesky

Vice President & Group Executive Publisher
Richard Swadley

Vice President & Publisher
Barry Pruett

Book Designer
LeAndra Hosier

Project Coordinator
Maridee Ennis

Graphics and Production Specialists
Jennifer Click
LeAndra Hosier
Amanda Spagnuolo

Quality Control Technicians
John Greenough
Brian H. Walls

Proofreading
Susan Sims

Indexing
Lynzee Elze

This book is dedicated to the landscape and nature photographers who have struggled to master new digital technologies, who have been determined to say, "I can" and not, "I can't," and to those photographers who love making images and have found digital to offer an exciting realm of possibilities to take their photography to new heights of art and expression.

foreword

The year was 1999 and I had just received a Kodak DCS 620. This Kodak digital camera based on an F5 body wasn't my first digital camera, but it had a funky three folder file system for its images. After hacking around in frustration for a while, I sent an email off to my good friend Rob. Just like always, a cheerful and direct answer was soon in my mailbox, enlightening me on the idiosyncrasies of the file. It was not the first and by no stretch of the imagination the last conversation we would have about our shared passion of digital photography and the environment.

I've had the pleasure of getting to know Rob and calling him a friend apart from the typical "photographer-editor" relationship. Many of our conversations directly deal with the environment, photography, digital and how they are all combined to communicate and in many ways sway public opinion. We don't always see eye to eye, which is what makes the conversations so memorable because in the end, we solve world problems, at least as far as we're concerned.

Rob's incredible passion for the environment and photography are overshadowed though by his passion for sharing all this information with others. I've never met or known any one person who works so hard to break down myths, pass along solid information in a very easy to understand language with as much enthusiasm as Rob. And while readers might get a hint of this in his writings and students experience it firsthand when he works with them one-on-one, the photographic community as a whole never sees his tireless efforts on behalf of all of us. We're very fortunate that he is on "our side" on many photographic issues that affect us all.

This book is a perfect example of what I mean. On many occasions, Rob and I have discussed the ramifications of digital on nature photography. The established taboos that are just silly now, the line of ethics that some have drawn and the creative opportunities now afforded anyone willing to stretch their imagination. Sharon and I have always been thrilled to work with Rob in his role as editor of *Outdoor Photographer.* But we are honored by the fact we can call him a friend and know all he does to make our world, both for the photographer as well as the public at large, a better place for present and future generations.

What you have before you here are words of wisdom garnished from a lifetime of passion in the wilds of North America and behind the camera. Rob always puts his best foot forward in all of his endeavors and none so much as in this text. You have a challenge before you of soaking up all the knowledge in this book being passed along and being infected with a passion that nature photography truly deserves! You will come to know a little of the Rob Sheppard we've so treasured over the decade. You're in for a treat!

Moose Peterson
www.moosepeterson.com
October, 2005

preface

I have long believed that nature photographers have needed a different model for use of Photoshop than simply becoming better Photoshop technicians. Nearly ten years ago in *Outdoor Photographer* magazine, I proposed that Ansel Adams and other traditional darkroom workers offered a better approach to Photoshop even though they never spent any time with the program. What they offered was a way to look at and affect photographs so that they better expressed what the photographer originally saw in the scene. They brought a certain level of craft to the image that, I felt, offered much for the photographer using Photoshop as well.

This book reflects some of that thinking and is based on my evolution of work with Photoshop and nature photography. You will learn about Ansel Adams and how his technique, philosophy and craft can influence your approach to an image in Photoshop. But you'll go much farther than Adams and his contemporaries ever could do in the traditional darkroom. I am not talking about "faking" or "manipulating" nature and passing off the images as real, which most nature photographers don't care much for. I am simply referring to the ability to bring more out of an image, especially in color.

Few photographers doing serious nature photography during Adams' prime did much color work other than Eliot Porter. While a lot of nonsense has been written about black-and-white's "artistic" qualities compared to color, this really was not why so much great black-and-white nature photography exists from the traditional masters. Color was difficult to work with, especially for getting satisfying prints for fine art display. Adams referred to color prints as looking like television sets a little out of tune.

But today, Photoshop gives photographers the chance to work any image the way black-and-white photographs were traditionally adjusted and enhanced in the darkroom. And all with the perfect color that Adams felt was missing. This book is written from a nature photographer's perspective on doing just that with Photoshop CS2. There are more technical books on Photoshop, there are more basic books, and I felt there was no point in adding another book like them to the bookshelves. What I have tried to do is offer a nature photographer's point-of-view on how photographers can really benefit from using Photoshop. I have worked as a professional nature photographer, but more important, I have seen how photographers have adapted to and adopted digital technologies as I have worked on *Outdoor Photographer* magazine.

So I wanted to do a book that addressed photographers' needs and concerns, one that made photography as important as the technology, just as Ansel Adams did with his books on photography. Just as in my other books, I have tried to bring ideas and examples that reflect what I have learned about how photographers can respond to and benefit from Photoshop. I truly want photographers to say, "I can!" and believe it.

Many of the photos that are demonstrated in this book are available for download at www.robsheppardphoto.com. Some of these are large files, so you're going to need a broadband, high-speed connection to the Internet or else a lot of patience.

acknowledgments

There are a number of people who really helped me understand and adapt to new technologies early on so I could better explain them to photographers. Michael Guncheon taught me how technology can be used in service of visuals so that creativity and craft is not imprisoned by the tools. George Lepp was in there exploring digital photography at the same time as I was so we could share many ideas as we grew in knowledge. Bruce Dale gave me new perspectives on how digital could be used as an effective communications tool. The late Galen Rowell challenged me to prove the value of digital to photographers. Dan Steinhardt of Epson encouraged me to find a broader audience for showing how digital could help all photographers. Chuck Westfall and Rudy Winston of Canon have always freely answered any and every technical question I have had about digital technologies. Bill Fortney of Nikon has long been a great supporter of my efforts to help photographers better use digital photography. Steve Werner has constantly made me think how to best communicate about digital technologies to photographers. I also have to really thank all of the great folks who have been at my workshops and seminars who have taught me what photographers really need to know about digital photography and Photoshop.

I owe a big thanks to Bill Turnage of the Ansel Adams Trust for helping with the Ansel Adams work represented in this book.

I have to acknowledge my terrific parents who often wondered what the heck this photography business was all about when I was growing up but supported it anyway and now understand the beauty of it all. I have to especially thank my family, particularly my wife, Vicky, a terrific partner, who has had to put up with me writing on a laptop while between our daughter's soccer games, who tolerates me photographing all over the place saying I will just be a minute (but rarely am) then spending much time in my office working at the computer.

Please visit www.outdoorphotographer.com.

contents

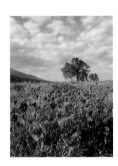

Contents

chapter **3 Start Right 23**

chapter **4 Setting the Stage: Basic Steps 41**

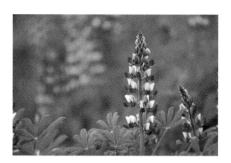

chapter **5 A Short Course in Camera Raw 73**

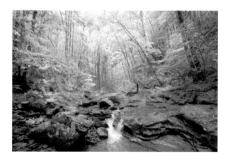

Part II Layers and Other Essential Tools **97**

chapter **6 Layers 101** **99**

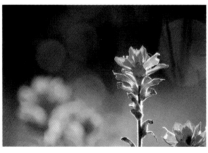

chapter 7 **Developing Midtones 129**

chapter 8 **Color Adjustment Refined 151**

chapter **9 Better Images through Local Adjustments 171**

chapter **10 Putting It All Together: An Approach that
Works 205**

chapter **11 Clean It Up 223**

**Part III Special Techniques for the Nature
 Photographer 247**

chapter **12 Extending the Tonal Range of Scenes 249**

chapter **13 Classic Black and White 277**

chapter **14 Finishing the Image 309**

chapter **15 The Better Print** **335**

appendix **A Photoshop Plug-Ins for Nature Photographers 357**

glossary **Pro Glossary 365**

Index 371

CORE PHOTOSHOP SKILLS FOR LANDSCAPE AND NATURE PHOTOGRAPHERS

Part I

AN APPROACH TO PHOTOSHOP

Photoshop was once very intimidating to the nature photography community. It seemed to do things inappropriate to the goals of a nature photographer. Most photographers no longer feel that way today because the use of Photoshop has evolved beyond tricks and clever manipulations; however, a lot of information on using Photoshop has not. The nature photographer needs an approach to Photoshop that honors the traditions and needs of nature photography.

I learned nature photography during my teenage and college years, working in black and white. The photograph in figure 1-1 of Delicate Arch in Arches National Park is similar to such work. At that time, color was considered just for those who could not deal with the art of black and white or for those who had to shoot it for professional reasons. So, I spent a great deal of time in the darkroom, as did most serious photographers, both pros and amateurs. Most of us revered the old black-and-white masters

such as Ansel Adams, W. Eugene Smith, Bill Brandt, and Andreas Feininger. We spent a great deal of time in the darkroom perfecting our craft and trying to make our photographs sing, as Adams once put it. A lot of what Photoshop offers actually comes from the traditional black-and-white darkroom way of working on an image.

Through the 1980s, color became the dominant way of photography. The traditional darkroom began to disappear. Pros began to shoot slides (for reproduction reasons), while amateurs made print film the dominant media. Magazines quit using black-and-white photos, and eventually, even newspapers largely relied on color.

Color was the way that everyone seemed to be going and most new photographers learned the craft through shooting color. Plus, to be perfectly honest, a lot of nature simply looks its best in color, such as the field of Owl's-Clover in figure 1-2. The result was that many photographers

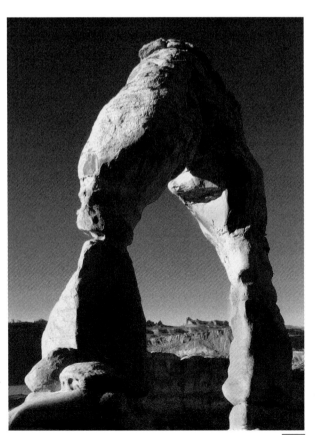

1-1

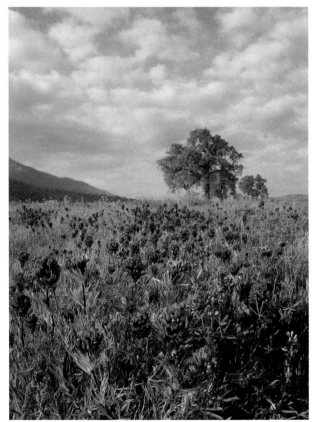

1-2

An Approach to Photoshop

1

never experienced the darkroom. Color darkroom work was difficult and required the use of toxic chemicals. And color darkroom work wasn't always very satisfying in terms of results.

For that reason, Ansel Adams never published his personal color work (it only appeared in print after his death). He felt that color just didn't allow the control and craft that he had available to him in the black-and-white darkroom. Because it was hard to make changes after taking the picture when shooting color, a new idea became common to photography through this time of color dominance. This was an idea not part of black-and-white work: that whatever was shot on film had to be complete when the photograph was made.

PHOTOSHOP AND NATURE PHOTOGRAPHY

Adobe Photoshop first came out in the early 1990s and totally changed how color images could be seen. However, at the time, few people really knew much about it. Computers were very expensive and had little power compared to what you can get today. Photoshop became the tool of commercial artists and photographers who wanted to change photographs and make them into illustrations because they were the only ones who could afford it.

When Photoshop and digital capabilities really became known in the photography world (beyond the early adopters), but before the capabilities were commonly used, many nature photographers felt very threatened. They only saw the "fancy footwork" of the image manipulators using Photoshop for advertising and such things.

Even Adobe demonstrated the powers of Photoshop with rather silly examples of cutting out a hot-air balloon and showing it flying by Delicate Arch in Arches National Park. (I didn't make that up — Adobe actually did do that at a photography show!) This didn't do anything to reassure nature photographers. In fact, when *Outdoor Photographer* magazine started introducing readers to Photoshop in the late 1990s, there was much apprehension and even anger that *OP* would do such a thing.

I do not believe Photoshop, when used for nature photography, is about doing funky things to an image. Compare the naturally stunning image in figure 1-3 with the manipulated version of the image seen in figure 1-4. Unless you are trying to do some surrealistic statement, why bother? I am perfectly comfortable with nature's capabilities.

In addition, an important part of nature photography is the experience of being outside; connecting with nature; and relating to flowers, wildlife, landscapes, wind, heat and cold, and so on. None of this can be replaced by time in front of the computer.

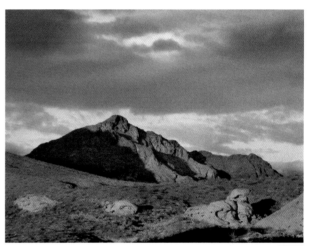

1-3

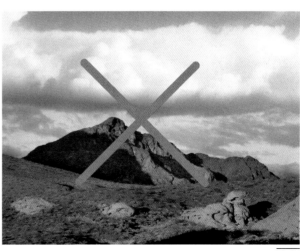

1-4

However, the camera, whether film or digital, simply does not record reality the way you experience it. In fact, though photography's mythology is that the camera is a good way of capturing reality, it really isn't. W. Eugene Smith once said that photography is a great liar because it looks so real — and he died before Photoshop!

Photoshop's great strength for landscape and nature photographers is that it gives you the opportunity to help an image get back to the way you saw the scene in the first place. It gives you the chance to work an image, to bring a level of craft to the photographic process like black-and-white photographers have always done (and are still doing). This program allows you to enhance images so that the true nature of the scene comes across. It also lets you define and enrich a composition so it more clearly communicates everything from the scientific reality of a subject to the emotional meanings of a scene as you photographed it.

PHOTO-BASED APPROACH

My approach to Photoshop and nature photography is photo-based and not program-centric. A long time ago, when I first started learning Photoshop, I was frustrated with the approach that many instructors and authors used. They were typically computer folks or graphic artists — photographers were not heavily invested in digital at the time. The computer folks tended to talk about using Photoshop as software. What was it capable of? How many selection tools did it have? Here's a demo of all the filters and what they did. They didn't focus on what the photograph needed as much as what Photoshop could do *to* the photograph.

Graphic artists, designers, and such folk used and still use Photoshop to fix photos for their design work or to create illustrations. For them, photographs are never a finished item, but merely raw material for designs they create (see figure 1-5). You can't fault them — that's what they do, and they do it well. But when I was learning Photoshop, these well-meaning experts didn't always give me satisfying answers (and today, they often miss the real

meaning of photographs for the photographer). They would often brutalize an image, from my photographic perspective, showing an interesting technique perhaps, but not really the photography I was interested in.

So, in my workshops and books, my goal is to put the photograph into Photoshop for the photographer. This book is no different. You will see how photographs are approached through Photoshop from a photographer's perspective, and how to look at a photograph to get the most from it, not how to look at Photoshop to remember all of its tools. Trying to remember all of Photoshop's tools is an exercise in frustration for most photographers, and in my experience, can really frustrate nature photographers. While Photoshop is very powerful because it has so many tools, this also makes it quite flexible. And, it also makes it a pain to learn at times. The good news is that if you stay photo-centric, in other words, making the photograph king over the technology, you will discover

Secrets of the Forest

An inside look at what really goes on behind closed leaves

by F. A. Kin

1-5

you never need to know all of Photoshop's tools. Using a few tools well and with sensitivity to the photograph will always yield better results than simply knowing a lot of tools superficially.

MORE ANSEL ADAMS THAN BILL GATES OR STEVE JOBS

Lots of books offer everything you could possibly want to know about all the Photoshop tools: where they are, what they do, and so forth. Not as many books give you the techniques needed to integrate Photoshop with nature photographers' specific needs. This book is more closely aligned with the craft of photography that Ansel Adams represents than with the computer technology as represented by Bill Gates or Steve Jobs.

Nature photography is not simply a different subject matter. I don't believe this is an affectation. As editor of *Outdoor Photographer*, I have worked with nearly all of the top nature photographers at one time or another. For them, landscape and nature photography are not simply photography, they are a lifestyle, a way of paying homage to something they love, a way of showing off the world, a way of highlighting environmental issues; in short, it is their life.

A good example of this is seen in figure 1-6, which is a photograph of a cecropia caterpillar happily munching on

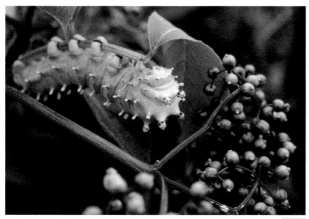

1-6

an elderberry bush. I like taking pictures of little critters such as this insect and sharing them with others. This cecropia caterpillar is as fantastic as any space movie creature, yet is rarely seen except when a photographer shares an image like this. Such a photo allows me to truly show off an incredible part of our natural world.

Discussion of Photoshop and nature photography needs to keep the factors that make landscape and nature photography appealing to photographers in mind or the resulting techniques will be rather superficial.

This, then, is a book about the photo needs of nature photographers and how those needs can be met using the tools of Photoshop CS2. My model is one of craft, meaning the application of tools in a skillful way in order to create something using the hands and mind. You will be doing all of that in Photoshop. Craft is much more than memorizing Photoshop keystrokes, and involves your strong interaction with the medium; in this case, the photograph. As you work, you learn and gain experience, so that your craft improves with practice.

Ultimately, the photograph, not Photoshop, will tell you what needs to be done. I don't mean this as some Northern California New Age sort of thing. I am simply responding to a way of working that involves watching your photograph evolve in Photoshop and then picking tools that will help you further enhance the image step by step. Each adjustment is then based on making the image do something very specific that makes it fit your needs better. Compare figure 1-7 (the original) and figure 1-8 (adjusted). I am not showing anything about Photoshop here, just two images that show adjustments based on the needs of the subject to have the flowers stand out more from the background.

These photos, though, have used Photoshop for the adjustments. I am not saying that Photoshop and all its wonders are not worth learning for their own sake (and some people do), but that while the changes you make to a photograph use the tools from Photoshop, they are subject- and photo-centric, not Photoshop technology based.

Obviously, throughout this book, I am going to give you specific tools and techniques to try. My point is that these are tools available to use, not tools you must use, and the difference is significant. You always need to go back to the image and really look at it. What is happening to it? Are the changes making the photo better? What can be done that will further enhance the photograph, its composition, its message?

1-7

1-8

A WORKFLOW OVERVIEW

You are going to see a lot of different techniques in these pages. They all relate to working with Photoshop and nature photography. There is also a process, a workflow, if you prefer, that the book follows as well. If you move through the chapters from front to back, you will see a progression of working with images that follows my chosen Photoshop workflow. You will learn more about this later, but a basic workflow goes like this:

1. Adjust and fix overall tonalities of the image: blacks, whites, and midtones.

2. Adjust and fix overall colors of the image: color casts and hue/saturation. You can see overall tonality and color adjustment in the comparison between figures 1-9 and 1-10

3. Look for local changes that need to be made. Adjust and fix specific areas of tonalities and color that are localized to small parts of the photo. Clone out problems.

4. Finish the photo: size it for the use needed and sharpen appropriately.

If you keep referring back to these simple workflow steps, you will find that nearly everything you do to an image fits somewhere in this group. It is in the execution of these ideas that the complexity occurs.

And Photoshop can be complex; there is no doubt about that. However, as you will see in Chapter 2, you don't have to master that complexity in order to master your photograph's needs in Photoshop.

I believe that Ansel Adams is actually a superb model for Photoshop usage, which is an idea that has rarely been expressed in discussions about Photoshop. His methods and workflow can really help the nature photographer.

He believed in going beyond a good print to make a better print. You want to strive for that as well — to create a print that truly fits you and your subject.

Now that you've taken a quick look at a workflow, it's time to get this process going with a visit to Ansel Adams. What would Ansel do about the digital revolution?

1-9

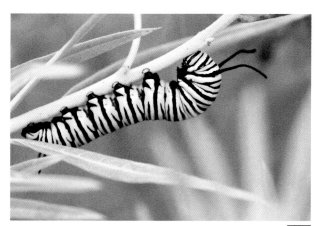

1-10

Chapter 2

WHAT WOULD ANSEL DO?

The legacy of classic landscape photographers such as Ansel Adams, Eliot Porter, and Edward Weston is very strong. These photographers died years ago, yet each still influences the medium. Their work can still be found in everything from books to museum exhibits: a testament to the power of good photography.

It is hard to define good nature photography, yet most critics and certainly the public would say that these three photographers made great photographs of nature. They each brought a unique approach to the medium: Adams had a strong attraction to the effect of light on the land as it translated to black and white, Porter shot intricate color images way before color was popular with "serious" photographers, and Weston created iconic images in black-and-white that emphasized form and shape in nature.

While other photographers have brought new visions of how they saw nature and translated that vision into photographs, the tradition of craft and disciplined approach to photographing nature that Adams, Porter, and Weston demonstrated are still valid today. Every nature photographer brings his or her own vision of what is important to photograph and how to capture that in an image, but the craft of a disciplined approach when working with the medium will always apply to the careful worker.

Ansel Adams was particularly well known for his careful and thoughtful approach to the craft of photography. This approach worked extremely well for Adams, and when you see all the books and other materials still around with his work, it is obvious that his approach created art to which people respond strongly even today.

I believe that if you understand some of Adams's way of approaching an image, you will be a better Photoshop user. In this chapter, you will find an overview of the Ansel Adams approach and some ideas on how that might affect your own ways of working with Photoshop.

Working well in Photoshop also requires craft and a discipline reminiscent of these traditional masters. While they did not work in Photoshop, the way they approached photography, and particularly darkroom work, definitely applies to working on nature photographs in Photoshop today. Adams is especially appropriate because of the extensive effort he put into his books and other teachings. You can learn much about how to approach a photograph to get the most out of it in Photoshop by examining Adams's texts.

ANSEL ADAMS'S LEGACY

Ansel Adams died more than 20 years ago, yet his legacy as a photographer lives on. It is probably the most instantly recognizable name in nature and landscape photography. Books and calendars of his work still resonate with both photographers and non-photographers alike. His work has appeared on everything from postcards to prestigious museum walls.

Though Photoshop did not exist when he died, Adams had seen what computers could do with an image and in interviews at the end of his life, he said he believed the computer offered a great deal of potential for the photographer. He had always been an advocate of smartly used technology in photography — technology that served the art but did not dominate the photographer.

I believe Adams is a superb model for the nature photographer using Photoshop today. This approach definitely influenced how I optimized figure 2-2 from the original digital capture in figure 2-1. Yet, this is not often discussed in Photoshop texts. Adams is recognized for his imagery but often forgotten for the disciplined approach he brought to photography.

2-1

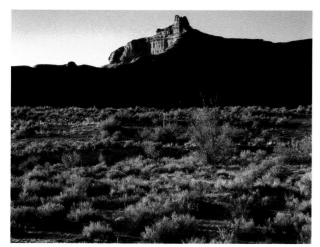

2-2

of their own and entice photographers to do things that may not be in the best interest of their photography.

Adams says something very important in the foreword repeated in each of his Basic Photo books: "Photography is more than a medium for factual communication of ideas. It is a creative art. Therefore emphasis on technique is justified only so far as it will simplify and clarify the statement of the photographer's concept."

Photography needs the science, needs the technology, but the danger comes because art can be difficult to define. This makes the technical side easier to discuss, even to the point of some camera clubs judging photos on strict technical terms that really have little to do with the art of photography.

A good example of this can be seen in figures 2-3 and 2-4, both shots of manzanita flowers taken the same time (manzanita is a common shrub of the Mojave Desert).

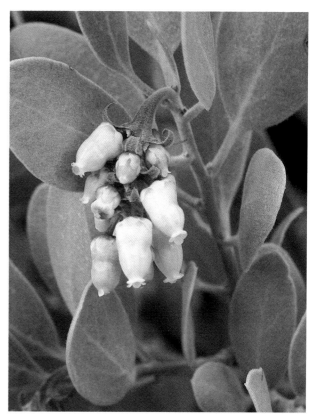

2-3

ART VERSUS SCIENCE

One challenge that has long faced photography is the fact that this medium represents both art and science. Creating a unique balance of art and science in photography can be a challenge; it is easy to have either element overwhelm the other to the detriment of the image.

A big problem can occur when the science, the technique, takes over the photography. This happens when megapixels become more important than the content of the photo. It also occurs when the tools of Photoshop take on a life

There is nothing wrong with figure 2-3, but it is rather technical and scientific — great for identifying the plant. Figure 2-4 goes beyond that simple interpretation of the flowers to find something more lyrical and evocative of the beauty of the blossoms. Yet, you can still clearly identify these flowers. It is possible to have both the technical and artistic in a photograph, and Adams proves that, but only when the technique helps the photographer make a better photograph.

It is interesting, however, that no one used to say they were going "to learn the darkroom." One learned to work in the darkroom on photographs. It wasn't about the darkroom so much as it was about what the darkroom could do for the photograph. And, in the same way, you don't need to "learn Photoshop." Consider the thought of learning to work in Photoshop on photographs. The difference in attitude between these two thoughts is significant.

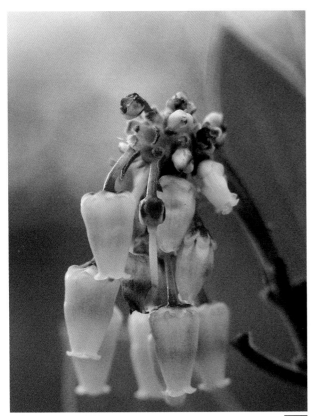

2-4

ADAMS'S WORK WAS A MODEL OF CRAFT

Craft is the learned skill of doing something well; it suggests the idea that someone is making or constructing something in a way that requires care and ingenuity.

For Adams, the making of a great print began with the right use of the camera. In his book, *The Negative*, he explains his famous Zone System. This is a complex way of dealing with exposure that doesn't fit everyone's needs, but it became an important part of Adams's way of working. The Zone System is essentially a way of metering specific tones in a scene then making those tones a specific brightness or darkness in the negative and print based on how the exposure is chosen, the development of the film, and the way the print is made.

The Zone System is a complete system that definitely fits the definition of craft, doing something with care and ingenuity. For best results, Photoshop also requires an integrated approach that recognizes the importance of everything from exposure of film or sensor to monitor calibration to how a print is made.

An image like figure 2-5 comes only from a complete integration of craft. This photograph of the desert agave in bloom required several elements to be in place:

> The right exposure

> A polarizing filter used properly

> A composition that used the image area fully

> Adjustment in Photoshop to ensure the blacks and whites were correct

> Adjustment so the polarized sky read properly and that the yellows of the flowers held detail

> Sharpening of the flower without causing problems with the background or any possible noise.

In *The Print*, Adams gives a detailed process for making a print, including describing how he dealt with many specific images. He says that the process leading to a fine print requires "meticulous craftsmanship."

Okay, I hope I have not scared you off by all of this talk of craft. That isn't my point. What I want you to consider is that craft, working with care and ingenuity, is as important to working in Photoshop as knowing all the controls. In fact, trying to know all the controls can even be counter-productive just because Photoshop is so filled with them.

If you read a lot about using Photoshop, you will quickly discover there are a lot of ways of doing things in the program. This gives the program its power and flexibility, but it can also be unnerving to the photographer who just wants a better photograph. Adams comments on the concept of tools overwhelming the image in such statements as "the final photographic statement should be logical and complete, and transcend the mechanics employed" (from *The Print*).

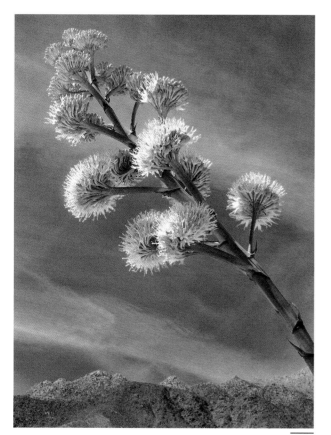

2-5

How Many Tools Did He Use Anyway?

Think a minute about what Adams did with a print. How many things could he control? How many tools did he use? He could make the overall photograph lighter or darker and change its contrast. Then he could go in and affect the details by affecting local (small area) light or dark tones and the contrast there, too.

Basically, that was it for controls. And tools? He had film-developing tanks and chemicals, an enlarger with lens, a set of three processing chemicals, simple dodging and burning tools (that might be just a piece of cardboard with a hole in it), a few special chemicals that refined tonalities, and a choice of papers.

You can see that his controls and tools weren't extensive, yet his body of work is. Now with Photoshop, you have a huge range of tools. But for fine nature photography, do you need them all? Not really. You learn how to apply many of them to nature images in this book, but my point is that Photoshop tools are only that, tools, and the photograph is ultimately the most important part of your work, not the processing in Photoshop. For example, in the two photos shown in figures 2-6 and 2-7 of a rocky scene in Red Rock Canyon near Las Vegas, Nevada, the differences come from very simple work in Photoshop, basically some contrast changes, some dodging and burning, and some slight color work.

The objective for Adams in creating an image was not to show off his mastery of the darkroom, but to create satisfying photographs. He had to know his tools well from practice and experience, but this was a relatively few tools compared to Photoshop. Using a few tools well was more important than having to remember lots of tools. I believe that is also what the landscape and nature photographer needs to keep in mind in order to best use Photoshop.

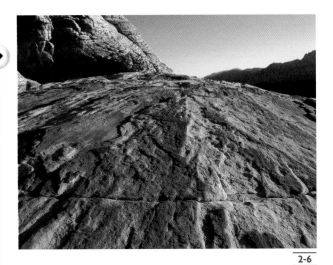

2-6

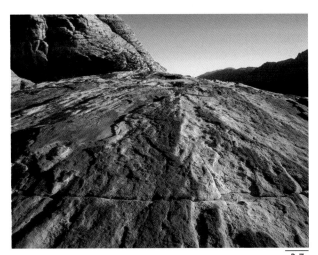

2-7

CAN INDOOR WORK MATCH THE OUTDOORS?

Photoshop and nature photography can be a fun and satisfying experience. But some nature photographers think that Photoshop is not for them because it is about indoor work and not the outdoor time that they want most.

Yet Adams is a model for the nature photographer here as well. He was well known for his high-country adventures in Yosemite, and the gear he carried far outweighed anything the average nature photographer carries today. He loved spending time in the Southwest and Alaska, and his photographs reflect that.

But he also spent a great deal of time inside, in the dark without windows, working on printing his images. He could spend days on a single print. Think about it — after spending time processing each frame of film (he shot mostly 4 × 5-inch film that only came in single pieces, though he could group-process them), he would begin the printing process.

To make a print, Adams would make a test print and process it, which could take 10 to 15 minutes until he was sure of what he got. Every test print would take that time. Then he started making work prints, again, each one taking at least 10 to 15 minutes. For every one that didn't work, he'd check it but then throw it out. He would go at it step by step as the image evolved. Then he might want to get a complete dry down of a print to be sure of how it looked when dry. This all took time.

Today, you and I can do all this very quickly with Photoshop. You can immediately see the effects of lightening or darkening the photo, or making changes to small areas. You can experiment with color and tone as much as you want and there is little cost in time and no cost in materials used.

A good example of this is seen in figures 2-8 and 2-9 of a bristlecone pine before the storm in the Patriarch Grove of the Ancient Bristlecone Pine Forest in California. The difference between these two images would easily represent hours in a color darkroom, yet was accomplished in Photoshop in 15 minutes.

In addition, I was there in this awe-inspiring place of 1,000-year-old bristlecones. I felt the change in the air as

the clouds came in, the temperature dropped, and I debated how quickly to return to the car as raindrops began to fall. Working on this image in Photoshop brought back that experience, and, if anything, intensified a great memory of being at that location.

I figure if Adams could enjoy his time outside in some wonderful areas and still spend this darkroom time, I can do some of that time in front of Photoshop to bring out the most in my images. I believe it is possible to be outside and enjoying nature and still spend time inside enjoying the process of bringing an image to life, or as Adams put it, making it sing.

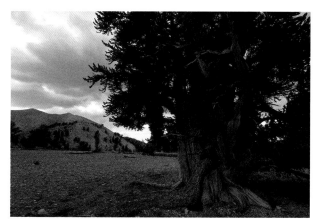
2-8

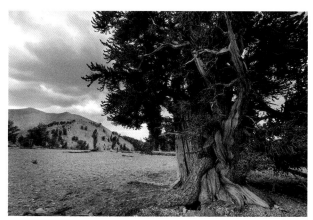
2-9

EXPRESSIVE IMAGES

Photoshop, for me, is a way of working with an image so that it better expresses the experience of being in nature with that subject. The camera tends not to do a very good job of that except as a disaffected, technical observer. I know very few nature photographers who want to stand back and be disaffected, uninvolved, technical observers of nature. As a group, nature photographers care deeply about their subjects and want to express those feelings in their photography.

Adams also had this feeling about his photography. He states very plainly in the first chapter of *The Print* that his philosophy "is directed to the final expression of the photographer's visualization" or what the photographer saw in the scene when it was photographed. Adams also states that this expressive image comes from a "unique combination of mechanical execution and creative activity." That could easily apply to Photoshop — the unique combination of digital execution and creative activity.

He adds that in printing, "we accept the negative that determines much, but not all, of the character of the final image. Just as different photographers can interpret one subject in numerous ways, depending on personal vision, so might they each make varying prints from identical negatives" (from *The Print*).

That is such an important statement as it truly affects how one can work with Photoshop. You do not have to see working with Photoshop as doing it right or wrong. You have the ability to interpret your image in your own way that best represents how you respond to the subject and the image. Figure 2-11 is a distinct interpretation of the original image capture of figure 2-10 (which is also an interpretation of reality).

I don't want to give the impression, though, that using Photoshop is just random and the photographer doesn't have to worry about its tools. Adams doesn't say that, either. In both cases, darkroom and Photoshop, you start with some givens about the subject — the exposed image

2-10

2-11

and your feelings — all of which limit and affect any interpretation of the photograph.

VARIATIONS ON A THEME

In some circles, a strangely conservative way of looking at images has evolved that implies there is only one way of dealing with the subject and any other way is somehow "wrong." The implication in these circles is that if you do Photoshop "right," meaning it has perfect and extensive tonalities and carefully corrected color, your image and

the subject will also be "right." But if you do Photoshop "wrong," meaning you have not met some arbitrary standards for tonality and color, you have screwed up and made an image that doesn't accurately represent nature, or worse, you've let down the Photoshop gods.

Adams actually addresses this issue in *The Print*. He says that photographers have generally assumed that a fine print will "have a full range of values, clear delineation of form and texture, and a satisfactory print color." While those things can be important, Adams goes on to say, "what a catastrophe it would be if all photographs only met those criteria!" As an example, he says that "true, a note of pure white or solid black can serve as a key to other values ... but there is no reason that they must be included in all images, any more than a composition for the piano must include the full range of the eighty-eight notes of the keyboard."

Of course, it is possible to go crazy and not follow any standards for Photoshop/subject interaction and create an alien landscape, for example, from an image that is really just from Arches National Park, as seen in figure 2-12 But you could have done that years ago with no help from Photoshop. This is not really nature photography. The real photo is seen in figure 2-13.

That said, it is important to realize that we all see nature differently, and how a camera and film or sensor sees nature is something different, too. Andreas Feininger, an early *LIFE* magazine photographer and photo book author from the past, noted in his classic book, *The Creative Photographer* (long out of print, but worth having for any photographer), that the photograph can never duplicate reality. A photograph is flat, not dimensional; it has no smells or sounds, the subject is frozen without movement,

and so forth. As a photographer, you experience all of these things during the photography, but can take none of it home. It still influences your experience of the time in nature and how you approach working on your photograph.

Keep this in mind as you read this book. Of course, I have to give you specific examples, and I will try to let you know how to use the tools of Photoshop effectively. But in the end, you still have to be satisfied with your photograph. If a photo expresses what you want about your subject, then you have succeeded.

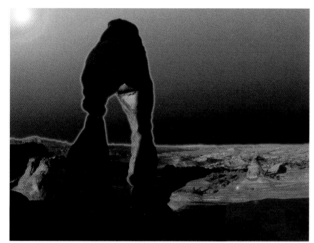

2-12

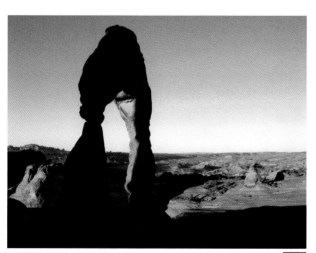

2-13

Ansel Adams even interpreted some of his images differently in prints made years apart. He discusses this in his books as being influenced by seeing different things in his photographs and how he wanted to portray them. There are photo critics, however, who prefer his earlier work, even though Adams himself often did not.

INTERPRETATIONS

This makes more sense if you can see a specific Ansel Adams photograph and learn how he interpreted it. Two of them are reproduced here with the permission of the Ansel Adams Trust, along with a summary of his interpretations from *The Print*.

Figure 2-14 (*Leaves, Mount Rainier National Park, Washington, 1942*) is a simple image that still shows quite a bit of how Adams approached an image to craft an expressive print. This was shot on a cloudy day without a lot of contrast, so Adams's basic processing of the negative and first work prints gave some contrast to the scene so the leaves would have more life to them.

This made the central leaves, which reflected a bright cloud as well as being slightly lighter, brighter than he wanted them. They were out of balance with the rest of the photograph. (You will learn how to balance an image in Photoshop in Part II of this book.) Adams darkened just those leaves to bring their tonal values down so that they didn't overpower the rest of the image.

He didn't stop there. Adams did some edge burning on most of his photos because he felt this darkening of the outside tones of the image kept the viewer's eye from drifting from the subject. He did darken all the outside parts of this image to do that and add some dimension to the subject. Finally, he darkened a brighter leaf at the lower right to keep it from competing with the composition.

X-REF

You will find another Ansel Adams example in Chapter 6 during the initial layers discussion.

2-14 — *Leaves, Mount Rainier National Park, Washington, 1942*
Photograph by Ansel Adams.
Used with permission of the Trustees of The Ansel Adams Publishing Rights Trust. All Rights Reserved.

Craft is care and ingenuity in working an image. That's definitely key to this photograph of leaves and lifts it from being a simple snapshot of vegetation.

Figure 2-15 is a famous photograph from the Eastern Sierras — *Winter Sunrise, Sierra Nevada, from Lone Pine, California (1944)*.

It is a classic landscape example and is a very expressive image based on Adams's work in the darkroom.

After working out a basic exposure to deal with the overall image, Adams went in and worked on specific parts of the photo. The sunlit trees were kept light to enhance the feeling of a shaft of light on them. To further emphasize this feeling, he burned in, or darkened, the foreground, the right and left sides of the lower part of the photo, plus the dark hills above the trees. This is done with a gradual blending of tones so that the effect is not obvious.

Adams continued to work the image by darkening slightly the top of the image from the mountains through the sky, sort of like using a graduated filter, but with very specific control over what is darkened. He notes that this takes a bit of care because if the sky is darkened too casually so

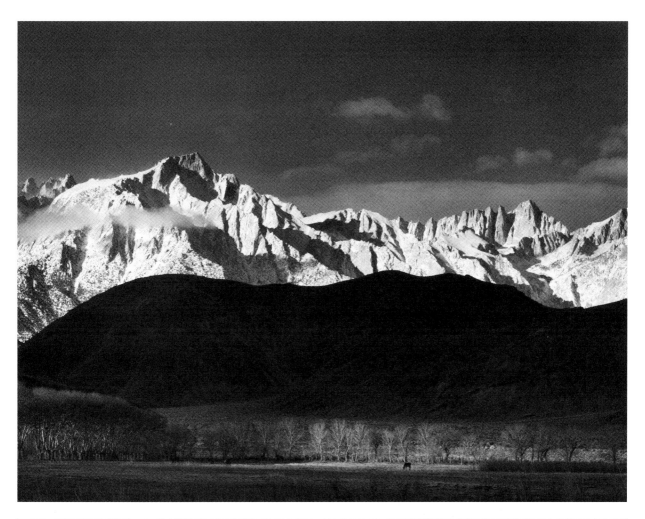

2-15 — *Winter Sunrise, Sierra Nevada, from Lone Pine, California (1944)*
Photograph by Ansel Adams.

that the mountains are affected too much, the tops of the mountains lose some of the brilliance of the snow. However, the far-right snow-covered mountains reflect a lot of glare from the early sun and need extra darkening.

In Adams's book, *Examples: The Making of 40 Photographs*, he notes that this photo showed the letters LP (for Lone Pine) whitewashed into the dark hill below the mountains (somewhere on the left side, though I am not sure exactly where as they were evidently very small). Adams believed this was a hideous and insulting manmade scar no better

than left-behind trash, so he removed it by spotting out its details in the print. This is exactly like cloning!

Adams was criticized by some people for that removal, but he has a very eloquent reply to that in *Examples*: "I am not enough of a purist to perpetuate the scar and thereby destroy — for me, at least — the extraordinary beauty and perfection of the scene."

It truly is a beautiful photograph, carefully controlled by a master craftsman and artist.

Q & A

What other traditional photographers could I look up that represent the level of craft that Adams had?
I would highly recommend checking out W. Eugene Smith. Smith was not a nature photographer, but he was an expert at creating expressive black-and-white images. Ansel Adams once said that Smith was a black-and-white master that he looked up to.

Smith is often considered the father of modern photojournalism, and his work had to be grounded in reality, just as nature photography is. Smith had a reputation for never being satisfied with an image and therefore spending weeks in the darkroom after an assignment. Yet his work is really remarkable, even today, and communicates strong feelings about his subjects.

John Sexton is another photographer to consider. He was Ansel Adams's last assistant and has become one of the top nature photographers on his own. He has a number of books on his work, plus he does regular workshops.

Sexton is also a black-and-white photographer. Because color work used to be so difficult in the darkroom, as mentioned at the beginning of this chapter, the attitude that you really can't change the original color image has stuck around. As you'll see in this book, however, the rich tradition that black-and-white photographers established, setting the bar high for nature photographers (in both quality and aesthetics), is possible in color when using Photoshop.

I've seen darkroom classes still available. It seems like you are saying that they might help me with Photoshop. Is that true?
In no way do I think everyone needs to go to the traditional darkroom in order to be a better Photoshop user. Ansel Adams, W. Eugene Smith, and Edward Weston used the darkroom because it fit their needs and there was no other option at the time. The point is that they mastered their craft of carefully and smartly working an image to get the most out of it, a model that is worth considering for Photoshop, too.

That said, could you learn some ways of dealing with an image in the traditional darkroom that would help you do better Photoshop work? Sure. If you have the time and inclination, you can sure try it, but it is certainly not a necessity.

START RIGHT

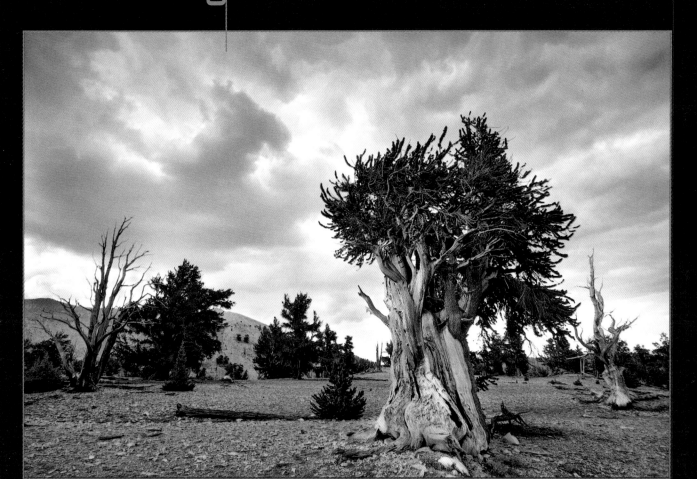

Photoshop sometimes seems like magic out of a Harry Potter story. It allows you to do some amazing work on an image, even if exposure or color isn't right from the start. But Photoshop is not magic, and it really does work best when the image coming into the program is the best that it can be from the start as seen in figures 3-1 and 3-2.

Look carefully at the photos. There is very little difference in the color and tonality of the key, sharp parts of the images, which says that the photo was shot right in the first place. However, the photo was then brought into the digital darkroom, Photoshop, and the color and tonality of the outlying areas, especially the sky and the edges, have

3-1

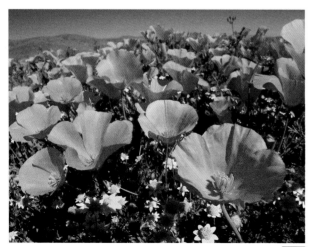

3-2

been significantly changed in figure 3-2 compared to figure 3-1. This makes the image much, much stronger. Look especially at how flat the first image looks compared to the second. But those changes occur because the photo was shot right in the first place.

Yet, there is a popular myth that Photoshop is great for fixing problems; therefore, one can always "fix it later in Photoshop." That idea can get you into trouble, as you'll see in this chapter.

This chapter is an overview of some of the critical parts of the actual photography that affect how an image is adjusted in Photoshop. It is not a how-to summary of photography. I am going to make the assumption that you, the reader, know a bit about photography. You know your camera and how to use its controls efficiently. You know what things like overexposure and underexposure are.

Few Photoshop books address the actual photography in its relationship to the use of Photoshop. I have a feeling that many Photoshop experts are superb computer technicians, but are less comfortable with the photography, so it makes sense that they spend little time with it in their books and seminars.

I really do believe that connecting the actual photography to quality use of Photoshop will help the nature photographer get better and more satisfying results, and that was the genesis of this chapter. In addition, putting the shooting together with the Photoshop work will mean less time in front of the computer fixing things and more time outside enjoying nature.

SHOOT IT RIGHT FROM THE START

Okay, everyone knows Photoshop is a marvelous invention for photographers. It offers a lot of great features for getting the most from an image. Obvious, right? But somehow Photoshop has transformed into something magical; it has powers beyond imagination. The idea has become that you don't have to shoot the image perfectly in the first place because you can always fix it in the computer.

Years ago, this was an attitude some darkroom photographers had, too. You'd hear photographers say that they really didn't worry about getting everything nailed down at the time of the exposure because the darkroom let them do so many things.

Marvelous as Photoshop is, the old acronym about computers, GIGO (garbage in, garbage out), is still important to remember. Paying attention to the craft of taking the picture is also about using Photoshop because how you first capture that natural subject on film or sensor tremendously affects what you can do in Photoshop and how you do it.

You see two images of the same subject, paintbrush flowers in the Hill Country of Texas, in figures 3-3 and 3-4.

These are unadjusted photos directly from the camera. While figure 3-4 is properly exposed for the subject, figure 3-3 is not. An Image like figure 3-3 will never look as good as it would if had it been properly exposed to begin with, no matter what changes you make in Photoshop. The dark colors will never have the right color or tonalities without a lot of work. Some of the darkest tones have missing tonalities that could have been originally captured, but weren't.

There is also a misconception among many photographers that RAW files capture everything, and that somehow these files see everything in the scene and hold it at the ready for use just as long as you have the right software. Unfortunately, the RAW file can only deal with what

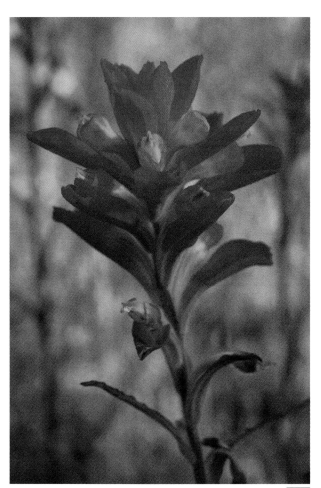

3-3

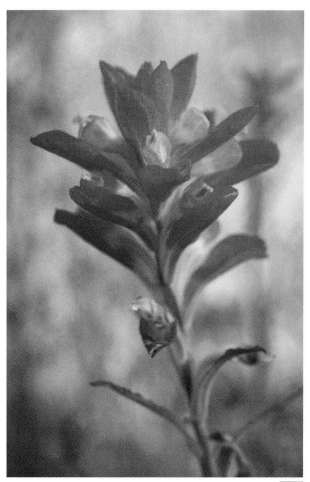

3-4

the sensor can see. Any sensor has only so much of a tonal range that it can see from black to white, and RAW cannot extend that.

If the pixels are so overloaded that detail is lost, as in the highlights of figure 3-5, no amount of work in Photoshop or any RAW conversion software will bring that overexposed detail back. If the pixels are so understimulated that no detail is captured in the blacks, as seen in figure 3-6, no fancy tricks in Photoshop will ever show that detail. RAW capture cannot expand or change the tonal range capacity of a sensor.

3-5

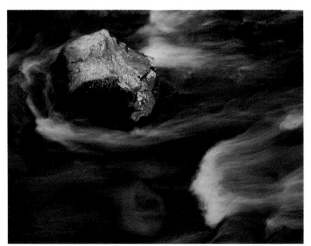

3-6

The important thing to remember is that fixing it in the computer is always just that — a fix — and a photographer will never get the best image by expecting to fix bad technique in the computer. Exposure must capture important detail, whether that is in the highlights or shadows. The histogram must show that important highlights or shadows are being recorded without clipping.

A carefully crafted JPEG file where exposure was measured thoughtfully, where the histogram was checked, where the white balance was selected correctly, will always beat a carelessly shot RAW file, both in terms of quality and in time required to "fix it." Even if an image can be fixed, what's the point of the extra time at the computer if it could be shot better from the start?

THE EXPOSURE CHALLENGE

A very popular myth with digital photographers is that an image must be underexposed to protect highlights from being blown out, and that this underexposure is easily corrected later, especially when the image is shot in RAW. This reasoning can cause some serious color and noise problems for the photographer who wants to get the highest quality images from Photoshop.

On the surface, keeping highlights from being blown out is a good idea. Once their brightness passes the threshold of a sensor, there is no detail. No amount of Photoshop work will bring the detail in those highlights back, though there are some "fixes" that can fill in washed-out highlights.

PRO TIP

Review your shots regularly, checking for exposure. Don't count on Camera Raw in Photoshop to pull out an image that is not captured correctly in the first place. When shooting landscapes and similar non-moving subjects, I recommend turning on image review in your camera for at least 6 to 10 seconds so you will immediately see the shot in your LCD after taking the picture and have time to decide if you have shot it properly or not.

For an efficient workflow, you never want to needlessly increase your work in Photoshop.

But what I have seen happening is an overcompensation of this idea, as seen in the photograph of rhododendrons in figure 3-7. Photos are underexposed so that no over-exposure flashing warnings appear in the LCD on image review, and the histogram is nowhere near the far right edge.

WHAT REALLY HAPPENS WITH UNDEREXPOSURE

Consider that a sensor is designed to respond to a certain tonal range from black to white in an image. If the full range of the sensor is not being used when the image is captured (underexposure), then some of the capabilities of the camera have not been used — capabilities that you paid for!

Now, I have heard the argument that this is not so bad. After all, especially when shooting RAW, the argument goes, there is often a lot of excess data anyway that can be used during processing of the image. That "excess" data can then be put to good use by filling in the gaps of underexposure. In truth, this is actually a much more serious issue.

A sensor does its best job of capturing bright colors if they are exposed to keep their inherent brightness registering fully on the sensor. As colors are underexposed on the sensor, obviously, they get darker. If you change exposure on a color, it appears darker or lighter in the image,

but clearly, the color doesn't change in real life. More exposure reveals the original color.

This is not true with the underexposed image itself. Increasing "exposure" in the processing, even when using Camera Raw, makes the color brighter, but does not exactly reveal the original color. This is because, as a color is underexposed and gets darker, the sensor does not respond the same to the chroma or actual color information in the image. There is less chroma with the underexposed color, offering less color to work with when processed in Photoshop.

Figures 3-8 through 3-11 show this. Figure 3-8 is an accurate exposure of the same flowers as seen in figure 3-7. Figure 3-9 shows 3-7 processed to try to match what

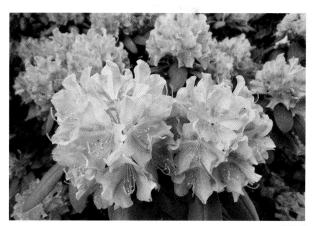

3-8

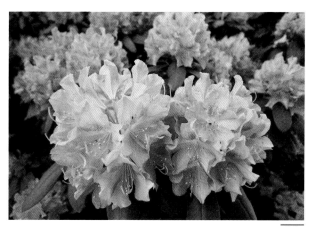

3-9

3-7

is seen in figure 3-8. This immediately meant much more work in Photoshop, and even then the colors are not a perfect match. You can see a detail of 3-8 in figure 3-10 and a detail of 3-9 in figure 3-11. The light colors of the flowers are okay as they fit the range of the sensor well, but when you compare dark tones, especially in some of the greens and overall contrast, the image from the correct exposure has more color and tonal information.

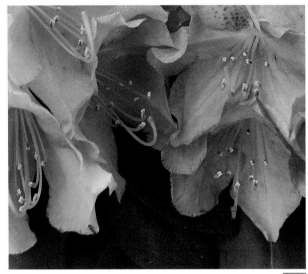

3-10

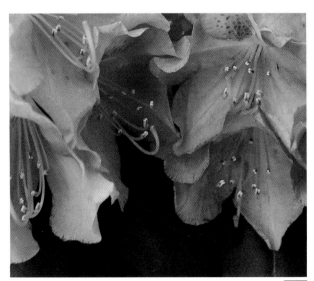

3-11

UNDEREXPOSURE CAUSES WEAKER DIGITAL IMAGES

Underexposing forces tonalities into a smaller range that especially affects darker tones and colors. When processed, these tones can be expanded, but this increases contrast (especially local or small area contrast within the photo). Subtle tonalities can be lost. A lot of photographers say "so what" to this because they shoot RAW, but I can guarantee that if you shoot a test that includes subtle colors and tones, you will see them change when you compare images with proper exposure and processed underexposure.

This can especially be a problem with higher-pixel-count digital SLRs. These cameras are squeezing more pixels into the sensor, which means the individual photosites must be smaller. Physics alone means fewer photons of light energy can be seen by each photo site. That can restrict the sensor's ability to deal with colors. Camera designers have done remarkable things with these sensors that a few years ago folks said would be impossible, but they are limited by the physics of light. So if you underexpose these cameras, you are really stretching the capability of the sensor to deal with colors at less than optimum brightness.

NOISE AND BANDING ISSUES

Another very important image artifact affected by underexposure is noise. The latest digital cameras do a remarkable job of controlling noise, and they allow higher ISO settings with less noise nearly across the board. The problem, however, is that noise is best controlled at proper exposures.

Underexposure will always increase noise, at least to a degree, and as underexposure increases, noise can increase dramatically. I have seen the same camera deliver a remarkable, nearly noise-free image when exposed properly, yet when underexposed, the noise increases so much that you would swear the ISO setting was changed. Notice the noise in figure 3-12, which is a detail of figure 3-13 after processing.

3-12

3-13

PRO TIP

Probably the easiest way to deal with good exposure is to always expose for the most important colors or tones in your subject first and check your image in the LCD. If your subject is dark, give it a little under-exposure to keep the colors and tones dark as they are in reality (and to prevent unneeded overexposure of bright areas). If your subject is light, give it a little overexposure to keep colors and tones light.

The final problem of underexposure is tonal banding. This is more of a problem with JPEG capture than RAW, but can occur in both. What happens is that the smaller tonal range represented by an underexposed image must be expanded when processed in Photoshop. This expansion can cause banding because there is not enough tonal information left to cover certain tonalities. Because JPEG starts out with much less tonal information than RAW, this can quickly present a problem in that format.

This is one reason why some photographers say JPEG is not as good as RAW. However, if JPEG is carefully exposed, you can get an excellent image file that can be processed well in Photoshop. If that JPEG file is much underexposed, though, you limit the tones you can work with, therefore making JPEG less able to be adjusted without problems.

OVEREXPOSURE IS BAD, TOO

On the other hand, everyone who says there are problems with overexposure and digital images is also correct. Overexposure puts details too high in the tonal range. When highlights themselves start losing important detail, there is no magic in Photoshop that can bring them back. Yes, you can do some repair work, but that is always time consuming and can be quite frustrating.

Overexposure can also make colors go too high in the tonal range, as seen in figure 3-14. They lose color up there, too, so when they are darkened, they look gray and lack their normal saturation (if they have any color at all) as seen in figure 3-15.

In addition, high levels of brightness can cause unneeded flare on the image. Sensor photosites can get overwhelmed by all the light and start affecting adjacent photosites, causing some blooming or bleeding of the light into darker areas. This can cause contrast to decrease, requiring you to expend even more effort in Photoshop to make the image work.

EXPOSURE ANSWERS

The answer is obviously to expose as well as possible to use the whole tonal range of your sensor. This is one reason why some wedding photographers have become frustrated with digital imaging. They were used to relying on the latitude of print film to help them deal with changing conditions. Quality digital images that allow the best control in Photoshop simply do not have that kind of latitude.

For nature photographers, this means being careful about exposure, truly paying attention to the craft of photography right from the setting up of the camera in order to capture a great scene. You can bracket exposures (not all digital photographers know what this means — it is simply the changing of exposure as you take several shots). That can be helpful, but not all subjects will allow that (such as wildlife).

Luckily for digital photographers, you have the LCD and image review, as shown in figure 3-16. You can check exposure and see where your tonalities lie. You certainly don't have to check every single image (unless you want to), because, frankly, the exposure meters in cameras today do a wonderful job. But this does provide an important tool to keep tabs on your meter and how it is interpreting the tonal values of challenging scenes.

After using a digital camera for a while, you will learn to judge good exposure from the LCD, although this little monitor alone is not the best tool for doing that. You have two resources on most digital cameras that will help: overexposure warnings (some cameras have underexposure warnings, too) and the histogram.

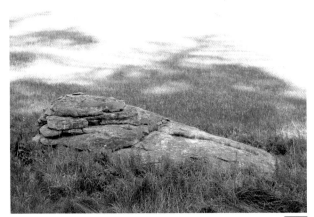

3-14

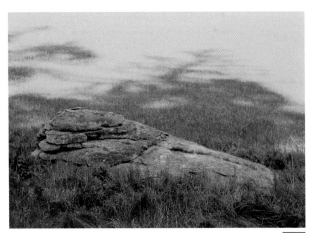

3-15

3-16

3-17

3-18

Overexposure warnings are typically blinking areas on the image where highlights are either gone (too much light for the sensor) or close to overexposure. Figures 3-17 and 3-18 simulate this warning. The best way to deal with them is to decrease your exposure until either they just disappear or they are only present in small, unimportant areas. Do not, as some photographers have started to do, overcompensate and go an extra stop or two under just to be sure the highlights aren't blown out.

PRO TIP

Don't forget that flash warnings are only rough measures of overexposure.

PRO TIP

Don't blindly follow the idea that clipping is bad. On some images, you need to clip detail in the white or black areas when the contrast range of the scene is too great for the camera sensor. Then you must decide what is most important in the photograph, expose for it, and let the clipping go.

It is interesting that Photoshop's Camera Raw will often find detail in highlights that have just started to blink as warnings, so with RAW, especially, there is no reason to overdo underexposure. Even with JPEGs, keep exposure high enough that the warnings have only just disappeared or they are barely present.

The histogram is a very important tool for ensuring that exposure will be good for Photoshop. This graph of data should avoid large gaps at the right side. That is a sure sign you are not fully using your sensor's capabilities. You want to move the histogram toward the right, as long as important highlights don't block up or clip (this is seen on

the histogram as a sharp drop-off at the right), even if the photo looks too bright in the LCD. You can always make properly exposed highlights darker, but if underexposed shadows have to be opened up, you will find noise and weaker color.

Figure 3-19 shows a good histogram for the subject, with tonalities well balanced between the ends, and the main light tones (the light colors) are on the right side of the histogram as they should be. It is important to remember that histograms take all sorts of shapes depending on the proportion of light and dark tonalities. There is no "correct" shape for a histogram.

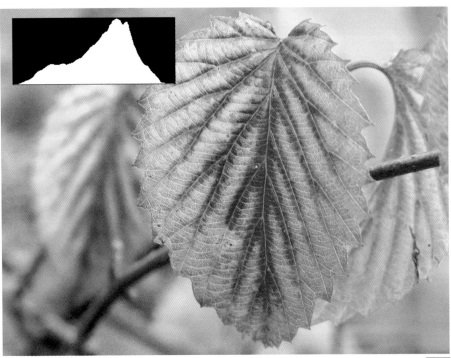

3-19

FILM CONCERNS

Film can also present exposure problems no matter how well you scan it. A poorly exposed image often means a lot of work in Photoshop. Print and slide film react differently to exposure, plus the right exposure for viewing slides may not be the same as the best exposure for scanning.

Underexposed slides are a distinct problem, even though they look great on the light table or projected on a viewing screen. This limits the tonal range available to scanners, which results in a scan that may cause problems in Photoshop. Just like in digital cameras, this can result in weaker colors, more contrasty tonalities, and increased grain.

Many film photographers have found that they need to shoot two exposures, especially when shooting the popular Fujfilm Velvia slide film — one for the light table or slide projector and one for an optimum scan. What is the correct exposure for each? That depends on how you work. Frequently, the best exposure for the slide projector is less than the best exposure for a scan. However, if you typically project in a bright room, the best exposure for projection will likely be more than the best exposure for a scan. That said, it is important to remember that overexposure is a problem with slides because when highlight details are overexposed, they can be lost, so that important detail is gone. These blank areas will present real problems for work in Photoshop.

Print film needs a solid exposure that ensures dark tones and colors have enough exposure. Underexposure causes problems with print film, too. Though print film is tolerant to a range of exposures, it is sensitive to underexposure of more than an f-stop or so. Underexposure definitely results in weaker colors and more grain. Slight overexposure, on the other hand, often benefits print film and gives it better colors and reduced grain.

PRO TIP

Bracketing is often a good solution for dealing with exposure and film (especially slide film) because you get several exposures from which to choose. You can bracket by taking pictures with more and less exposure than the meter recommends, but often you do not need to do that. With experience, you will know that certain scenes will need more exposure and others will need less. In those cases, you can just use exposures on one side of the meter reading, that is, either more or less exposure, but not both. There is no point to shooting images with exposures that are never needed for such scenes. With slide film, bracket in half-stop exposure changes. With print film, anything less than a full-stop exposure change is a waste of film.

SHARPNESS

Bear with me on this one. I know that most photographers understand the importance of sharpness. In landscape and nature photography, this is especially important, which is why the tripod market is so strong there.

However, I can tell you from experience in judging many nature photography contests with thousands of entries, that achieving the highest level of sharpness can be challenging for a lot of photographers. I have seen very fine photographs that don't quite make it because sharpness was a little off.

I am not talking about something as simple as the difference between a sharp image and a blurry one. Most photographers can discern the difference and will work to avoid the distinctly blurry or fuzzy image. I am talking about the difference between a crisply sharp image and one that is almost sharp. The latter often looks sharp if seen as a small image on the computer monitor or printed in a small size. It may even look sharp when printed at an 8 x 10-inch size and not compared directly to another image that really is crisply sharp. This is demonstrated in

figures 3-20 through 3-22. At the print size in the book, the slightly fuzzy figure 3-21 looks okay except when compared to the completely sharp 3-20.

Photoshop cannot correct a sort-of-sharp image to make it match a truly sharp photo. What is going on happens at a very small level of detail in the image that affects the appearance of the overall photo. If the camera moves at all during the exposure, the image will be blurred, as seen in

figure 3-22, which is the detail from 3-21. It shows the chattery look typical of camera movement during exposure. This is obvious as large amounts of blur, but it shows up in an image that sort of looks sharp by degrading contrast and image brilliance in the photo. Photoshop cannot replace lost image brilliance.

What is image brilliance? It is an appearance of a photograph that reflects the crispness of the sharp parts of the photo. It is very visible when you compare a tack-sharp image with one that is sort of sharp. If you enlarge the photo to small details, you will find tiny highlights that are crisply sharp in the sharpest photo. On the sort-of-sharp picture, these highlights are degraded and no longer crisp. This is reflected in the overall photo by giving a duller image with less sharpness. The crisply sharp image sharpens better in Photoshop.

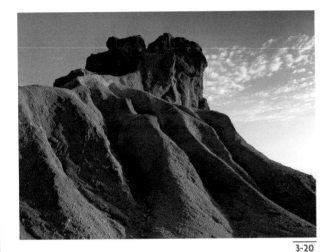
3-20

3-22

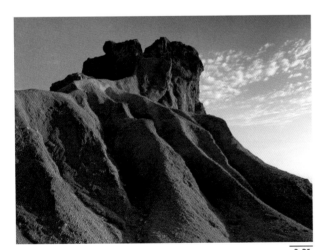
3-21

THINKING AHEAD

As you learn more about Photoshop, you will find that you begin to alter the way you photograph in order to get the most from the subject. You will think about the shot in terms of exposure, color, noise, and more so that you are dealing with the best image you can get for Photoshop processing.

This is not a new idea. Ansel Adams called it visualization. In his book, *The Camera*, he defines it as "the entire emotional-mental process of creating a photograph...it includes the ability to anticipate a finished image before making the exposure, so that the procedures employed will contribute to achieving the desired result."

Consider every choice that a photograph from a camera represents. Here, for example, are ten out of the many decisions that can be made. These decisions that a photographer can make have been selected just to illustrate how decision-rich photography is.

1. A subject is seen and selected.

2. Light and color related to the subject are considered.

3. A composition is chosen.

4. Focus point and depth of field are selected.

5. Exposure is determined.

6. The image is brought into Photoshop and overall tonalities are checked and new ones chosen as they are adjusted.

7. Overall color is checked and new variations of the color chosen as it is adjusted.

8. Local areas of tonalities are selected to be enhanced.

PRO TIP

You can see how your technique works by making several test shots. Set up your camera on a tripod and photograph a scene with a lot of detail. Shoot at a shutter speed of 1/60 second or faster to eliminate camera movement on the tripod. Then photograph the same scene handholding your camera at high to low shutter speeds. Enlarge the images in Photoshop and compare them all with the tripod-mounted shot to see how image sharpness and brilliance degrade.

9. Local areas of color are chosen for specific improvement.

10. The photo is resized based on a choice of a size for a specific need.

From the start, the photographer has to compare how the camera sees the world differently than he or she does. The camera sees contrast and color in ways that are inconsistent with human vision. In addition, the camera sees the world much flatter than you do. It wants to make everything equal within the composition, yet people don't see that way. So decisions have to be made to compensate for these things as well as to ensure later processing in Photoshop can be done efficiently and effectively.

VISUALIZATION AND COMPOSITION

Because Photoshop CS2 has resizing algorithms that are very, very good, increasing the size of a digital camera file can be done quite nicely. This, plus the fact that the number of megapixels available in digital camera sensors is increasing, means that images can be cropped and still offer excellent quality at moderate image sizes.

This brings up a very real danger. In the traditional darkroom, there was always the idea that you could "fix it in the darkroom" by cropping a large photo when enlarging it. Now you can crop a large image in Photoshop, thereby "fixing" composition problems.

This is not a good idea. Visualization or planning of your shot should include getting the best composition possible of your scene. If you casually shoot a scene thinking you can correct composition in the darkroom, that image has not been fully visualized. The question comes, then, if the composition was missed, which is very important, what else was missed when taking the picture. To me, there is no sense in making more work in Photoshop than necessary. So, get it as right as possible when you take the picture.

I typically compose photos to use the entire image area of the viewfinder. For example, figure 3-23 is the exact, original composition as seen by the camera. I may decide to crop because I see something new later in the scene, but usually it is because something was missed.

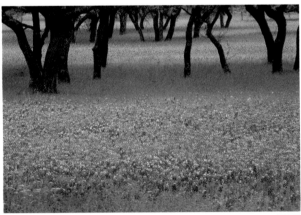

3-23

DIGITAL IMPROV

Getting the best images in the field often requires you to do a little experimenting. No matter how well you prepare, no matter how much gear you take with you on a trip into the wilds, you can never be ready for everything. Sooner or later, you will run into a photo problem that demands to be solved, yet you don't seem to have the gear to handle it.

You then have three choices — forget the photo opportunity, take a photo anyway knowing it won't succeed and hope you can "fix it in Photoshop," or do a little photographic improvisation to ensure you get the best image you can. You may have to think like MacGyver, but when you are photographing nature, which is constantly changing, the subject may demand attention now. You have little choice, but this doesn't have to be seen as a problem. I find photo improv to be fun and very satisfying when I bring a photo into Photoshop and discover a very workable file.

Film photographers often did this kind of improvisation by bracketing exposures and taking multiple compositions of the same subject, among other things, but they had a distinct challenge. They could not see results of these experiments until the film was processed much later.

Photographers with digital cameras have the ability to experiment and see the results immediately. Figure 3-24 of a snowy egret offers a good example of this concept. This was shot in the amazing Alligator Farm in St. Augustine, Florida. Really a zoo of alligators and their relatives, this place has boardwalks going through the area at shrub level where egrets, herons, and more nest. These birds have little fear of anything here because the alligators below keep predators away.

3-24

I liked this snowy egret. The boardwalk area had a lot of people jostling for position (politely, though) at the more obvious photo opportunities. I didn't want to be part of that crowd and this bird looked good. The problem was that it sat among a lot of brown, distracting branches (you can see some in the background of this shot).

Sure, I could have spent a lot of time in Photoshop trying to somehow remove or disguise these branches. Instead, I improvised while there with the subject. I knew the bird wasn't going anywhere (they pay little attention to the people there). I found if I moved just a little and changed my angle to the egret, I could shoot through a lot of leaves.

Keeping the bird in the clear, I used those out-of-focus leaves as a nice swath of color that accented the overall image quite well. Plus, I got rid of some annoying branches without any extra work. I took some test shots, reviewed them in the monitor, found the leaves looked good, but then tweaked my position a little to improve the composition and made the shot you see here.

This story points out how you can integrate a way of shooting into an approach to digital photography. You can work through problems with a subject when you are right with the subject, rather than being disappointed with the shot later or trying to "fix" it in Photoshop. You can always try something and check it on the LCD.

Some new-to-digital photographers try to keep an old film style of shooting. They turn the review off for the digital camera (the image that shows up in your LCD right after shooting) and discourage others from using the LCD. I don't think it is ever useful to say another photographer's way of working is "wrong" if he or she gets good photos. That's the bottom line — the photograph. And for some people, the LCD is a distraction, so it should be turned off. I do have a problem, however, when they then tell everyone else they should work the same way. I am all for trying anything to see how it fits my way of working, but such "should's" can be counterproductive.

The LCD is such a tremendous resource. Here are some digital improv situations that can be made better with it:

> You don't have a long enough lens for a distant subject. Can you enlarge the photo in Photoshop later? Only if the subject is sharp, so you photograph it toward the center of the image area (the sharpest part of the lens), then check it in the LCD by enlarging the subject to see its sharpness.

> Your ideal camera position makes it impossible to see the viewfinder. Take the picture; remember how the camera was set, check the shot, then try again until you get the shot you want. Figure 3-25 represents a variant of this. There was no way I could get down into these lupines like the camera could. I had an

3-25

advanced compact digital camera with flip out LCD. The LCD let me roughly aim the shot from afar, but I tried multiple exposures until I got one I liked.

> A great wildlife shot appears in front of you, perfect for your focal length, but the animal is backlit in such a way that you know its eyes will be dead black caverns that will be impossible to deal with in Photoshop. The lowly built-in flash to the rescue again! Not sure if it will work? So what! Try it anyway!

> You find you could get an exciting shot of flowers at cliff's edge or maybe a wide-angle shot of a snake that you don't want to approach too closely. There's no way to do that without putting yourself into harm's way. Or not? Maybe a bit of digital improv. Put your camera on a tripod, and then stretch the tripod out to the subject by holding it at the bottom, after first setting the camera off using the self timer. For a subject

that might be spooked by this, such as the snake, you could pretest the shot on something nearby to test the angle of the camera, the lens choice, exposure, and so on. Refine the shot by checking it on the LCD.

> You're stuck. It's a great subject, but maybe too great. The scene overwhelms your photographic senses. This can be among the most disappointing of photographs to deal with in Photoshop because the subject and your technique are okay, but the scene just never comes to life. One answer is to start improvising on site, but do it rapidly. Shoot overhead, down low, wide-angle, telephoto, more foreground, less foreground. Try a whole bunch of odd compositions to see if anything jars loose some creativity. After looking at the LCD, you'll usually find something does and you'll have a better shot that you will enjoy working with in Photoshop.

Additional ideas will come, not from thinking of every possibility, but by being open to the idea of digital improv. Whenever you find a shot that challenges you, one that you can't take with "normal" techniques, try a little improvisation. This is not about what equipment to use or what technique to try, because you can never know that until the situation arises.

This is all about being open to experimenting and just trying something to see what happens. In film, this is difficult. Some pros even take Polaroid cameras into the field in order to do some of this, but that is never easy for nature photographers. If nothing else, what the heck do you do with the Polaroid "leftovers" — the sticky chemicals on the peeled paper, the extra paper, and even the Polaroid shots themselves. With digital, you need none of that.

Q & A

I have heard that Ansel Adams used previsualization. How is that different from visualization?

A lot of people use previsualization for visualization and will say that Adams talked about previsualization. Some people claim that Adams actually used that term early in his career and writings. I don't know about that, but I have only seen the term visualization used in his primary photographic books.

Adams and others have pointed out that previsualization seems a bit odd. How do you do something before you visualize a scene as a photograph? You might get a camera out of the bag, I suppose, but even then, you are still thinking about the subject as a photograph.

Visualization is a more direct and accurate term for the process of seeing an image in your mind before you set up to take the picture. Adams said that this implies a photographer has total freedom of expression, allowing him or her many choices as to how to photograph a particular subject.

I believe this is also an approach to Photoshop. As you work with the program, you begin to visualize how certain controls work on your image before you actually use them. And it is also true that you have total freedom of expression on how you use those tools on your photographs.

What about white balance in a digital camera? Do I get any benefit from shooting anything other than automatic?

I believe you do. I rarely shoot automatic white balance because I find it makes more work for me in Photoshop. I don't mind working in Photoshop to bring out the best in an image, but I don't like doing unneeded adjustments that could have been done in the camera.

Automatic white balance (AWB) does work very well and rarely results in awful photos. However, using the preset white balance settings or custom white balance can give you more consistent results. AWB gives you two very distinct problems in nature photography:

> Inconsistent color among multiple shots of the same scene. Because AWB constantly reads the scene and changes its adjustment for every shot, you can have a group of photos that have different colorcasts. Back in Photoshop, you then have to figure out which one is right or best and then how to adjust the others to match it. Shooting with a preset white balance setting gives every shot the same overall color balance. Even if the white balance is not perfect, you can adjust all of the shots equally, making easier work in Photoshop.

> Problems with sunrise and sunset. AWB is designed to remove colorcasts, yet sunrise and sunset have natural colorcasts. If they are removed, the color we expect to see in such a photograph is not there. The internal algorithms of the processors doing AWB in some advanced digital cameras do try to recognize the color patterns of a sunrise or sunset and so do a better job of dealing with such conditions. However, you will consistently get good sunrise and sunset color that Photoshop can use well if you choose a preset white balance setting. I typically use Cloudy or Shadow settings, which give warm, rich colors to sunrise and sunset. You may prefer the Daylight setting, which is not as "strong" for such conditions.

SETTING THE STAGE: BASIC STEPS

You may have heard that there is good news and bad news about Photoshop. The good news is that this is a powerful program filled with many great tools that give it a tremendous variety of choices for working an image. The bad news is that this is a powerful program filled with many great tools that give it a tremendous variety of choices for working an image. The power and flexibility of Photoshop makes it both a wonderful tool and a challenge to learn.

As mentioned in the book's introduction, one key to working with Photoshop is to set up a standard way of working, a workflow that works for you, and stick with it. This book identifies key nature photography adjustment choices that I guarantee will work for you in the order presented. This chapter starts that process by introducing important first steps in working with an image brought into Photoshop.

With all the choices that Photoshop offers, it can be hard to know where to start. The first steps in this chapter represent critical steps for me, so I at least check them every time I open an image in the program. I do have to qualify this however, as you may have heard that you have to use adjustment layers for even some of the earliest adjustments to an image. I often use adjustment layers for many of the steps in the last part of this chapter. However, they are not a necessity to understanding this part of the process and I have found that they will get in the way if a photographer doesn't know them yet. You can do everything in this chapter without layers and do fine. Layers simply provide more options and you will learn all about them in later chapters

OPEN AND SAVE AS

Once you open an image in Photoshop, whether directly from a JPEG or TIFF file or from Camera Raw, save it right away as a separate file using the Save As

command (see figure 4-1). This immediately protects you from a number of problems. If you open from a camera or scanned file, and then save it as a new file, you have isolated your original image from any changes. You will only be working on the new file, so you can go back and get that original file at any time if you run into trouble with the image on which you are working.

If you open a RAW file, this isn't so serious, because you cannot save over your original RAW file. Saving the RAW file immediately to another format protects your time investment in adjusting the photo in Camera Raw. When the Save As dialog box opens, select a folder where you can store your file, then give it a new name to better identify it. As seen in figure 4-1, the name at the top of the original is an obscure camera number that means nothing. I recommend using some sort of code in the naming to give at least a rough reference as to what your photo is. Leave the other checkboxes at their defaults.

The biggest question most photographers have is what format to use when saving a copy of the photo to protect the original. When you open the Save As dialog box, you choose which format to use with the Format box. When you click the down arrow, a drop-down list of possible formats appears, as shown in figure 4-2. This is very confusing because Adobe gives essentially a laundry list of formats that anyone and everyone might ever possibly use. Most of these formats are useless for the photographer. It would have been nice if Adobe had allowed this to be customized for each user instead of giving such a confusing set of choices.

NOTE

You may notice that a choice under Save Options is Save as a Copy. This adds the word "copy" to your file, so if you rename the file, there is no need to select this option.

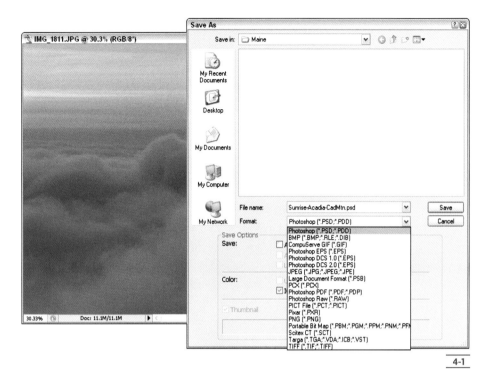

4-1

4-2

There are only three formats that are important to the photographer: TIFF, PSD or Photoshop, and JPEG.

TIFF

TIFF is a ubiquitous file format, which makes it very useful. It is a good working file format, as you can save and reopen a TIFF file as much as you want without any degradation of the image. However, Photoshop allows you to save a TIFF file with layers, and unfortunately only Adobe products recognize the layers.

When layers are discussed later in the book, you learn about managing them, including flattening them. I always flatten files for saving them in the TIFF format. That way I know I have a file that I can use as a master printing or distribution file format without layers so that it can be used anywhere.

PSD

The Photoshop (PSD) format is a perfect working format. You can open and close it as much as you want with no degradation to the file. In addition, it holds all Photoshop information and layers that can be saved. It is a great master format for use within Photoshop. It is not a good distribution format because the programs that can recognize and open it are limited (regardless of whether it has layers or is flattened). The PSD format is simply designed as a proprietary or native file format for use within Photoshop.

JPEG

JPEG is a commonly used file format for digital capture because it is a compression format that reduces the actual file size when the image is saved. Nearly all digital cameras include it.

It is also a very good format for posting images on the Web and for distributing photos via e-mail, again because

the file size can be reduced. This is also a benefit for backup when space is limited.

JPEG should not be used as a working file format in Photoshop because it is a compression format that loses data every time it is opened and then resaved. While it uses some very smart algorithms to do this compression, high compression levels and multiple resaves can cause problems because the compressed data must be rebuilt every time the file is opened. This can lead to quality loss.

But the advantages of JPEG are that it is a ubiquitous format (meaning it can be opened in any program that recognizes photos) and that it smartly compresses files to make them much smaller for storage.

ROTATE

Once your image is open and saved, you need to be sure it is rotated to the correct orientation. If the image orientation is horizontal, it normally comes into Photoshop correctly, like the image in figure 4-3. If your vertical shots come in as horizontal frames, as in figure 4-4, then you need to change them to vertical.

The rotate command is in the Image menu under Rotate Canvas. The choices there are straightforward. For verticals residing as horizontals as seen in figure 4-4, choose from the 90° CW (clockwise) or 90° CCW (counterclockwise) commands. If the photo is upside down, choose the 180° command. Arbitrary rotation is for straightening horizons, which is covered later in the chapter.

If you have a scan that is backward (flipped from reality), or you just want to see what a composition looks like reversed, you can use the Flip Canvas Horizontal command. If the scan is upside down and flipped, you can try Flip Canvas Vertical.

4-3

4-4

CROP

Cropping a photo trims away excess parts of an image to clarify the composition or to make the subject stronger within the image area.

You can crop an image at any time. While you often do a final crop at the end of image processing just before printing, there are some reasons for cropping an image right away:

> **Cropping removes distractions.** If you have photo elements that distract from the subject, they will also distract from your work in Photoshop.

> **Cropping removes excess data.** Photoshop is a RAM hog. It wants lots of RAM and this is proportional to the image size. If the image is reduced by cropping, you are not dealing with as much data. And, this excess data can add up if you have multiple layers.

> **Cropping gets rid of data that may influence adjustments.** An unneeded bright bit of sky along an edge, for example, can throw off your interpretation of brightness and contrast adjustments.

You certainly should not be cropping every image — part of the craft of photography is shooting the best image you can from the start, as discussed in Chapter 2. However, sometimes you will want to crop before doing further editing, as in figure 4-5, the harlequin bug on a bladderpod plant. The bug is a little too central for my taste so cropping helps the composition.

Cropping an image is done with the Crop tool from the Toolbox. Seen in figure 4-6, it looks like two "L's" with one inverted over the other and mimics an old cropping tool used by graphic artists. It is used like a cursor — once the tool is selected, you simply click and drag to crop the photo.

It can be used freehand or tied to specific dimensions. I recommend the freehand approach for a first crop

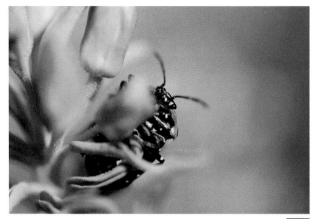

4-5

Crop tool

4-6

because this lets you remove only the problems. You can do a specific dimension crop later when the composition is better revealed, for example, through your processing in Photoshop.

For the freehand crop, follow these steps:

1. Make a rough crop over the photo to give you a start, as shown in figure 4-7. The area you keep is unaffected in tone, while the cropped area is toned down. You can change the cropped tone by clicking on the color swatch in the toolbar above the work area. You

4

Setting the Stage: Basic Steps

4-7

can also change how transparent the cropped color is by changing the Opacity setting.

2. Adjust the sides of the crop to leave only the area you want to keep. See the example shown in figures 4-8 and 4-9. The examples give you an idea of the flexibility you have. The sides are quickly and easily moved by clicking on any of the little boxes in the outline of the area and dragging them in or out. If you click on a corner and press and hold Shift, the whole area expands or contracts proportionally. The crop you choose is a very subjective thing, but relates to how you see your subject and its relationship to the rest of the photograph.

3. Move the crop area for better positioning by clicking inside the dotted lines of your crop selection and dragging the area around.

4-8

4. Crop the photo by double-clicking inside the cropped selection or by pressing Enter/Return. The final crop is shown in figure 4-10.

5. If you need to quit the crop before completing it, press Esc.

To crop to a specific size, follow these steps:

1. Set up a crop size before doing anything else by typing specific numbers in the Width and Height boxes, as seen in figure 4-11. I recommend you do not put anything in the resolution box; wait until much later in the process to deal with image resolution.

2. Click and drag the cursor on the image exactly as described before. The crop area now follows specific proportions based on the numbers you selected. You can change the overall size by grabbing and moving the corners, but the proportions will remain the same.

If you are unsure of the specific size you should crop to, you can pick a preset size by clicking the arrow next to the Crop tool icon in the toolbar above your work area. A drop-down menu with many specific sizes appears. However, I don't recommend this option at this point because it gives a specific resolution that may require Photoshop to do some interpolation to match that resolution. It is better to do any resolution changes later, especially when interpolation is involved, because pixels are being changed. As a rule, you want to minimize pixel changes this early in the process.

4-9

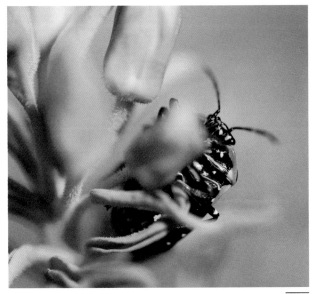

4-10

4-11

STRAIGHTENING HORIZONS

It is not uncommon for a landscape photo to have a crooked horizon, as seen in figure 4-12. This was difficult to correct when color dominated the marketplace and everyone had to have their film processed by someone else. You could not change the horizon in a slide and you had to order a custom print to fix it with print film.

Photoshop has two great tools for straightening your horizon — the Crop tool and the Rotate Canvas command.

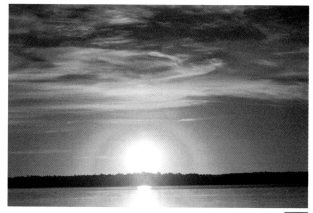

4-12

WITH THE CROP TOOL

To use the Crop tool to straighten a horizon, follow these steps:

1. Make your basic crop.

2. Move the Crop tool just outside of a corner. It becomes a two-pointed, curved arrow symbol. If you click and drag the cursor, the photo rotates, as seen in figure 4-13. Sometimes you can correct a crooked horizon just this easily.

3. For most crooked horizons, it can be very helpful to now drag an edge of your crop area close to the horizon, as demonstrated by figure 4-14. This gives you something very visual to line up with your horizon. You will not use this as the final crop, it is just for a quick reference.

4. Move your cursor outside the box until it turns to a curved arrow again, then click and rotate the crop area until the crop edge you moved close to the horizon is parallel to it. You may need to readjust the crop edge closer to the horizon so you can better see if it is parallel for best work.

5. Pull your edges out to the desired crop area (see figure 4-15). Watch the corners or you may go beyond the active area of your photograph. If you do, the crop fills them with the background color on your toolbar.

6. Double-click inside the image to finish the crop. The rotated image is seen in figure 4-16.

4-13

4-14

4-15

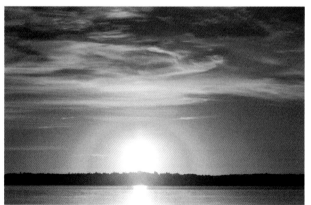

4-16

4-17

WITH THE ROTATE CANVAS COMMAND

To use the Rotate Canvas command to straighten a horizon, follow these steps:

1. Select Measure tool in your Toolbox. It is grouped with the Eyedropper tool (see figure 4-17). Click the small triangle in the lower-right corner of the Eyedropper tool and a flyout menu appears showing the other tools available. Once you select the Measure tool, it replaces the Eyedropper tool as the active tool in the Toolbox.

2. Click the tool at one point on the tilted horizon, then drag a line out along the horizon and release the cursor. You will have a line that should match the angle of the horizon, as seen in figure 4-18. If the line doesn't, you can click and drag the line off the photo and start over.

3. Set your background color to white (in the Toolbox, click the paired black/white squares icon below the foreground/background colors).

4. Choose Image ➪ Rotate Canvas ➪ Arbitrary. The Rotate Canvas dialog box with a number and direction for image rotation appears, as seen in figure 4-19. Click OK. The image rotates to match the line you drew on the horizon. It fills in the gaps along the edges with the background color (see figure 4-20), which is why it helps to select white for it early in this process.

5. Use the Crop tool to remove the odd edges that were created by the rotation.

Maine-FreeportSunrise.psd @ 16.7% (RGB/8)

16.67% Doc: 22.1M/22.1M

4-18

4-19

4-20

OVERALL ADJUSTMENTS

Once the basic cropping and rotating are done, look at the overall exposure (or brightness and contrast) and color of the photograph. If you have any severe problems, such as a color issue or a small area that has a big exposure issue, you can deal with them first. But most of the time, you want to set the overall exposure and color first.

This is important because without an overall assessment and tweaking of the image now, other adjustments can be skewed and even misleading, making your photo go in directions you did not want it to go. After making overall adjustments, start looking at local changes that need to be made. Local adjustments are small area enhancements of the image that affect only a small area or a "local" part of the photo.

In addition, by getting a photo looking its best quickly, you start to feel good about your photos. It makes the whole process much more pleasurable. If you try to fix a problem with cloning right away, for example, you might spend a lot of time doing that, getting frustrated, and never seeing the potential of the image. If you do the overall adjustments described in this chapter first, you see the beauty in your photo right away, which makes that frustration with cloning easier to work through.

SETTING BLACK AND WHITE

The first major adjustment that I always do with an image is to check and set the black and white points in a photo.

This affects every area of black and white throughout the image and is sometimes referred to as setting the blacks and whites.

> **NOTE**
>
> Technically there is only one black and one white; the reference to setting the blacks and whites may be a little misleading as it implies that there is some arbitrary, singular point for both tones that you have to find. There isn't. However, it is a shortcut way that many photographers use to describe this process.

This is important to do right away because the black and white areas in a photograph visually impact much, much more than just what is pure black or pure white, as you can see in the photograph of a lotus flower in figures 4-21 and 4-22. The only change in Photoshop that was made was adjusting the black and white points. This is probably the most important thing you can do for a nature photograph, in my opinion. It affects contrast, tonalities, and color. Without proper black and white tones, those properties of an image can not be adjusted properly.

4-21

4-22

In addition, this simple step of fixing the blacks and whites affects all uses of the image once it is done. If you print photos from an inkjet printer, a good print starts right here. A good print is not simply about using the right settings in the Photoshop Print dialog box, a proper printer profile, or the correct choices in the printer driver. If your blacks and whites are not set correctly, your final print will usually be less than what it could be.

X-REF

For a lot more detail about printing and all that it entails, refer to Chapter 15.

This step also affects pros selling their work for publication. In my work with several publications, many books, and a lot of photographers, I have seen all too many images submitted for publication that do not have proper black and white set. Many publications do not have Photoshop experts and so the designers use these photos as is, resulting in dull printed images with less color than should be there.

When you begin to work with the black and white area adjustments, remember that every photograph is different, and every photographer interprets how the blacks and whites of a photograph should look. Just compare the work of traditional black-and-white photographers such as Ansel Adams and Bill Brandt and you will see a huge difference in how they dealt with these tones.

USING LEVELS AND THE THRESHOLD

I prefer to use Levels (Image ⇨ Adjustments ⇨ Levels) for setting black and white areas because blacks and whites can be adjusted separately and because this control makes it easy to see where they appear on a photograph. It also retains subtle colorcasts that can be important in nature photographs, and it is very easy to do.

Levels has a whole bunch of controls that you don't need to worry about for working the blacks and whites of a photograph to start. You are going to be working with the main graph and its controls, which are right below it. This graph, a histogram like the one on a digital camera, represents the range of tones in an image file by graphing how many pixels represent each tone from black (on the left) to white (on the right). You don't have to know anything else about it in order to use Levels effectively.

To set blacks and whites using Levels, follow these steps:

1. Open the Levels dialog box by choosing Image ⇨ Adjustments ⇨ Levels as shown in figure 4-23. You can also press Ctrl/⌘+L keyboard to open it instantly.

Be Wary of Auto Settings

I want to emphasize how important your photograph and your preferences are. You could actually set black and white with Auto Levels or Auto Contrast in the Image ⇨ Adjustments menu. This works to some degree, but it is an arbitrary change of your photo based on computer engineer math. Adobe engineers made these controls based on looking at the data in a photograph and making the darkest part black and the lightest part white.

If all photographs were of the same subject in the same lighting, this would be fine, but they aren't. Using these auto controls takes you away from the craft of working an image, of doing work with care and ingenuity. They often take you in a direction inappropriate to the needs of your image.

4-23

2. Position the dialog box so it is up by your photograph
but not covering important detail (click the top of the
box and drag it into place), as shown in figure 4-24.

3. Press and hold Alt/Option, then click and drag the left
slider under the graph. This is the black slider. The
whole image turns white with some detail. Every
photo will be different as to what you see at this
point. This is the blacks threshold screen showing
you where areas are pure black without detail. The
colors are where channels are reaching their limit.
This is shown in figure 4-25.

4. Move the black slider further to the right (while press-
ing Alt/Option) and more and more black areas appear
on the screen. The point at which you stop moving
the slider is very subjective. I suggest moving beyond
what is normal (that is, lots of black appears), then
backing it off and releasing Alt/Option. You can now
see what your photo looks like with blacks intensified.
Don't worry about the overall tone of the image at this
point! You are only dealing with the blacks.

4-24

4-25

The Histogram

The black graph that looks like hills and mountains in the Levels dialog box is a histogram. You don't have to know anything about histograms to set black and white in a photograph. However, the histogram is simply a graph of the number of pixels at a given point of tonality, with black at the left, white at the right, and all the midtones in between. It is the same thing that appears on a digital camera. It can give you information about where the tonalities of a specific picture fit in the range from black to white.

One thing that is useful to know is that when the histogram drops off abruptly at either end, it means you have a sudden cutoff of tonal detail in the image. Once tonalities reach these extremes, they are pure black or white and cannot hold any darker or lighter detail.

PRO TIP

Don't be afraid to really play with adjustment controls throughout Photoshop. Push them beyond what looks good just to see what they do. Photographers have a tendency to be too timid in their use of the controls, which can limit their effectiveness and can even cause overadjustment. If you immediately overadjust, then back off the control until the image looks good, you will quickly find a good setting. If you only adjust a little, then a little, then a little more, each adjustment may look okay, but they can accumulate to an overadjustment without you being aware it is happening.

5. Turn the preview on and off to see the difference by clicking the Preview check box in the Levels dialog box. You can play with the black slider a bit here until you like what is happening to your blacks. With practice, you will learn what works best for your images and your preferences. For many nature images, I move the slider until blacks just appear. For a more dramatic look when the image can support large very dark or black areas, I go much farther.

6. Now go to the white slider located at the right under the histogram. Press and hold Alt/Option and while dragging it to the left. Now the screen turns mostly black. This is the white threshold screen showing you where parts of your photograph are turning pure white without detail. The colors again are where channels are reaching their limit. You see this effect in figure 4-26.

7. Move the slider further to the left (while pressing Alt/Option), and more and more white areas appear on the screen. Just as with the blacks, the point you stop moving the slider is very subjective. I also suggest moving beyond what is normal (that is, when lots of white appears), then back off the adjustment, and then release Alt/Option. However, remember that these are the highlights of your photo, and you don't want to go too far or you lose detail in important highlights. Fixing the whites in an image can lighten your photo, but do not use this control to make your photo brighter because that can mess up your highlights.

4-26

8. At this point, you can do a slight adjustment of mid-tones (overall brightening or darkening of the image) by moving the middle slider under the histogram. I don't recommend using this for any major adjustment, but if your image is almost right after fixing black and white points, this might help you finish it without a lot of extra work.

The before-and-after images of this photo can be compared in figures 4-27 and 4-28. You can see how much is affected by just using the black and white sliders in Levels.

After making black and white point adjustments, you may find that the histogram, if Levels is opened again, is no longer a solid black graph. These white lines are gaps in the data. If they are small and scattered, this is really not a problem (although some Photoshop purists will try to make you anxious about it — seriously, don't worry about it).

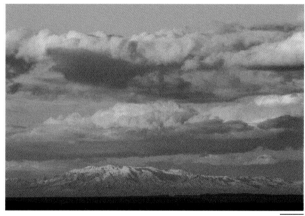

4-27

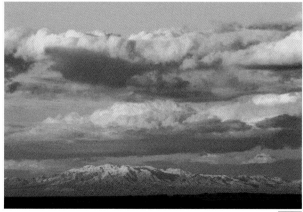

4-28

If you push the black and white adjustments too far, you may find significant gaps in this histogram, and that often translates into banding or tonal tearing in the image. Banding is where gradients do not blend smoothly but show steps, and tonal tearing happens when tonalities separate in a ragged way instead of looking smoothly photographic.

Banding is most likely to be seen in subtle gradients like the sky. You may see tearing in same-color tonalities like those seen in leaves. If your photograph has no such image artifacts, then forget about what the histogram looks like. If you are happy with the image, it really doesn't matter how the histogram looks. You will never be displaying the histogram with your photograph!

MIDTONE CONTROL

Once you adjust your black and white areas, it is time to control your overall midtones, the tonalities and colors between black and white. The setting of black and white largely affects image contrast, while in many cases, midtone adjustment is really changing the overall brightness of the image. Most of the time, you use Curves (Image ⇨ Adjustments ⇨ Curves) to adjust midtones.

Levels does have a midtone control — the middle or gray slider under the histogram as seen in figure 4-29. You can also see the gaps in the histogram discussed in the previous section — for photographs like this that have such a textured range of tonalities, they really don't mean much. While the gray slider in the Levels dialog box works and can be used to affect midtones, it is a down-and-dirty way of quickly adjusting a photo and less effective than using Curves. All you can do with the gray slider is move it left to make the image darker, or right to make it brighter.

Using Curves gives more control over midtone adjustment. It blends the change evenly from the point of difference in the tonalities where you are making the change to the ends (black and white). But it does intimidate a lot of photographers because it looks more like something from a math class than something used in photography.

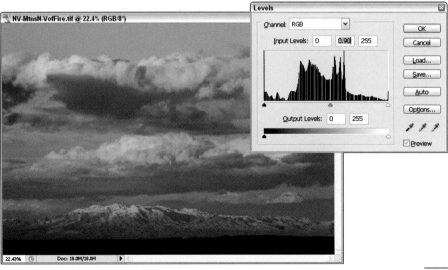

Approach Curves in a step-by-step manner and you will gain control over it. Here's how:

1. Open the Curves dialog box as seen in figure 4-30 by choosing Image ➪ Adjustments. You can also press Ctrl/⌘+M. Position it to best see your image.

2. Click on the diagonal line somewhere in the middle. Drag it up to lighten midtones (see figure 4-31) and down to darken them (see figure 4-32). This creates the tonal curve that Curves is named after. Your first click on the line can be middle, high, or low — each spot emphasizes different tonalities: middle for middle midtones, high for bright midtones, and low for dark midtones.

3. Try a big movement to see how it affects the image, and then back it off to a reasonable amount. Some images require very little change, but that little change can have a big effect. You can use the up- and down-arrow keys for slight movement of the curve at the selected point.

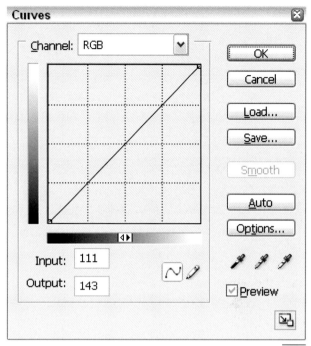

4-30

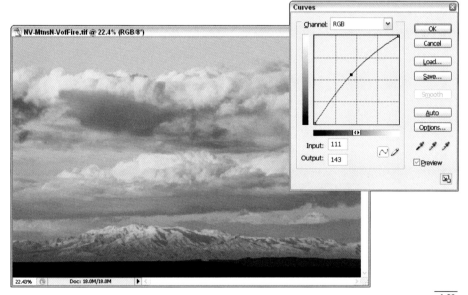

4-31

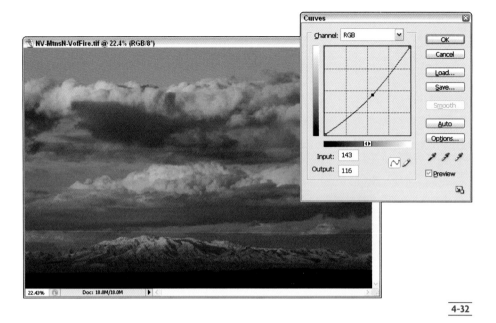

NV-MtnsN-VofFire.tif @ 22.4% (RGB/8*)

Curves

Channel: RGB

Input: 143
Output: 116

OK
Cancel
Load...
Save...
Smooth
Auto
Options...

Preview

22.43% Doc: 18.0M/18.0M

4-32

4. Now, here's the really cool part of Curves. You can add new points to change the curve. If dragging the curve upward makes the whole image look great, but the bright areas are too bright, click in the upper part of the curve and pull it back toward the center diagonal. Or maybe the dark areas are not bright enough, so click in the lower part of the curve and pull it up. In figure 4-33, two points are used, one toward the bottom dragged down to darken the darker tones and one toward the top to lighten light tones.

You can click and move the curve in as many places as you want, but most nature photographers will find that they usually use between one and three points. It is possible to anchor the curve by adding points all along it so that movement of any area of the curve is very limited.

I find that for most of my images, it is easier and more intuitive to first set an overall adjustment of the curve, then specifically tweak dark and light areas as needed by adding points there. Some experts use many points on the curve to excellent effect, but I find that for most photographers, this is confusing and not particularly effective for them. This is something you have to play with to get maximum benefit. The neat thing about Curves is that you can have a great deal of flexibility without significantly affecting the blacks or whites, as shown in the final image in figure 4-34.

PRO TIP

If you aren't sure of any control in Photoshop, try it! Play with it; move the sliders, the curves, the controls all over, and see what it does. You hurt nothing because you can decide not to use the adjustment (Cancel), you can reset the control (press and hold Alt/Option for the Reset button to appear), and even use it and then decide you don't like it, so you undo the adjustment by pressing Ctrl/⌘+Z or by backing up in the History palette.

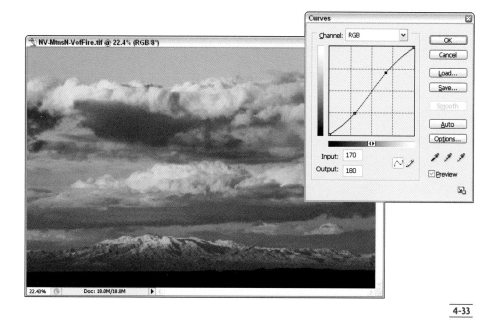

4-33

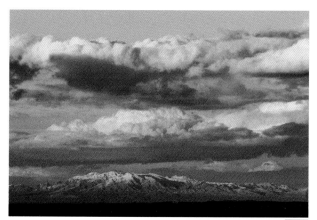

4-34

DEALING WITH COLOR

Film and digital sensors don't always record the world's colors exactly as the eye sees them. Sometimes unique, clearly identifiable colors are specifically lacking a certain quality that is normally associated with them.

For example, blue flowers frequently photograph with red in them, making them look purple when they aren't.

Or a scene may have an unnatural colorcast to it. While it is natural to find colorcasts to a scene in nature (the best example being a sunset), there are subjects that have problems with colors contaminating neutral tones. A good example of that is a stream in a dense forest that picks up a lot of green light from the trees as seen in figure 4-35. This eastern Tennessee streambed picks up the colors of the diffuse light coming from the forest all around it. As human beings, we normally don't see such a colored light, but the camera does.

There are a lot of ways of dealing with color in Photoshop, but many of them are rather complicated for the photographer who doesn't want to think like a computer technician. The next couple of sections show you two techniques that are very effective for dealing with colors in nature photographs, yet are simple and easy to use.

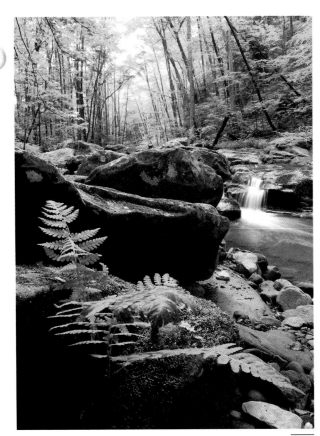

4-35

nature's colors are constantly adjusting to the changes in the sky, the quality of the light, the time of day, and the direction of the sun.

A quick and easy way of correcting problems with colorcasts that don't look right is to use Levels again. But I recommend doing this as a separate step, not as an addition to the same step where you adjust blacks and whites. This allows you to freely work the color without worrying about messing up the black and white settings.

To use Levels to deal with colorcasts, follow these steps:

1. Open the Levels dialog box. Select the gray (middle) eyedropper at the bottom right of the Levels dialog box as shown in figure 4-36. This is not for setting a midtone but for finding a neutral gray tone.

2. Move your cursor onto the image and look for something that should be a neutral tone. This can be a gray, white, or black. Click on it and Photoshop makes it neutral, shifting all the rest of the colors in the photo accordingly, which is demonstrated in figure 4-37.

QUICK AND EASY COLOR CORRECTION

Nature photographers don't need to deal with perfectly neutral colors or colors that match a specified hue like a commercial photographer would have to. The key is to get an image that reads correctly to you and the viewer. Nature is filled with colorcasts and what looks natural is always very subjective.

There is really no such thing as an arbitrary singular "color balance" to an image from nature because of the way each person's eyes adapt to a scene and because

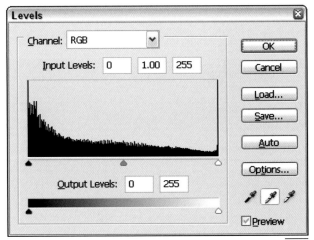

4-36

3. Try clicking on several different neutral spots (see figure 4-38). You can almost always find something that should be neutral or close to it. Some of your clicks will give you wild colors. Just try somewhere else if this happens. If things get really screwy, just reset Levels by pressing Alt/Option to make the Cancel button change to Reset, and then clicking it.

4. When you get close but the color is not perfect, stop. Photoshop has a neat tool to help here. Click OK, and then immediately choose Edit ⇨ Fade Levels. The Fade dialog box appears. This control becomes available immediately after most adjustments you make to an image (it is grayed out if you do anything else and can't be used). It lets you fade or temper the adjustment. You can scale back the colorcast change you made by adjusting the Opacity from 0 to 100 percent, as seen in figure 4-39. I like to move the slider to 0, then move it up toward 100 while watching the photo until I like the color.

This combination of the gray eyedropper in the Levels dialog box and the Fade control quickly and easily adjusts most colorcast issues in a nature photograph. Compare the finished photo, seen in figure 4-40, with the original greenish figure 4-35.

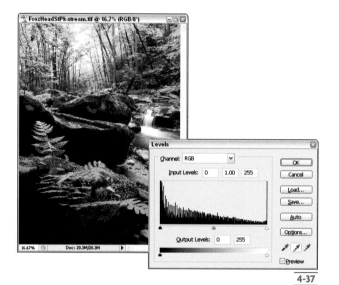

4-37

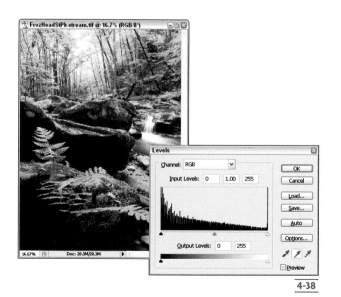

4-38

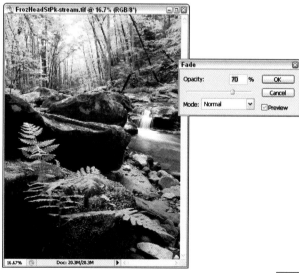

4-39

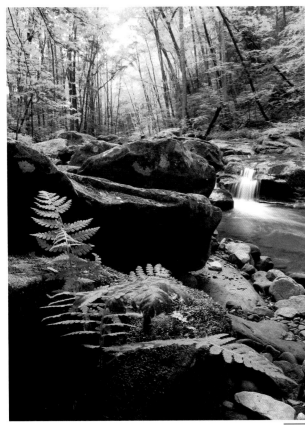

4-40

COLOR SATURATION

Another core color adjustment is saturation, and it is controlled by the Hue/Saturation tool in Photoshop (choose Image ➪ Adjustments ➪ Hue/Saturation) to open the Hue/Saturation dialog box. Saturation is the intensity of a color. Hue is, in essence, the color of a color. Photographers have grown so accustomed to the intense color of Fujichrome Velvia, long the preferred film of professional nature photographers, that they expect to see similar colors in digital images. This can require some increase of saturation.

However, because increasing saturation in Photoshop is so easy, many photographers overdo the saturation of their photos. This most often occurs when saturation is increased a little at a time. Just as you are better off to make a large adjustment and then back off with setting

black and white levels, you are better off to oversaturate and then back off. If you increase saturation in small increments, your eyes get used to the little adjustments and pretty soon the photograph's saturation is over adjusted, though a little at a time.

To use the Hue/Saturation control, follow these steps:

1. Choose Image ➪ Adjustments ➪ Hue/Saturation or press Ctrl/⌘+U to open the Hue/Saturation dialog box. It has three sliders, one each for Hue, Saturation, and Lightness, as seen in figure 4-41. Hue is mainly used for fixing out-of-tune colors and is discussed in more detail in the next section. Lightness can be used in moderation if a hue or saturation adjustment makes the photo too dark or light, but most lightening or darkening of an image should be reserved for Curves.

2. Adjust the Saturation slider to the left to remove color, or to the right to intensify color. You will see Master in the Edit box at the top. This tells Photoshop to adjust all colors equally.

3. If a photo needs some additional saturation, consider a setting somewhere between 5 and 15 overall, as was done with the lupines in figure 4-42. Most nature photos do well in this range. Anything more than that can cause problems from garish colors to increased noise.

4-41

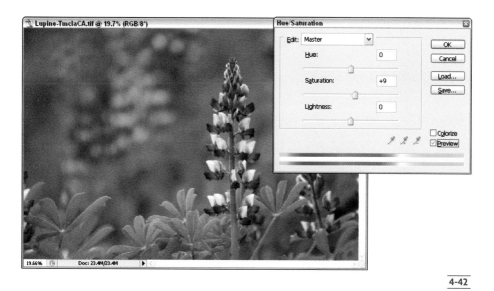

4-42

FIXING COLORS THAT RECORD POORLY

It isn't unusual to find that certain colors in an image are not recorded properly by film or sensor, even though the rest of the photograph looks fine. This happens for a variety of reasons, from film or sensor limitations with certain color wavelengths of light to the way some objects mirror adjacent colors (which degrade their own color) to sky light reflecting on shinier objects in a scene. For example, in the lupines shown in the figures throughout this section, the color is not as blue as it is in real life. Blue colors often photograph with more red then they should have.

Luckily, Photoshop has an answer to that, also in the Hue/Saturation dialog box. If you click the Edit drop-down arrow, a menu appears with a set of color choices. Choose one of those colors and Photoshop centers its Hue/Saturation adjustments around that color and without affecting the other colors. This can be a huge help in making a natural scene come to life more realistically.

To use this part of the control, follow these steps:

1. Open the Hue/Saturation dialog box and click the Edit drop-down arrow. A menu of colors appears as seen in figure 4-43.

4-43

2. Look at your photograph for the specific color you need to adjust. Select the color in the drop-down menu that seems closest.

3. Move your cursor onto the photograph. It turns into an eyedropper. Click on the exact color you want to change. The selection bars at the bottom of the dialog box shifts to match your color as seen in figures 4-44 through 4-46. Photoshop may or may not agree that

67

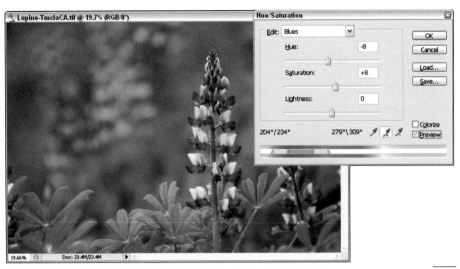

you picked the "right" color — it changes the name in the box if it disagrees (green was picked for figure 4-45, but Photoshop changed the name to yellow).

4. Refine the color choice by using the plus and minus eyedroppers in the dialog box (you can also press Shift or Alt/Option for the same effect) to be sure you are fully and only dealing with a specific color in your photo. (You can drag the markers between the color bars to make the selected color range larger or smaller.)

5. Adjust the Hue of your photo to affect the specific color you selected. You can even change the color completely, but for nature photography, you just want to refine a color to bring it into a more realistic range.

6. Adjust the Saturation as needed. You may find that some colors just don't read right in saturation as first captured by film or sensor. You may need to increase the saturation of some colors (blues are often weak and can need a big adjustment) or decrease the saturation of other colors (reds are often the culprit here). For example, in figure 4-44, I knew the blues were contaminated with red, so after changing their hue, I increased their saturation some. In addition, the greens seemed too yellow and a bit strong, so in figure 4-45, I adjusted their hue and reduced saturation. Finally, I felt the magenta in the out-of-focus background was not reading properly, so I reduced its saturation, seen in figure 4-46.

Figure 4-47 shows the photo before Hue/Saturation adjustments; figure 4-48 shows the after effects.

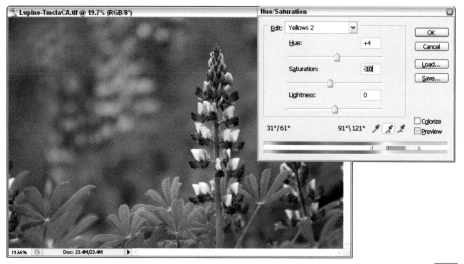

4-45

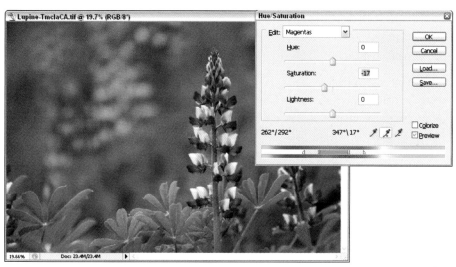

4-46

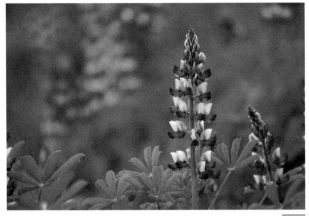

4-47

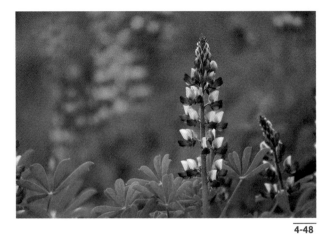

4-48

Color Space

Color space affects how you adjust the image and what you see of colors and tonalities. However, it is not so simple as it is sometimes portrayed, that is, use Adobe RGB (1998) or else. While some professionals who work with color are choosing from multiple color spaces, at this point for most nature photographers, the color spaces to use are either Adobe RGB (1998) or sRGB.

Adobe RGB is a larger color space than sRGB and offers more ability to adjust colors in an image. However, the smaller color space of sRGB will often adjust faster to an image that the average nature photographer likes. Both are valid choices, though it is true that with experience, most photographers will pick Adobe RGB for its increased control.

That does not mean you have to use either one. It is interesting to me that many photographers who once would only shoot Velvia now proclaim that Adobe RGB is the

ONLY way to go. Velvia is a contrasty, highly colored slide film with a limited color space compared to print film, yet these photographers never said you had to use print film for its increased color space.

Adobe RGB and sRGB are like film choices. They deal with colors slightly differently. You may find you prefer one over the other and there is nothing wrong with that. You can set your digital SLR to work in either, though most compact digital cameras will record in sRGB.

Then in Photoshop, you need to go to Color Settings (in the Edit menu) to tell Photoshop which RGB color space to use. Leave the rest of the Working Space section at the default settings. Then in the Color Management Policies area, use Preserve Embedded Profiles for all of the choices. If you want Photoshop to be polite, you can tell it to ask when there are profile mismatches.

Q & A

Suppose I have a photo that was shot with the wrong color balance. Should I adjust that color first or do the black-and-white thing with Levels first?

One school of thought with Photoshop is that you should take care of the biggest problem with the image first. There are good reasons for that. If a photo is strongly colored in the wrong way, for example, that color can be disconcerting and make adjusting the image more challenging.

Though that makes a lot of sense, I tend to follow the order of workflow described in this chapter. There are two reasons for that. First, I believe that a standard workflow is important. Once you establish something that works for you and consistently use it, you become better practiced at using the controls and your craft is more refined. Second, color really is affected by the tonalities of an image, especially the black-and-white areas, even if tiny. So if you don't have proper blacks and whites, you won't adjust color in the most effective way.

Where I adjust the biggest problem first is if the problem is really huge, such as having the camera set way wrong, shooting manually, and not checking the review on a digital camera. That's unusual, but can happen when the shooting is rushed.

You mention that Hue/Saturation affects noise. How is that possible, as it is affecting just color?

That is exactly right. Hue/Saturation is a color control and a very good color control at that.

Noise often has a color component to it, especially from underexposure. This is called color or chromatic noise. When you change the saturation of colors, you intensify the colors that make up the little noise details. That makes them stand out from each other more and so also intensifies the appearance of noise.

Another factor can come from overadjustment of certain colors, especially the blue of skies. One thing that is different in film compared to digital is that digital does not have the infinite gradation of tone and color that film has. In colors with slight tonal variation, digital will sometimes "cheat," in a sense, showing off the colors just fine with good gradation, but just barely. Any strong adjustment of that gradation can pull them apart (16-bit color, described in Chapter 5, can help, though). Saturation changes can overemphasize the digital quality of a gradient, making it break up like noise.

A SHORT COURSE IN CAMERA RAW

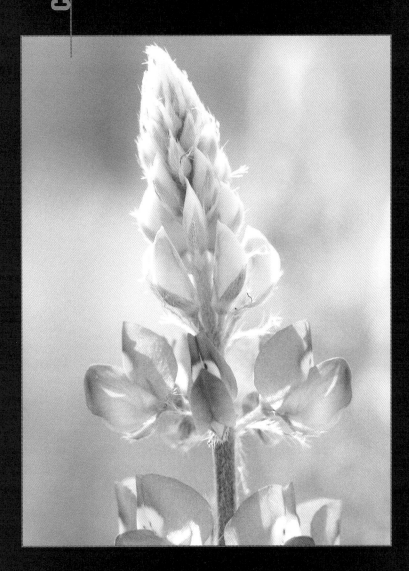

Raw image capture is an important tool for the nature photographer, but it has gained a mythology beyond its true value. It is not necessarily for everyone or every photograph. It is not, as it has been called, the pro format, as pros do shoot JPEG. JPEG shot at its highest quality gives excellent results. It also is not a magic format that somehow makes a camera sensor capable of capturing details beyond its range.

What RAW does offer is increased control and flexibility in adjusting an image. It allows strong adjustments to an image without causing banding or tonal tearing within the image. It often brings in needed detail in highlights and shadows that JPEG cannot hold. It offers better image data for photos that need to be enlarged within Photoshop.

On the other hand, RAW means more work. You need to open RAW files in a separate program connected to Photoshop called Camera Raw, shown in figure 5-1, then move them to Photoshop to continue the work. RAW files are large files when opened, and this can stress your computer system if you don't have enough RAM. RAW files can be a pain to review and edit because not all browser programs recognize them, and even if they do, you can buy a new digital camera and find that your programs don't recognize its RAW files.

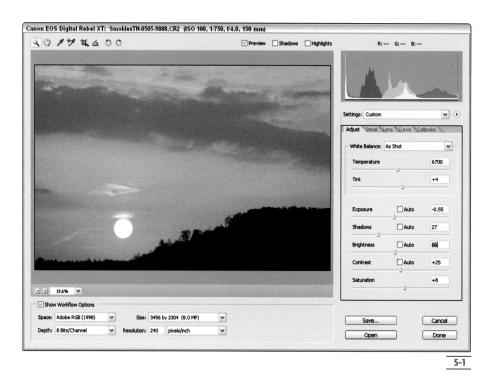

5-1

Comparing **RAW** and **JPEG** files

A RAW file is not, as some photographers believe, the raw data coming straight from the sensor. Data coming off of the sensor does have to be processed as the sensor puts out analog information, and the computer needs that information to be digital. So every camera has an analog-to-digital converter (A/D converter) that does this and can also do things like reduce noise and process color.

JPEG files offer quick and ready access to images because they don't have to be processed in order to be used. They use internal processing done by the camera to optimize the image before it is recorded to the memory card. This processing can be very sophisticated, making the JPEG image look better than the unadjusted RAW file, which means a JPEG may have a head start when it gets to Photoshop.

On the other hand, the RAW file is important for the processing potential in it that can help you gain the most from your shot. One way of looking at it is demonstrated in figure 5-2. You see an illustration showing a visual representation of comparing JPEG and RAW being used to construct the same image. The bottom-left image is like JPEG, holding all the information needed, but limited if it has to be stretched too much. The bottom-right image is like RAW, bulging with all the information needed plus a lot more, so it is less likely to be stretched too much in the processing.

Raw does allow a higher degree of control over the image that is not possible with JPEG. It does this by adding

additional data in between the black-and-white tones of the image. (It cannot expand the black-and-white range of the sensor, but it can better use the data coming from the sensor.) It can be considered a fatter file than JPEG, and with that added data, you can do more to the image.

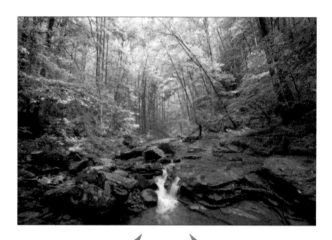

JPEG RAW

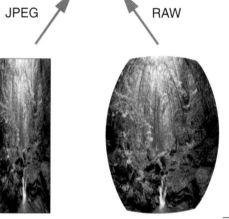

5-2

Most digital cameras have 12-bit color capabilities (this is true of all digital SLRs based on a 35mm camera body style as well as compact digital cameras). You will hear about 16-bit files; the camera is putting its 12 bits of data into a 16-bit file, but it doesn't fully use that file space. Still, with a 12-bit file, you get billions of colors for the computer to work with compared to millions of colors in the 8-bit data in a JPEG. However, this isn't an entirely fair comparison because the JPEG file is a smartly processed image based on the original 12-bit data. JPEG doesn't simply throw out the extra information. Regardless, RAW does offer considerably more maneuvering room.

Many nature photographers are now shooting RAW + JPEG to gain the benefits of both formats. Lower-cost memory cards, faster camera file handling, and low-cost high-gigabyte hard drives make this possible.

RAW DONE SMART

Always remember that when you start working on a RAW file in a RAW converter, you are working on the best data possible from your camera. For that reason, as much as you can, you should be making all major adjustments such as brightness, contrast, and color to your image in that converter.

But to get the most from your file, you need to make those adjustments smartly, with the craft of a traditional photographer as discussed throughout this book. Just because this processing is done in a special place, Camera Raw as seen in figure 5-3, does not mean you can forget the basics of the previous chapter. You need to remember the purpose of the photo and make adjustments that support its purpose. Respect your photograph.

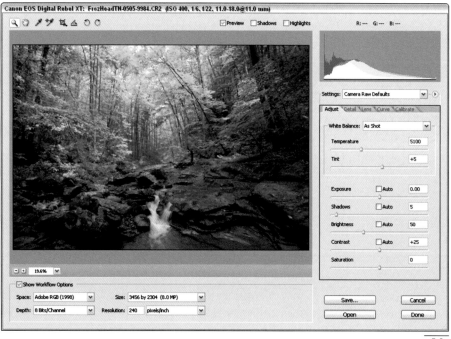

5-3

CROP AND ROTATE

You can crop and rotate the image in Camera Raw, though you don't have exactly the same controls as in Photoshop. I actually prefer doing the main cropping and rotating in Photoshop after processing the RAW file in Camera Raw.

The Camera Raw Crop tool looks identical and acts similarly to the Photoshop Crop tool (shown in figure 5-4). A big difference is that this Crop tool never actually crops the image. You see the cropped area as a tilted, highlighted box. It is only cropped when you finish processing in Camera Raw and open the photo into Photoshop or save it to a file. You can go back and change it at any time.

5-4

WORKFLOW OPTIONS

Once the photo is opened, I start at the bottom left of the Camera Raw interface and check the settings there. The Show Workflow Options check box should be selected as seen in figure 5-5. You now have several things that can be selected. Most of them I tend to set once and leave them at those specific settings. (Camera Raw will use these settings until you change them.) You need to make a decision, at least the first time you open Camera Raw, about them.

The following sections explain how to decide what Workflow Options you need to choose.

5-5

SPACE

Click this box or on the drop-down arrow to open a menu of color spaces as seen in figure 5-6. I recommend using Adobe RGB or sRGB. (You are always safe with Adobe RGB, though many photographers find sRGB gives them faster results that they like.) You can click back and forth between these two color spaces for comparison.

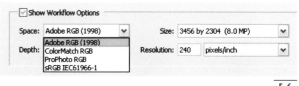

5-6

DEPTH

You have a choice of 8 Bits/Channel or 16 Bits/Channel, as shown in figure 5-7. It is very important to understand that this is an output choice for how the image is exported from Camera Raw and will not affect what you are doing in the Camera Raw program. Any processing you do in Camera Raw is done in the 16 Bit/Channel space. For most nature photographs, an 8-bit output works fine most of the time (though some photographers just like to have 16 bit as a sort of insurance that this amount of bit depth is always available).

PRO TIP

The problem with 16 bit is that it doubles your file size and can clog your computer system. But when you need it, such as when making large local adjustments on subtle tonal gradations, 16 bit can help. If you see banding occurring in an image you have opened in Photoshop as 8 bit, go back and reopen it as 16 bit. If you have enough computer power, you can choose 16 bit all the time and see if it makes any difference to you once the photo is in Photoshop.

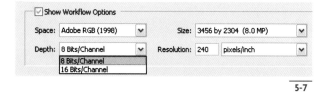

5-7

SIZE (OUTPUT SIZE)

This setting has another drop-down menu with a series of choices for image size. The number without a plus or minus sign is the native file size that your camera produces based on the size of its sensor, as seen in figure 5-8. If the number has a plus, the file is increased in size; if it has a minus, it is decreased compared to the original. If you know you need a large file from your photo, this is a good place to upsize your image. There are, however, mixed opinions as to whether it is better to do this here or in Photoshop CS2 with its latest interpolation algorithms.

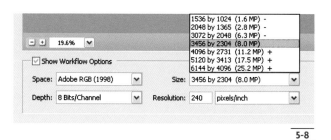

5-8

CS2 is critical for this point as there are no mixed feelings for any earlier versions of Photoshop. For them, I have never heard anyone disagree that resizing in Camera Raw is absolutely best. It was in CS2 that these algorithms were changed.

Resizing in Camera Raw theoretically builds that size better because it is using more basic data from the camera. Frankly, the sizing algorithms used with both Camera Raw and Photoshop are superb. If you do resize in Camera Raw, you get a much larger file. If you decide to use 16 bit, make sure your computer has adequate processing power and RAM or you will have problems.

X-REF

If you have questions at this point about sizing an image, Chapter 14 goes into detail about resolution.

Resolution (output resolution)

This has no effect on image quality, but is here purely for workflow reasons. Output resolution only changes how close or far apart the computer puts pixels and does not affect their quality. This can always be changed later without any harm to the photo. For most photos, 240 pixels per inch (ppi) is as good a place as any to start (it is a common printing resolution). If you are going to use your photos for publication, use 300 ppi. An image with an appropriate resolution for its final use means less work later checking image size.

Auto Settings

When Camera Raw is first opened in Photoshop CS2, all of the auto settings are turned on by default as seen in figure 5-9. The auto settings do work, but with varied amounts of success, depending on the photo.

I recommend that you deselect the Auto check boxes — Camera Raw is the epitome of control so you don't want to waste that control by using auto settings. Auto settings allow arbitrary mathematical formulas to decide what your photo should look like (sort of like Auto Levels and Auto Contrast mentioned in Chapter 4). Once you deselect them, save the change. Select Save New Camera Raw Defaults from the Settings drop-down menu seen in figure 5-10.

PRO TIP

Sometimes you just want to quickly see what a certain control can do for a photo. You can always select any individual auto setting to see if it helps (and sometimes it will).

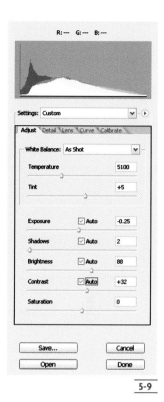

5-9

5-10

TONAL ADJUSTMENTS

The exposure of a scene affects the tones and contrast of an image. Together, they have a great impact on how it is perceived by a viewer. Composition is affected, but mood is probably the most strongly changed element of a photograph when it is made brighter, darker, or the contrast is changed. These are other reasons why I like to start work on an image by controlling tonality, which was also described in Chapter 4. In Camera Raw, you can apply much of what you learned in that chapter to the adjustment of a RAW file.

Here's an overview of the tonality controls of Camera Raw, most of which can be seen in figure 5-11:

> **Exposure:** Though the whole image gets brighter or darker, use this slider to change highlights. A control named Exposure sure seems like it would be for overall tonal adjustment (which exposure in the camera is used for), but it actually controls the bright areas of a photo. Exposure acts just like the highlight slider of Levels when you press and hold Alt/Option while adjusting it.

5-11

> **Shadows:** This slider affects the shadows and black levels of the photo. The whole image darkens, but the key to this adjustment is the actual dark elements of the subject or scene. Shadows acts just like the black slider of Levels when you press and hold Alt/Option while adjusting it.

> **Brightness:** This is like the middle (gray) slider of Levels but offers a better algorithm for adjustment. Simply move it back and forth until you like the overall tonality of the image. As you change Brightness, you may find highlights (Exposure) and shadows affected such that they have to be slightly refined in their own adjustments.

> **Tone Curve:** This adjustment of Camera Raw (introduced in Photoshop CS2) has its own tab, Curve, and is an excellent way to adjust the overall brightness of the image (midtones). In the adjustment section of Camera Raw, there are a set of tabs. Camera Raw opens with the Adjust tab by default. You will see more about the adjustments in the other tabs later in the chapter. You work the Tone Curve in its tab (see Figure 5-14) just like Curves in Photoshop as described in Chapter 4. One difference is that this curve comes with three "preset" curves: Linear (the same as the default for Curves), Medium, and Strong Contrast. You can try these immediately or set your own points to create a custom curve.

> **Contrast:** This slider affects the overall contrast of the image, but is a bit too heavy-handed for my taste. I believe you gain better control of the contrast by separately adjusting the Exposure and Shadows settings and by using the Tone Curve. Most of the time you can leave it at its default.

Understanding these controls helps you judge how to use them. They are interactive — once you make an adjustment with any control in Camera Raw, you can go back and readjust it at any time. You may see things differently as you work an image. That's one advantage of Camera Raw — you are not doing anything permanent to the underlying file and can change controls as much as you want.

Now that you have the basics of the first set of controls, try this workflow. I find it helpful in working an image in Camera Raw to optimize its tonalities first.

1. Press and hold Alt/Option and click on the slider for Exposure. The whole image will usually get black except for a few small areas as seen in figure 5-12. As you move the slider, the bright or colored areas represent highlights. The white is pure white, no detail. Be sure to alternately click on and off of the slider or press Alt/Option on and off to see how these areas relate to the whole image.

2. Continue to press and hold Alt/Option, and move the Exposure slider to the right to increase bright areas, or to the left to decrease. This is a very subjective decision, but generally you want at least something very bright in most photos. Try moving the slider too far and then backing off the adjustment to get the best setting for your image. One thing to watch out for in landscape photographs is the sky. Large areas of sky should remain bright without clipping (losing detail and color).

3. Press and hold Alt/Option and click on the slider for Shadows. Just the opposite of Exposure, the whole image becomes white except for a few small areas as shown in figure 5-13. The black or colored areas represent the deepest shadows — the black is pure black, no detail. Again, try alternately clicking on and off of the slider or pressing Alt/Option on and off to see how these areas relate to the whole image. Depending on your image's original exposure, the threshold screen

5-12

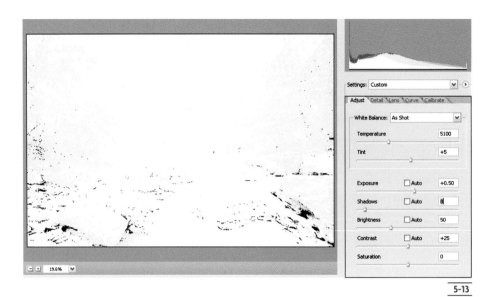

5-13

that appears using this technique might also show up as pure white at first until you move the slider.

4. While pressing Alt/Option, move the Shadows slider to the right to increase dark areas or left to decrease. This is also a very subjective decision, but generally you want at least some area of black or near black in most photos as this affects both color and contrast. In many photos, the blacks appear in ways that are quite clearly defined. I often adjust the blacks until they just start to outline some key features in the composition. Again, try moving the slider too far and see how the image is affected; you may find the whole thing becomes rather dark. Be careful not to leave this slider too far to the right — you can tell you've gone too far when the dark areas block up and the image looks harsh.

5. Making the exposure (highlight) and shadow adjustments often make the photo too dark. To correct that, adjust the midtones. If you are comfortable with Curves, use the Tone Curve. It has its own separate tab (see figure 5-14). You click the tab to reveal the curve. To adjust it, follow the same instructions given for Curves in Chapter 4: Click on the curve, move it up or down to make those tones lighter or darker, add

points to adjust tones in other areas (lighter tones are higher on the curve, darker tones lower), and so forth. One difference from Curves in Photoshop is that this curve adjustment includes four settings in the Tone Curve drop-down menu: Linear, Medium Contrast, Strong Contrast, and Custom. Linear is the standard, straight-line curve that opens with Curves in Photoshop. Custom shows up when you make any changes to any curve. Medium and Strong contrast give you some starting points for making further adjustments (though you can keep them as is, too).

6. If you are less comfortable with any type of curves, try using the Brightness slider for midtone adjustment as shown in figure 5-15. Like the Tone Curve, this adjustment is very subjective and is totally a matter of taste. This also demands a calibrated monitor for best results. Making your image brighter lets you see more details, but that photo can also lose some of the drama that comes from darker tones. Do not press and hold any keys for this adjustment; however, it can be useful to try the auto setting here before making manual adjustments. When you use the auto setting, the slider moves to a specific point that can be used as is, or you can adjust from that spot if needed.

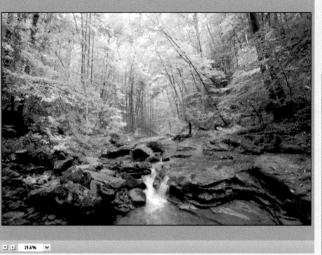
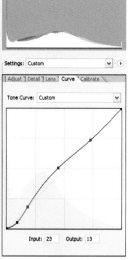

5-14

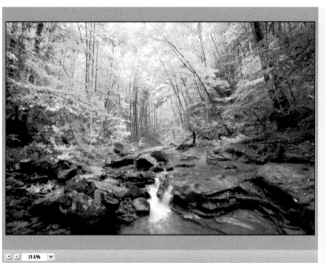

5-15

X-REF

For more information on monitor calibration see Chapter 4.

7. Leave Contrast at its default. I don't find this slider as useful as the Tone Curve for dealing with contrast in an image, so I rarely use it. Even when there was no Tone Curve, I rarely used it. I found I liked the results better when I affected the contrast of an image by how I used the Exposure and Shadow sliders.

8. As a final check, you can turn on the Shadows and Highlights warnings. I am not fond of them, but you will hear so much about them that you should know what they are. These are located above the image preview (see figure 5-16). They turn on colored warnings to tell you that highlights and/or shadow areas have lost detail (or are clipped as Adobe calls it). You can select them one at a time or turn both of them on at once as seen in 5-16 to see where the darkest and lightest areas ended up in the photo. With these warnings, you see colored areas: red for highlights, blue for shadows. I find them confusing, which is why I don't like them.

9. Select and deselect the Preview check box as you make adjustments to see how the image has changed. (This only affects the adjustments in a single tab, unfortunately, so as you use the other tabs described more in detail later, the preview only works for the last things you do.) If you find you lose something important in the tonalities when you compare the preview with the older version, readjust the image.

5-16

Once you've made some adjustments, if you are unhappy with the changes, you can reset the whole thing by clicking the Settings drop-down arrow above the sliders (see figure 5-17). Select Camera Raw Defaults from the menu. This resets Camera Raw to the original image settings. You can also press and hold Alt/Option and click Reset, which will appear at the lower right, replacing Cancel.

PRO TIP

Small adjustments can make a big difference. Sometimes I wish this interface had two sliders for each control — one that had the main adjustment and another for finer tuning. But it doesn't, so realize that small changes can be enough. If you really have trouble doing a small enough adjustment, type new numbers in the box above the adjustment in slight increments at a time.

5-17

COLOR ADJUSTMENTS

Color of an image is a tricky thing. Many images of nature have an accepted colorcast that viewers expect to see, such as a landscape at sunset. On the other hand, some subjects pick up colorcasts that the average person does not notice in real life, but the film or sensor definitely sees.

Start working the overall color of the scene by adjusting the color balance first. You do this by using one of four controls:

> **White Balance tool:** This tool sits above the preview image to the right of the Hand tool in figure 5-18. Selecting it changes your cursor to an adjustment tool. It turns your cursor's icon into an eyedropper (assuming you have set your preferences to show tools as icons). It acts like the neutral gray eyedropper in the Levels dialog box. Click on something in the photo and Camera Raw makes that point neutral gray, plus everything else in the photo compensates for this change. If you try this tool, you can always get back to your earlier "as shot" colors by double-clicking the tool in the toolbar or selecting As Shot in the White Balance box.

5-18

5-20

> **White Balance:** This set of options on the Adjust tab (see figure 5-19) mimics your camera's white balance settings. Choose from a number of white balance presets in this menu to jump from one overall color to another. If you are working in Windows, view the different color balance settings by double-clicking on a setting choice so that it is highlighted, then move through all of the settings using the up- and down-arrow keys or the scroll wheel on your mouse. For the Mac OS, you must click on each choice individually.

> **Temperature (color temperature):** This slider (see figure 5-20) lets you tweak the image by adding warmth (moving it to the right) or adding coolness (moving it to the left). Slight changes make a big difference, so try typing smaller number changes in the box above the slider scale.

> **Tint:** This is a green/magenta scale that adds green to the photo as the slider is moved to the left and magenta as it is moved to the right (see figure 5-20). Unless you are after some special effects, it is rare to use big amounts for this adjustment. It changes as you click with the White Balance tool and can have a very big jump if the original image was not shot at the proper white balance setting on the camera.

Camera Raw has two additional controls for color: Saturation, located near the bottom of the Adjust tab; and the Calibrate tab. Most nature photographers use Saturation a lot and Calibrate rarely, though the settings in the Calibrate tab can help when individual colors need to be affected because it allows you to adjust both hue and saturation of red, green, and blue (the actual channels of color information that are used to make up the RGB of the computer, which in turn gives all the colors).

Saturation is another highly subjective control, and you have to be very careful with it. A little addition of saturation goes a long way. A common mistake of many photographers is to increase saturation too much so that the image either looks garish or doesn't reproduce properly outside of Photoshop.

The Calibrate tab is new to Photoshop CS2 (shown in figure 5-21) and is something many photographers are just discovering. It is not something the average photographer will use regularly, but it does offer some unique color controls. It allows you to adjust Shadow Tint, Red Hue, Red Saturation, Green Hue, Green Saturation, Blue Hue, and Blue Saturation. This gives the RGB colors of the computer two individual controls each.

5-19

5-21

by the little waterfall — note that the White Balance changed. This tool gets you a variety of color balances to the image. Keep going until you get what you like. If nothing works, check the Temperature and Tint settings of a correction that is close. You can then type in those numbers in above the Temperature and Tint sliders, then move the sliders from those points, using them as a start.

2. Examine the picture when White Balance is set to As Shot. This is Adobe's interpretation of what the camera meant to capture for a certain white balance. Now try selecting each setting. (Most of the time you will only use the daylight settings of Daylight, Cloudy, Shade, and Flash for nature photography.) The settings do not directly correspond to camera settings (they are Adobe's interpretations), but they give you a quick way of changing white balance. In many nature photos, Cloudy adds a nice bit of warmth to the photo, Shade can be too strong, and Daylight often makes green foliage look its best. Daylight, however, is not how people see photographs of sunsets.

WORKING RAW COLOR

Here's a way of workflow that will help you deal with color using these color controls:

1. Starting with the White Balance tool, click around the photo on elements that seem like they could be neutral in tone. In figure 5-22, I clicked on the rocks

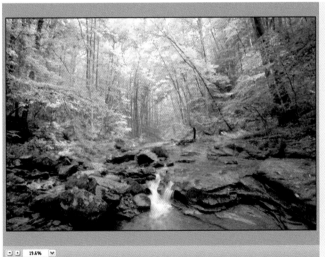

5-22

87

3. If you don't like any of the presets, adjust the Temperature and Tint as shown in figure 5-23. If the photo needs to be warmer from that preset, move the Temperature setting to the right. If the photo needs to be cooler in tone, move the slider to the left. A photographer friend of mine used to shoot many outdoor subjects with strong warming filters and film, so he is willing to push the slider farther right than I am with this adjustment on his digital images. This is a very subjective thing, but be careful that you don't make the photo look artificial.

4. Temperature adjustments usually need some Tint tweaking. Most of the time in nature photography, you don't need too much of a change. You may find that a scene with a lot of foliage looks better with some additional green, so move the Tint slider left. On the other hand, gray rocks sometimes look better with the slider moved a little to the right. That adds magenta, but it also subtracts green, and the reduction of green

may be key to working this, rather than thinking about the addition of magenta. Watch your neutrals for too much of either color.

5. Check Saturation as shown in figure 5-24. This is tricky in that you need to be careful about overdoing this control — a little goes a long way. It is also a very personal control that you will temper over time by working with Camera Raw. That said, many subjects, especially in nature, look good with a slight addition of saturation (saturation is the intensity of a color) of perhaps 5 to 10 points.

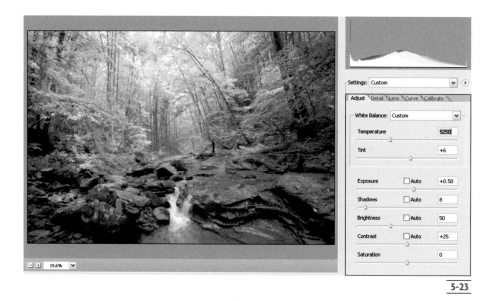

5-23

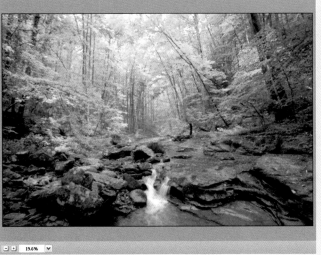

5-24

6. If you have some colors that don't quite adjust correctly, the controls on the Calibrate tab (seen in figure 5-25) can help, though this is not a tool most photographers use regularly (and many never use it). The key to Calibrate is to work the sliders based on specific color adjustments you want to make. In other words, affect the colorcast of shadows separately from the rest of the photo by using Shadow Tint. If you need to tweak reds, use the Red Hue and Saturation controls. The hue affects the actual color of the red, while saturation affects its intensity. For green and blue, use their controls in the same way. You can affect other colors if you keep in mind that magenta comes from the combination of red and blue, yellow from red and green, and cyan from green and blue.

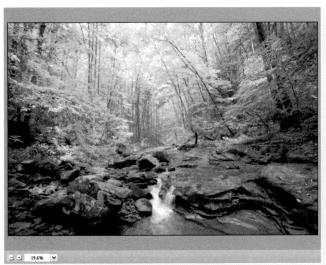

5-25

DETAIL ADJUSTMENTS

After working the overall tonalities and color in Camera Raw, I like to check noise issues in the photo. Noise (or grain in a film camera) is a very important part of how a photograph looks, so you will find I mention it several times in this book. Camera Raw processing affects noise. Adobe even includes a special section for it found in the Detail tab seen in figure 5-26. You see three new adjustments here: Sharpness, Luminance Smoothing, and Color Noise Reduction.

5-26

> **Sharpness:** I feel that this is too early to deal with sharpening for a number of reasons, one of which is that it can adversely affect noise. Just set this to 0.

> **Luminance Smoothing:** This affects the general noise that comes from a sensor and may be seen in skies and other smooth tones.

> **Color Noise Reduction:** This affects color noise that often comes in dark parts of an image, especially when that image is underexposed.

It is important to note that these noise reduction settings are not for getting rid of problem noise but to reduce normal levels of noise so that the image goes into Photoshop at as high a quality as possible. If you use these controls to try to remove high levels of noise, you can also cause problems with details in the photo. You are better off in those situations using a program specially designed to deal with noise problems.

Here's how to use the controls on the Details tab with most photos processed in Camera Raw:

1. Using the Zoom (magnifying) tool, greatly enlarge a smooth-toned area in the photograph so you can see any noise that might be there (see figure 5-27). A good place to look in many nature photographs is the sky. It is hard to say what you might find. Every camera is different, plus different exposures and image tonalities can affect the appearance of noise. This particular shot has very little noise in it.

2. Try moving the Luminance Smoothing slider with big jumps back and forth to see any changes that might be possible. I also move the image around, looking for luminance noise, by holding down the spacebar, which turns the cursor into the Hand tool and allows you to click and move the photo inside its preview. If you really don't see much noise, keep the adjustment low, maybe 10 to 15 points or so like in figure 5-27. If noise is high, try going up to 40. Usually, I don't like going much higher because it can adversely affect small details.

5-27

5-28

3. Again use the Zoom tool, but this time greatly enlarge a dark area in the photo. This could be a deep shadow, a dark tree, or something similar. Now you are looking for chromatic or color noise — in figure 5-28 there is really none. If you had color noise, it would look like color speckles in the dark like what figure 5-30 shows (a different image than 5-29 just to illustrate what color noise looks like).

4. If you exposed the image correctly and at low to moderate ISO settings, the image will likely have little color noise (an image with no noise is said to be very clean). In that case, you don't need to add any Color Noise Reduction. I am very conservative in using this tool with nature photographs, because Color Noise Reduction reduces color in the little details as well as the noise. In many nature subjects, all of the color that comes from the scene is important. If you find color noise, use the slider cautiously, only to remove the worst of the problem.

PRO TIP

The Ctrl/⌘+0 keyboard command is one of the most useful for the photographer and worth memorizing right away. This works in any part of Photoshop and allows you to instantly go from any magnified part of your photograph to seeing the whole image placed between the toolbar and work palettes. This is so useful because you can use the magnifier (Adobe calls it the Zoom tool, but it looks like a magnifying glass) to check a detail's adjustment, then immediately go back to the whole photo.

5-29

5-30

FIXING LENS ABERRATIONS

Lenses today are really pretty good. So, lens quality issues such as lens aberrations are usually pretty small. However, they can occur in some lenses, especially extreme-range zoom lenses at certain f-stops and focal lengths, in inexpensive lenses on low-priced digital cameras, and with strong accessory lenses used on compact digital cameras. Camera Raw gives you an opportunity to correct some aberrations in those lenses and greatly improve an image. You find these controls on the Lens tab.

To find out if your lens has some issues, enlarge a photo to see details along the edges, especially contrasty details like tree branches. If the edge is clean, you have no problems. If colors appear around the edge, an effect called color fringing, then you have a problem. An example of a problem image using the Lens tab interface is shown in figure 5-31. It was shot using an extreme fisheye lens on a compact digital camera. If the colors are red and cyan, move the Fix Red/Cyan Fringe slider back and forth to reduce them. If the colors are more blue and yellow, use the Fix Blue/Yellow Fringe slider for control. Photoshop actually goes into the image and affects how it lines up colors along the edges with this control.

The other two settings available for adjustment in the Lens tab are for vignetting. Vignetting has to do with some lenses that have a hot spot in the center. Again, these are not so common today, but some lenses, such as mirror telephoto lenses and extreme zooms, have this effect. It can be corrected here with the Amount slider. The Midpoint slider affects where the center of this vignetting adjustment occurs.

5-31

Save Your Work

The default for Photoshop CS2 is to automatically update your adjusted RAW file's thumbnail in the Bridge when you open the file, save it, or click Done. This is not a permanent change — actually, nothing at all is changed to the file itself, only the instructions about processing this file have been changed so that this file will reopen in Camera Raw with these settings.

To keep this photo with its adjustments, you have several choices at the bottom right of the Camera Raw interface seen in figure 5-32: Save, Open, Cancel, and Done.

5-32

> **Open:** This is the most common use of Camera Raw. It simply applies the settings on your photo as it converts it to the Photoshop working space.

> **Cancel:** This cancels everything and returns you to Photoshop.

> **Save:** This lets you save your adjusted image to your hard drive as one of four file types: DNG, JPEG, TIFF, or PSD. Plus it gives you some choices as to how to save these files, such as the location (what folder) and a new name.

> **DNG:** This stands for Digital Negative and is Adobe's all-purpose RAW file. It keeps the RAW data of your original intact. This format is still developing; it is a good format for archiving RAW files. For most purposes, you will use the default settings (lossless compression and medium JPEG preview).

> **JPEG and TIFF:** These give you image files that can be opened by anyone on any platform. JPEG also lets you compress the image when you need quickly a smaller file to send to someone over the Internet. TIFF gives you an uncompressed (or losslessly compressed) larger file.

> **PSD:** PSD is a Photoshop file. It is the ideal working file for an image that you will work on more in Photoshop (you can just open the image to do this — using the Save choice here would be to keep a file to work on later).

> **Done:** This merely updates the instructions for processing the RAW file and returns you to Photoshop without actually opening or saving the image. All of your settings are retained as instructions that will be used any time you reopen the RAW file in Camera Raw, but this is a specialized and not very common way of using Camera Raw.

Setting Up Camera Raw for Your Camera

Camera Raw recognizes image files from your digital camera. Now that you know how Camera Raw works, you can set it up so that when it opens with a file, the starting adjustments are set as you prefer to work on them.

Before you save new defaults for Camera Raw, open an image and make these setting adjustments:

> **Auto:** Deselect all the Auto settings on the Adjust Tab.

> **Space:** Put in the most common color space that you want to use in Workflow Options. If you aren't sure, use Adobe RGB (1998) for now.

> **Size:** Choose a size in Workflow Options that is appropriate for most of your photography. You may find it best to use the native size of the photo (the original megapixels — the choice that does not have a + or − after it).

> **Depth:** Most work looks fine with 8 Bits/Channel setting in Workflow Options. You always have the choice to go to 16 Bits/Channel when needed.

> **Resolution:** If you are making prints from an inkjet printer, 240 is a good number. If you shoot for publication, use 300. These are in Workflow Options.

> **White Balance:** Use As Shot on the Adjust Tab.

> **Sharpening:** Set Sharpening on the Detail tab to 0. Don't sharpen images in Camera Raw.

Once you have made all these settings, click the right-facing arrow in the circle to the right of the Settings drop-down menu. Choose Save New Camera Raw Defaults from the flyout menu that appears (see figure 5-33). These settings will now occur any time you open a RAW file from the same camera.

There are several other options in this flyout menu.

> **Load Settings:** This setting lets you use settings that you have saved in the next section.

> **Save Settings:** This setting allows you to save certain settings that you find work consistently for your images. I find they apply mainly to photographers working on images from a shoot that has consistent conditions, such as studio photography. Consistent conditions are rare in nature, so it is rare that you can save settings that will apply to a lot of photos. However, if you are doing flash close-up work or nature photography under other controlled situations, you can make changes to a single photo, then save those settings so they can be applied to other images brought into Camera Raw.

> **Save Settings Subset:** This setting just gives you the option to limit what settings are saved rather than saving everything that Camera Raw does.

> **Export Settings:** This setting allows you to save the settings for use on another computer.

> **Use Auto Adjustments:** This setting turns on all the Auto settings, which you may have realized by now I don't find very useful.

5-33

> **Reset Camera Raw Defaults:** This setting takes you back to the original Camera Raw settings.

> **Preferences:** This setting opens a new window (see figure 5-34) that lets you control a couple of small features. One is how image settings — the adjustments you've made to your file — are saved. Remember that when settings are saved with a RAW file, nothing is actually changed on that file — this is only processing information or instructions that are applied when the file is opened. These settings can always be changed. The choice seen in 5-34, Save settings in Sidecar ".xmp" files, is best. These are small system files that Photoshop keeps with your photo and lets Camera Raw and Bridge know how you have adjusted this file, so an adjusted image appears as a thumbnail in Bridge and when the photo is opened in Camera Raw.

Camera Raw Preferences (Version 3.1)

Save image settings in: Sidecar ".xmp" files

Apply sharpening to: Preview images only

OK

Cancel

Camera Raw Cache

Maximum Size: 1.0 GB Purge Cache

Select Location... C:\Documents and Settings\Owne...n Data\Adobe\CameraRaw\Cache\

DNG File Handling

☐ Ignore sidecar ".xmp" files

☐ Update embedded JPEG previews: Medium Size

5-34

Apply sharpening to is a choice you have in how sharpening is used. You can simply turn off sharpening altogether in Camera Raw by moving the slider in the Detail tab to 0 (my preference) or you can choose Preview images only from the drop-down menu so you can see what effect final sharpening might have when you sharpen at the end of the process. You can generally leave Camera Raw Cache set to the default unless your main hard drive is short on space. This is the "thinking room" that Photoshop uses for working on Camera Raw images. If you have multiple hard drives, you can set it to your fastest, most open drive.

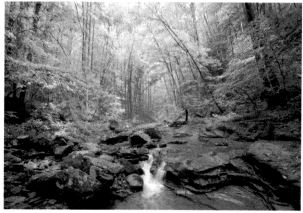

5-35

The image in figure 5-35 is the finished image shown in most of the examples throughout this chapter. This has had no further processing other than the Camera Raw tweaks and sharpening in Photoshop.

The histogram at the top right of Camera Raw is different than the Levels histogram. It is confusing to me. What's it all about?

What you are seeing here is a histogram of the individual RGB channels. The histogram for Levels is a luminance-only histogram and is easier to read. I find the channel histogram confusing, too, and I rarely look at it. It would have been more useful, I think, to have a histogram that could be switched between luminance and channels.

Still, this colorful histogram is read similarly to the standard one in Levels. You need to watch the right and left edges. Anything that hits either edge without tapering down to 0 (in other words, looks like a cliff) will be clipped. It shows if your detail is gone in the brightest or darkest areas.

What if I have several similar photos that need to be adjusted? How do I do that in Camera Raw?

Camera Raw for Photoshop CS2 added the ability to adjust more than one image at a time. It is really pretty simple to do. Select the photos you want to adjust in the photo browser that comes with Photoshop (File ⇨ Browse), which is Adobe Bridge, and then press Enter/Return to open them into Camera Raw. You use this browser like any other browser or file open command. Select images by clicking on one, holding Shift, and then clicking on another so all in between are selected. Or Ctrl/⌘-click each image you want, one at a time.

Camera Raw opens with all of the images ready for processing. One image is displayed in the main work area, with others appearing in a filmstrip at the left. You can click on any image to choose it for adjustment. Then when you like it, you can click on another image. You will then notice that a new button, Synchronize, becomes active. Clicking it gives you a choice of what parts of Camera Raw to synchronize between the main image and the image you have just selected.

Or you can Ctrl/⌘-click multiples or click Select All (above the images) to adjust them at the same time as you adjust the main one open on the preview screen. Everything is adjusted similarly unless you use the Synchronize button to control what is or isn't being adjusted among the multiple photos.

LAYERS AND OTHER ESSENTIAL TOOLS

Part II

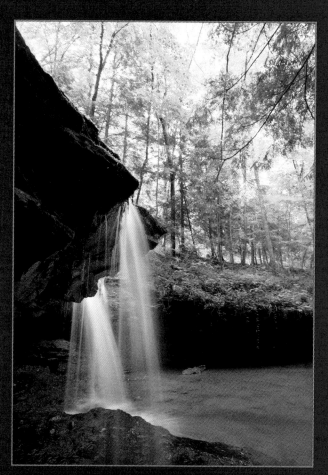

LAYERS 101

In all my classes and workshops, using layers is consistently the most feared part of Photoshop for new users. Yet, the layers feature is also one of the most valuable parts of Photoshop. In this chapter, I want to give you the tools that enable you to say "I can!" when faced with layers because once you start using layers with confidence (and I believe you will), you will never go back to not using them.

Look at the before and after images in figures 6-1 and 6-2. Nothing too intimidating here. You can clearly see

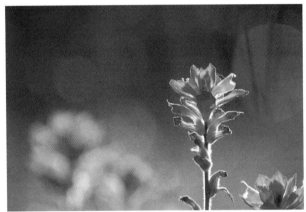

6-1

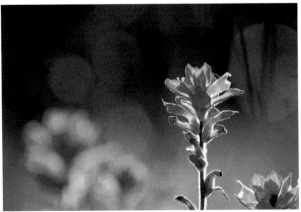

6-2

the benefits of Photoshop processing to bring out the best in the photograph. However, layers made this change easier, and believe it or not, faster to do than not using layers, plus it was done with a lot more control. You, too, can gain from the power of layers.

WHY NOT SELECTIONS?

You may know selections and how they can be used to isolate and control parts of a photo separately from each other. For example, circle a flower with a selection and you can change and adjust it without affecting anything else in the photograph. But, layers offer the chance for the photographer to isolate key parts of the adjustment of an image with more power and flexibility, and you can put layers together in such a way that they interact with each other for even more control.

Layers can do so much with flexible and changeable control, which is not possible when making selections directly to an image. If you already use layers, you understand what I am talking about; use this chapter as a review, with perhaps a few workflow ideas you can use. If you are not familiar with layers, this chapter gives you the tools you need to be able to successfully and effectively use layers.

I do discuss selections a little later in the chapter. They are useful, but once you know layers and their accompanying layer masks, you will find you no longer need to spend the time that selections often require to do well.

KEYS TO UNDERSTANDING LAYERS

To use layers, you need to understand what they are and how they work. Every photographer really has seen layers at work. Your mouse on a mouse pad over the desk is a set of three layers: the mouse, the mouse pad, and the desktop. You cannot see the desktop under the mouse pad, nor the part of the mouse pad under the mouse. You look from top down and see whatever is on top first.

Or consider a pile of photos as represented by figure 6-3. You can easily understand this pile, and it is another set of layers: the top landscape photo; the grasshopper photo; the flower photo;, the stream photo; and at the bottom, an earth-toned, textured surface. You know you can move each photo separately, move it up or down in the stack, rotate it, and so forth. You can remove any or all of them, add new images, and play with the group.

This is exactly how layers work, and at the right of figure 6-4 you can see the actual layers that are used to create this "pile" of photos. This screen shot shows each image as a separate layer in the Layers palette (if your Layers palette is not open, choose Window ⇨ Layers). The Layers act like real life, too — the top photo of the stack is the top of the Layers palette. The bottom, textured surface is the bottom or background layer for Photoshop. You view the Layers palette just like you would view a

6-3

6-4

real-life stack of stuff — from the top down. The top layer blocks the view of things under it just as a top photo would.

Suppose you put a piece of clear red plastic on top of a stack of photos as seen in figure 6-5. Everything under the red plastic would take on the color of the plastic, though this is not a permanent change, of course, as it is only sitting on top of the photos. But, just like a filter in front of your lens, everything seen through this red is colored by it because we look from top to bottom.

Now look at figure 6-6. This shows the Layers palette, and there is the red filter on top (called Layer 5). It also affects everything underneath it because you also look at Photoshop layers from top to bottom, and it also is not part of the other layers, so it can be moved, rotated, or otherwise changed without affecting any other layer. Always remember that the Layers palette acts like a stack of anything in real life — you look at it from the top down.

6-5

6-6

ANSEL ADAMS WORKED IN LAYERS

Okay, so he really didn't work with layers, because his prints had no layers. However, he acted as though he did have layers, making adjustments very carefully, one stage at a time as if each adjustment was a layer. Take a look at figure 6-7. These are Ansel Adams's notes for making his famous *Clearing Winter Storm, Yosemite National Park, California* photo in figure 6-8. Everything in figure 6-7 could be done easily, effectively, and consistently with layers. Shortly, you learn about adjustment layers (if you don't know them already), which could be used to match everything in Adams's notes.

For those not familiar with traditional darkroom work, the notes are read from left to right, top to bottom. The first simply includes general notations about the image and processing chemicals and paper used. The rest show the exact adjustments Adams used, step by step (or layer by layer). Circles represent selected limited adjustments to that area. Arrows represent a moving change, that is, Adams was moving his dodging (lightening) or burning (darkening) tool during the exposure.

6-7

Ansel Adams's notes used with permission of The Ansel Adams Publishing Rights Trust. All Rights Reserved.

Exposures are listed in seconds. A minus in front of a number means that the area was given less exposure to lighten the area (the area was dodged). A plus means the area was given more exposure to darken the area (the area was burned in).

Now, imagine that each step adds a layer to the image. First, the dark trees at the bottom right had a lightening layer added for them. Next, a darkening layer made the lower part of the image, especially the left corner, a little darker. Then the right and left edges had another darkening layer added to tone them down. Obviously, Adams felt at this point that the left-top corner was too bright, so another layer is added to darken it.

Now, notice that Adams spent a lot of work with the top of the image. Skies are often captured on film much brighter than they are seen in real life, which is reflected in the original negative that Adams was working with. A graduated neutral density filter would not have helped because it would have made the entire top of the image dark, including the already dark sky at the top right, which did not need to be any darker.

So the next imagined layer affected the central portion of the sky. Adams then obviously found the overall top of the photo to be too bright and out of balance with the rest of the photo, so he darkened the top part of the image significantly with 10 seconds of added exposure. Next is another darkening layer, this one darkening the central top area of the sky. A final burning in occurred in the central area of mountains to the left of the falls.

FLEXIBLE, ISOLATED CONTROL

The Adams example gives a great example of very flexible and isolated control over an image. He gained this control because he went at the photograph one step at a time. He looked at what happened to the photo with each change, and then went on to the next adjustment. Each step was isolated because each had to be done one at a time and in a distinct order.

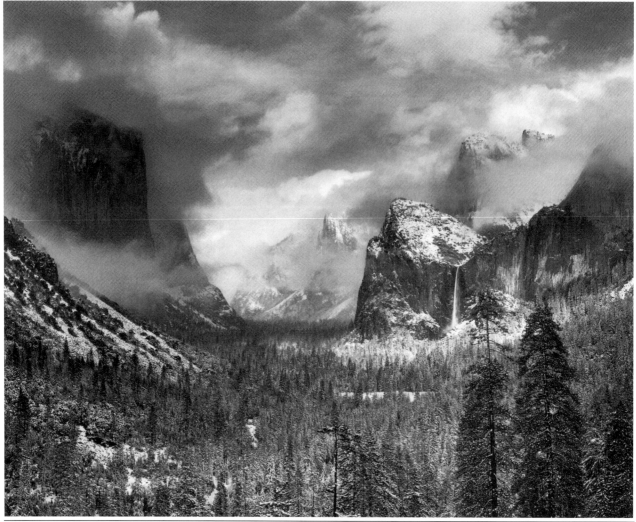

6-8 — *Clearing Winter Storm, Yosemite National Park, California*
Photograph by Ansel Adams.

Layers offer you exactly that control over your landscape and nature photography, but go beyond what Adams had available in the darkroom. He had to make all of the adjustments directly to a single sheet of enlarging paper. He then had to process it in order to see how any new effects would work (which would take 10 minutes or so each time). If it wasn't right, he'd try again with a new sheet of paper. This trial-and-error process could take hours, and Adams was even known to take days to get to a final print.

With Photoshop, however, you can make a change and see it instantly. There is no waiting for the print to develop and you are not stuck in an isolated, darkened room with toxic chemicals for hours. With layers, you can try different adjustments and not change the original image, unlike Adams, who had to physically alter the printing paper. This

means you can do all sorts of adjustments, keeping them isolated, until you find what works best for you and your image. It also means you can do this much faster, achieving high levels of control without spending days in the darkroom.

Easing into Layers with Adjustment Layers

Adjustment layers are a tremendous asset to the photographer, and, I believe, one of the most important parts of Photoshop that a nature photographer must learn. They allow you to make changes to a photograph without actually affecting the image file's pixels. That means you can readjust any adjustment layer as much as you want with no degradation of the underlying image. This is important because the more you adjust a photo directly to its pixels, the more likely quality issues or image problems begin to appear.

Imagine the changes described in Adams's *Clearing Winter Storm* photo being done entirely to the original image. That would mean a lot of pixel-level changes that could be very harmful to the final photograph. By doing this with adjustment layers, all of those changes could be made without harming a single pixel.

Adjustment layers can do this because they are simply instructions that sit over the photo. They are like a filter over your lens. The filter doesn't change the actual scene being photographed, but it does affect how the scene looks in the photograph. Because you always look at Photoshop layers from top down, any adjustment layer will affect whatever is below it.

Photoshop offers a whole set of controls in adjustment layers, including Levels, Curves, and Hue/Saturation, which were described in Chapters 4 and 5. Adjustment layers can be opened from two places: in the Layer menu (Layer ⇨ New Adjustment Layer) and at the bottom of the

Layers palette when you click the Adjustment Layer icon as shown in figure 6-9 (the icon is a circle, half black, half white). When you click that icon, you get a list of all the adjustment layers possible. Select the adjustment you want and a new layer is added to your file. If you go the Layer menu route, you will also get a set of adjustment layer choices. Chose one and the the New Layer dialog box seen in figure 6-10 appears. For now (and actually in most landscape and nature photography), you can just click OK and ignore the choices in the dialog box.

6-9

6-10

In figure 6-11, you see a photograph with its associated adjustment layers: Levels 1 and Curves 1. The Levels 1 layer was added first and the Curves 1 layer second. Just like if you added filters to a stack of photos, each added layer is normally added to the top of the stack and affects everything below it. What you are seeing in figure 6-11 is the effect of both adjustment layers. Remember though, that because you added these adjustments in layers, the pixels represented in the photograph layer, which Photoshop calls Background by default, are unaffected.

An important thing to know about all adjustment layers is that you can always reopen any of them at any time and readjust them. All you do is double-click the adjustment icon in the layer (the little diagram in the box at the left side of the layer). This reopens the exact adjustment you used before, and you can change it at will, still with no ill effects to the original image. You can even reset the whole adjustment by holding down Alt/Option to get the Reset button to appear in the dialog box in which you happen to be working.

PRO TIP

You can change the size of the icons and thumbnails in your Layers palette. Click the right-facing arrow at the top right of the Layers palette. At the bottom of the drop-down menu that appears, select Palette Options, and a whole set of choices for layer thumbnail sizes appears.

ADDING YOUR FIRST ADJUSTMENT LAYERS

Figure 6-11 shows the first steps you normally use when dealing with an image — adding Levels and Curves adjustment layers to set blacks, whites, and midtones. And, by using adjustment layers, they are done in a non-destructive, readjustable way. This section shows you how this is done, plus introduces concepts of layer naming, turning layers on and off, and changing layer opacity. This section also reviews the information from Chapter 4 to put it into context of adjustment layers, and to help you understand the principles of adjustment layers.

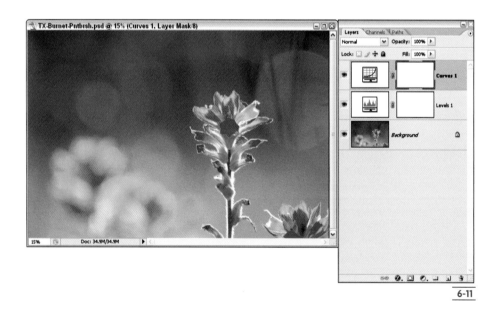

6-11

▶

To adjust blacks, whites, and midtones with adjustment layers, follow these steps:

1. Open your photo (and remember to Save As a new file for protection of the original), and open a Levels Adjustment Layer (Layer ⇨ New Adjustment Layer ⇨ Levels). The Levels dialog box appears. You may recognize this dialog box from Chapter 4, but now there is an adjustment layer in the Layers palette above the original photo, as seen in figure 6-12. It is that layer that you are adjusting, not your actual photo.

2. Adjust blacks and whites. Press and hold Alt/Option as you click and drag the black and white sliders to show you the threshold screens for black and white. Figure 6-13 shows the black threshold screen.

Figure 6-13 also points out an important concept for nature photographers in setting a black. There is no such thing as an arbitrary right way of doing this. You need to see what your image is doing with a particular black setting. Some people (like me) prefer a more aggressive black than others, particularly in a photograph like this. To me, I want the dark background to be a rich dark, which means I need to at least start to see a pure black there. I don't care about the dark channels represented by the colors in this specific image; I will deal with midtones that affect the important colors later. I am more interested in the relationship of colors within the photograph than I am in how the graph and graphics of Levels represents them.

PRO TIP

Always set your black and white areas of your photo first. I mentioned this in Chapter 4, but I know some readers will skip to this chapter. Good black in a photo is absolutely critical for the best color and tonality in an image. White is also important, though less so. By setting your blacks and whites first, you set a stage for proper adjustment of everything else in the photo.

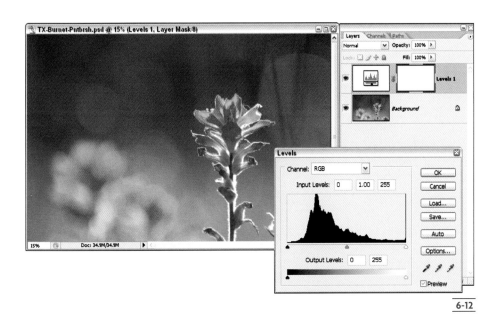

6-12

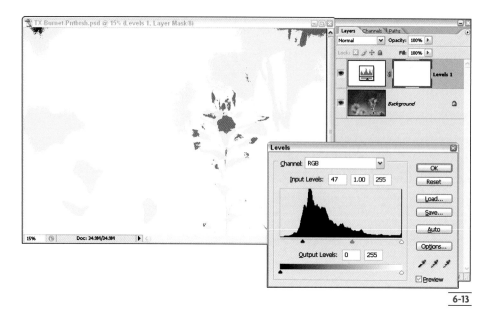

6-13

3. Adjust the midtones. Just as in Chapters 4 and 5, I use Curves to adjust midtones, but this time with a Curves adjustment layer as seen in figure 6-14. I clicked the Adjustment Layer icon at the bottom of the Layers palette and selected Curves. I am able to bring up the colors of the flowers quite nicely, making the image a lively one. Notice that the layers still sit over the original background image, which has not been changed.

4. Name the layers. In figure 6-15, you will notice the names of the adjustment layers have been changed. I highly recommend you name your layers — it is easy to do and helps you remember what each layer does. Double-click on the layer name and type a new name (in figure 6-15, Midtones is being typed). I also think

naming layers makes them more intuitive. Seeing "Midtones" instead of "Curves" makes more sense in photographic terms.

PRO TIP

Previewing changes made to an image is important throughout the processing of a photograph. It helps to compare the adjustment by turning the Preview option on and off. Once you have layers, you get a new chance to see these changes. You can turn the layers themselves on and off quite easily to see their effects. Just click the Eye icon at the left side of each layer. You can also turn all of the layers off above a chosen layer (to see what they are doing to the image) by pressing Alt/Option and clicking one layer's Eye icon. Usually you will choose to do this with the bottom, background layer.

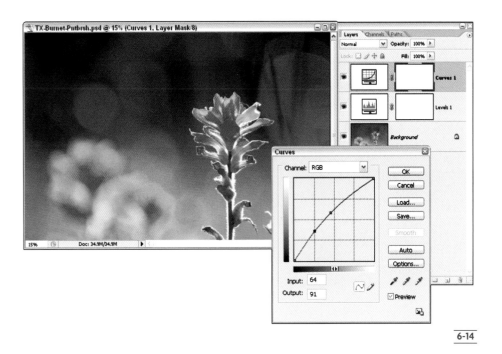

6-14

6-15

5. One click color correction: In Chapter 4, you learned how to use Levels and the gray eyedropper for color correction. You do the same here, but now add a new Levels adjustment layer just for this purpose. Using Layers makes this easy color correction method even better. This is because if at any time you find you don't like the color, reopen the adjustment's dialog box by double-clicking the adjustment layer's icon and try using the gray eyedropper again on something neutral in the scene.

6. If the one-click color correction almost works, but not quite, you can often accept it and then change the Opacity of the layer (you can also see this as the opposite of transparency). Consider the Texas hill country paintbrush flower shown in the examples. The photo looks good, but the color seems a little brown.

In figure 6-16, you can see the color of the photo has changed due to clicking with the gray eyedropper just to the right of the sharp flower. This made that area neutral, shifting the overall color balance, but now the photo looks too neutral and has lost its warmth.

7. At the top of the Layers palette, click on the arrow at the right of Opacity. A slider appears that allows you to change how much of the layer is used to affect the photo underneath. I often set this to 0 and then move the slider quickly to the right until the photo looks right. In this case, the color correction looks about right to me at 36 percent, as shown in figure 6-17. When you do this, do it visually and don't pay attention to the percentage.

8. If the colors need adjustment for color saturation, add a Hue/Saturation layer. Use the dialog box exactly as described in Chapter 4. In this particular photo, however, Hue/Saturation is not needed. Never do an adjustment just because you can. Always be sure it relates to the needs of the photograph.

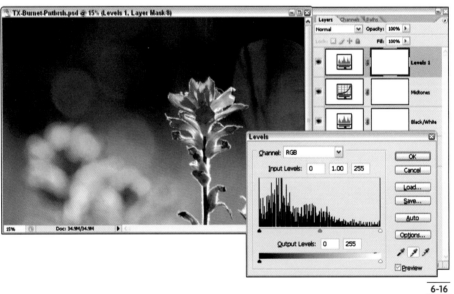

6-16

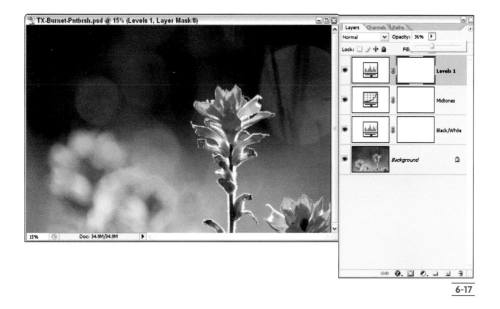

6-17

ADJUSTMENT LAYERS GET EVEN BETTER WITH LAYER MASKS

You may have noticed a big, white, empty box in each adjustment layer to the right of the adjustment icon box. This represents a very important and useful tool, a layer mask. However, layer masks tend to confuse photographers at first because they are not very intuitive, but they are definitely worth learning to use.

A layer mask allows you to selectively turn the effects of a layer on and off. White is on, black is off (and grays fit in between). So far, you have seen adjustment layers with their complete effects, and you will notice that in all the figures so far, the layer mask box is white, meaning the full effect of the layer is in use. You could fill any of the boxes with black to simply turn the adjustments off, but there is little point to this because you can always turn a layer off simply by clicking its Eye icon.

The big advantage of layer masks is that you can isolate different parts of the photo to turn the layer on or off just for that part of the image. A layer mask can be used with any layer, but because they come automatically with adjustment layers, this is a good place to learn them and see the control they provide.

Looking at the Texas paintbrush photo, you may notice that the bottom left of the image is a little out of balance from the rest of the photo. It is too bright compared to the main subject. In the traditional darkroom, this would have required some burning in. There is a Burn tool in the Photoshop Toolbox, but that can give you spotty, uneven results and a lot less control than I show you now. You could also use a Selection tool to select the lower left of the photo for adjustment, but selections are tedious compared to using a layer mask.

To make use of a layer mask to carefully and quickly balance one area of this photo to the rest, follow these steps:

1. **Darken the photo.** You need to get an overall darkening to start. For this kind of change, I add a new adjustment layer for Brightness/Contrast as shown in figure 6-18. I know that all the experts say this is an awful thing to do, and it is true that Brightness/Contrast is a blunt instrument that causes problems for overall adjustments. In this case, however, indiscriminately making everything darker or lighter (which is what Brightness/Contrast does) is exactly what you need. I arbitrarily dropped the brightness 15 points in this case, but every photo requires something different. However, because this is an adjustment layer, guessing an amount is no problem as it can be changed later.

2. The photo needs to have the effect of this darkening layer limited to the out-of-focus flowers in the foreground at the bottom left. Black in the layer mask turns off the effect, white turns it on. In this case it is easiest to turn off the whole effect first and paint it back into the areas that you want it. This is done by filling the layer mask with black. Be sure the layer mask icon is active (it will have an outline), then choose Edit ➪ Fill to open the Fill dialog box shown in figure 6-19. Click the Use drop-down arrow and select Black — leave the rest of the dialog box options at default. You can see the effect in figure 6-20. The photo looks identical to what is seen in figure 6-17, even though an extra adjustment has been made. The top adjustment layer has a big black box, meaning the layer mask is filled with black, turning the effect off.

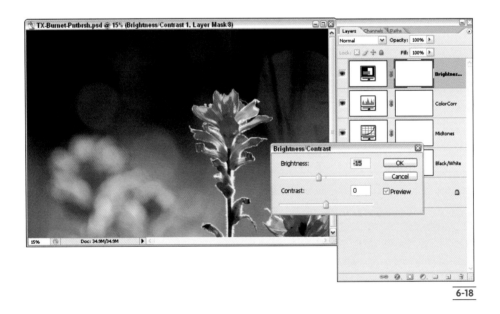

6-18

PRO TIP

Remembering what black and white do to a layer mask can be hard at first. Keep in mind that with Photoshop you can always try something and see what it does if you aren't sure. Some people like the little saying, "White reveals, black conceals." Another thing that helps is to compare the layer mask to a light in a room. If the light is off, the room is black, and you can't see anything in it. Turn the light on and white light helps you see what is in the room.

6-19

3. The darkening effect needs to be brought back into the photo by putting white into the layer mask in limited areas. In this example, this is best done by painting white on the layer mask. Select the Brush tool from the Toolbox. Choose a large, soft-edged brush with the tool options bar at the top of the screen, below the menus as seen in figure 6-21. (This brush view can be selected by using the drop-down menu by Brush in the Options bar, and then selecting Small Thumbnail from the fly-out menu accessed from the arrow there.) As you learn this technique, you can change the Opacity of the brush to reduce its intensity, but at this point, leaving it at 100 percent works great.

4. Be sure the correct layer mask is active in the Layers palette, and then paint white over the areas of the photograph where you want to turn on the effect. Make sure white is selected as the foreground (top)

6-20

color in the Toolbox as seen in figure 6-22. You can see the limited area of the effect in figure 6-23. Note the darker lower-left part of the photo and the white area in the layer mask icon. The neat thing about this technique is that if you mess up painting in white, you can easily fix it by painting back in black (just change the foreground/background colors by clicking on the curved arrow just above them to the right or just press X). Layer masks are totally and completely changeable by painting in black or white wherever you need the change and at any time.

NOTE

So far, not much has been said about the little overlapping color boxes near the bottom of the Toolbox. That's because you really haven't needed to know much about them to do anything up to this point. Here you do need to know where they are and how to deal with them. In a layer mask, these overlapping colors are usually black and white (though they can be gray, but never a color like red or green). The top color is the foreground color; the bottom is the background color. You can always get to the default of white on top, black below by clicking the white/black icon just below the actual foreground/background colors. You can switch them by clicking on the curved arrow above them or by pressing X on the keyboard.

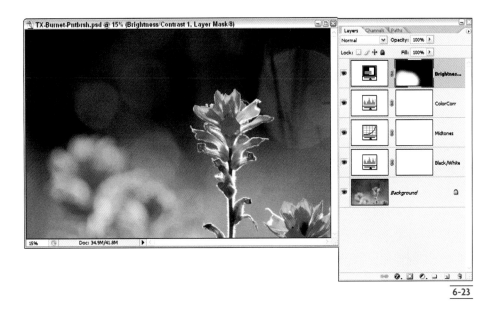

TX-Burnet-Pntbrsh.psd @ 15% (Brightness/Contrast 1, Layer Mask/8)

6-23

5. In this photo, I thought the Brightness/Contrast adjustment was too strong. You can tweak the adjustment by reopening the dialog box for the layer (by double-clicking the icon), but if the first adjustment of Brightness/Contrast was close, I usually don't do that because it takes too much time. It is faster, easier, and just as effective to change the opacity of the layer as seen in figure 6-24.

6. Compare your adjustments. Alt/Option-click the Background layer's Eye icon, and you turn off all of the adjustments. This is a quick and easy way to see what you have done and compare the adjustments to the original image as seen in figures 6-25 and 6-26. You can see the effect of any one layer by clicking its Eye icon.

You can accomplish a great deal with a photograph by using adjustment layers one adjustment, one step at a time. If you look at the Layers palette in figure 6-26 and compare the adjustments to the actual image, you can see exactly what was done and the order in which it was done. (I renamed the top layer to make this clearer, too.) Each step is in the layers, starting from the bottom. The whole effect is seen because we see effects from the top of the layer stack on down.

This is a very important concept. Take your adjustments one step at a time, putting each change into a different layer. Can you now see how much Ansel Adams's notes reflect this way of working with layers? Of course, he did not have layer masks that allowed effects to be painted in or out at will, and this gives you a great advantage in working your own images.

Layers and Other Essential Tools

115

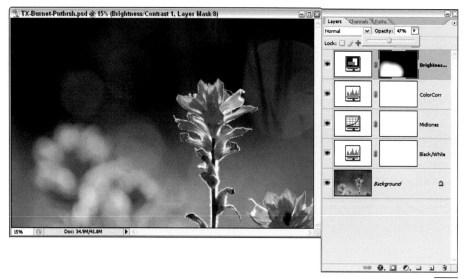

6-24

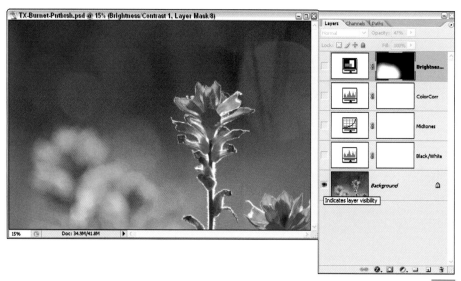

6-25

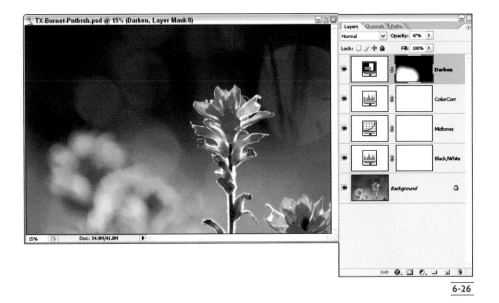

6-26

Selections and Layer Masks

I f you understand selections, you can use them to help you create a layer mask. Photoshop works quite nicely by making a layer mask based on a selection. Before I do that, here's a quick overview of selections in case you have not used them much. If you need more information, there are many excellent Photoshop books on the market that go over them in depth.

Using selection tools effectively requires practice. It is important to remember that once you make a selection, everything inside it can be adjusted, everything outside cannot.

Selection tools are at the top of the Photoshop Toolbox as seen in figure 6-27.

> The Marquee selection or shape tools at the top left of the Toolbox allow you to select areas based on specific shapes. Click and hold the tool to get a flyout menu of the tools possible: the Rectangular Marquee tool (or Square with the shift key) and Elliptical Marquee tool (or Circle with the shift key); ignore the single row tools. Use any of these by clicking and dragging your cursor over an area in the photo.

Marquee selection tools (Rectangular Marquee and Eliptical Marquee)

Freehand selection tools (Freehand Lasso, Polygonal Lasso and Magnetic Lasso)

Magic Wand tool

6-27

> The Freehand selection tools are below (click and hold for the flyout menu giving the Lasso, Polygonal Lasso, and Magnetic Lasso tools). These allow you to freely move your cursor over the photo to select whatever you want. The Lasso is pure freehand and can be hard to use — click and drag the selection line and release the mouse button to complete the selection. The Polygonal Lasso is easier because you click each point along the line you are selecting (do curves by using short distances between clicks) — double-click

to complete the selection. The Magnetic Lasso is an automated tool to select areas that have strong edges (it will have trouble with edges that blend in or have low contrast). Click on or near a contrasty edge in the photo and the lasso finds that edge for you. You then move the cursor around that edge as the tool finds it. Double-click to complete the selection; press Backspace/Delete to back up.

> The Magic Wand tool (to the right of the Lasso tools) is another automated selection tool. With it, you select areas with similar tone (commonly a sky in landscape and nature photographs) by clicking in the area you want to select. The tool finds all the surrounding pixels that are similar to the area where you clicked. You can change the Tolerance number in the toolbar to affect how much of an area is selected. Selecting the Contiguous option (also in the toolbar) tells the tool to only look for similar pixels that are connected. If you deselect it, the tool looks for similar pixels everywhere.

Selection tools work well when combined. All tools add to a selection when you press Shift and subtract from a selection when you press Alt/Option. Add and subtract

from a selection, changing tools as needed, until you have the right area selected.

Here's how you can use selection tools with layer masks. I'll return to the Texas paintbrush example. After doing Step 1 (darkening the image with a Brightness/Contrast adjustment layer), you go right to making a selection.

1. Select the area you want to change. In figure 6-28, I used a Lasso selection tool to roughly outline the lower-left part of the image. The Lasso works well here because the area is indistinct (no clearly defined areas for automated tools) and irregular in shape. You can see that there is no Brightness/Contrast layer here.

2. Choose the desired adjustment layer. In this case, I once again selected Brightness/Contrast for this layer in order to duplicate the effect done by painting earlier. Notice in figure 6-29 that the layer mask that is automatically created with the adjustment layer matches the selection.

3. Make the adjustment. I can darken the image, but just the lower left changes because of the layer mask as seen in figure 6-30. I make enough of an adjustment to balance the lower left of the image, but notice the sharp edge to the change — that has to be fixed.

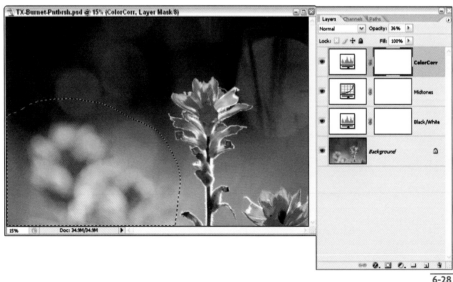

6-28

6

Layers 101

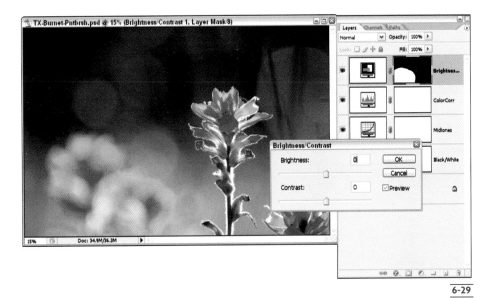

6-29

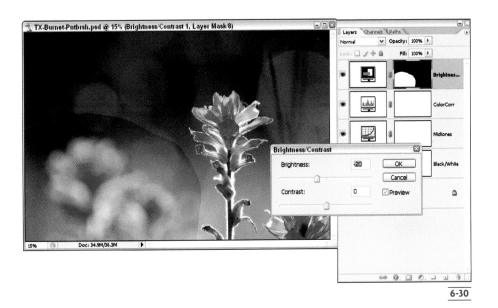

6-30

4. Blend the mask boundary. A layer mask is totally controllable by the rest of Photoshop. To blend the ugly selection edge seen in figure 6-30, you have to blur the sharpness in the Layer Mask. Use Gaussian Blur (choose Filter ⇨ Blur ⇨ Gaussian Blur). In the Gaussian Blur dialog box, move the Radius slider until the edge blurs enough to blend in as seen in figure 6-31. You can see the blur's effect in the photo and on the layer mask icon. I can't give you a specific number to use because this will change depending on the photo.

5. Tweak the mask. If the selection and blur don't completely do it, just paint in or out parts of the layer mask. In this photo, I thought the adjustment was not working just above the out-of-focus flowers, so I used black to paint that out as seen in figure 6-32 (you can also see the circle of the Brush tool).

You can't use selections all the time; however, they can be a real help for quickly creating a defined layer mask. You don't even have to be accurate with the selection, just approximate, because you can refine it by painting in black or white in specific areas and with the use of Gaussian blur.

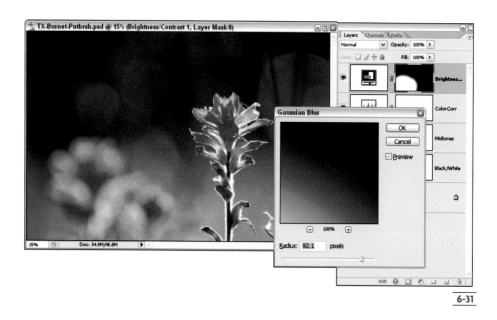

6-31

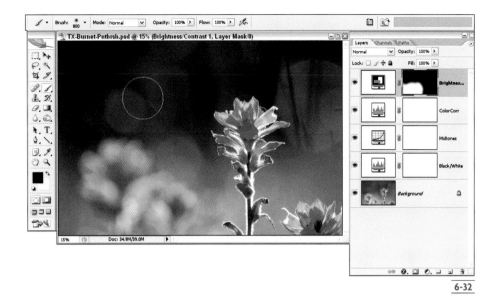

6-32

DUPLICATING LAYERS FOR EFFECT CONTROL

Before leaving this chapter on layer basics, I want to give you another simple way of using layers — by duplicating the original image (Background layer) to allow you to make changes without affecting the original. This can be a very important thing to do whenever you have to deal with actual pixels on a layer (adjustment layers have no pixels, only instructions).

To explain this, I use an example with a slightly bowed horizon as seen in figure 6-33 (black, white, midtone, and color have all been already set for the image). Many wide-angle to telephoto zoom lenses have this barrel distortion where straight lines near the edges of the image bow out-ward. In many nature photos, there are no straight lines to worry about, so this doesn't matter. But for a wide-open horizon landscape like this, it does.

6-33

Photoshop CS2 includes a new tool that allows you to correct lens problems like this barrel distortion; its called Lens Distortion. It is found in the Filter Menu (choose Filter ⇨ Distort ⇨ Lens Correction). But before using it (and any other pixel-based filters), I like to create a duplicate layer of the Background and make changes to that. As hinted at previously, this allows you to make changes to a duplicate image rather than to a one-and-only photo layer, protecting that original rendition of the photo. Because you already protected your real original by doing a Save As early in the process, this is more of a convenience than a real protection. With this extra layer, you can go back to the original scene without closing and opening photos. And if you don't like the results, you can just delete the layer and start over.

What I find is the real value of this technique comes from being able to make changes to an image and instantly see how the change compares to the original without having to go back in the History palette. You just turn the changed layer on and off.

DUPLICATING A LAYER

There are three main ways to duplicate a layer. They all work and give the same results, but you may find that one is easier than the others for your personal workflow:

> **Use the Layer menu.** Choose Layer ⇨ Duplicate Layer to open the Duplicate Layer dialog box seen in figure 6-34. You can rename the layer here if you want or just keep "copy" with the original layer name. Destination allows you to copy this layer to another open photo. Click OK and the new layer appears.

> **Click the Create New Layer icon.** This icon sits at the bottom of the Layers palette, second from the right. It is supposed to look like a couple of pages, with the top one bending up. Click on any layer and drag it to this icon. That immediately gives you a new layer. You can see both the new layer and the icon at the bottom of the palette in figure 6-35.

> **Press Ctrl/⌘+J.** This is a quick and easy way of duplicating the active layer. If there are multiple layers, select the layer you want to duplicate first. In the example, there is only a Background layer so that is what is duplicated.

6-34

Create New Layer

6-35

WORKING THE DUPLICATE LAYER

Once you duplicate your layer, you can do anything to it without affecting anything else. Here's how using the Lens Correction filter can work to improve your image:

1. Duplicate the layer.

2. Open the Lens Correction filter seen in figure 6-36 (choose Filter ➪ Distort ➪ Lens Correction). This opens a whole new interface with a grid to help you make the changes. You can straighten horizons, correct tilted scenes, and so forth in reference to this grid. The size of the grid can be changed with the Size box at the bottom.

6-36

3. **Fix the photo.** In this image, Remove Distortion is the key, though you can see a whole set of other choices that can fix lens problems. Click OK to go back to Photoshop. The horizon has been corrected in figure 6-37, though you will see the edges are now curved.

4. **Compare the change.** Turn the corrected layer on and off to be sure you like the change. If you don't like it, undo the correction and try again.

5. **Fix the edges.** Having the original scene under the corrected layer gives you options. Sometimes you can use the underlying layer to fill in the edges — select

the Move tool at the top right corner of the Toolbox. Click and drag to move the layer to see if you can match them better. You can also use the arrow keys to move the layer in small increments. If this or cloning (discussed in Chapter 11), doesn't work, crop the image. You will find it helpful to turn off the lower, Background layer so you can better see the edges of the corrected layer as shown in figure 6-38.

You can duplicate layers for many reasons. If you decide to experiment with filters in the Filter menu, for example, applying the effects to a duplicate layer lets you turn the affected layer on and off to compare it with the original. A duplicate layer can help at any time you want to experiment with some adjustment or control and be able to compare what you've done with the original by simply clicking the layer on and off. You can also duplicate a layer in order to fix a tough problem so that you still have the original underneath that can be used for repair if the fix isn't working perfectly.

6-37

6-38

LAYER MANAGEMENT

Before leaving this chapter on layer basics, there are some things you should know about layer management and making layers work best for you. Some of these things have already been described, but here I put the whole group in context.

> **Naming layers:** Name your layers so you better remember what they are doing for your photo. Double-click the name and type a new name.

> **Active layer:** This is the layer that you can work on and is selected simply by clicking on it (single-click — don't double-click).

> **Turning layers on and off:** Click the Eye icon at the left side of any layer in the Layers palette to turn it on or off.

> **Opacity:** A layer can be dense with full, 100 percent in the Opacity box or somewhat see-through by reducing that number. This allows you to affect the strength of the layer effect.

> **Deleting layers:** Layers are easily deleted in the Layers palette by simply dragging them to the trashcan icon at the bottom of the palette, the small icon farthest to the right, seen at the bottom of figure 6-39.

> **Moving layers:** You can move any layer (except Background) up or down in the layer stack by clicking on the layer and dragging it into place. You see the dividing line between the layers open up when you have dragged the layer into position for dropping it as seen in figure 6-40.

Trashcan

6-39

6-40

(see figure 6-41). You'll see Flatten Image near the bottom. Merge Down and Merge Visible can also be used to flatten only part of the image to simplify it. Merge Down merges the active layer with the one under it. Merge Visible merges all the layers that are turned on.

6-41

> **Saving layers:** Whenever you save a file in the Photoshop PSD file format, you automatically save all of your layers. You can also save layers in a TIFF file, but I do not recommend it because it mucks up a good, ubiquitous file format, making it unreadable in anything other than an Adobe product.

> **Flattening layers:** To flatten all your layers (to save your file as a TIFF or JPEG file, for example), use the drop-down menu that appears when you click the right-facing arrow at the top right of the Layers palette

Q & A

When I use adjustment layers, does the layer order matter?

That is an excellent question, but the best answer I can give is, "It depends." Most of the time, the order does matter because the upper adjustments affect the adjustments made in the underlying layers; but not always. Layer order always matters when there are pixels in the layers, but when there are simply instructions as used by adjustment layers, it depends entirely on what those instructions are. Often, you can't predict this. The best bet is to use adjustment layers in a specific order that works for your photo and leave them in position. Try the order suggested in this chapter, and then if you find you have unique needs requiring another order, experiment to find what best fits into your workflow.

What if I have worked on the layer mask of an adjustment layer and need the exact same layer mask for another layer. Do I have to start over and try to duplicate it?

In the past, you did (or you had to do some tricky selections and filling of them). But Photoshop CS2 introduced the capability of moving and copying layer masks to other layers by clicking and dragging. It is really very simple now. To move a layer mask, click on the layer mask you want to move and drag it to the layer where you want it to now appear. If you want to copy it to a new location, press and hold Alt/Option as you make the move. Photoshop will ask you if you want to replace any existing layer mask at that new location. Click Yes.

What if I want to try out a new adjustment based on an existing adjustment layer, but I don't want to lose that original layer? If I just reopen the original adjustment and change it, then the original adjustment is gone.

The answer to this question points out a real beauty of layers. You can try all sorts of things and keep everything! You will need to duplicate the adjustment layer before doing any new adjustments. You duplicate an adjustment layer in the same way you duplicate any layer. After you duplicate an adjustment layer, rename it so you know this is your test layer, then turn off the original layer so the two adjustments don't fight with each other.

DEVELOPING MIDTONES

Midtones are the tonalities and colors that lie between the darkest and lightest tones of a photograph. These tonalities can make or break a photograph by giving it life or making it sit lifeless on the screen. Paying attention to midtones and working them carefully can reap big benefits for the nature photographer because this is where the beautiful greens of a forest reside, the tonalities of desert rock live, or the range of colors in a sunset dwell.

Midtones are also not an either-or thing for most photographs; that is, you either adjust them right or they are wrong. How midtones play out in an image affects the emotional tone of a photo, among other things, and definitely give personality to an image. Some photographers love open and bright images with lighter midtones as illustrated by figure 7-1. Other photographers prefer something darker and moody such as the way midtones are interpreted in figure 7-2. This makes midtones quite subjective and variable according to your needs.

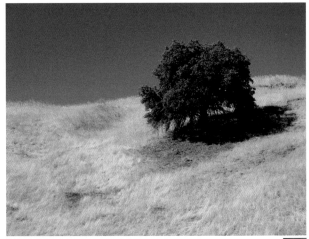

7-2

BACK TO CURVES

Using a Curves adjustment layer is the best way to first deal with midtones because of the way an adjustment layer deals with midtone control and because of its flexibility. You saw how to use Curves for this purpose in Chapter 6, but this chapter takes you way beyond that.

When I create a Curves adjustment layer, I first look at what it does to the overall tonality of the image by clicking once on the center line and moving it up or down to see how the photo changes. Sometimes, this leads to surprising changes that you did not expect. I pay attention to that, especially to what is happening in specific tonalities such as the dark and light areas. Then I work to affect those areas first by tweaking the curve to change their adjustment. This also affects image contrast, so I watch that, too.

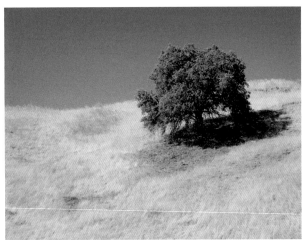

7-1

To better explain, I will work through a specific image starting with figure 7-3. This photo of a wetland landscape in the Everglades area of Florida is interesting because of the low angle to the floating water lettuce plants. Following the workflow established early in this book, this image has already been corrected for a slight horizon lean by cropping, and then the blacks and whites were set with a Levels adjustment layer. At this point, midtones are the next step and now you will learn a more advanced way of dealing with them.

7-3

seemed the dark tones were getting too bright, so I set a lower point and moved it back to the center of the graph. This increased contrast nicely through the midtones of the plants, but raised the sky at the top too much. (When you change one point of two in a graph like this, the rest of the graph will curve in response, which may cause tonal changes you do not want.) So I added a third point toward the top and pulled the graph back toward the middle. I didn't go too far as it made the image look too gray in the bright areas.

PRO TIP

Curves adjustments often do a lot with minimal change to the actual curve. However, I typically move the curve too far until the photo does not look right, then bring it back into correct alignment for the image. This forces me to see what the curve changes will do to the image and where it can go wrong. This makes it easier to get back to the best adjustment. Fine changes to the curve can be done with the up- and down-arrow keys.

Follow these steps to proceed with an advanced technique for working on the midtones after creating a Curves adjustment layer:

1. Set overall Curves. You can see three separate points in figure 7-4. Because the water plants have so many middle midtones, I started with the middle point on the curve. It didn't need to go up much. Then it

7-4

2. Separate the tonal adjustments. You will likely want to adjust certain tones individually. In this example, the clouds at the top of the photo are there, but are weak. A new Curves adjustment layer has been added in figure 7-5 and adjusted totally for the sky. I ignored the rest of the image — I prefer this approach rather than selecting the sky and adjusting it because I don't have to do the selection work, as you see in the next steps. I first set the middle point of the three (which is high on the curve, affecting most of the brighter tones most strongly). I brought the bottom point up closer to the center; otherwise, the adjustment was looking way too heavy in the darks. Finally, I cleaned up the whites in the clouds by grabbing the top corner point (pure white) and moving it along the top of the graph to the left. This makes the whites of the clouds a pure white. The clouds look good, but the rest of the photo looks terrible.

3. Remove any unneeded adjustments. This photo needs to have the bottom part of the sky tones adjustment layer removed while keeping it where it affects the sky. This is what the layer mask is made for (be sure you have the correct layer active — click the layer if you are not sure). You could fill this layer mask with black, and then paint in with white to show the sky.

4. Make a layer mask. In cases like this where there is a distinctive horizon, use the Gradient tool, seen in the middle of the Toolbox in figure 7-6, to quickly and easily make a layer mask. This tool makes a gradient between two points using the foreground and background colors. Click on the photo where you want the foreground color to start and drag the cursor to where you want the background color to appear, as demonstrated in figure 7-7, and then release the cursor. Photoshop automatically creates a blend between the two colors; in this case, black and white to conceal and reveal the Sky Tones layer effect as seen in figure 7-8. You can refine the layer mask with the paintbrush to more precisely fit it to the scene.

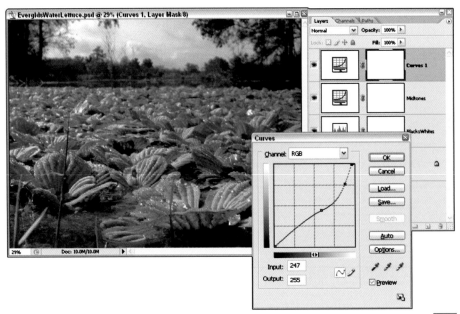

7-5

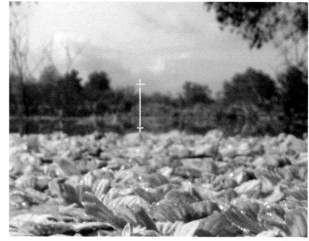

7-7

— Gradient tool

7-6

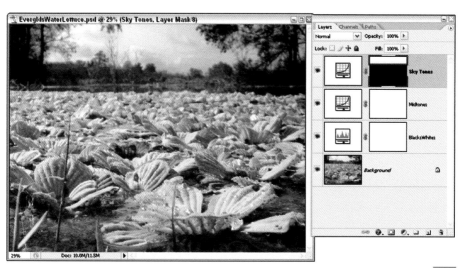

7-8

133

5. Balance the midtones. In this photo, the midtones of the water lettuce are very even, a natural way the camera captures such a scene, but not true to how our eye responds to it. This even tonality makes the viewer's eye move off the edges of the frame. In figure 7-9, I added a Brightness/Contrast layer to drop the entire brightness of the image. I then filled the layer mask with black to turn off the layer's effect and painted in the effect with white along the edges, effectively toning the edges down as seen in figure 7-10 (look at the layer mask, too). This figure also shows the effect turned down by reducing this layer's opacity.

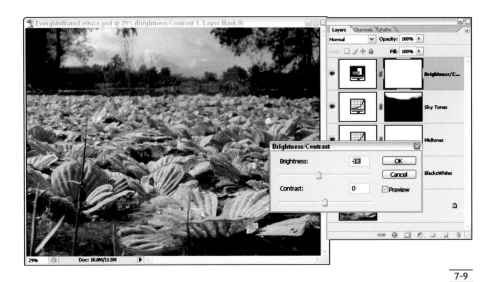

7-9

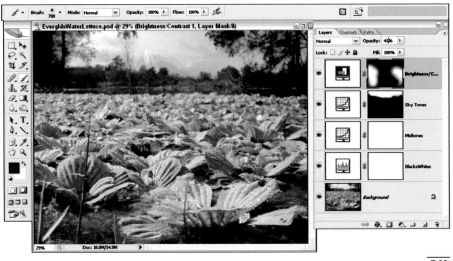

7-10

This final effect of toning down the edges of the photograph also adds some dimension to the image. A photograph is essentially a flat representation of a three-dimensional world. I believe that when a photograph can be given more of a three-dimensional feel to its inherent flatness, the image becomes a truer interpretation of the real world.

ANOTHER MIDTONE TOOL

In Chapter 6, you learned a bit about how to use the selection tools in the Toolbox. They can be very helpful in working with layer masks. There is another selection tool that can be very helpful for all sorts of selections, but I find it especially helpful when dealing with specific midtones: Color Range in the Select menu.

In figure 7-11, you can see a photograph of a giant leather fern in a cypress swamp in Florida. It is shot against the sun with a small f-stop, which gives the starburst effect. (This is not a filter or a Photoshop effect.) You can see from the Layers palette that the first adjustments of Levels for blacks and whites and Curves for midtones have been done.

But I did not feel this was optimum. I wanted to get more of the feeling I had when I took the photograph — one of bright light making the leaves really glow. The midtone adjustment has helped the leaves, but it has made the sky too light, and I wanted the leaves to be even brighter. So I deleted the Midtones layer to try another approach.

I needed to isolate the leaves. That's exactly what Color Range can do. This tool lets you create a selection based on specific colors and tones in a photograph. Here's how to use it with this image:

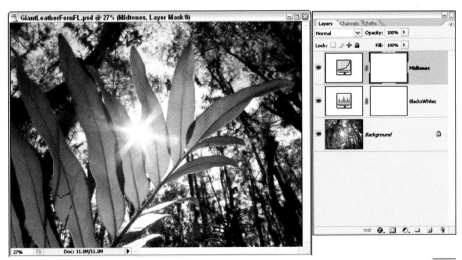

7-11

1. Open the Color Range dialog box (choose Select ⇨ Color Range). Start by selecting Sampled Colors from the Select drop-down menu. The drop-down list contains a whole series of choices, all of which are self-explanatory once you understand how this control works. The key parts of control are the pre-view area, the eyedroppers, and the Fuzziness slider, in that order. I recommend leaving Selection Preview on None.

2. Select your subject. Move your cursor onto the photo and click somewhere on the subject. Then refine the resulting selection by using the + and – eyedroppers to add and subtract from what you see in the preview.

In this image, I needed to isolate the fern leaf, so I clicked once on it. Then I selected the + eyedropper and continued to click on the fern leaf in many areas, all the time watching what was happing in the preview. A black-and-white negative image of the leaf began to appear as seen in figure 7-12. Some of the green tree leaves are showing up, too. If a single click goes too far, press Ctrl/⌘+Z to undo the last choice.

3. Refine the selection with Fuzziness slider. Fuzziness changes how Color Range looks at the selected areas, but does it quite smartly. You can try moving the slider left and right to refine your selection as demonstrated in figure 7-13.

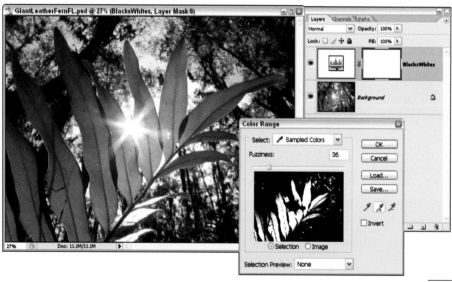

7-12

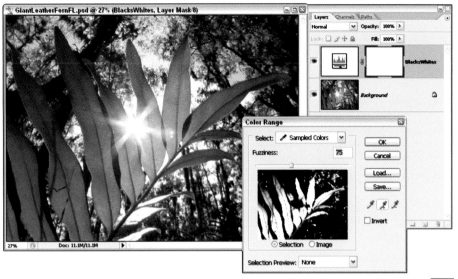

7-13

4. Click OK to make the actual selection as seen in figure 7-14.

5. Add a Curves adjustment layer. This opens with a layer mask based on the selection made by Color Range as seen in figure 7-15. Note the small thumbnail of the layer mask in this figure — it looks exactly like the preview that was in the Color Range dialog box.

6. Adjust the midtones with Curves. As seen in figure 7-16, this adjustment affects only the areas selected. The fern leaf really starts to glow, though there are a couple of problems that need correcting.

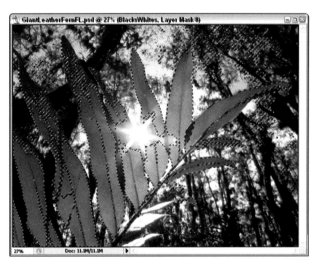

7-14

X-REF

You can see more about selections and how they affect layer masks in Chapter 6.

7-15

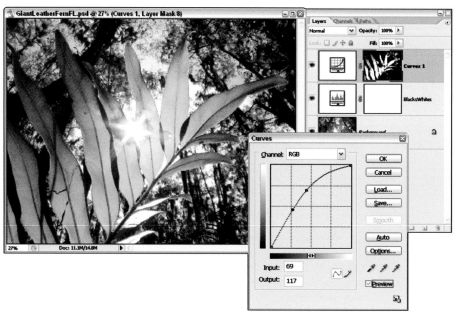

7-16

7. Fix problems by painting in the layer mask. In this fern photo, there is some weird stuff going on around the sunburst and flare because it wasn't selected. This is a fairly simple fix — simply paint white over the area with a soft brush. Also, consider whether the bright leaves in the background help or hinder the photograph. I decided to tone them down, not eliminate them. To do this, I used a soft black brush, but set the opacity to 30 percent in the tool options bar. This paints in black but not 100 percent solid, resulting in the layer mask turning gray in those areas. Some of the effect of the layer shows through, but not all. This effectively tones down the background leaves. The results of this step are shown in figure 7-17.

8. Check the color. Making midtone adjustments like what I did in this sequence affect color, but you may get more color than you bargained for because of the way Photoshop applies large adjustments. To get a more normal color, change the Layer Mode of the adjustment layer that you just made. Click the layer modes drop-down arrow to the right of the box that says Normal at the top of the Layers palette. Adobe does not label this box, but the mode is always seen first as Normal. Clicking on that arrow will give you a menu of Layer Modes as seen in figure 7-18. There is an intimidating set of modes. Ignore all of them except the bottom one, Luminosity, for this use. Select Luminosity to make the layer act more directly on just the luminosity changes, but if you prefer the color when the layer is set to Normal, go for it!

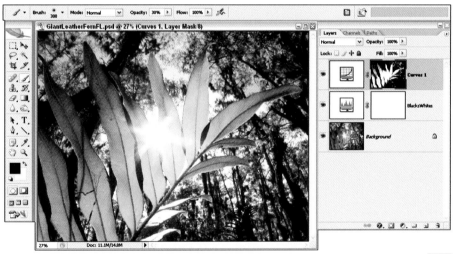

7-17

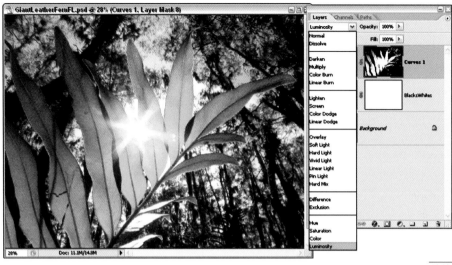

7-18

Using Shadow/Highlight to Tweak Specific Tones

Shadow/Highlight is a new control in Photoshop CS (choose Image ⇨ Adjustments ⇨ Shadow/Highlight). It is designed to allow you to adjust the shadows or the highlights separately from each other, giving you another control over tonalities in the photograph. It can be used with or without layers, though I usually prefer the added control of layers.

You might wonder why I did not include this adjustment feature earlier in the book. The answer is simple: control. The Shadow/Highlight control does a remarkable job on many images, but for me, it offers less control than the techniques described in Chapter 6 and earlier in this chapter. The water lettuce photo is a good example of this type of control you might need in the highlight areas. The Shadow/Highlight control would have toned down the sky but I would not have had the power that comes from changing a curve in a Curves adjustment layer specifically for that sky.

I like using Shadow/Highlight for dark areas in a photo such as the one in figure 7-19. This photo is of a

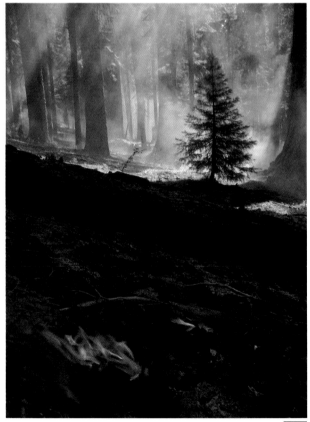

7-19

prescribed burn in Sequoia National Park. Fire is a natural part of that ecosystem. Without it, certain plants don't grow well, the understory (or lower parts of the forest) gets too thick, and fires can actually get worse (because too much fuel builds up).

The image has already had the first adjustments of Levels and Curves for basic black, white, and midtone enhancements as seen in figure 7-20. I emphasized the top part of the photo to keep the young sequoia dark and the midtones of the smoke looking good. I could have then added another Curves adjustment layer just for the charred area and flames and used a layer mask to limit its effect. But in this case, I felt the large dark area would work well with Shadow/Highlight.

This adjustment control needs pixels to work on, however, so it works best on duplicate layers that have data, such as a duplicate of the background layer or selections of it.

You could use Shadow/Highlight directly on the Background, but this would mess up the adjustments in any layers above it.

You need to get a layer that combines all of the layers thus far into one layer that holds pixels (and shows up as a photo in the layer thumbnail). Photoshop does have a trick to bring together all the visible layers, flatten them, and add this flattened group of layers to the top of the layer stack.

This technique has only one step, but it requires a little dexterity on the keyboard. After checking to be sure you are in the top layer, press and hold Alt/Option+Ctrl/⌘+Shift, and then press E. This creates a new layer that shows the photo file at this point flattened and put into that layer as seen in figure 7-21 (Photoshop calls this Stamp Visible — in earlier versions of Photoshop, you press N, then E).

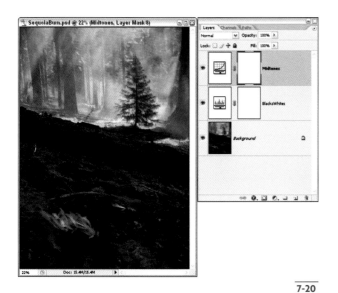

7-20

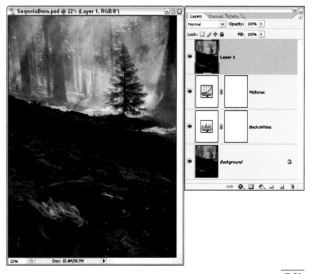

7-21

Now here's how to use Shadow/Highlight after you have created the Stamp Visible layer just described:

1. Choose Image ➪ Adjustments ➪ Shadow/Highlight to open the Shadow/Highlight dialog box. If yours is smaller with fewer choices select the Show More Options check box.

2. Correct the shadows. The dialog box opens with the default settings. I believe these are set way too high for most nature photographs, making the shadows look unnatural in most cases. I recommend the settings shown in figure 7-22.

 • **Shadows:** In the Shadows section, set Amount to 30 percent and Tonal Width to 25 percent.

 • **Highlights:** In the Highlights section, set Tonal Width to 25 percent.

 Make these your new default settings by clicking Save As Defaults. You can see that some nice detail has appeared in the dark bottom of the photo.

3. Refine the Shadows adjustment. I toned the Amount down to make the area stay dark, and then increased the Tonal Width slightly to change how the tonalities are affected as seen in figure 7-23. Because Radius influences contrast, I boosted it slightly. The dark

areas are looking good now, showing detail, but not looking too bright. Using the Highlight controls for Amount and Radius dulls the smoke in the photo, so in this image, I would not use them. They do help to tone down very bright highlights in other photos.

4. Compare the layer with the rest by turning it on and off. This is where I find having my Shadow/Highlight adjustment done on a layer as seen in figure 7-24 (note the layer has been renamed) very helpful. You don't necessarily want to have the adjustments done by applying Shadow/Highlight over the whole image. I found that I did not like the lightened dark areas in the top part of this sequoia burn photo.

5. Restrict the Shadow/Highlight area. Restricting any layer's effects on an overall image is best done with a layer mask because you can add or subtract at will. A layer mask is added either through the Layer menu or by using the Layer Mask icon at the bottom of the Layers palette. I prefer the Layer Mask icon — it is a gray rectangle with a white circle in it. Clicking it adds a white layer mask as seen in figure 7-25 (if you press and hold Alt/Option when clicking, you get a black layer mask). I painted black on the layer mask to remove the effect of Shadow/Highlight on the top

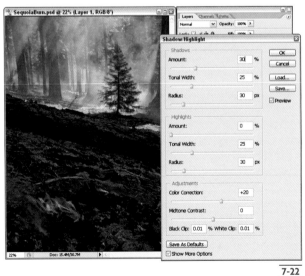

7-22

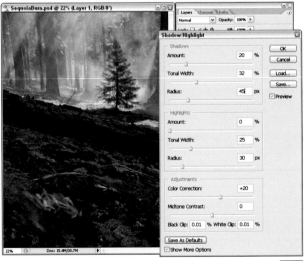

7-23

of the photo, making the little tree stand out better and making that area of the image look richer.

The final photo in figure 7-26 now tells a story that the original image did not. The adjustments done in Photoshop have now revealed the scene far more accurately than the original exposure, and also, I believe, more expressively. This is an important concept as there are many who believe adjustments in Photoshop are unnatural and make the photo less truthful. While Photoshop has the tools to allow a photographer to create that kind of image, this is not the goal of most landscape and nature photographers. This example clearly demonstrates that Photoshop can be used in the service of truth just as well as it can for obscuring truth.

7-24

7-25

NOTE

If you were wondering about the other two sliders, I don't find the color Correction or Midtone Contrast sliders at the bottom of the dialog box that useful compared to other controls, so I never use them.

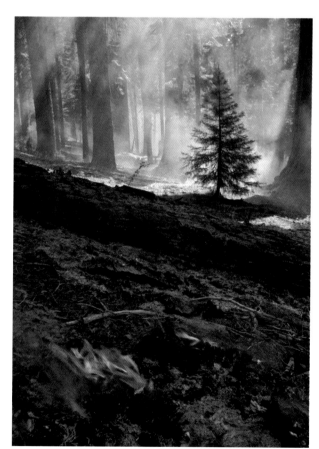

7-26

INTENSIFYING SKY TONALITIES

I use the phrase "intensifying sky tonalities" deliberately. While you always want to get the best exposure possible in all situations, sometimes you have a special challenge with skies. If you expose correctly for the ground, you often overexpose the skies, resulting in skies that are too light or even washed out. In that case, you need a way of bringing them back, intensifying them to at least the level you experienced them. The technique described here can be used to bring back bright areas of any kind in a photo, from snow to white water to overexposed backgrounds, though in many of those cases, you may find the Shadow/Highlight control does well.

The photo in figure 7-27 is a good candidate for sky work. This scene really has two lighting conditions at work, something that makes the scene interesting, but difficult for the camera to deal with. The bottom of the photo shows the typical water and forested islands and fingers of land that make up the coast of Maine. The light is soft and foggy, a common morning condition for this part of Maine as well.

At the top, the sun is starting to break through the clouds. The light there is brilliant, with the clouds very bright. Less exposure would have captured detail at the top better, but the bottom of the photo would have become muddy. Muddy, dark midtones can be a real problem in dealing with foggy conditions because you don't have the tonalities needed for Photoshop to do its best work.

This photo needs to have the fog at the bottom preserved while also enhancing the bright clouds above, but without losing the feeling of brightness. First, as shown in figure 7-28, a levels adjustment layer was added (called Levels 1) to enhance the foggy bottom. I did not look for a pure black or white there as that would be unreal. I wanted the light fog to look like a light fog. However, even those minimal adjustments affected the sky adversely, so I removed that effect on the top of the image — note the gradient in the Layer Mask icon.

7-27

7-28

Then, I added a slight midtone adjustment with Curves and also added a gradient in the layer mask. This is an important point. You can make your first adjustment layers affect a key part of the photo, and then limit that effect if it adversely affects another part of the image. You do not have to use any layer "as is" if it causes problems somewhere in the photo. Simply remove the effect with the layer mask.

To intensify a sky, follow these steps:

1. Add an adjustment layer to the photograph without doing anything to the adjustment. If you compare figure 7-28 and figure 7-29, there is no difference except in the addition of a new Levels layer (Levels 2). You only need the layer itself for the next step; you do no adjustments yet. I recommend using Levels or Curves — they often come in handy if you do need to adjust this layer later.

2. Click the layer modes drop-down arrow at the top of the Layers palette. The menu of Layer Modes seen in figure 7-30 appears. These are all layer modes, ways of making the layers communicate with each other. While useful to graphic design artists, this long list includes a lot of modes the nature photographer will rarely, if ever, use. The one needed to intensify tonalities is Multiply.

Layers and Other Essential Tools

7-29

7-30

PRO TIP

Photoshop CS2 offers a neat layer mask feature — the ability to copy one layer mask onto another. All you have to do is press Alt/Option then click and drag an adjusted layer mask onto another one. If the layer mask on the new layer needs to be reversed (that is, it is masking the wrong things), then use the keyboard command, Ctrl/⌘+I to invert the layers.

3. Choose Multiply for the top, unadjusted layer, and watch how the scene magically darkens. The light, airy clouds appear, but the bottom of the photo is too dark. Use a layer mask to change that. I used a long distance between clicks for the Gradient tool to make a larger, gentler blend between the bottom and top of the scene. What you see in figure 7-31 is much closer to what I originally saw. A graduated filter on the camera would have created too harsh a transition for this photo. If you find the strengthening of your bright areas is not strong enough, you can simply duplicate the top layer (drag it to the Duplication icon to the left of the trash can icon). You can also open the adjustment itself and try tweaking it.

Look closely at figure 7-31 and check out the History palette. Notice the multiple Gradient entries. This is because I didn't like the first two I did. (If the blend is not right, a photo like this will not look good — often the

blend will be obvious and ugly on subtle grays like those in this photo.) The real beauty of a layer mask is that you can keep working it as much as you need in order to make the photo look right.

Compare figure 7-32, the finished image, with figure 7-27, the first in this sequence. Notice how much better and realistic the top clouds look, yet they still have a great feeling of morning brightness. In addition, note how the photo is much better balanced visually.

7-31

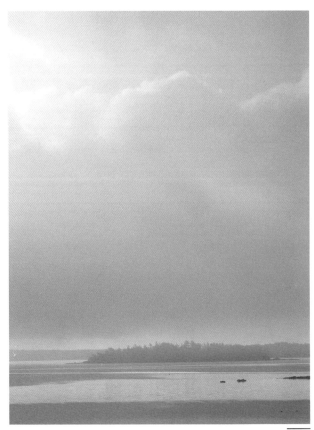

7-32

Opening Up Shadows

A similar effect to the one created in the previous section is possible when you have dark shadows that need to be opened up. While it is possible to open shadows with Shadow/Highlight as described, I find that the layer technique described in this section often gives me better-looking shadows and more control. Opening up shadows with layer modes is very simple. You basically do the same thing as in multiplying bright areas.

In figure 7-33, you see a shot of Otter Point in Acadia National Park in Maine at sunrise. It is shot with a full-frame fisheye lens, which gives the composition its unique curved feel. The blacks, whites, midtones, and color have all been adjusted. The dark rocky beach and cliffs are

dramatic, but hardly what you would have seen if you were actually there.

Now look at those areas in figure 7-34. The rocks look normal and the cliffs in the distance actually show off some rocks! The sky is too bright, but that can be fixed. The only difference between figures 7-33 and 7-34 is the addition of a Levels adjustment layer (with no adjustment) and a new choice for the layer mode (Screen) in figure 7-34. Screen lightens a photo quite dramatically.

Screen made the sky too light, however. In figure 7-35, the sky is corrected with the layer mask. I filled the mask with black, and then painted in the lower part of the mask with white over the rocks and cliffs. The rocks are beginning to look much more natural.

7-33

7-34

7-35

I wanted more detail in the rocks, so I duplicated the Screened layer, which doubled the effect. That was too much, so I toned it down by reducing the opacity of the layer until it looked good, as seen in figure 7-36.

If you know Screen and Multiply, you know two of the most useful layer modes for landscape and nature photographers. These layer modes will help you again and again to quickly and easily bring out details in dark and light areas, respectively. That said, I feel it is important to emphasize that there is no arbitrary right or wrong here. The rocks in the Otter Point photo look more realistic, but a photograph with very dark rocks is still a good interpretation of the scene. In the past when shooting slide film, dark rocks were the only interpretation one could get from such conditions. Photoshop gives the nature photographer more options for making images more realistic, more dramatic, more evocative, or to make other interpretations of the scene.

PRO TIP

When reducing the opacity of a layer, I find it helpful to first reduce the opacity to 0 then move it up gradually toward 100 percent while watching the photo, stopping when the photo looks good. In Photoshop CS2 you have a handy way of adjusting opacity — click on the word Opacity and drag your cursor left and right to change the percentages seen in the Opacity box.

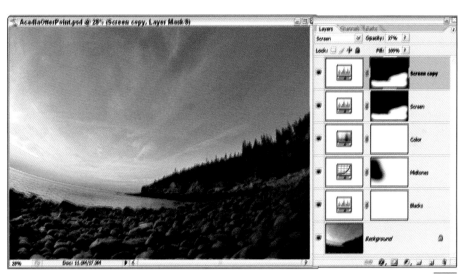

7-36

■ **I am not sure I understand about Shadow/Highlight versus using a layer with the Screen or Multiply layer modes. Why would you use one over the other for dark parts of the photo?**

A good question. The easy answer is that you can do a lot of things in Photoshop multiple ways. They often give similar results and come down to a personal preference as to workflow. But that is not a complete answer. Shadow/Highlight and Screen or Multiply layer modes really do dissimilar things. You can see different results. I think you have to try both and get a feel for what they do because it is difficult to describe the differences in words. You may find you like one better than the other.

I use both. I tend to use Shadow/Highlight for difficult shadows and when highlights are too hot (meaning nearing, but not reaching, washed out). It sometimes does a remarkable job in digging detail out of a shadow and in toning down a highlight without changing its color too much.

I probably use a layer and Screen or Multiply more often, however. I find that I can get tonalities in the dark or light areas that I like faster than I can do something similar with Shadow/Highlight. Shadow/Highlight tends to make the dark areas especially look unnatural if you are not careful as to how you adjust them, whereas using Screen with a layer can look right with just a shifting of the Opacity.

On the other hand, if you have disjointed areas of darkness all over the image, I guarantee that will be easier to adjust with Shadow/Highlight compared to a screened layer. In the latter, you will spend a lot of time with a layer mask to make it work on those disjointed areas compared to Shadow/Highlight, which automatically looks for and adjusts those areas.

What if I use an adjustment layer to tone down certain parts of the photo, but the effect needs to be variable? Is it better to use the brush set to several opacities as you work or use separate layers on the different tones?

This question is very hard to answer directly. It is really going to depend on the photo to a degree and how much you need to vary your control. When I work to control the tonalities of specific areas in a photo, I generally prefer to use multiple layers. The advantage is that I can very carefully control each tonality separately, including changing the opacity of the layer and affecting only a specific area.

On the other hand, if you have one main area adjustment and just a few smaller ones to affect, it is probably quicker and easier to work the image with one adjustment layer. You can always go back and forth in your layer mask with white and black (at different opacities) to finesse the changes. After you've done the adjustments described in this chapter on a few images, you will get a feel for what works best for you.

COLOR ADJUSTMENT REFINED

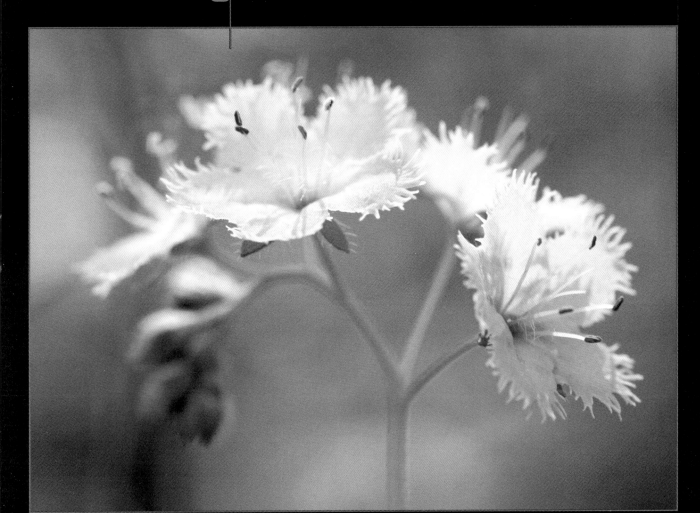

Color is a key part of nature. It was not part of Ansel Adams's work, but even though black-and-white is enjoying renewed interest, color is still a critical part of landscape and nature photography. People respond to the bold colors of flowers, the rich colors of a sunset, and to the subtle greens of a woods in the spring.

You learned a quick and easy way to do color correction in Chapter 4. That often works quite well, but sometimes you need more. You also learned how the Hue/Saturation control works in that chapter. But you may find your particular photograph doesn't respond the way you want it to when using those controls, so in this chapter you will learn other ways of working color.

WHAT IS REAL COLOR ANYWAY?

Color is a real challenge to deal with, even if you try to do it completely "scientifically." Your eyes adjust to different colors of light to make physical colors look the same. An apple looks quite similar in sunlight or incandescent lighting because of the way our eyes compensate, yet it usually looks very different in those two locations if photographed with a digital camera set on auto white balance.

Colors take on different appearances when the light changes, to be sure, but how color appears also changes when shot with different digital cameras (even when using the same settings) or different film types. In addition, variable surroundings affect the impression of colors, including what range of hues end up in a photographic composition. This makes it very hard to say when a color is "correct."

Look at figure 8-1, a close-up of leaves in fall. Examine the color of the leaves and remember what the image looks like. Now compare the red color in figures 8-2 and 8-3. The leaf has not been changed at all! Do you believe your eyes? The black and white areas around the leaf cause the color changes.

Compare figures 8-4, 8-5, and 8-6. Again, the leaf stays the same, but it is the surrounding color that affects the

8-1

8-2

8-3

8-4

8-5

appearance of color in the leaf. (The brightness of the color has an effect, too, though in these cases, the color has the most effect.)

You might say that these are strong effects not common in nature. Compare figures 8-7 and 8-8. Figure 8-7 is a warmed-up version of 8-1, and figure 8-8 is a seriously messed-up version to change the colors. The surrounding colors change the appearance of the color of the leaf tip at bottom left. If you doubt all of the colors really are the same, cover up all of the image except the leaf tip and compare. Figures 8-2 through 8-8 were all adjusted with matching layer masks to keep the adjustments off of the leaf tip. (The mask was blended along the edges slightly for 8-7 and 8-8 so the edge would not be obvious.)

Other than showing optical illusions, what does this have to do with Photoshop and nature photography? Everything. Colors in nature do not exist in isolation from their sur-roundings, either in the real world or in a photograph. Often you have to adjust color to what you believe is true or representative of the scene, which may not be the same as an arbitrary "right" use of Photoshop tools.

When everyone was shooting film and scanning slides, there was always this discussion of making the monitor and output from Photoshop perfectly match the original slide. I would hear photographers proudly say how much their image file "matched the slide." I believe it would have been better to think about matching the real scene, as matching the slide is more technology than either reality or art.

8-6

8-7

PRO TIP

Calibrate your monitor. Calibration tools are quite affordable today and they all work reasonably well. They give you a consistent and predictable workspace. What they do not do is give you perfect colors. Colors are always affected by many things. Calibration can only make your monitor a "neutral" space in which to work. It is also important to keep bright colors away from your work area, either on the computer screen or around your monitor. Keep the light fairly consistent, too.

8-8

COLORCAST CORRECTION

It is interesting that a lot of discussion about color management deals with removing colorcasts or making colors arbitrarily "correct," as if they just came from a scientifically accurate chart. That has some validity in commercial photography where a photographer has to match a specific color on a product or in scientific documentary work where absolute color precision may be critical for identification of a plant or animal.

But nature has colorcasts as part of its condition. Colors in a field or forest do not exist isolated from the way light shines through trees, bounces off grass, or comes directly from a cold, blue sky. Sunrise and sunset give very strong and totally natural colorcasts that, if removed, leave the scene looking oddly sterile.

Still, photos will have unnatural colorcasts, too, and these need to be dealt with. You learned a quick and easy way to do that in Chapter 4. You can expand on this for a higher level of color work by using a Levels adjustment layer and layer mask. Figure 8-9 is a spring scene with lots of green contamination of neutral colors, yet removing the green contamination at the same level all across the image is not best for the photo. A Levels adjustment layer with its layer mask gives you the control needed to make the most of such an image.

This scene is from a beautiful park in eastern Tennessee called Frozen Head State Park. The falls is on the Flat Fork River. The overall green cast is not awful — it offers warmth to the image, but the falls and the rocks at the bottom, especially, have a distinct colorcast to them. I like to make water more neutral where there is not an obvious reflection, such as in these falls.

8-9

To use a Levels adjustment layer for colorcast correction with such a scene, follow these steps:

1. Do basic adjustments first because they affect color. In figure 8-10, Levels (fixing black/white) and Curves (adjusting midtones) layers have been added. The most important tonal adjustment, however, comes from the second Levels layer that has its mode set to Screen. The layer mask limits that last change to the bottom of the photo, but you can see how much detail has opened up.

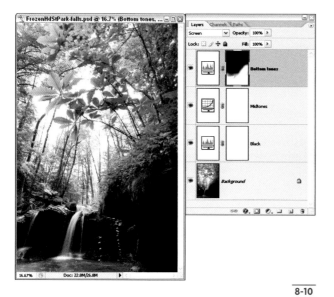

8-10

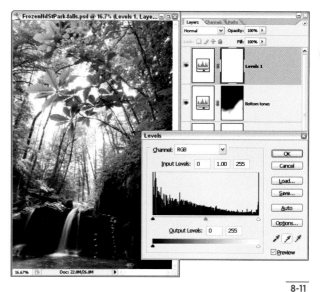

8-11

2. Correct the main colorcast problem. Open a new Levels adjustment layer using the adjustment layer icon on the Layers palette. In the Levels dialog box (see figure 8-11) use the gray or middle eyedropper as described in Chapter 4 to click on something that should be a neutral gray (it can be dark, mid, or light toned). In this case, I tried clicking around the falls itself until I removed the colorcast in that area. It took several clicks. I ignored what was happening in the upper part of the scene.

3. Remove the correction where it isn't needed. The color correction really isn't needed in the top of the photo. In fact, the forest looks better with the added green cast that comes from all the leaves. I removed the correction using the layer mask in two steps: first, I used the Gradient tool to cover most of the top; second, I used a brush to refine the adjustment in the bottom part of the photo by painting black and white to turn it on and off as needed. You can see the effect as well as the brush in use in figure 8-12.

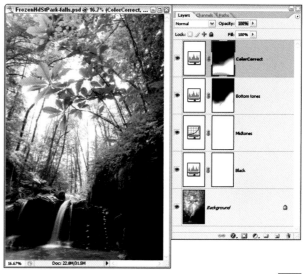

8-12

4. Adjust the adjustment. In this photo, I thought reduction of the green cast overall was a little too strong, so I changed the opacity of the layer as seen in figure 8-13. This had no effect on the leaves and trees because the layer effect in that area was turned off with the layer mask. The opacity change therefore only affected the bottom rocks and falls. It seemed to look best at about 60 percent, though this is very subjective.

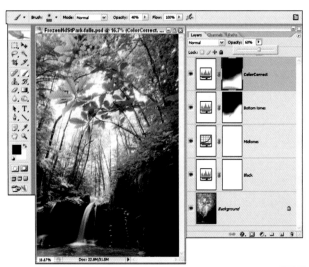

8-13

ADDING WARMTH

In many natural scenes, all or part can stand some warming up. There are three main reasons for this need:

> Blue sky tends to reflect into scenes, and the camera overemphasizes that color.

> Gray days tend to record more blue than you actually see in them.

> People respond positively to warm tones.

Nature photographers consistently use warming filters from Skylight to 81B to enhance the warmth of an image when using film. Films themselves like Kodachrome and Velvia also enhance the warm side of an image. In a digital camera, you can add warmth to a scene by changing your white balance setting. With Photoshop, however, you can add warmth to an image more selectively so that you avoid colorcasts where you don't want them.

In figure 8-14, you see a scene in the Valley of Fire State Park in Nevada. This is a spectacular photographic location about 45 minutes from Las Vegas. There are actually quite a few incredible locations for landscape photographers within an hour of Las Vegas. This scene looks good with its basic adjustments done, but it can be better. Here's how:

1. Make basic adjustments. In figure 8-14, you can see the standard black/white Levels layer, a midtone layer, plus two others for refinement of tonalities. I felt the rock at the lower right was out of balance with the rest of the image, so I toned it down in the Balance layer. The clouds in the image are very important, but I felt the clouds in the top-right quarter of the image were a little dull and weak, again, out of balance, so I used a Levels layer to brighten them.

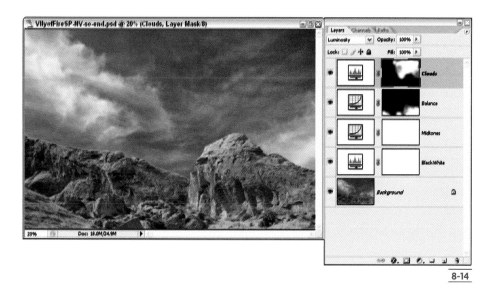

rightLayers and Other Essential Tools

2. Add a Color Balance adjustment layer by selecting Color Balance from the adjustment layer menu (remember you can do this through the Layer menu or the adjustment layer icon at the bottom of the layers palette). The Color Balance dialog box offers a series of sliders that allow you to affect the overall color of an image. It is fairly intuitive and easy to use — just play with the sliders and see what they do to your image. In this case, I wanted to add some warmth to the rocks. I kept the Tone Balance set to Midtones, then added red and yellow (because yellow is on the opposite side of the same slider as blue, it is the same as minus blue, which is why the number at the upper right is a minus) in equal amounts as seen in figure 8-15. This did a nice job of bringing some natural color to the rocks. (Hue/Saturation

could be used, but it tends to be a little heavy-handed in this situation.)

3. Limit the adjustment. While the rocks look good, I did not like the color of the sky. The added warmth was okay on the brighter clouds, but the sky lost some of its natural blue color. I needed to select the sky for a layer mask, so I used the Color Range tool as shown in figure 8-16. I then filled this selection in the layer mask of the Color Balance layer (now named Warming) to turn off the effect on the sky as seen in figure 8-17 (I also removed the selection by pressing Ctrl/⌘+D). In such a scene, you could also remove all of the adjustment in the clouds by painting out the layer mask through the entire top of the image, but I like some warmth in the clouds, so I did it this way.

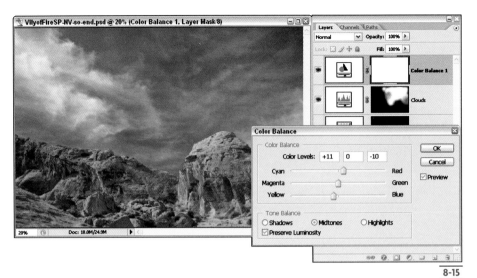

8-15

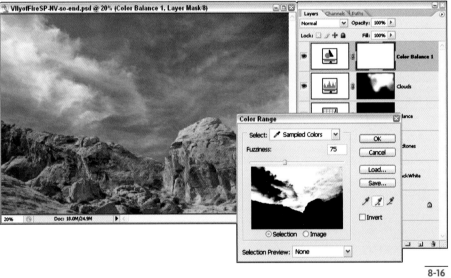

8-16

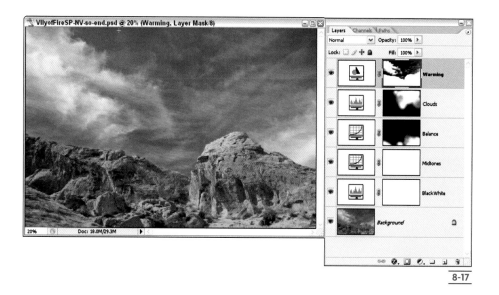

8-17

WARM AND COLD CONTRAST

Warm and cold colors are a very natural part of nature. Blue sky and orange fall color are very strong examples, while the contrast from the warm sun to the cool shade sides of a rock is more subtle. Yet it is this richness of color that makes nature so real and vital.

One thing that often gives away a photograph of "nature" created in a studio (such as for an ad) is the lack of color variation due to light.

Color variation can be enhanced in a photograph to make the scene look more vivid and real without resorting to heavy-handed Hue/Saturation changes (though Hue/Saturation controls can be important). In addition, accent-ing natural warm/cold relationships in a photo can increase the depth of the image as you see in the example here.

Figure 8-18 is a scene in the Sacred Valley of the Incas in Peru. This is an incredible area filled with great photo-graphic opportunities and a rich history. Figure 8-18 has the core adjustments already made. Notice that the mid-tones were adjusted in three parts for this photo as seen in the Layers palette and the layer masks. I first worked the clouds and sky, then the overall mountains at left and right, and finally, focused on opening up the mountain on the right.

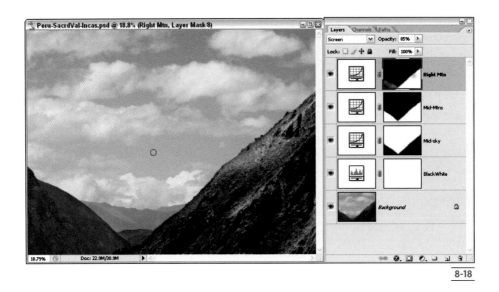

8-18

By warming up the mountains and cooling off the distance and sky, images like this gain some richness of color and definitely have an increased feeling of depth.

To adjust the warm and cold colors, follow these steps:

1. Warm the foreground. I added a Color Balance adjustment layer and increased red and yellow of the Midtones until the rocky slope looked right as seen in figure 8-19. This sort of warming adjustment usually looks good with 8 to 12 points of red and 8 to 12 points of yellow (which registers in the Color Levels as minus blue). The Tone Balance affects where most of the effect occurs. Midtones is usually best for warming a photo.

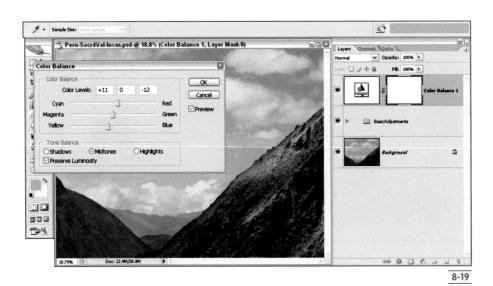

8-19

Layer Housekeeping

You can simplify your Layers palette by putting layers into a folder, or Group as Photoshop calls it.

Grouping layers is really easy to do in Photoshop CS2. Select the layers you want to put into a group by Ctrl/⌘-clicking them (do not click the layer icon or the layer mask). Then go to the Layers drop-down menu as seen here and select New Group from Layers.

In the New Group from Layers dialog box, shown in the following figure, type a name for the group, leave the rest of the sections at their defaults, and click OK.

This now gives you one folder in the Layers palette that represents all of the layers as seen in the next figure. You can get to them at any time by clicking the little arrow to the right of the eye icon to open the folder or group.

2. Limit the adjustment with a layer mask as demonstrated by figure 8-20. I did this by rough-selecting the sky with the Polygonal Lasso tool, feathering it slightly, and then filling it with black. Then I refined the edge with a soft paintbrush. Watch out for the edge or these adjustments will look odd.

3. Cool the background. I created a Color Balance adjustment layer and increased blue and a little cyan until the sky looked right as seen in figure 8-21. This sort of cooling adjustment usually looks good with 8 to 12 points of blue and something less in cyan (which registers in the Color Levels as minus red).

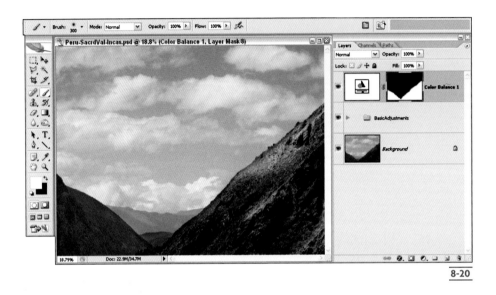

8-20

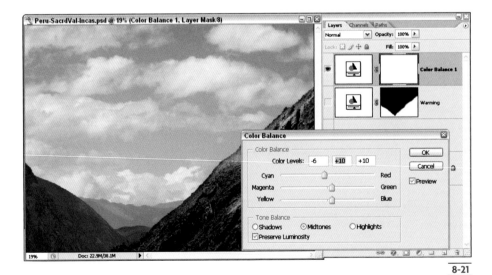

8-21

Experiment with selecting Midtones and Shadows for the changes. Color Balance uses these modifying choices singly or all together. Midtones and Shadows are usually best for cooling purposes. Note that in this image, some green was added. Very often you will find that adding blue also makes more neutral tones (such as clouds) look too magenta. Green neutralizes the magenta.

4. Limit the adjustment again. This time the cooling adjustment can be changed quickly and easily in Photoshop CS2. Press and hold Alt/Option, click on

the layer mask of the first Color Balance layer, which has been renamed Warming, and drag that to the layer now being used to cool the image and labeled Cooling. Click Yes in the dialog box that asks if you want to replace the layer mask. This now looks ugly as seen in figure 8-22 because the cooling and warming effects are applied to the same areas. The opposite of the Warming layer mask is required, so you need to invert the mask. This is easily done by pressing Ctrl/⌘+I and is shown in figure 8-23. The image now has a richness that was not originally captured.

For a more dramatic look, you can add the effect of a graduated neutral density filter quite easily. This richens the sky and intensifies the image. Do this by adding a new Curves adjustment layer, darken the sky with it (still keeping the bright tones of the clouds), and click OK. Then add a gradient to the layer mask to keep the darker sky but not affect the lower part of the photo. This is shown by figure 8-24.

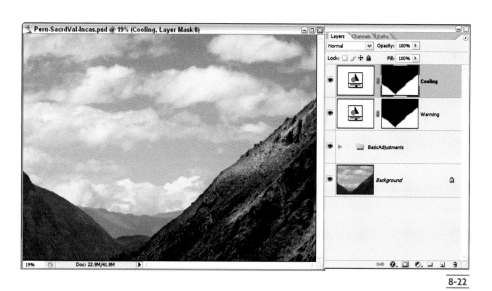

8-22

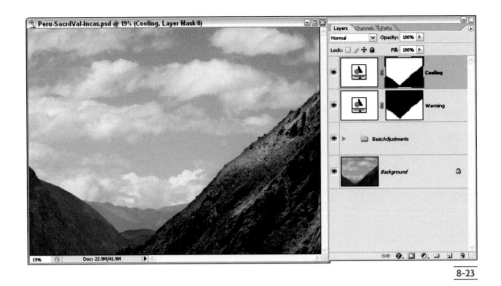

8-23

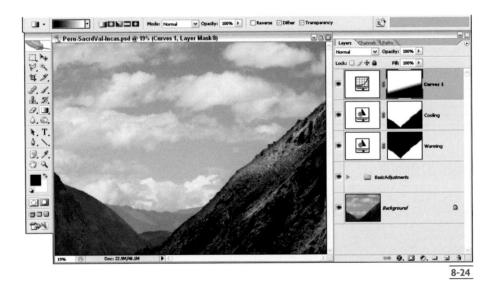

8-24

BEWARE SATURATION FASCINATION

Okay, I know I've mentioned it already, but you have to be careful of color saturation increases in an image. Over the past few years, I have been involved in reviewing digital prints sent into *Outdoor Photographer* and *PCPhoto* magazines for submissions and contests. In contests, we get thousands of entries and it is literally quite disturbing to open an envelope and have your eyes jarred by an oversaturated natural scene. Unfortunately, this is not a rare thing. Way too many images have saturation boosted inappropriately. I have also seen a number of nature books where the photographer has boosted saturation so that certain parts of the image look like something from an alien world.

Compare figure 8-25 (the final Nevada landscape seen earlier in this chapter) with the oversaturated version in figure 8-26. Figure 8-26 certainly is colorful, but in no way represents anything real. It is garish. Now if one wants to do something very abstract, like that in figure 8-27, that's a fun but different thing, as the image is no longer trying to be representative of the real thing.

As described in Chapter 4, there seems to be two main reasons for many photographers increasing the saturation too much:

> A love of the high-saturation Velvia and E-100 VS films by nature photographers in the past

> The tendency to do a little adjustment at a time, then a little more, a little more, and so on, with none of the adjustments looking like too much alone, but together definitely putting the photograph over the edge

I think there may be an additional reason: When a photograph looks flat because it hasn't been processed with proper attention to blacks, whites, and midtones (or it was just shot in the wrong conditions), it looks livelier and has greater color vibrancy with a lot of saturation. That makes Hue/Saturation an attractive control, but unfortunately, such adjustments can also make colors garish, unnatural, and create color relationships that make the viewer squirm.

Be careful as you change saturation. Do it for very specific purposes that support the natural conditions of the photograph, not for its own sake. If I find a photograph needs boosting in saturation, I usually add a maximum of 10 to 15 points for an overall color adjustment (affecting individual colors can be a different story). In figure 8-28, you see another scene from the Sacred Valley of the Incas in Peru that has had its core adjustments, but the color is a little weak. In figure 8-29, the image has had 12 points of saturation added, enough to make the light on the middle hill look like the morning light it was and boost color everywhere else. In figure 8-30, 25 points were added. The photo is more colorful, but the mountain has very odd coloring, and the clouds look like nothing you would see in Peru in the conditions that existed at the time of the photograph.

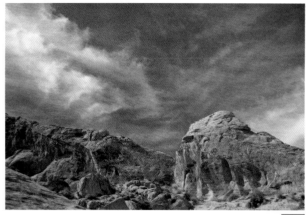

8-25

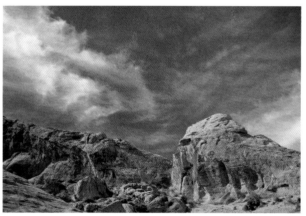

8-26

8-27

8-28

8-29

8-30

CORRECTING COLOR WITH HUE/SATURATION

In landscape and nature photography, it is not uncommon for colors to be recorded in varying degrees of accuracy in the same photo. This can be controlled somewhat in the studio by carefully profiling how the camera deals with colors. That doesn't work that well in nature because colors change as a result of a variety of contributing factors as discussed earlier. Sometimes just different angles to a blue sky can change the colors of objects in a landscape. And, such changes can be especially common with flowers, as you saw in Chapter 4.

In figure 8-31, you can see the original image of a group of fall leaves that are too blue compared to their real color. They were recorded a bit flat because they were in a heavy blue shade from an open sky. In addition, there is a reflected tree that is in the sun with a different aspect to its color.

Figure 8-32 shows the addition of Levels, but nothing else. The colors are better, and I saw no need to affect the midtones any differently. Also, I liked the blue tone to the water, so I didn't want to arbitrarily color correct and lose that. There is no requirement that you do all the steps shown in this or any other book. You still have to honor the image and what you want from it.

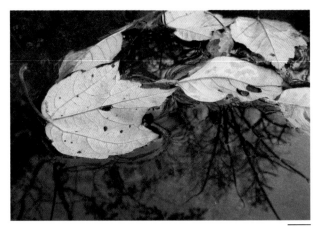

8-31

One way of adjusting the colors would be to just use Hue/Saturation in one layer and tweak individual colors as described in Chapter 4. However, while this can work, it doesn't offer the control that I like, and believe it or not, can take longer to do than what I describe next. One challenge you have is that as one color is adjusted, it can affect another one. I like to deal with situations like this one color at a time, one layer at a time. This way I can go back and tweak any color as needed without affecting any others. Here's how I would approach this image:

1. Adjust the reds. I added the first Hue/Saturation adjustment layer. You could take any color you want to start, but typically I like to start with the dominant color and get it right first. I selected Reds from the Edit drop-down menu to limit the color change, then I clicked on the photo to set the color scale. I increased saturation but also adjusted hue to remove some of the blue in the red color as seen in figure 8-33.

8-32

8-33

2. Limit the adjustment. Notice that the layer mask is limiting the red change just to the red leaves as seen in figure 8-34. In some photos, this can be really critical and requires some care in making the layer mask.

3. Adjust and limit the next color. I added another Hue/Saturation adjustment layer and limited it to Yellows, adjusting hue and saturation again as seen in figure 8-35. This time I did not use a layer mask because I didn't care if this affected the other leaves, and the blue of the water would not be affected.

I figure why waste time on a layer mask if you don't need it.

4. Adjust and limit the next color. The next color, in this case, was the reflected tree. While the tree was affected by Step 3, I wanted the change to it to be a little stronger, so I added another Hue/Saturation adjustment layer limited to Yellows, but also restricted to the tree reflection with a layer mask as seen in figure 8-36. I also toned the adjustment layer's effect down with an opacity reduction rather than trying to redo the Hue/Saturation changes.

8-34

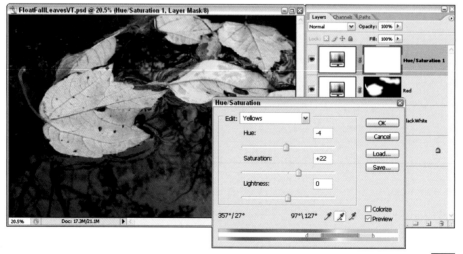

8-35

8

Color Adjustment Refined

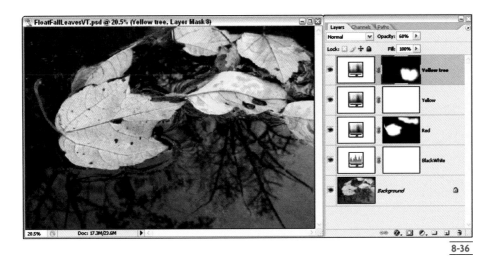

8-36

I had been thinking of tweaking the blue sky reflection, but once I got to this point, I decided I didn't need to. The contrast of the warm colors that I did adjust worked well against this dark gray-blue, so I stopped adjusting here.

Figure 8-37, the final image, illustrates my point about being careful when using Hue/Saturation. You can see some of the individual colors had quite high saturation settings. However, if you were to use a high overall setting on a photo like this, it would cause multiple problems because all the colors should not be processed equally. The blue of the sky reflection would have gone particularly garish or unnatural looking.

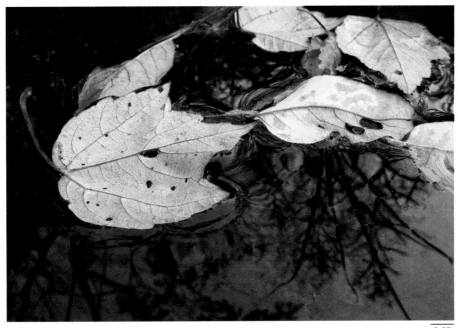

8-37

■ **What if I find there is a really weak color that needs a lot of color saturation or I just want something wildly colored? I find that as I increase the saturation with Hue/Saturation, the colors can get really weird.**

That's very true. For strong saturation adjustments or even for general warmth/saturation changes, I recommend checking into nik Multimedia's Color Efex (www.nikmultimedia.com). This is a terrific Photoshop plug-in that offers a great range of color and tonal adjustments in a very photographer-friendly form. In it you will find something called Brilliance/Warmth, which is really saturation/warmth. It is quick and easy to use.

Sometimes I have several pictures that have a similar colorcast, and I would like to adjust them so they all look the same in color. I seem to spend a lot of time trying to match them. What could I do to improve my odds?

This is a great question because it points out another benefit of adjustment layers — the ability to move them from one file to another. What you need to do is adjust one image using adjustment layers to get it the best you can. Then be sure your other photo is open and visible in Photoshop. Click on the photo with the adjustment layer correction to be sure you are on that specific photo, select the Move tool from the Toolbox, click on the adjustment layer you want to move, continue holding down the mouse button, and then drag the adjustment layer over on top of the new photo. You must drag this layer all the way onto the other image or this will not work. You will see a distinct cursor change when you are in position.

This brings over the exact adjustment. You can alter it for the new photo by reopening the adjustment (double-click on the layer icon) and tweaking the adjustment specifically for the new image. You can also change where the layer mask is because it isn't likely to be placed just right for the new photo. The best bet for the layer mask is often to fill it with black or white to turn it all off or all on, and then paint in the effect on the specific places you need it for the new image.

BETTER IMAGES THROUGH LOCAL ADJUSTMENTS

Over the last few chapters, you learned some ways to control tones and colors in specific areas within a photograph. This is, in essence, local control as compared to overall changes made to the whole image. Local control is a key aspect of photography and was essential for traditional nature photographers such as Ansel Adams or the great photojournalist W. Eugene Smith. In this chapter, you learn some additional techniques to give more depth and richness to your images as well as make them better communicate to your viewer what you find to be important about the scene.

For example, compare the scenes in figures 9-1 and 9-2. The camera wants to record a scene visually flat like that in figure 9-1. It can't interpret what is important or not important across a scene. In contrast, people look at a scene by focusing their attention on a part of it and scanning this focused attention across it. A scene is fully perceived with a wide angle of view, but it is not sharply interpreted by the brain except in the focused area as interpreted by figure 9-2. In this chapter, you learn how to control this focused attention mostly with tonality, but at the end of the chapter, with the appearance of sharpness.

Photographers have long recognized this and worked in the traditional darkroom to make images better communicate the way normal people see. Photographers like W. Eugene Smith would spend days on an image to control how it communicated what he saw in the original subject and its environment.

Color photographers are not able to do this easily, as mentioned in Chapter 1. So they would do a number of things to counteract the tendency of the camera to visually flatten a scene, including shooting certain subjects in specific light that avoided the flatness and using filters to control colors and tonalities, reflectors and diffusers to add light to shadows or alter the light from the sun to make it fit the subject better, and flash to isolate and control the light on a subject, even in nature where such artificial light does not exist.

9-1

9-2

All of these methods are important and valid ways for a photographer to control the image so that it gains more visual depth and interest, and so the image communicates better about the subject. But Photoshop is an equally valid use of technology. You can use it to bring an image closer to your vision of the subject and to help the image better communicate to the viewer. And that is what this chapter is all about.

DODGING AND BURNING

The way the traditional darkroom worker controlled tones in a photo was by dodging and burning while printing the image. Dodging means putting something in the path of the light that made the image, blocking that light, thereby subjecting the printing paper to less exposure and making that area lighter in tone. Burning (or burning in) means carefully adding light from the enlarger to control small areas of the image. This darkens the areas.

There are specific tools in Photoshop that correspond to the traditional dodging and burning tools and are called the Dodge and Burn tools. They are in the middle of the Toolbox as shown in figure 9-3. The Adobe engineers based the design of these tools on the traditional darkroom ways of doing these things, the Dodge tool representing an actual dodging tool and the Burn tool showing a hand as used to burn in an image in the darkroom.

9-3

173

However, Photoshop's Dodge and Burn tools are not as easily used in the way artists like Ansel Adams and W. Eugene Smith worked their dodge and burn tools over specific areas of the entire image. Photoshop's tools present two challenges for the photographer:

> They have to be used on pixels, altering those pixels in such a way that it can reduce quality if done too much, which also makes the changes hard to alter later.

> They tend to apply the lightening or darkening in uneven, splotchy patches when used over large areas.

You have already learned better ways of making large areas lighter or darker by using adjustment layers and layer masks, and you will learn additional ways of using these adjustment layers and layer masks for eye control in this chapter.

This doesn't mean the Dodge and Burn tools can't be used. They actually work quite well when you need to make small area adjustments, tweaking lightness or darkness selectively for very specific tonalities in your image that are too small or scattered to deal with in any other way. One very good example of this is found in running water as seen in figure 9-4. The primary focus is the water,

and with the Dodge and Burn tools, it can be enhanced. Here's how:

1. Create a new layer based on pixels. This can be done as a duplicate layer or by combining layers into a new one using the Stamp Visible Photoshop trick explained in Chapter 7 (press and hold Alt/Option+Ctrl/⌘+Shift, and then press E). In this image (because all the early work has already been done), the Background can simply be copied to a new layer as seen in figure 9-5 (press Ctrl/⌘+J to do that or click and drag the layer to the New Layer icon at the bottom of the Layers palette). If you have multiple layers, use the technique described in Chapter 7 to get this layer: Be sure you are in the top layer, then press and hold Alt/Option+Ctrl/⌘+Shift all at once, and then press E.

2. Start on the highlights. Click the Dodge tool in the Toolbox as seen in figure 9-6. This is a brush tool and has options to set in the top Options Bar (also seen in figure 9-6). You need to choose a brush size appropriate to the area you are working. You also need to adjust the Range and Exposure settings.

 • Give Exposure a low setting — 5 to 10 percent is plenty. Build up the adjustment by going over it several times. A high number causes problems with blending the dodging with the area surrounding your work.

 • Photoshop gives a little-used, but very important control here for how the Dodge and Burn tools change the area being affected — Range. In this case, the highlights will be worked, so select Highlights from the Range drop-down list seen in figure 9-7. This tells Photoshop to keep its adjustments focused on these tones and to ignore the other tones.

9-4

9

Better Images through Local Adjustments

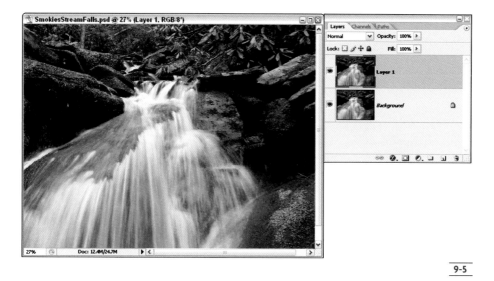

9-5

9-6

9-7

3. Work the highlights. Brush the Dodge tool over the highlights you want to lighten. In this case, I did not want to brighten the lightest parts of the stream, but I did want to develop the weaker streaking of the water, so I went over them as seen in figure 9-8 (you can also see the brush size — the circle). To see how the work is progressing, click the Eye icon of this work layer on and off to see the original image below. Do this dodging in short bits at a time and keep comparing it to the lower layer to be sure you don't overdo it.

4. Choose the Burn tool from the Toolbox (also seen in figure 9-6). Again, in the Options Bar, set up this tool like you did the Dodge Tool. Choose a brush size appropriate to the area you are working, as well as Range and Exposure. Exposure should still be set at 5 to 10 percent. In this case, the dark areas will be worked, so select Shadows from the Range drop-down menu seen in figure 9-9. This tells Photoshop to keep its adjustments focused on the dark tones and to ignore the brighter tones.

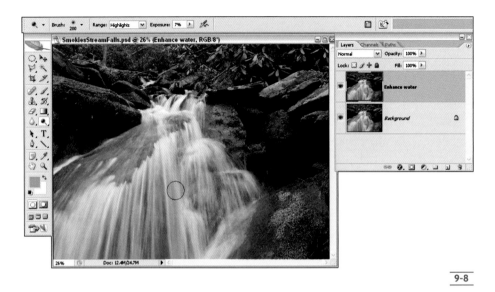

9-8

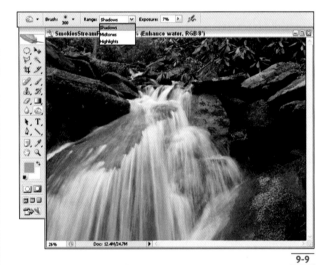

9-9

PRO TIP

As you work an image using this technique, go back and forth between the Dodge and Burn tools because the tonal relationships will change as you work. You cannot remove these adjustments except by backing up in the History palette, so be sure to check your progress frequently so you do not use up your allotted history states.

5. Work the dark areas. Just brush the Burn tool over the dark areas (they don't have to be shadows) you want to darken. I wanted to intensify the water movement — the streaking — by darkening the dark water around the light water, so I went over the dark tonalities around the light parts of the water as seen in figure 9-10 (you can also see the brush size). Again, as you work, click the Eye icon of this layer on and off to see the original image below.

Now compare figure 9-11 with figure 9-4, the first in this series, to see how the water comes alive with this technique.

A quick reminder: As you read back in Chapter 4, you should always work on a copy of your original. When opening your image for the first time in Photoshop, do a Save As for a new copy, then work on that. This protects your original. This is especially important when you are doing work directly to pixels such as when working with the Dodge and Burn Tools. This is also why you will see the addition of a specific layer of pixels used in this section so that if the dodging and burning gets all mixed up, you can just delete that layer and start over.

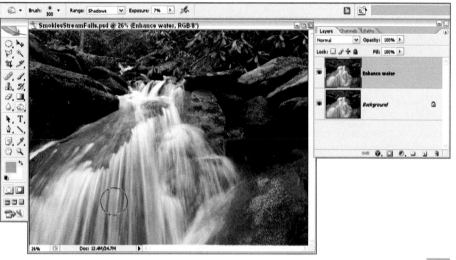

9-10

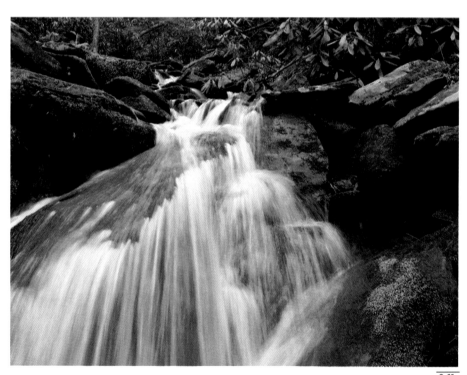

9-11

BASIC EYE CONTROL

One core technique of the traditional darkroom is to darken the outer edges and corners of the image to keep the viewer's eye inside the frame and on the subject. This was called edge burning and also gives the two dimensions of a photograph the illusion of three-dimensional depth that enriches most photos and compositions. Like any Photoshop technique, it can be overused. If your photograph needs no added edge burning, don't do it just because it seems like a good idea.

Anything that darkens the outer part of the image will work, from the use of Brightness/Contrast to Levels to Curves and more. I prefer a technique that I think is easy, fast, and offers excellent control. Using the colorful image of fall leaves seen in figure 9-12, I demonstrate how:

1. Create a darkening layer. I added a Brightness/Contrast adjustment layer as seen in figure 9-13. Did I shock you? As I noted in Chapter 6, everyone says you must never use Brightness/Contrast for any serious Photoshop adjustments. Largely, that is a good idea because it is a rather blunt tool. But in this case, the Brightness/Contrast adjustment is actually perfect, as you'll see (and I have a little section next about why this tool is so good for darkening parts of a photo like edge burning). Normally, you start by arbitrarily picking an amount of darkening by setting the Brightness slider to about -15 to -25. Because this is an adjustment layer, this can be changed at any time. The whole photo gets dark.

2. Fill the layer mask with black. This turns off the effect as seen in figure 9-14.

9-12

9-13

9-14

3. Paint in the effect along the edges. Pick or make a big soft brush (right-clicking on the photo will get you to brush sizes quickly) and brush white where it seems most appropriate. Change the brush back and forth from white to black to change where the effect is painted in or out as demonstrated by figure 9-15. Change your brush size as needed, too, but this should not be a precision paint job. A quickly done, more fluid brushing looks more natural.

4. Tweak the darkness of the "burned edges" by either changing the Opacity of the layer or by readjusting the Brightness slider in the adjustment layer as seen in figure 9-16 (remember that you can always get back to any adjustment in an adjustment layer by double-clicking the icon for that layer in the layers palette). This is very subjective and depends on the subject and the photographer's taste.

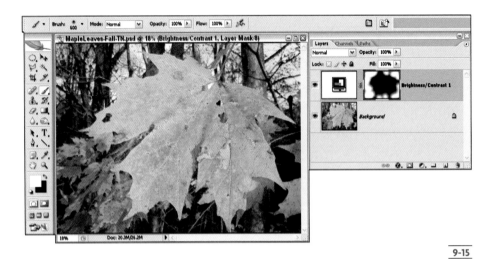

9-15

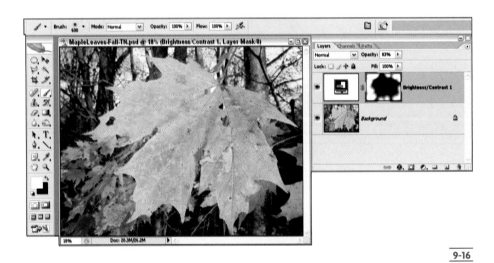

9-16

Now I want to show you something very interesting: the before and after photos in figures 9-17 and 9-18. With the darkened edges, the leaf looked a little muddy, so its midtones were lightened slightly. If you look steadily at figure 9-18 for awhile, and then look directly at figure 9-17, you may find a number of differences. The central leaf looks like it has a gentle spotlight on it in figure 9-18, yet the appearance of lightening comes more from the darkened edges. The edges of figure 9-17 may also look like they have been lightened rather than the edges of figure 9-18 darkened. You should also notice how much more dimensional the image looks.

PRO TIP

When blending adjustments into an image, it is very important to keep the blending edges soft. Do that by using larger soft brushes, large gradients with the Gradient tool, and even by adding a Gaussian Blur (choose Filter ➪ Blur ➪ Gaussian Blur) to a layer mask.

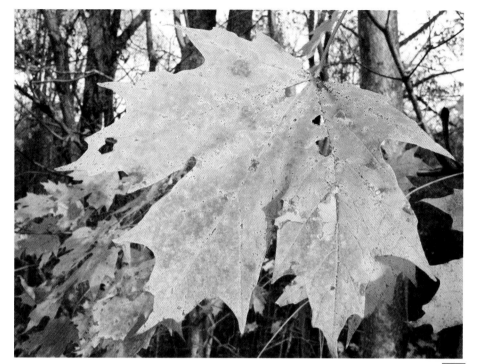

9-17

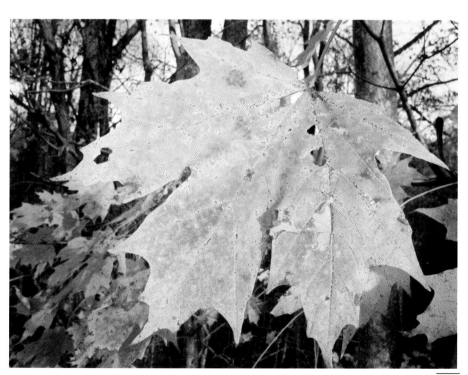

9-18

THE DREADED BRIGHTNESS/CONTRAST CONTROL

I know that if you've read anything about Photoshop, you have learned to avoid the dreaded Brightness/Contrast (shown in figure 9-19) like you would avoid that aunt who always wants to pinch your cheeks. And for serious work on the brightness and contrast of a photo, that is mostly good advice.

Brightness/Contrast is often used by beginners with their first experiments with Photoshop because it is very intuitive for a photographer (you don't need complicated explanations of what brightness or contrast means, and the controls are simple sliders). Brightness/Contrast as a direct adjustment is found in Image ⇨ Adjustments, or in the list of adjustment layer choices. However, as I've said before, it is very much a blunt instrument when it comes

to tonalities. It makes everything lighter or darker and contrast is not very controllable. For example, compare figures 9-20 and 9-21. You can see that the Brightness/Contrast-adjusted figure 9-20 is an okay photo, but its tonalities and colors have lost some of the richness and gradations seen in the Levels-adjusted figure 9-21. Such differences are magnified when prints are made.

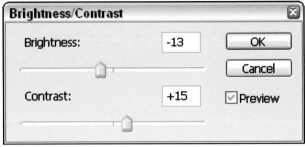

9-19

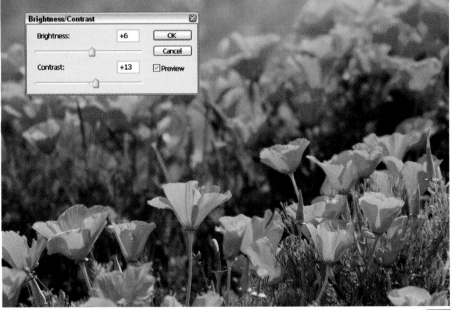

9-20

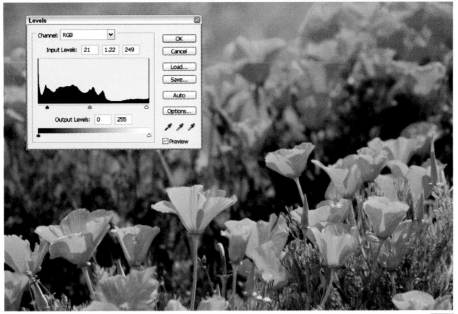

9-21

If Brightness/Contrast is a limiting choice for adjustment, why use it at all once you've mastered Levels and Curves? The answer is that using Brightness/Contrast for darkening areas of an image away from the subject is quick, easy, and uses exactly what is needed — an overall everything-gets-darker adjustment. You don't want brighter tones of these areas to be controlled differently than the midtones and dark tones. They all need to go down in brightness. This is exactly what burning in an image in the darkroom did — everything in that part of the print got darker in the same way.

I only use Brightness/Contrast as an adjustment layer so that it can be applied very selectively with the use of the layer mask. I also only use it to darken things in a photo. If something needs lightening, it is usually something that needs better rendering of its detail (otherwise, why would you lighten it?), so Levels or Curves generally supports that better than Brightness/Contrast.

FURTHER ADVENTURES IN EYE CONTROL

Because the photograph is a flatter visual experience than the real scene, you can do a lot for your image in terms of supporting the composition and communicating to your viewers how you want them to see the overall photo.

Generally, you will be adjusting a photo with these things in mind:

> Make your subject look its best (or if your subject fills the whole image, adjust its features so it looks right to you).

> Take all adjustments one step and one layer at a time. This gives you far more flexibility than trying, for example, to make local darkening and lightening adjustments with a single Curves change.

> Remove adjustments where they cause problems by painting in the layer masks in those areas.

> Darken parts of the image so that they become more part of the background and therefore set off the subject better.

> Reevaluate key areas of your subject and see if any need lightening or further color adjustments because of the darkening changes — use a Curves adjustment layer with layer mask for tonal adjustments.

In figure 9-22, you see an image of a marsh and sky that has had its basic adjustments of tonality and color made in Camera Raw. As you look at the photo, you will see a group of houses on a far hill. This is an image of an endangered habitat in California, a coastal wetland. It would have been possible to make a similar photograph without the houses, but as a nature photographer, I believe I must at times document and show some of the challenges nature faces, as well as the beauty.

X-REF

You will see more detail about using adjustment layers with layer modes in Chapter 7. The adjustment layer is used just to provide a layer for the mode change.

PRO TIP

When using the Gradient tool, don't try to make it perfect on your first try. You might or might not make that happen, but most often you need to put down a gradient in the layer mask just to see how it works and where the gradient works best. Because it is a simple click-and-drag application, you can redo this as much as needed until it looks right.

9-22

This is still a beautiful scene, but the houses are a little disturbing. On the one hand, it does show hope that such natural areas can coexist in built-up communities (the scene is Ballona Marsh in Los Angeles). On the other hand, it also shows the real threats to areas like this as the hillsides in the back are obviously man-manipulated with possible further development. The potential for problem run-off from those hills shows clearly because they butt up to the marsh directly, plus a road on the left hems in the area as well.

To make this photo communicate those ideas better, I needed to make some local adjustments. To start, there is a problem that needs correcting from the beginning. The wide-angle lens used for this shot has taken in an expanse of sky from close to the sun to far away from it, making the sky rather uneven in tone. The problem with the uneven tone is that the bright left side really attracts the viewer's eye and wants to draw it away from the rest of the photo. After fixing the uneven tone, individual area tweaks will take care of the rest of the composition.

Here's how to work such a photo:

1. Fix the tonal imbalance. As seen in figure 9-23, I added a layer and changed the mode to Multiply. I happened to use a Levels adjustment layer, but I didn't make any adjustments — just using it for the layer that can be multiplied. Almost any adjustment layer could have been used. As you would expect, the whole image got dark, but by using the Gradient tool in the layer mask, I was able to blend that adjustment from left to right, limiting the darkness to the left side.

2. Tweak the layer mask. Often, you need to refine the gradient used in this sort of image. The darkening of the sky is fine, but the marsh below is way too dark. So I painted the adjustment out by using black to turn off the sky layer effect at the bottom left as seen in figure 9-24.

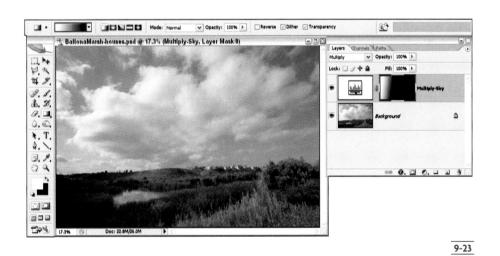

9-23

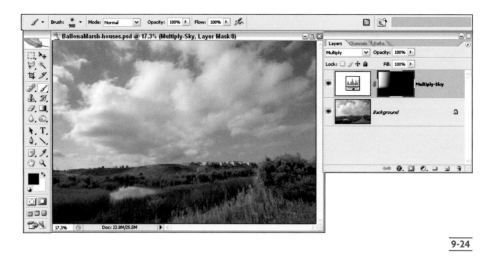

3. Refine the sky. The sky looks good now, but notice how different the clouds look at the left compared to the right of the image shown in figure 9-24. This is partly a natural effect, but partly a problem with the camera dealing with the contrast of light from left to right in the clouds. To bring the clouds back to a fluffier look, I used another Levels adjustment layer just for the layer, not making any adjustments with it.

This time I used a different Layer mode called Overlay. This makes brighter tones lighter and darker tones darker, increasing contrast with a very simple adjustment. The overall change, seen in figure 9-25, is pretty harsh and ugly, but when the layer mask is filled with black and white painted over the clouds at the right, the effect is just right, as seen in figure 9-26.

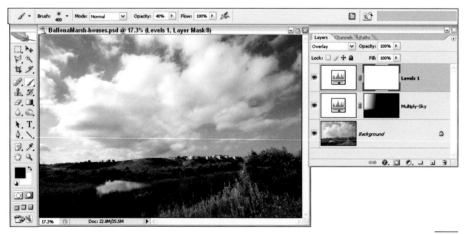

9-25

Better Images through Local Adjustments

9

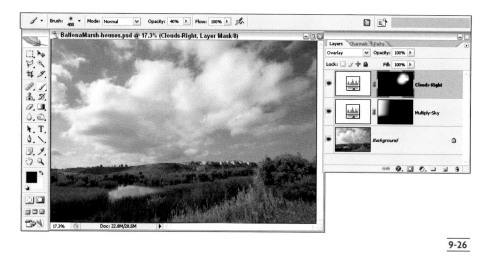

9-26

This gives the scene a nice sky and you can notice the expanding nature of the clouds much better now. But perhaps the clouds have become a bit too dominant over the photo. The next step is to work the marsh so the viewer wants to look there, too.

4. Bring in some color. Color is not adjusted just by controls like Hue/Saturation. Changing tonalities of areas also affect color, as you've seen happening even with the first adjustments of blacks and whites. The colors of the marsh need to be revealed before they can be changed with color controls. So I used another layer with no adjustments, this time setting it to Screen, as seen in figure 9-27. This makes the photo look way overexposed overall, so I filled the layer mask with black

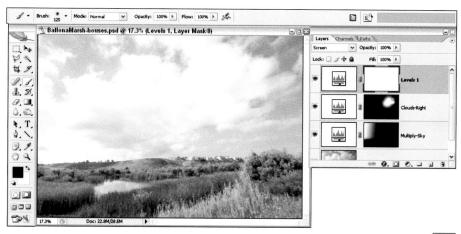

9-27

and painted in the effect over the green vegetation of the marsh, as seen in figure 9-28. I did not bring up the plants at the lower right because I did not want the eye to go there. I also brightened the water slightly by using the brush at a lower opacity. Finally, I toned down the layer a bit by lowering its overall opacity.

Now the photo not only looks more like the scene really appeared to my eyes, but it is also more balanced for the viewer's eye to really perceive and understand the composition. The sky and the marsh are becoming more equal in the photo. Note how nice the color of the marsh looks without any saturation change.

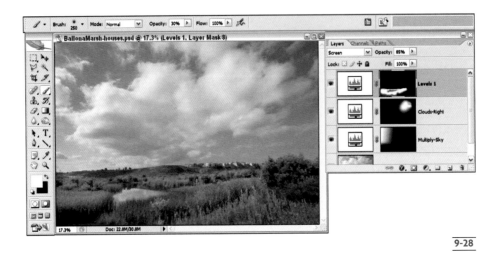

9-28

Useful Layer Modes

A note on Layer modes: When you click the Modes drop-down menu, you get a ton of choices as you've already seen. Each choice does unique things, though for nature photographers, most are not very useful. I find that, besides Normal, I generally use these modes:

> Multiply to intensify and darken

> Screen to brighten

> Overlay to intensify contrast

> Soft Light to also intensify contrast, but not as strong as Overlay

> Color to apply a color only to an area of the photo (the color is painted onto an empty layer, for example)

> Luminosity to limit adjustments to the tonal changes without altering color (used most often for strong tonal adjustments)

5. Reevaluate. I constantly watch the image as I go, to see if changes in local areas influence the overall impression of the photo. In this case, I found that with the bottom of the image brought up in value, it actually made the whole image now look too light. I decided that the sky needed darkening. So I added a Curves adjustment layer and reduced the midtones of the sky, limiting the adjustment to the sky with the layer mask as seen in figure 9-29. I did not want the brightest clouds to be dulled, so I used Curves instead of Brightness/Contrast so I could mainly darken the midtones.

6. Darken the edges. The edges can be darkened with Brightness/Contrast. I added the appropriate adjustment layer, darkened the photo, filled the layer mask with black, and then painted in darkness with white on the mask as needed (demonstrated in figure 9-30). In this case, the upper right is already the darkest part of the sky, so there is no point to making it darker. I used a low opacity for the brush so I could vary how

strong the darkening was by how many times I went over the area. I added a little darkness to the top left, slightly more to the middle left edge, then the most to the lower-right-hand side. That latter area was filled with some lighter, scruffy plants not in the marsh itself, so while the space was important to the composition, it needed to be toned down to give it less importance.

7. Keep the composition clear. The adjustments could easily have stopped at figure 9-30, but at this point, I was concerned that the houses might have been too balanced with the rest of the scene. Because I wanted them to stand out so they were a little jarring to the rest of the photo, I added a Curves adjustment layer to lighten that area of the photo. I made the adjustment, filled the layer mask with black to turn off the effect, and then painted it in with white over the houses as seen in figure 9-31. I also thought the tree at the right had become a little dark, so I brightened it here, too.

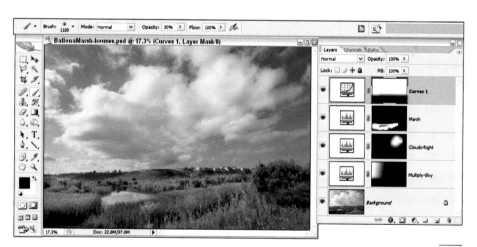

9-29

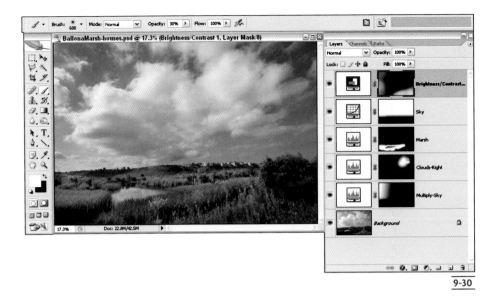

9-30

Better Images through Local Adjustments

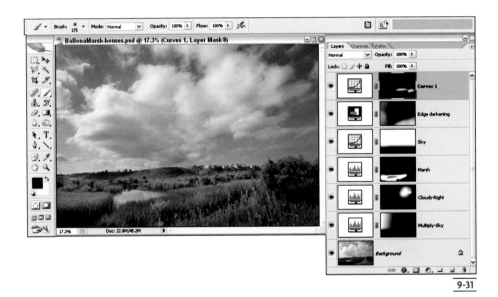

9-31

A NEW LEVEL OF ADJUSTMENT

Now look at figure 9-32, the Layers palette of the photo that was just adjusted. Compare it to Ansel Adams's printing notes in figure 9-33. Note how much they relate to each other.

This approach to local adjustment, the "dodging and burning" of the traditional darkroom, is a very effective and efficient way of adjusting your photo. It works far better than using the Photoshop Dodge and Burn tools or trying to do impressive contortions with one adjustment, such as Curves. Note that each layer has basically one adjustment. This makes it very easy to control your photo as well as making the layer stack easy to understand. It also gives adjustments infinite flexibility.

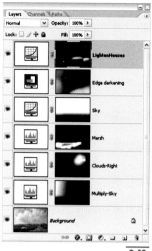

9-32

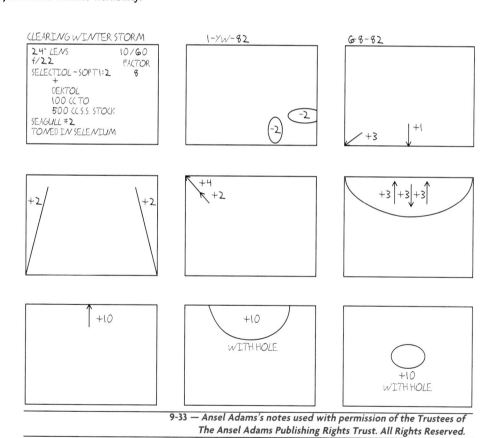

9-33 — Ansel Adams's notes used with permission of the Trustees of
The Ansel Adams Publishing Rights Trust. All Rights Reserved.

I know from experience in working with other photographers through *Outdoor Photographer* magazine and in my workshops that many are intimidated when they first see a layer stack like this, and they almost always feel that this represents a lot of time. I certainly don't want to spend any more time in the digital darkroom than I have to either, so you should know that this approach is actually quite fast once you have used it a few times.

Look at figures 9-34 and 9-35, the before and after photos of Ballona Marsh. It looks like a lot of work, perhaps, but by using adjustment layers and making quick modifications to the layer masks, this can be done without taking a lot of time. Granted, it will take time at first as you learn the process and gain understanding of the different controls and the use of layer masks, but with a little practice, this process will go quite efficiently without holding you hostage to the computer.

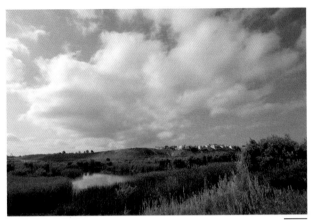

9-34

9-35

SELECTIONS AND THE LAYER MASK

The layer mask is an important control for dealing with local, isolated adjustments. Photoshop even offers additional ways of controlling the effects of the layer mask that are worth exploring. Selections can be very helpful in making a layer mask do what you want it to do. You can apply any of Photoshop's selection tools to do this, too.

You can use selections either before or after opening an adjustment layer to select where you will add black or white to the image. I'll show you how both methods work in dealing with a simple, very fast overall edge burning of an image, though you can use this technique with all sorts of photos that need local changes. Which is better, before or after selections? That's hard to say because it really depends on the subject, the scene, and what needs to be selected.

The example photo used in this section has had basic adjustments applied to it. The next step is to darken the edges to give it a little more depth. Here's how to do it by making an adjustment layer, then using a selection:

1. Create a Brightness/Contrast darkening layer as seen in figure 9-36.

2. Make a selection that surrounds the subject. I used an Elliptical Marquee selection tool.

3. Fill the selection with black to remove the effect and deselect the selection (press Ctrl/⌘+D). You can see in figure 9-37 how this has removed the darkness on the flower and kept it on the outside. But the edge is way too sharp when the selection was first filled.

4. Soften the edge of the layer mask. This is done very quickly, easily, and flexibly with Gaussian Blur (choose Filter ⇨ Blur ⇨ Gaussian Blur) also seen in figure 9-37.

9-36

9-37

Here's how the same adjustment can be done by making a selection first:

1. **Make a selection around the subject.** In the example in figure 9-38, I decided to use a more irregular selection by using the Lasso tool.

2. **Create a Brightness/Contrast adjustment layer.** For me, the easiest way to do this is by using the adjustment layer icon at the bottom of the Layers palette. The Brightness/Contrast dialog box opens with a pre-made layer mask based on the selection as seen in figure 9-39. Notice that the mask is truly based on the selection so the adjustment is made to the area selected. In this case, it is the central part of the photo, which is the wrong part, but that is easily corrected.

3. **Invert the mask.** If a mask is dealing with the area opposite of what you really want, just invert it (see figure 9-40) by pressing Ctrl/⌘+I.

4. **Soften the edge of the layer mask.** This is again done very quickly, easily, and flexibly with Gaussian Blur as seen in figure 9-41.

9-39

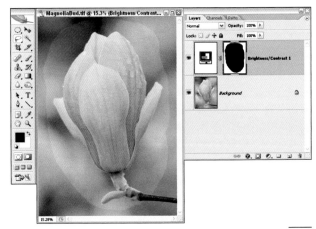

9-40

9-38

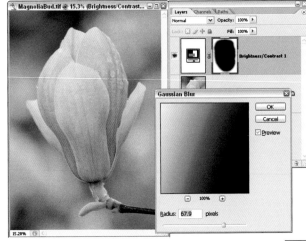

9-41

COLOR RANGE TOOL

The Color Range tool is another important asset for use with layer masks. This tool lets you find and select specific tones and colors in an image so that you can limit adjustment to them. It can be as variable as the exact colors and tones in your image are, and you don't have to have perfect hand-eye coordination to use it. When the Hill Country west of Austin is in bloom, it is always a dramatic sight. The image seen in figure 9-42 was shot on a hazy day with a telephoto lens to compress the elements from foreground to background in the scene. It has had its basic adjustments and because of the variations in color and tone, is a good example of how to use Color Range and adjustment layers.

Figure 9-43 shows the basic Color Range adjustment dialog box. To open it, choose Select ⇨ Color Range. When Sampled Colors is selected as seen in the figure, your cursor changes to an eyedropper when it is moved over the photo, and wherever you click, that color and tone are selected throughout the photo. This selection shows up first in the small preview as a black/white mask (when Selection is active), showing white for the selected parts of the photo, black for no selection, and gray for partial selection. Fuzziness expands or contracts the selected area, as do the plus and minus eyedroppers. This is a basic, key way of using this tool.

The rest of the interface has additional options that may or may not be useful to you, so I'll touch on them briefly. In figure 9-44, you see a drop-down menu of other items that can be selected automatically. I don't find the colors that useful, as it is usually easier, faster, and better to just select them directly as Sampled Colors. However, Highlights, Midtones, and Shadows can be very useful.

9-43

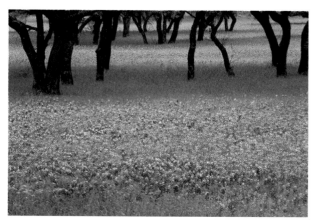

9-42

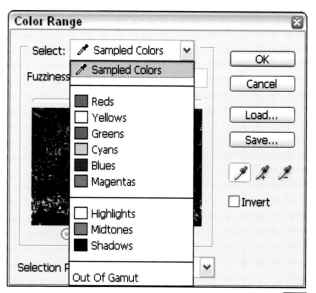

9-44

Out Of Gamut is more for the printing industry. Selecting the Invert check box inverts your selection, making it actually the opposite of what you are clicking on.

In figure 9-45, you can see the drop-down menu for Selection Preview — these are simply special previews for looking at how this selection tool is finding similar colors and tones. White Matte is selected from that menu, which is why the image looks very different in this figure. No preview choice is particularly better or worse than others. It all depends on what you, the photographer, like. I tend to use None most of the time because I find it easier to read. Then I watch what is happening in the small preview area of the dialog box.

Here's a brief look at how you can use Color Range and adjustment layers:

1. Use Color Range to select an area of the photograph. Figures 9-46 shows the effect of clicking on the dark blue flowers (bluebonnets), then using the Fuzziness slider and finally clicking OK to get the selection you see in the figure.

2. Adjust the selected area. By adding an adjustment layer, you pick up the selection as a layer mask as shown in figure 9-47. I often use a Curves layer because of how it gradually changes tones across the curve. In figure 9-48, you can see a Hue/Saturation layer with a strong Saturation adjustment, but it is limited to the flowers by the layer mask. Its mask was copied from the Lupine 1 layer by pressing Alt/Option, then clicking and dragging the lower mask onto the blank upper one.

PRO TIP

You can use tonal adjustments, from Levels to Curves to Brightness/Contrast on a layer mask in order to tweak its effect. If you look closely at figure 9-49, you will see the Hue/Saturation mask is slightly different than the mask on the layer marked Lupine 1, even though they are both based on the flowers. You can tweak layer masks quite easily by using Levels to make the lighter areas more white (more effect) and the darker areas more black (less effect), which was done here to make the effect stronger on the flowers.

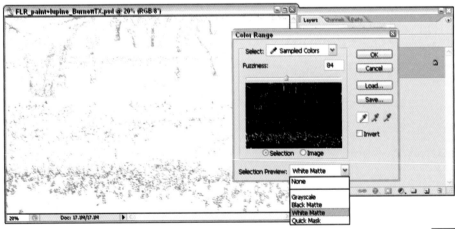

9-45

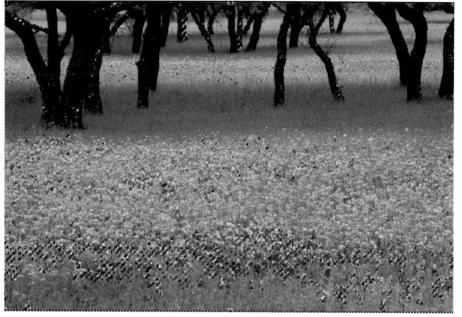

9-46

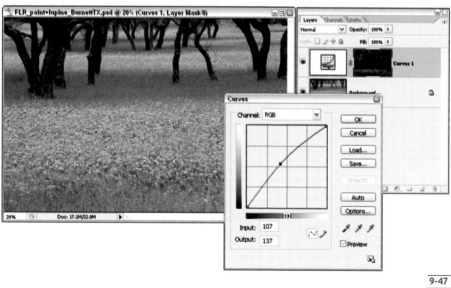

9-47

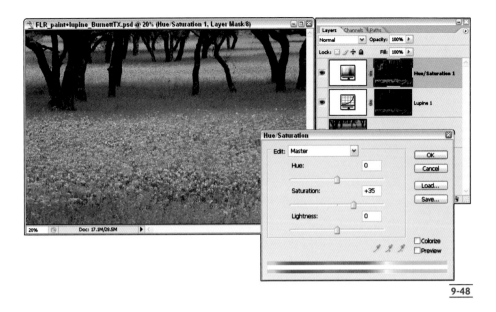

9-48

3. Adjust another color or tone. As you can see in figure 9-49, the green grass was selected by Color Range. You might think, as I did at first, that the grass should be lighter so there is more color in it.

But I discovered that darkening the green, as seen in figure 9-50, makes the photo more dramatic and better emphasizes the real subject, which are the flower colors.

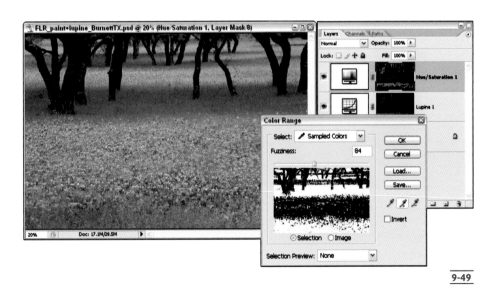

9-49

Better Images through Local Adjustments

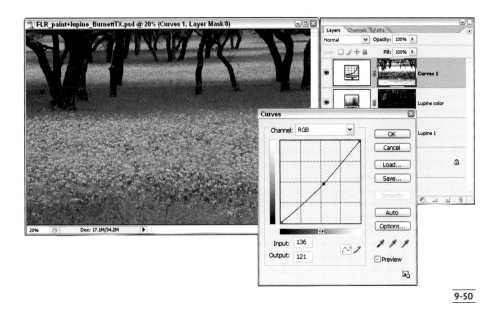

9-50

4. Adjust as many tones or colors as you need. The image shown here doesn't necessarily need a lot of additional adjustment, but tweaking the orange color (paintbrush flowers) did enrich the photo. The orange was selected with Color Range using the + eyedropper as shown in figure 9-51. Then I used Hue/Saturation to adjust the orange flower color to something a little closer to the red-orange they really are as seen in figure 9-52.

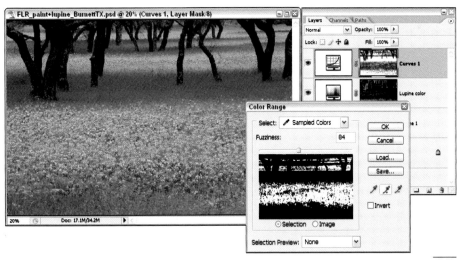

9-51

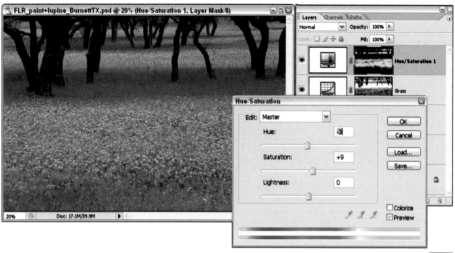

9-52

It is important to notice how the photo has become more saturated, but the saturation has occurred in steps, limited to specific areas. In photos with a lot of diverse colors, it is often best to adjust color saturation in this way because all colors rarely need the same adjustment. It is also important to understand that this is not an arbitrary thing — colors typically do not photograph with the same relative saturations actually seen in real life.

BACK TO THE BEGINNING

In the first part of this chapter, I showed an image that emphasized a part of the photo in brightness, which you have seen, but also in an appearance of sharpness, which has not been discussed yet. I'll explain how to do this now using the same principles shown throughout this chapter.

In this case, the lower trillium plant (toadshade or sessile trillium) is isolated then adjusted separately from the rest of the image in terms of tonality and sharpness. You should have an idea of how the darkening works. As shown in Figure 9-53, a Brightness/Contrast layer

darkens the overall scene, then the area around and on the flowering plant was removed from that layer by painting black on the layer mask. That made the plant almost in a spotlight.

The appearance of a sharper flower and plant in the bottom center of the image comes not from any technique applied to the subject, but by blurring the outer surroundings to the subject. Here is an overview of the process:

1. Copy the bottom layer. I copied the bottom layer and kept it under the Brightness/Contrast layer as seen in figure 9-54 (I clicked on the bottom layer and pressed Ctrl/⌘+J). Remember that everything is seen from top to bottom. I wanted to be sure that anything I did to the actual pixels of this image stayed adjusted in the same way I had been working the image, so the Darken layer had to stay on top.

2. Blur the copy of the Background, the now-named Blur layer in figure 9-55. I used Gaussian Blur enough to make the photo look out of focus, but not so much that it stopped looking photographic.

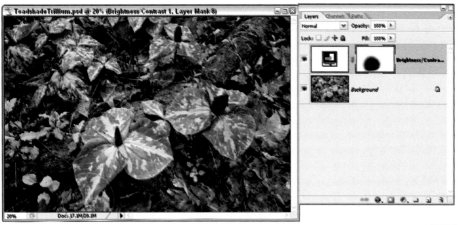

9-53

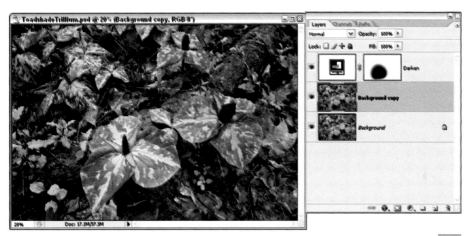

9-54

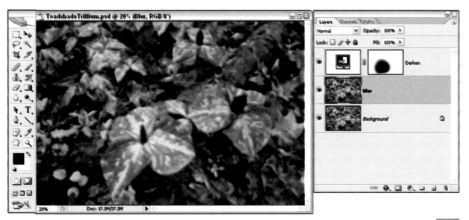

9-55

3. Add a layer mask. Photoshop allows you to add layer masks to pixel layers by using the layer mask icon at the bottom of the Layers palette or by using the Layer menu. Because most of the image needed to be affected, I kept the mask white as seen in figure 9-56. If you need a black layer mask (to hide the layer at first), you can press Alt/Option while clicking on the Layer Mask icon.

4. Paint out the effect in the layer mask. In this case, I knew that the area that should be sharp was roughly the same as the brighter area. I copied the Darken layer's layer mask to the new Blur layer mask by holding down Alt/Option while dragging it down. I used multiple white and black paintbrushes to work the photo further. The result is in figure 9-57.

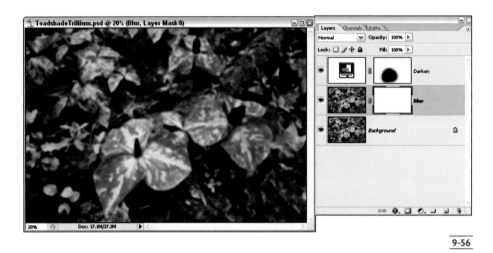

9-56

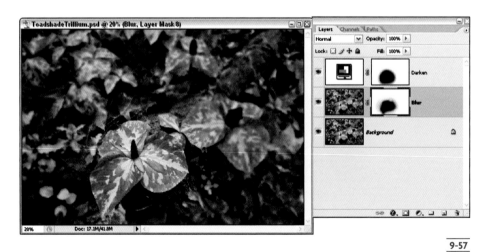

9-57

Q & A

It seems to me if you can use multiple adjustment layers to make a photo right, you should be able to use the same idea to experiment with adjustments. Am I right?

Absolutely. Adjustment layers used for different amounts of adjustment are a great way to work. More than once I have made what I think are the best adjustments for the photo, but then find out they are not the best if I am making a print. I am not talking about color management, but about the fact that a print and a monitor are two very different things and people respond to them differently.

I will often add an adjustment layer just for experimenting. For example, I might add a Curves layer and make a strong adjustment to the photo, beyond what the normal adjustments were. That layer can come and go as needed, offering a great deal of flexibility and power without messing up any other adjustments.

You seem to mainly paint on your layer masks. You don't use selections much. Is painting better?

Better in a quality sense, no. Better for workflow, I believe so. Selections can be tedious to create and modify. Painting to the layer mask gives you more flexibility. Most photographers can paint the effect on and off quite quickly with just a little practice. With painting, too, you can more quickly modify how an area is controlled compared to adjusting a selection (though you can paint as needed around a selection once its work is done and you deselect it).

Many photographers find painting is especially easy when they use a graphics tablet such as those made by Wacom. A tablet uses a flat surface with an electronic pen to allow you to move your cursor just like using a mouse, but in this case, it follows your actions with the pen across the tablet. It mimics the actual use of a brush that you might hold and brush over a print or other physical image.

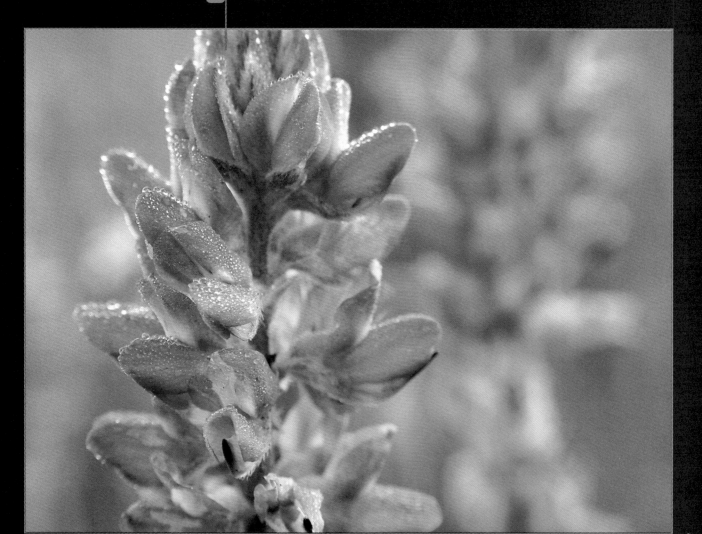

PUTTING IT ALL TOGETHER:
AN APPROACH THAT WORKS

Being able to use Photoshop's tools is one thing; using them to build the image you want is something else. That's what the craft of using Photoshop is all about — bringing together diverse tools to make image adjustments that result in a final image that meets your needs.

In this chapter, you'll see a single image processed from start to finish, along with analysis of why each step was taken. This puts everything described in the previous chapters into a single whole that hopefully brings you to a better understanding of the craft of Photoshop. It also brings the workflow that I've been following in the book together on one image. However, there is still more to Photoshop — some unique and special processing techniques. You learn more about these in the rest of the book, and how they can also be applied in the approach described in this chapter.

ONE STEP AT A TIME

I believe in working an image one step and one layer at a time. This has a lot of advantages for both the photographer and the photograph as compared to trying to do multiple adjustments at once. For example, you gain some real control by adjusting the highlights and the shadows separately even if you can do it all in one layer using Curves. Here are other advantages of taking a very deliberate, step-by-step approach as outlined in this chapter:

> Because you do things the same way, you can more easily follow your steps and keep track of what you are doing to the image. Photoshop can be confusing, so why make it more confusing?

> You can see exactly how each adjustment affects the overall image by turning its layer on and off.

> Using layers and going step by step make it easier to go back and analyze where certain adjustments did well or poorly.

> You can optimize specific parts of a photo more easily and more effectively.

> You can isolate each controlled area, making it easier to see the actual adjustment.

> Isolating adjustments allows you to more easily go back and make corrections.

EVALUATING THE PHOTO

What I want to stress, and this builds on some things I discussed in earlier chapters, is that the photo and how you saw the subject should define how you deal with the image in Photoshop. There are many, many ways of dealing with a photo in Photoshop, but not as many when you look hard at your image.

The photo (see figure 10-1) used in this chapter is from the Ancient Bristlecone National Forest in the Inyo Mountains east of Bishop, California. It is a miniature landscape (or as Eliot Porter called segments of a large landscape, an intimate landscape) — a clump of cushion buckwheat with an ancient bristlecone behind it, a few other flowers (out of focus) and dolomite rock all around on the ground.

It is worth evaluating this scene as an image before doing anything to it in Photoshop. You don't need to go into the detail I describe in this chapter with all of your photos (some you will deal with very intuitively), but to see how I approached this photo for this example, you need to understand a bit about the scene as shot.

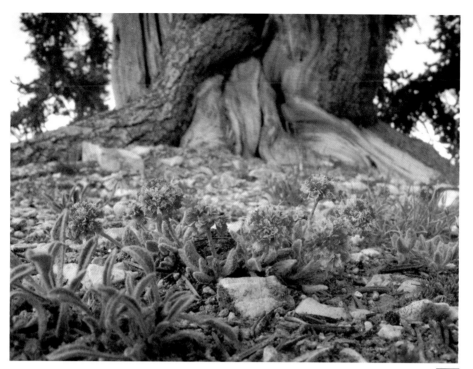

10-1

The photo is a textured landscape of plants, rock, and tree. The little flowers are just a few inches tall, and by bringing the camera down to their level, I tried to bring the viewer into a relationship with them that is not normally seen. This low angle also creates a strong foreground/background relationship with the tree trunk. So often, little flowers like this are shot from above, which does not provide the sense of intimacy seen here. Dirty knees can be a giveaway sign of a serious nature photographer!

The photo has a strong feeling of place and setting. It does not have the emphasis that I saw when looking at the flowers, which is what I want to adjust. The light is very gentle, but not helpful for that purpose. It is interesting to me that some purists will accept the use of a flash to accent the flowers, which works great, but is totally unnatural and artificial to the scene — a lie, in a sense, about what was really there. Yet they will not accept Photoshop being applied to define and refine the image using the actual and real elements of the scene.

First Steps

The first thing I always want to do is set my blacks and whites. These set the stage for the contrast and color of the image. Even on under- or overexposed images, I set

these first, unless the image is so dark that I need multiple Screen mode layers to really see it (and that would only be for a photograph that I just had to have because the results from such a technique would show a lot of problems, such as noise and tonal banding).

You learned how to set blacks and whites in Chapter 4, so there is little point in going through all the steps again here. However, I want to take you further here by analyzing how you might think beyond just getting a black or white point.

1. Figure 10-2 shows the black threshold of Levels without any changes. This image has a good exposure and blacks are just starting to appear.

2. In figure 10-3, the black slider of Levels has been used more aggressively. You can see the blacks strongly appearing in the branches at the right. It is very

10-2

10-3

important to look at the actual image (release Alt/Option) as seen in figure 10-4. At this point, you have to judge such an image on experience. It is difficult to say do one thing or another because the results are so subjective. But before you can make a complete evaluation, you need to set whites.

3. You can see in figure 10-5 that the unadjusted whites show up right away in the threshold screen of Levels. The brightest areas clip (meaning they show as pure white, losing all detail) in the sky. However, the sky here is pretty blank, so the photo might be better served with more clipping in the sky, which would open up the rest of the photo and make the highlights livelier.

10-4

10-5

4. Figure 10-6 shows a more aggressive change of the white slider. The sky is mostly clipped, and some bright details are appearing below. Comparing this to the actual image (see figure 10-7) shows an image with livelier tonalities.

5. I liked the blacks in the lower portion of the photo, but felt the darkness at the right side of the tree looked heavy. Of course, midtone adjustments would affect this, but I felt the photo was getting out of balance. With a simple use of the layer mask as demonstrated by figure 10-8, the adjustment was toned down (painting black with a low opacity) — the circle is the brush showing its size.

10-6

10-7

10-8

BACK TO MIDTONES

Again, you know the routine for dealing with midtones from Chapter 4, so I will give more specific analysis of working them in this photo.

1. I first made an overall lightening move with Curves as shown in figure 10-9. Mainly I watched what was happening to the flowers.

2. I thought that maybe the dark areas could be opened a little (doing this with Curves does not significantly affect the black or white points of the photo as black and white amounts are anchored by the points in the bottom-left and top-right corners of the Curves graph). I added a new point at the lower part of the

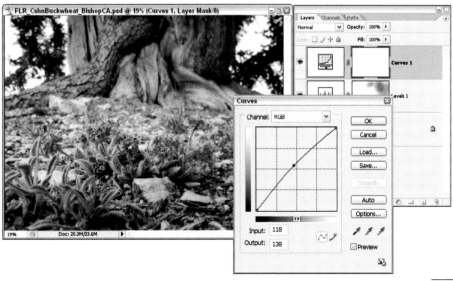

10-9

curve to open the dark areas, but found that made the brighter areas too bright. I moved the higher point (by clicking and dragging) higher on the line, and then back toward the center to compensate as seen in figure 10-10.

3. The top of the frame with the tree has become too light. I used a gradient in the layer mask to remove the effect of the midtone change up there as shown in figure 10-11.

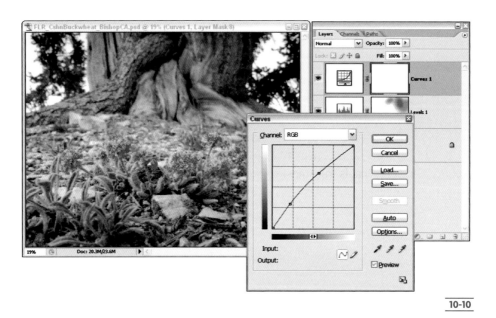

10-10

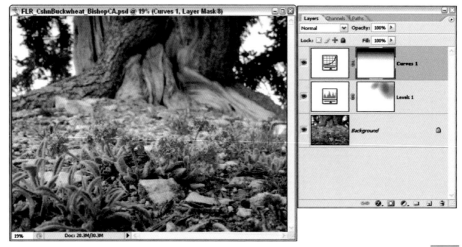

10-11

4. I thought the gradient layer in the layer mask resulted in the adjustment layer making the top of the frame a little too dark compared to the rest of the image. So, I wanted to slightly change the opacity with the Fade control (choose Edit ⇨ Fade tool). In this case, as seen in figure 10-12, it faded the density of the gradient. I found bringing it down to 35 percent was about right. Notice the layer mask now looks gray.

There is still a bit of work to be done; however, I want to point out something before continuing. Several things have been changed, yet because I worked with adjustment layers and layer masks, this work happened very fast. Sometimes there is the idea that using Photoshop can take a long time. While occasionally that is true, mostly you can work very quickly by using the procedures described here.

NOTE

Don't forget that to use the Fade tool, you must do it immediately after making any adjustment to the image. It can't be used by backing up in the History palette.

PRO TIP

I have a very specific way of using the Fade tool that may be of use to you. Rather than just reducing it from 100 percent, I prefer to immediately reduce the slider to 0 percent, then move it up quickly until I like the results. The advantage of this is that you are adjusting the image from its unadjusted point rather than bringing it down from an adjusted point that you don't like.

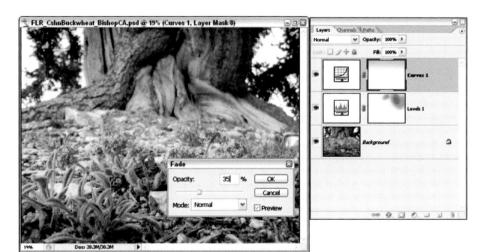

10-12

Naming Layers

You may have noticed that I had not named the layers in the earlier screen shots. Because my first two layers are almost always Levels (for blacks and whites) and Curves (for midtones), I don't always name them. I know what they are. However, as I increase the layer stack, I will name them so that I can keep track of all the layers as they increase in number.

Color Work

At this point, the photo is looking much more interesting and closer to my original vision. The color is also looking good. I have to qualify this a little. Purists will note, correctly, that making any significant adjustment (whether in an adjustment layer or not) can affect color (usually intensifying it). The way around this is to change the Layer mode to Luminosity. I won't always do this at this point because the color change is often appropriate to the scene and better than using an overall saturation

adjustment later, but the choice is yours. You can always go back and forth between Luminosity and Normal (use your History palette) and see what you like.

I did want to enliven the color of the flowers and leaves a little without making them look garish (or overadjusting the whole photo). Here's how this work can be done:

1. Open a Hue/Saturation adjustment layer. I had no need to do an overall adjustment, so I went right to the individual colors. Figure 10-13 shows the red flowers being favored.

2. Figure 10-14 shows the green leaves being adjusted. This could be done in two separate layers if the colors were close (either in actual hue or proximity) and needed more isolated control. Notice that I adjusted the hue and saturation. I happen to know that the camera I used for this shot tends to make greens a little more yellow than they really are in life, so I compensated for that here.

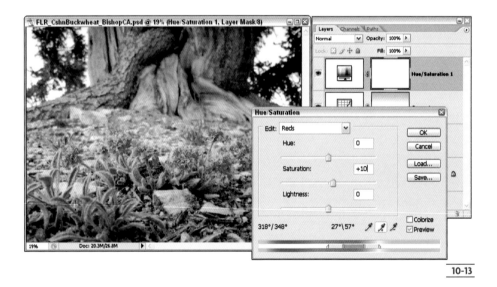

10-13

3. Even though you limit adjustments to certain colors with Hue/Saturation, you will usually find at least parts of the whole image are affected. This is definitely true here, so I turned off the layer's effects by filling the mask with black as seen in figure 10-15. Then I painted in the mask with white where the flowers and leaves are as shown in figure 10-16.

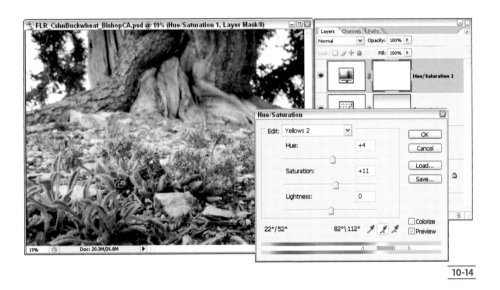

10-14

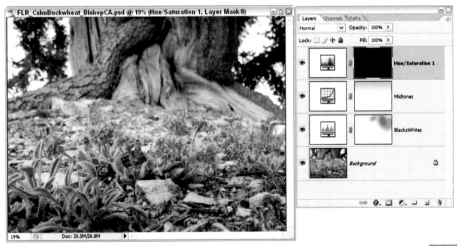

10-15

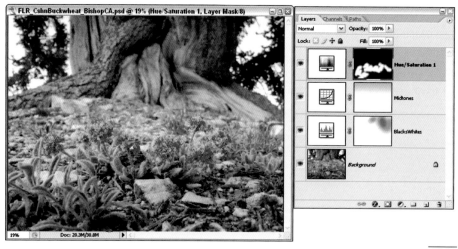

10-16

PRO TIP

Use your preview and review tools as a regular part of your workflow. Turn the preview setting on and off in dialog boxes. Turn your layers on and off to see their effects. This can be very important with the Hue/Saturation changes just described. This tells you immediately how much of the overall color has been affected by the specific color adjustments.

You may notice something very interesting and important going on with the photo now. Adding, but limiting, the color saturation change to the buckwheat flowers and plants has given the photo more depth because the color has come forward. Saturated colors will always look like they are in front of less-saturated colors and will increase the depth of a photo. In addition, the flowers are beginning to become more dominant in the photograph, coming closer to the way I first saw the flowers and their environment.

CONTROL THAT EYE

Now is the time to start better defining the photo in terms of tonalities so that they support the original vision of the scene as visualized, as Ansel Adams called it. I wanted to keep the area around the flowers at the adjusted tonalities

and color, while bringing down the rest of the image at least slightly in tone so as to visually emphasize the flowers. Here's the analysis of how I approached this:

1. Because the area around the flowers was pretty well defined, I used the Elliptical Marquee (selection) tool to select the area around the flowers. I inverted the selection with Ctrl/⌘+Shift+I (or choose Select ➪ Inverse), as seen in figure 10-17 to darken everything except the flowers.

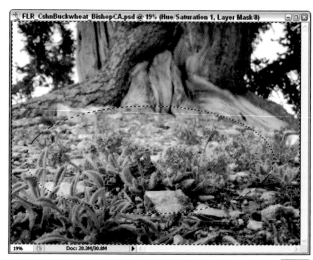

10-17

2. Opening up a Brightness/Contrast layer, I immediately got a layer mask based on the selection as shown in figure 10-18. It has sharp edges at this point, which need to be adjusted, but this is a quick and easy way to get started. I used moderate amounts of darkening by moving the Brightness slider to the left about 25 points.

3. Blend the edges. I used Gaussian Blur on the layer mask as shown in figure 10-19 to make the mask blend along its edges.

4. Refine the darkening layer. This adjustment was okay, but the elliptical selection gave me only an approximation of what was really needed. The light stones behind the flowers are a bit too bright for proper balance and the dark part of the foreground is a little too dark. I painted in black over the stones and a reduced opacity black over the foreground. In addition, the bristlecone in the background seemed a bit heavy in darkness, so I painted with reduced-opacity black over parts of it. The results are shown in figure 10-20.

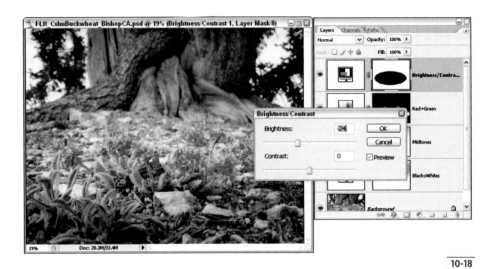

10-18

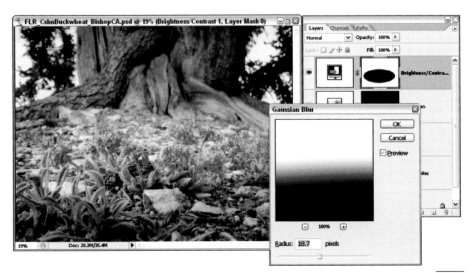

10-19

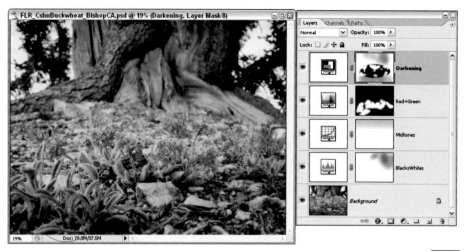

10-20

I have also included an image of the layer mask itself in figure 10-21 to show you the work done on adjusting this darkening layer. This screen can be turned on and off by Alt/Option-clicking the layer mask.

10-21

RE-EXAMINING THE PHOTO

This is a good spot in the process to look carefully at the photo. The changes that have been made to balance and adjust a photo can affect the overall composition and how you now perceive your subject. In this case, I wondered how much more I could darken things around the flowers to make them stand out even more. I reopened the Brightness/Contrast control for the top layer and tried moving the slider to the left. The image in figure 10-22 certainly looks dramatic, but the change is a bit too strong for my tastes. It doesn't look very natural. I tried other amounts, but none looked really good to me.

So I wondered if darkening the area around the flowers wasn't the problem, but maybe they were a little too dark.

10-22

So I added a Curves layer just for them as shown in figure 10-23, then filled the layer mask with black and painted back in the flowers' area as seen in figure 10-24.

But I didn't like that, either. This is such a great thing about Photoshop — these experiments take such little time to do.

10-23

10-24

Next, I tried something else. I darkened mainly the rock around the flowers by using a Brightness/Contrast layer, filling the mask with black and painting in the darkness where needed as seen in figure 10-25. That made a big difference; the photo had really come alive.

But the photo still needed something. It seemed now like the foreground was more than was really needed for the composition. I cropped it as shown in the finished image of figure 10-26. I liked what that did to the photo. It finished it off nicely.

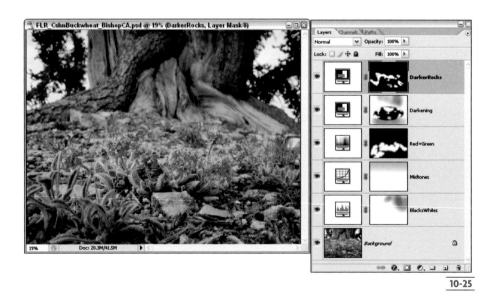

10-25

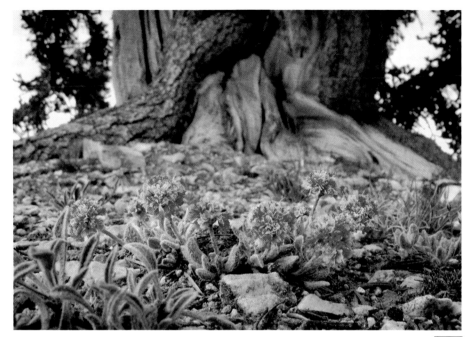

10-26

Layers and Other Essential Tools

You follow a very specific order. What if a photo doesn't need that order? Can't I use adjustment layers out of order?

Of course. There is no rule that you have to work a certain way, and there is no television show, "What not to do in Photoshop," with the hosts ready to ambush you and set you on the right path.

The workflow that I use in this chapter is a workflow that works for nature photographs. Will it work for every image and every photographer? I can't predict that. I can only say that this process does things in a defined way that gives predictable results in adjusting tonalities and colors.

If you find you really do like doing things in a different order and it works for you, the important thing is that you keep doing it that way. Consistency in workflow is very important because it makes your results predictable and makes your work easier, more effective, and more time efficient.

The use of the Brightness/Contrast adjustment layer is interesting in that it allows you to control specific tonalities to affect how someone looks at your photo. It seems to me that this would also work with color somehow. How would you do that?

It does work with color. You can tweak colors to also influence how the subject and the rest of the photo are seen. A good example of this would be to use cold and warm colors. Cold colors (those with more blue) tend to recede back into the photograph. Warm colors (those with more orange) come forward.

You can use that idea quite effectively on a landscape by first adding a Color Balance adjustment layer and warming up the image (add yellow and red). Then use a gradient in the layer mask to remove the adjustment from the top of the photo and the background while keeping the foreground warm (you can paint around foreground objects that go up into the scene).

Next, add another Color Balance adjustment layer and cool off the photo (add blue and cyan, which is actually the opposite adjustment of adding yellow and red so it can also be considered removing yellow and red). Now use a gradient to remove this cooling from the foreground and let it go into the background. This now makes the foreground warmer and the background cooler, mimicking a natural effect in a landscape where things in the distance pick up cool tones. The effect will give more depth to an image.

CLEAN IT UP

You sometimes hear the idea that nature is perfect, so all you have to do is take the right picture and the photo will need little because you captured perfection. While nature may be perfect, photography and photographers aren't. I'm not, and the locations I sometimes need to photograph are not perfect, either. While I try to do the best I can to get a good photograph from the very start of the process, sometimes things happen that force me to deal with imperfections that have nothing to do with the nature that was in front of my camera.

Common problems are dust on the sensor, scratches on film, branches that blow into the scene when the shutter was released but were never seen (or wanted) in the photograph, grain or noise that only exists in the captured image, and so on. Luckily, Photoshop offers some help in dealing with these problems. If you have a really annoying problem, you can certainly try fixing it early in the process. Most of the time, it is better to fix these problems after the main image adjustments because the adjustments can affect how you can best do this correction.

DEBRIS REMOVAL

Figure 11-1 shows a scene shot shortly after sunrise in the foothills of the eastern Sierra Nevada Mountains near Bishop, California. The light is nice, the photo has adjusted well, but there are two problems that I was well aware of when I shot the photo: the cable around the large boulder and the power pole in the background as seen in figure 11-2, a detail of 11-1. (Note: This photo has been sharpened so you can better see these details throughout this example; normally, sharpening is done at the end of the process as described in Chapter 16.)

No variation of my angle to the rock could change the cable. A different composition would have eliminated the pole, but then the nice relationship of boulder, right rock outcropping, and middle background hill would be lost. (The dirt roads in the left side, toward the back didn't

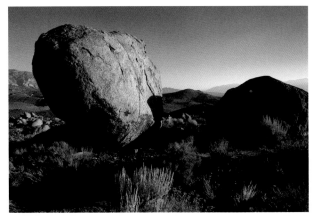

11-1

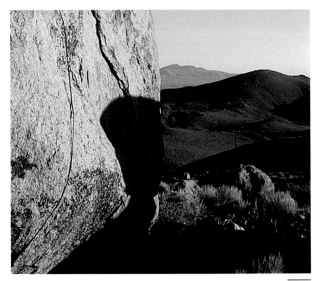

11-2

bother me.) I did not see the bit of flare on the right of the rock outcropping until later.

If I had photographed this to show how man has changed the landscape (or rudely leaves his garbage behind as evidenced by the cable), I would not worry about removing the cable or the telephone pole, but this photo is not about that. It is about a bold land of rocks and mountains.

This is a good example for showing how to use Photoshop's cloning tool — officially named the Clone Stamp tool. While cloning allows you to repair problems in an image, try to avoid doing too much. Overdone cloning can create an artificial image that will usually have major cloning artifacts. An artifact is something that appears in a photograph due to technology and does not exist in real life — grain, out-of-focus picture elements, and flare are all artifacts that do not exist in nature.

You can use cloning for all sorts of things, from removing dust on a scanned slide to removing that errant branch you did not see when you photographed the scene. Flare can also be removed with the Clone tool. Or you might have seen the beer can in the composition, but it was too dangerous to climb down and remove, so you decide to take it out in Photoshop.

UNDERSTANDING CLONING

Cloning using Photoshop's Clone Stamp tool is a valuable tool for the landscape and nature photographer, but it has been given a bad rap because of the way it has often been demonstrated. I have seen a third eye cleverly added to a person's forehead — an all-too-often seen parlor trick. For example, in figure 11-3, I added a clump of bushes that does little for the photograph but look clever. It does

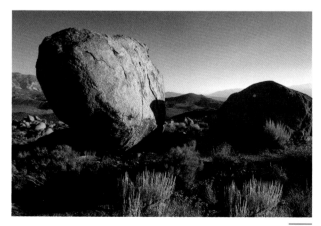

11-3

NOTE

Don't get me wrong, I do not have anything against photographers creating interesting images using cloning for artistic effects. As long as the images are presented as artistic photos or illustrations.

not really help you understand the power of cloning to really benefit your photography.

Cloning is basically a defined and constrained way of copying and pasting digital data. You decide what needs to be cloned out, then set a clone-from point (Alt/Option-click) and move the cursor to a new point to start cloning. This copies the data from the clone-in point and pastes it to a new spot where you click with the cursor. It's an easy thing to do, but not necessarily an easy thing to do well. I will give you some tips and offer ideas on how you can avoid common cloning problems.

GETTING READY TO CLONE

Photoshop's Clone Stamp tool is in the Toolbox shown in figure 11-4. This is a Brush tool, which can be quickly seen in the Options Bar below the menus (see figure 11-5) that immediately offers Brush as a choice. How you set these options will influence how well you are able to control your cloning and how it blends with the rest of the image. Blending the cloned area with its surroundings is a key concern, and the steps I show you use techniques to maximize the blending.

Clone Stamp tool

11-4

225

From the left, here are the options for normal cloning:

> **Tool icon:** Click the down arrow to access the drop-down menu of presets for a tool. Most nature photographers will have little need for these presets, so you can ignore it for the most part.

> **Brush:** This sets the brush size and softness. By clicking on the down arrow, or right clicking on the image itself, you get a drop-down menu of brush size and softness choices.(Ctrl-click on the Mac is the same as a right click, but you are much better off getting a right-click mouse so you do this with just a click). You need to set a size appropriate to the problem you are dealing with, and in general, you will use a very soft-edged brush (0 Hardness).

> **Mode:** Varied modes here can be helpful for the advanced user, but in reality, for most nature photography work, the Normal setting is sufficient; you may never feel you needed anything else. For using cloning on a layer, which is my preference, always use this as Normal.

> **Opacity:** This controls how strong the cloning effect is. You usually start at 100 percent and decrease it if you have some special blending needs.

> **Flow:** Leave this as is.

> **Airbrush icon:** Leave as is.

> **Aligned:** This is one setting you will change regularly. It is simply an on/off switch. Aligned means the clone-from point follows the cloning at the same distance and angle wherever you go on the image, even if you release your cursor (the most common way of cloning). If this option is not checked, the clone-from point goes back to where you started every time you release your cursor (this can be important when you have a very small clone-from area).

> **Sample All Layers:** This is another on/off switch. Generally in nature photography you want to clone using all layers, so this option will stay checked. Only uncheck it if you need to restrict cloning to and from one layer.

CLONING WORKFLOW

You need to be able to clone parts of an image in a very natural, blended way so those parts do not stick out and tell the viewer you did something there. Photographers run into trouble cloning when cloning artifacts start to appear, which makes the clone look bad. Then they try to fix the artifacts directly on the image, which can really mess up pixels and your photograph.

The worst comes from very obvious cloning artifacts like those shown in figure 11-6 (look at the doubling and tripling of shadows and other details in the upper-left quarter of the photo where the cable goes). This is a common fault of cloning. Good cloning work never shows this sort of problem and it is relatively easy to avoid it.

PRO TIP

You can quickly reset any tool to its defaults in Photoshop. This is a real help when a tool is not acting the way you want it to or the settings have become confusing. Simply right-click the tool's icon in the Options Bar all the way to the left. Two choices appear: Reset Tool or Reset All Tools. Normally, you will choose Reset Tool.

11

Clean It Up

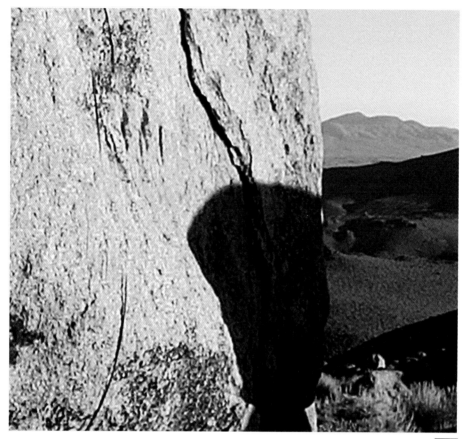

11-6

Here's the basic workflow to follow when cloning:

> **Clone to a layer.** Except for minor problems like the flare in the example photo, I always clone to a new layer. This will save you many headaches from cloning.

> **Never clone with the mouse or tablet pen working continuously.** Continuous cloning means Photoshop is always using the same set of cloning points, which will usually make a clone look too obvious. It is also a sure way to get artifacts you do not want.

> **Work in sections.** Click and release so the cloning is done in pieces. This allows the cloning to blend and merge better.

> **Constantly change your brush size and clone-from point.** A lot of cloning artifacts are a result of cloning that comes only from one side of the problem or one area of the photograph.

> **Watch for cloning artifacts.** If you start to see cloning artifacts appearing, immediately set a new clone-from point and brush size, and clone into the artifacts.

> **Use your layer.** Erase bad parts of a clone or use a layer mask to blend the clone in better.

CLONING EXAMPLE

Okay, now to work the landscape example I showed you. To fix the flare, pole, and cable problems, follow these steps:

1. Add a blank, empty layer as shown in figure 11-7. I named it Cloning Layer. I think it is a good idea to name your cloning layer because you often won't see much in the little thumbnail that represents what is going on in the layer. Then when you have other layers, you will wonder what this layer is doing. Add a layer either through the Layer menu (choose Layer ⇨ New ⇨ Layer) or by clicking the Create a new layer icon just to the left of the trashcan at the bottom of the Layers palette. If you add a layer through the Layer menu, you get a dialog box right away that has a place for naming the layer.

2. Enlarge the image to clearly see the problem. Select the Zoom Tool (it looks like a magnifier) on the Toolbar above the colors, and then click and drag around the problem to enlarge it specifically to that area. In figure 11-8, you can see the area around the little bit of flare enlarged plus the brush size I selected for the Clone Stamp tool.

3. Set the brush size and clone point in an area in which both would blend well with the problem area. In this case, there is little defined detail in this shadowed hill other than darkness, so the clone point probably isn't very critical. I selected a spot in the center of the circle shown in figure 11-8, held down Alt/Option and clicked my mouse. The circle is the brush size. I typically start with something close to the size of the problem or even slightly smaller. But there is no rule as this really depends on what the problem is and what surrounds it. Be sure Sample All Layers is selected in the tool options bar below the menus.

4. Click and clone. You can see in figure 11-9 that I did not complete even this simple flare spot with a single click. I probably could have, but I think it is a good habit to get into that you clone in pieces.

11-7

11-8

11-9

5. Enlarge around a new area. Figure 11-10 shows the offending power pole and line. Because you are cloning to a layer, you don't have to worry about cloning over edges like the rock below the pole; you can always correct that on the layer.

6. Work on the new problem. Again set the brush size and clone point in an area that would blend well with the problem area. In this case, I decided to start along the shadow line so that the cloning would line up on it (see the previous tip) — you can see the cross-hair

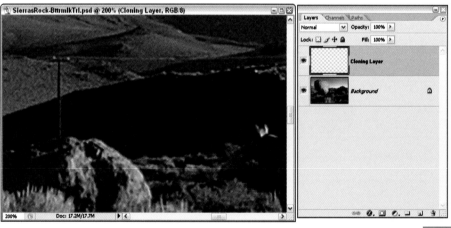

11-10

cursor in figure 11-11. In removing the pole, I tried to keep the brush size fairly small as seen in figure 11-12. You can try to remove the pole with a big brush, but that rarely gives the best results. I also changed the clone-from point as I went.

7. In removing the power lines, I kept the brush size even smaller, as seen in figure 11-13, and continually changed the clone-from point as I went.

8. Check your work as you go by turning the layer visibility on and off (click the Eye icon on the layer) to be sure the cloning is going right. Move the photo around by pressing and holding the space bar of your keyboard to turn your cursor into a hand. I knew I had gone over the rock below the telephone pole, but it looked okay as seen in figure 11-14, so I didn't change it. If the cloning had adversely affected it,

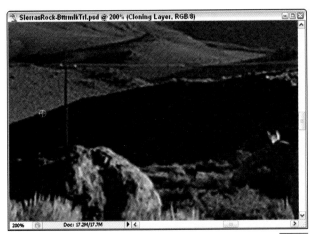

11-11

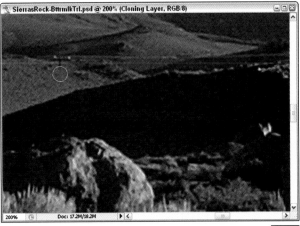

11-12

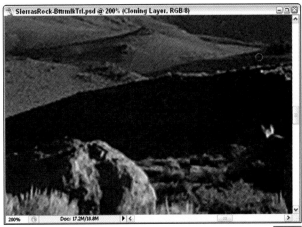

11-13

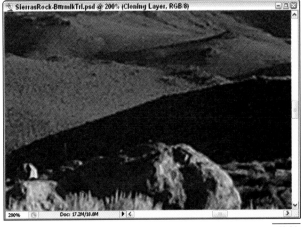

11-14

I would have added a layer mask and painted out the overlap (you may need harder-edged brushes for this). The layer mask icon at the bottom of the Layers palette (a rectangle with a circle in it) is the easiest way to add a layer mask.

MAKING THE HARDER CLONE

When I have several cloning jobs to do, I often do the easiest, smallest jobs first because it gets me comfortable with the cloning challenges of a photograph on a small scale before tackling the bigger ones. In this example, dealing with the cable around the rock is definitely the hardest cloning job on the photo.

It is also a good idea to occasionally save your file as you clone to protect your investment in the time it takes for good cloning. That way if your computer crashes or anything happens that can cause problems with the file you are working on, you can always get the file back from this saved copy of the file.

Continuing on with the rocky landscape, here's how to work the wire removal:

1. Enlarge the image area you are working with, as seen in figure 11-15. You will also notice that I added a new layer for the cable. I often put more challenging cloning work onto its own new layer to be sure I don't mess up any earlier cloning.

11-15

2. At this point, it is just a matter of moving along the area you want cloned, constantly resetting your cloned-from point and the size of the brush. I also continually turn the layer on and off to see how well I am doing. I do not hesitate to clone something back onto an earlier cloned spot if I see unwanted artifacts. Figures 11-16 and 11-17 illustrate the cloning of the cable in progress.

The completed photo shows no signs of the cable, the power lines, or the flare. In figure 11-18, you can see why I suggest naming the cloning layers. You can't see anything in the preview. By turning off the bottom, Background image, you can actually see the cloning against the default checkerboard pattern for blank areas in a layer as shown in figure 11-19. Figures 11-20 and 11-21 show details of the photo with and without the cable and power pole.

11-17

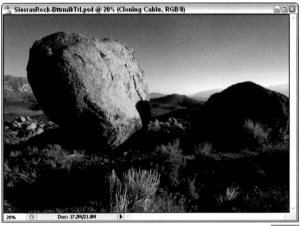

11-18

11-16

11-19

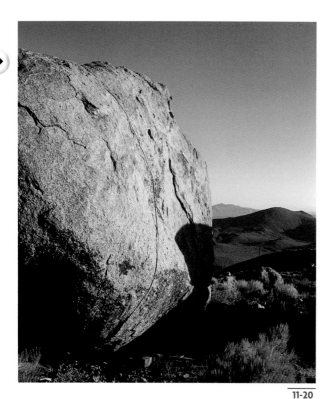

11-20

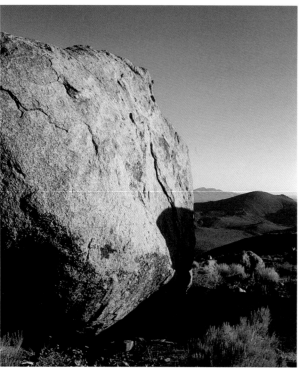

11-21

Photoshop has some interesting healing tools that are sort of like smart cloning tools. I explain them in the following sections, but this is a good time to talk about a very important concept in using Photoshop: You don't have to use everything Photoshop offers in order to use it well.

You see, other than the Spot Healing Brush, I am not a heavy user of the healing tools. I like them; I am very awed by the amazing software engineering that went into them; I am impressed by the Photoshop experts that use them well. I just find that for my work with nature photography, they do a job that I often don't need done or create an effect that I don't like. I am simply not one to go to the healing tools very often for most of my photography.

That said, I do use them for special purposes. I have used them quite heavily for restoring old family photos, but ripped pictures, damaged emulsions, and similar problems are simply not the norm in nature photography. The important thing to keep in mind is that just because something is in Photoshop or someone else really likes a particular tool does not mean you have to use it. I say this because I find in workshops and seminars that I conduct that some photographers feel guilty that they aren't doing Photoshop "right." I really believe photographers have to find their own way in this program and find a workflow and approach that fits their needs and personality.

With that little aside in mind, you can benefit from experimenting with the healing tools for certain needs. The healing tools are just under the Crop tool in the Toolbox (see figure 11-22). They include the:

11-22

> **Spot Healing Brush tool:** This is a brush tool that you click on or brush over something in the photo and Photoshop smartly covers it with nearby pixels. You learn how I use this tool later in the chapter.

> **Healing Brush tool:** This is like an automated cloning tool. With it, you set a heal-from point (like the clone-from point) and you click on the place to which you want to move those pixels. Photoshop works to blend the copied pixels into that area, using texture, surrounding pixels, tonality, and more to blend them. This works very well with restoration of photos, but I rarely like the way it deals with natural situations.

> **Patch tool:** This is like a big cloning tool. You select an area to cover a problem and have Photoshop merge it over the problem (actually you can select either the problem or the solution, depending on which is easier). This works extremely well with large areas that need to be repaired, such as a hole in an old photo. It is rare that a nature photographer wants or needs to make such a big change to a photo.

> **Red Eye tool:** This is used to fix red-eye problems from using a flash when photographing people in dark rooms.

USING THE SPOT HEALING BRUSH

The Spot Healing Brush comes in handy for a number of things in nature photography. I use it when I have problem spots from dust on a digital camera's sensor or to help remove flare spots. I will usually try it first for these challenges (as it often works quickly and efficiently on them), but I do find that the Spot Healing Brush won't always do the job and I need to add a little Clone Stamp work to the job.

In figure 11-23, you can see spots in the sky due to flare off of dust on the lens. This rock is part of a cliff face of an obsidian dome (volcanic rock) that pushes up in the middle of a forest near Mammoth Lakes, California. This was a difficult climb (not dangerous) because the obsidian talus slope below is extremely loose and unstable (plus

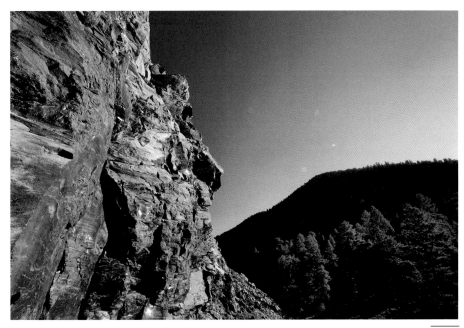

11-23

obsidian is like glass and the shards are sharp), so I wasn't paying as much attention to little flare details as I probably should have. Still, the Spot Healing Brush makes very quick work of such problems. Here's how to use it:

1. Add a layer and enlarge the photo to the problem area as seen in figure 11-24. As you could probably guess, I like the added control of a new layer, and, luckily, in Photoshop CS2, you can use healing tools on a separate layer.

2. Pick a brush size based on the problem. You can see that the brush just covers a flare spot in figure 11-25. Because this is working on a new layer, the Sample All Layers option needs to be checked. For most nature photography work, you will typically use Normal for the mode. Proximity Match works well for removing spots; however, in certain textured areas, Create Texture is worth trying (if it doesn't work, just undo it).

3. Click on each spot and watch it turn dark as seen in figure 11-26 (most of the spots have been cleaned up), then it disappears (see figure 11-27). That's all there is to it. You will have problems with spots that are close to a very different tonality (the Spot Healing Brush often brings in that tone inappropriately), so you may have to redo the click or change the brush size. The Spot Healing Brush also sometimes does a better job with a second or third click on the same spot. You can also try brushing over places where several spots are close together. I find the Spot Healing Brush is especially fast and easy for dealing with spots in the sky like in this photo.

11-24

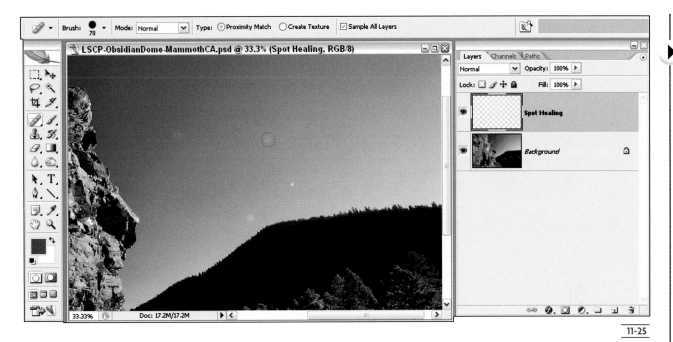

11-25

11-26

11-27

TILTING TREES AND OTHER PERSPECTIVE ANOMALIES

In the past, photographers like Ansel Adams and Eliot Porter would correct scenes shot with wide-angle lenses by using lens adjustments included on their view cameras. While there are special perspective control lenses available for 35mm-style film and digital cameras, most photographers do not have them. So tall objects, from trees to rock formations, tilt inward when shot with wide-angle lenses and the camera is pointing up or down toward them.

While technically, this is just perspective in action, it is also not how the eye/brain perceives such scenes. To humans, tall objects look tall. They do not look like they lean over or have any of the perspective effects that wide-angle lenses exaggerate.

You can see perspective exaggeration in figure 11-28. This is a photograph of the ferns in a cypress swamp in Loxahatchee National Wildlife Refuge in Florida. It is not a traditional sort of western landscape, but I find the image richly textured from the variety of plant life. It really expresses the essence of a southern swamp. This was shot on a cloudy day, which helps you see into such a jumble of vegetation, but it can make for a flat image. I used a flash held high and pointed down to add some color and contrast into the scene, plus I've processed the photo in Photoshop to emphasize the ferns.

The trees all seem to be growing at an angle so that they splay outward toward the top of the photo. This comes from shooting with a wide-angle lens up close to the scene. I was pointing the camera down to see the ferns, while the wide field of view made the trees in the distance also visible. This angle of view overemphasizes the natural change of perspective from close to far, making the tops of the trees farther apart than the bottoms, so the whole swamp looks like it is radiating out from the lower center of the photo.

11-28

This is an interesting visual, and like many photographers, I stay with it for the effect. However, it is certainly not as you would naturally perceive the subject. This can be corrected with the excellent perspective controls in Photoshop.

BASIC PERSPECTIVE CORRECTION

You may know that previous versions of Photoshop offered some limited perspective control in the Crop tool and the Perspective Transform command. These tools allow correction of leaning and converging verticals, but they do not offer the flexibility or accuracy that Photoshop CS2's new controls in the Lens Correction filter include. But before I get to those controls, I want to give an overview of the older perspective controls because they can be useful for quick adjustments.

Figure 11-29 shows an oddly skewed cropping selection. This is how the Crop tool can be used for perspective control (though this is a bit extreme in this photo). After you select your cropping area, a new choice appears in the Options area — Perspective. If you check this, you can freely move the corners of the cropping box around.

This allows you to move a corner in or out in order to line up a side with a tilted vertical as you can see in figure 11-29. You then do this on both sides and even parallel crooked elements at the bottom or top of the image. Then when you make the crop, Photoshop stretches and adjusts the image so all sides are at normal right angles to each other, thereby straightening out the verticals. It's actually easier to do the procedure than to explain it. Click on the Perspective check box and try it out.

In the Perspective Transform control (Edit ⇨ Transform ⇨ Perspective), you can freely change the perspective of a layer. You have to have a layer in order to use it (if you just have the Background layer, double-click it to change it to a layer). This control is really fun to play with. You simply grab a corner and move it in or out to change the perspective of the scene as demonstrated in figure 11-30. You can also click the center markers along the edge to shift the perspective center left or right.

I do use the Crop tool and Perspective Transform when I need to do something quickly and the change is not too strong. The Crop tool is especially useful because you can apply it while doing other cropping.

11-29

11-30

The main problem with these tools is that they don't do a complete job. I'll use a non-nature example because I think it is easier to understand. If you physically straighten a building that was leaning over backward (which is what it looks like when photographed from below), the building gets taller in appearance because it is lifted up toward you.

However, when using the Crop tool and Perspective Transform control described here, you don't get that same lifting. If you did have a building, you could correct it by stretching the image upward until the windows are correct. But in nature, there are no standard sizes to match, so often these controls end up with subjects with straight verticals but distorted height.

CS2 PERSPECTIVE CORRECTION

While the Crop tool and the Perspective Transform control are useful, they are not as accurate as I would like them to be. Luckily, in Photoshop CS2, you now have access to a great new control, Lens Correction (Filter ⇨ Distort ⇨ Lens Correction). When using it to correct perspective, it also changes the height of the image proportionately. In addition, it offers a whole set of other controls to deal with lens challenges that you may face.

Here's how to use it to adjust the swamp photo:

1. Create a duplicate layer. I pressed Ctrl/⌘+J for this photo. If you have multiple layers, you can use the Stamp Visible command to add a layer combining everything to the top of your stack (click on the top layer, press and hold Alt/Option+Ctrl/⌘+Shift, and then press E). I like to do this adjustment on its own layer so I can better judge the effect.

2. Open the Lens Correction filter (Filter ⇨ Distort ⇨ Lens Correction. This opens a new interface as seen in figure 11-31. There are lots of controls here that I explain at the end of this section, but for now, this photo only needs perspective correction, so I focus

11-31

on that. There are four key controls for perspective control in nature: Vertical Perspective, Angle, Scale, and the Grid. Horizontal Perspective can also be used, but it is not common in nature work.

3. Set the grid. The grid is a great help for seeing how straight your verticals really are. You can turn it on and off (select the Show Grid check box) as needed. In figure 11-32, you can see the grid is fairly large. The size is actually easy to set — just click on the word Size and drag your cursor back and forth; you can also use the drop-down menu or type a number.

4. Make the transformation. Move the Vertical Perspective slider until you see the verticals lining up with the grid. Keep in mind that nature is unlike architecture — not all verticals can be straightened. As you can see in figure 11-33, the whole shape of the photo changes with this control. It is a virtual tilting of the plane of the photograph to counteract the overly enhanced perspective change from the wide-angle lens.

11-32

11-33

5. Adjust the Angle and Scale. This photo is shot level, so there is no change in the Angle needed. Scale is important because as the photo is virtually tilted, important edges can disappear. Use the Scale to bring them back as shown in figure 11-34 (compare this to figure 11-33 — you can see I lost an important fern in the foreground without using Scale). In figure 11-34, you see the checkerboard pattern of transparency around the photo (and that is what is showing in Edge). Edge can also give you white around your photo or Edge Extension. The latter takes your photo's edge and stretches it to fill in the gap — it is not very useful for any big change because the stretching is very obvious.

6. Click OK and Photoshop processes the image to match the preview seen in Lens Correction. You can also press Alt/Option to make Cancel change to Reset; click Reset if you want to start over.

11-34

7. Crop the final image. In figure 11-35, you can see the transformed scene with the crop box in place. At this point, it still has its odd shape and transparency (gray now because of the crop box). If you apply this to the Background, Lens Correction creates a new layer with its work, but if it is applied to any other layer with pixels, it does not (in 11-35, the Background was already a layer, named layer 0). After cropping to a normal rectangle, flatten the image (use the Flatten Layers command in the drop-down menu for the Layers palette).

Now look at the finished photo in figure 11-36 and compare it back to figure 11-28. The trees are more normal in the background and no longer compete for attention with the ferns. In addition, the ferns themselves now occupy center stage. It is a photo that looks more natural as well. You may find that changing perspective causes the photo to look a little out of proportion compared to the original. If so, you can keep the layer. Choose Edit ➪ Transform ➪ Scale and click and drag a side out until it looks right.

11-35

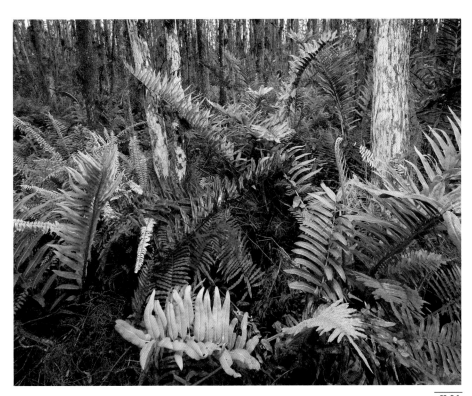

11-36

OTHER PARTS OF LENS CORRECTION

The Lens Correction Filter is a great tool in other ways as well, though you won't typically use most of the rest of the filter's powers, as they are very specific in the way they deal with lens problems. If your lenses have none of these issues, you have no need to use the controls unless you are after some rather funky effect. But when you do need the controls, they are very useful.

> **Settings:** The Settings drop-down menu lets you repeat settings for a particular lens.

> **Remove Distortion:** This is a very useful tool if you have horizons that need to be perfectly straight. Most extreme-range zooms that go from wide to telephoto have barrel distortion at the wide settings. This causes straight lines, like an ocean or lake horizon, to bow outward, which is obvious in the Pacific Ocean sunset in figure 11-37. You can see another example of this in Chapter 6.

Remove Distortion is very easy to use and quite intuitive. You work this control with either the cursor or a slider. You can move the Remove Distortion slider back and forth or use the Remove Distortion tool (top icon on toolbar), then click and drag to adjust the photo. The whole photo will pucker or bow to make the correction as seen in figure 11-38. Use the grid to see how well the correction is removing the bow to the horizon, for example. Then, unless you are after some creative effect, you have to crop the now deformed edges, as seen in figure 11-39, and flatten the image if needed.

11-37

11

Clean It Up

11-38

11-39

> **Chromatic Aberration:** This section offers settings you can use if you find a lens has the aberrations listed (Red/Cyan, Blue/Yellow, or both). The only way to tell this is to greatly enlarge a photo and look at the outside edges of the image and look for strong lines or contrast. If you see color fringing and don't see a clean line, then try these adjustments.

> **Vignette:** This section has options that affect another optical problem — darkening around the edges from the lens itself. Many older, long-range, telephoto/wide-angle zooms have this problem, as do the 500mm mirror lenses. Vignette simply makes the outer part of the photo lighter (to remove the lens vignetting described) or darker for effect. Midpoint just controls where the effect centers itself in the photo.

Chromatic Aberration and Vignette are two controls that you will rarely use. Lenses today are very, very good. However, the use of these is the same as in Camera Raw. You can refer back to Chapter 5 to learn more about them.

That's really about it. This is a very easy, intuitive tool to use. You won't always use its power, but it is there when you do need it.

■ **I don't like the idea of cleaning up dust spots in an image because my sensor was dirty. How can I prevent the dust?**

Sometimes, in certain windy and dusty natural settings, you have to accept that you won't be able to eliminate dust completely. There are some things you can do to minimize it in any conditions. Try these tips:

> If conditions are bad, avoid changing lenses without some sort of protection.

> Always keep something on your camera's lens opening. Never leave a camera sitting face up without lens or body cap. This is just inviting dust.

> Check to see if there is dust on your sensor by shooting a bit of blank sky. You may see the dust right away when you review your image on the LCD or you may have to magnify the photo so you can scan around the image and look for the telltale spots.

> Clean your sensor following the manufacturer's suggestions in the camera manual. It is very important to follow those instructions (which are different for nearly every camera) exactly or you risk scratching the sensor cover or worse.

When I clone large areas, for example, covering up an ugly jet trail in the sky, the cloned area looks blotchy. How can I avoid that?

This can be a real problem with cloning such areas. It can be very hard to evenly clone over skies, especially. There are two things to try. One is the Healing Patch tool. This often works quite well in such situations. I will set the tool to Source, and then use it to outline the problem area. Next the outline is moved to another location and the new location will be blended into the original problem spot. Play with it and see if it works for you.

Another way I do this is to use a Selection tool to make a selection around the offending area (you have to be on a layer with pixels to do this, either the Background or some other layer that holds the actual pixels for the problem). Here's how to use it to cover your problem: Move the selection area to a new place on the photo that could be used to cover the problem (you can move a selection as long as you are still in a selection tool by clicking inside the area and dragging). Feather the selection (how much is totally dependent on the size of the area — try 5 to 15 pixels to start). Feathering is simply the softening or blending of the edge of a selection so that it doesn't look so obvious. The command is in the Select menu (Select ➪ Feather). It tells Photoshop to start the selection very faintly on one side of the selection edge, and then gradually blend it in over the number of pixels selected.

I have not discussed feathering elsewhere in the book because for the selections used with layer masks described before, you get a more flexible control of this blending over the edge by blurring the edge in the layer mask (with Gaussian Blur). However, in this case, you have to feather the selection over the actual pixels of the problem area. You can't change the feathering later, though you can back up in the History Palette to the original selection if you don't like the results, and change the feathering (this is why you don't want to add feathering to the selection as you make it because then you can't get rid of that feathering).

Once you have made your feathered selection, press Ctrl/⌘+J, and you automatically get a new layer copied from the selection (remember that you have to be on a layer with pixels). Now use the Move tool (top right of the Toolbox), click on the copied area and move it over the offending spot. You may have to try again if the feather is too big or small. You can blend the edges as needed with a soft eraser or add a layer mask.

SPECIAL TECHNIQUES FOR
THE NATURE PHOTOGRAPHER

Part III

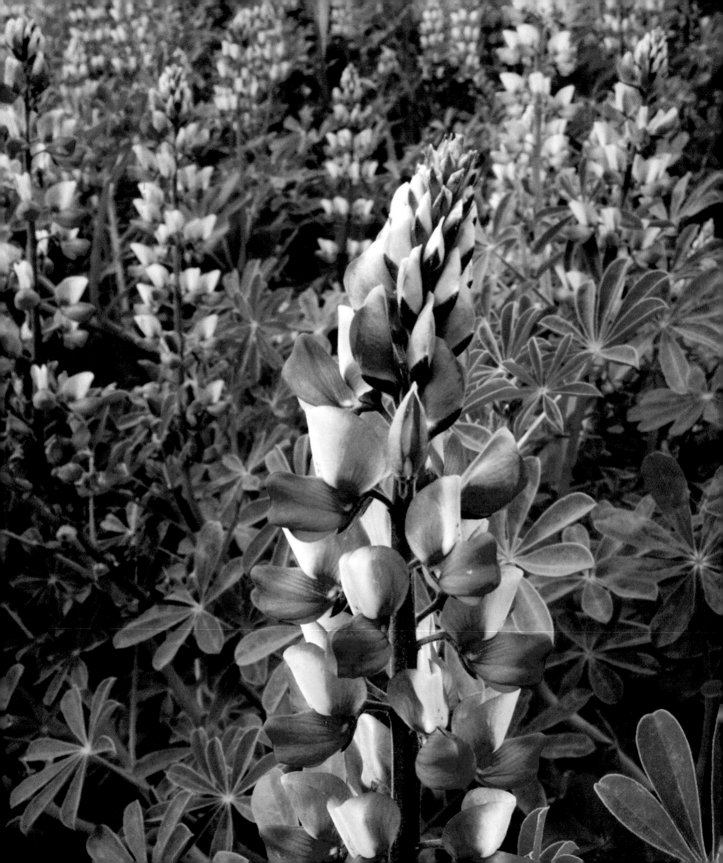

EXTENDING THE TONAL RANGE
OF SCENES

A fact of photographic life is that neither film nor sensors are capable of capturing the range of tonalities often found in nature and seen by the human eye. Ansel Adams and other traditional darkroom workers tried to compensate by creating special exposure and processing techniques to extend the tonal range of their photos. Images shot under varied conditions were handled differently when processed as a negative than when making a print.

In traditional color photography, this approach is simply not possible for most photographers. Special masking and printing techniques help a little for the few people who know these techniques. Mostly, tonal range problems are accepted as just the way color photography is. When graduated filters became readily available, those filters were commonly used to control tonalities in an overall way. For example, figure 12-1 would not have the rich colors without the use of a graduated filter to darken the sky and balance it with the land below.

Photoshop offers new controls for photographers that expand their ability to capture the tonalities in nature. These controls can be a tremendous asset because they offer a freedom to show more or less depending on how the scene is exposed and processed.

12-1

PHOTOGRAPHY'S DUAL NATURE

Nature photography has a very dualistic nature — it's a combination of art and technology. Neither can exist without the other. The camera, whether it is film or digital, is limited by technology. It can only interpret reality to within its limits, even if the real world is something much greater.

Figure 12-2 is accurate, but only in a superficial way. It is dramatic, to be sure, and looks exactly like a lot of traditional slide-film photography. But real compared to what was really perceived by people standing there? Hardly. Every photo, whether from film or digital capture, is an interpretation of the light and color based on what the camera plus film or sensor could handle.

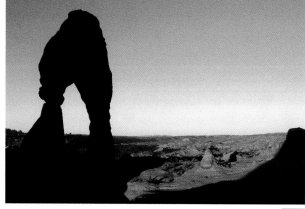

12-2

To ensure the camera better captures the reality of nature, photographers use many technological aids and gadgets, such as graduated neutral density filters to balance tones humans can see but the camera cannot. Photographers use flash to highlight things in a scene that the camera would not highlight or to balance a bright background. Photographers use different focal lengths of lenses to change how perspective is seen. These are all, in fact, manipulations of the scene that can make a better and truer photograph.

NOTE

A sad thing for nature photographers, I believe, is that a small, but vocal, group of photographers wants to make a big deal that their images have "not been digitally altered or otherwise manipulated." Besides this being a very divisive and unnecessary statement, it is also quite misleading. Nature may be reality and truth, but photography, in itself, is not. Can photography be trusted? It never could. You can only trust the photographer.

AN ARBITRARY LINE?

It seems that an arbitrary line has now been drawn. Technological manipulations of the scene done at the time of the photograph are okay, yet technology used after the photograph is taken, applied in service of making a more truthful image is not, according to a number of conservative photographers and publications. It is almost as though if they can understand the technology and it has been around a long enough time, it is okay, but new stuff that they don't understand is strictly taboo.

Consider how technology might be used to make a photo more true to the scene. Look at figure 12-3, sand verbena flowers shot at sunset in Anza Borrego State Park in southern California (when the spring is wet, there can be a spectacular spring bloom in the desert there). My eyes saw the reality of color both in the flowers and the sunset as shown in this image.

The camera saw something totally different that in no way represents what was seen. Figures 12-4 and 12-5 show what was possible for the camera — two versions of the same scene due to differences in exposure. When the exposure accurately captured the sky as seen in figure 12-4, the ground was impossibly dark. When the exposure accurately captured the ground and flowers as seen in figure 12-5, the sky disappeared, which is simply a lie about the scene.

Yet some reactionary folks would have us consider the camera's reality as the truth, a case of technology (the camera) being better than people (the photographer). I realize that may sound a little harsh, but I strongly believe publications have a responsibility to the public to present

12-4

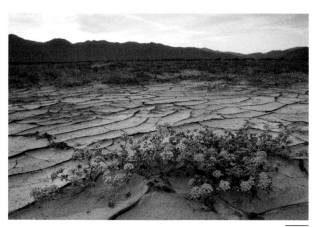

12-3

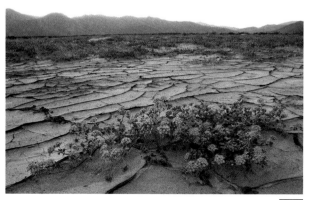

12-5

the best photos we can, images that reveal the truth and beauty of the world and are not arbitrarily limited by rules that restrict that revelation.

TONAL RANGE MANIPULATION

The flower and sunset scene from the previous images can be influenced with a special processing technique used on the images after the picture is taken. By deliberately taking two exposures of the same scene, you can match one exposure to the highlights (figure 12-4) and the other to the shadows (figure 12-5). Then you bring this expanded capture of tonalities together in Photoshop to bring them more in balance, as was actually done in figure 12-3.

You have to manipulate the tonalities, but just saying the "M" word upsets some people. "Manipulation is wrong!" they say. But look at figure 12-6. Little was done to this image other than using standard Levels for black and white and Curves for midtones. I used a flash to brighten the flowers and balance them against the sky. This is dramatic, but hardly natural and realistic, yet there are those who say, "Oh, well, that's different. That's capturing reality with the camera." I have yet to see flash naturally occurring in any park or wilderness area.

12-6

Remember the description of the manipulated image — two photos brought into Photoshop in order to create a new image that combines the best tonalities and colors of each. You gain a photograph that now more accurately and truthfully represents what was seen. It is certainly more truthful than a silhouette and far more accurate than using a flash.

I believe manipulation that changes the reality or truth of a scene is wrong for nature photography. I also believe that only the photographer can correctly and accurately interpret what he or she sees in a scene. As the previous example illustrates, some subjects need enhancement and proper manipulation for them to be seen truthfully.

TWO EXPOSURES FOR BETTER TONALITIES

All this discussion builds up to a very important technique for nature photographers using Photoshop: the use of two (or more) exposures for a single scene to capture better, more accurate tones with a very high tonal range or contrast. This is, in principle, like the work traditional photographers such as Ansel Adams did when they shot and processed a photo to specifically work with the tonalities of a scene.

When photographing a scene with a very high tonal range, the whole process starts with taking two distinct photographs exposed differently to deal with the dark and light areas of the scene. You combine them later in Photoshop.

Here's how to handle the photography (this can be done with either film or digital, but digital is easier because the sensor doesn't move like film does; that movement of film means the two exposures may not exactly line up):

1. Put your camera on a tripod. This is critical because you need to be able to match up the photographs later.

2. Take one photograph by exposing for the highlights of your scene as seen in figure 12-7.

3. Without moving the camera, take another image, this time exposing for the shadows as shown in figure 12-8. You need to really lock down your camera in order to do this because changing the exposure setting can cause the camera to move.

Note that these two photos are really exposed for different things. There is a distinct advantage to being able to expose specifically for highlights and again for shadows — tonalities and colors are optimum for each area and can be processed in Photoshop more easily and more accurately. In the image exposed for the hill, for example, the clouds are largely without the beautiful detail seen in the photo that was exposed for them.

Clouds can be a real challenge to expose correctly so that they hold the huge range of tonalities within them. On the other hand, exposing them correctly, as seen in figure 12-8, results in muddy colors and flattened tonalities (which could be brought out in Photoshop, but this requires more work and the image would never show the scene at its best). In addition, if I want to bring out more detail in the shadows (perhaps by using the Shadow/Highlight control), the better exposure in figure 12-7 offers more and better detail.

It is true that you can photograph a scene such as this with a graduated neutral density filter, but you are at a disadvantage because the filter's blend does not match the curve of the hill. You get an unnatural darkening across it, which in this case would look rather odd because it is darkening something that is already in shadows from the clouds.

PRO TIP

There are situations where even more exposures can help deal with extreme lighting conditions, but frankly, most of the time, I find I can do just fine with two. You will learn this by experience, but you can start to see how multiple exposures might help when you examine the LCD review and histogram on your camera. If you find that you can only get important shadow details when you expose so that the histogram clips on the right side (drops off like a cliff), then you need this technique. You will need an exposure to deal with the shadows and one to keep the highlights from clipping. If you find that the exposure needed for important shadow detail clips too much of the highlight detail down into bright midtones, you would probably benefit from a third exposure for those midtones.

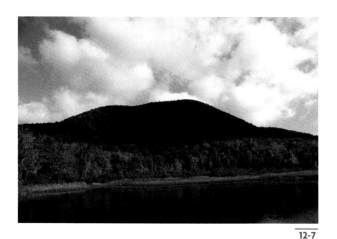

12-7

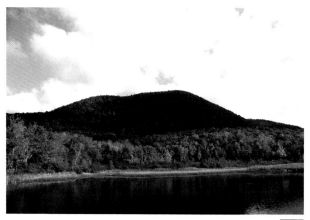

12-8

THE PHOTOSHOP COMBINATION

The two exposures you saw in figures 12-7 and 12-8 have
been processed in Photoshop, too. In each case, work in
Photoshop specifically optimized the important tonalities
that each exposure captured. This makes the Photoshop
work easy and fast because you are not trying to adjust col-
ors and tonalities overall that were not shot optimally. You
truly can make the best of each part of a scene.

Now the images have to be joined together. These two
shots can be done fairly easily. Here's how to bring the
clouds together with the hillside:

1. Open both images in Photoshop so you can see both
 in the interface as seen in figure 12-9. Move them so
 you can see at least a section of each one.

2. Decide which one of the photos goes on top. You will
 be bringing these two photos together, putting one on
 top of the other. There is no absolute rule for this,
 though generally, I prefer putting the photo needing
 the least change on top. In this example, the sky
 and landscape itself are about equal, so that doesn't
 help. When there is little difference in the amount of
 adjustment needed in each photo, I prefer to put
 the photo that looks better on top. I really don't like
 the washed-out clouds, so my inclination would be to
 put that at the bottom.

12-9

3. Move the top photo onto the bottom photo. Do this by
 selecting the Move tool at the top right of the Toolbox,
 then click on the photo you want for the top, press
 and hold Shift, and click and drag the photo all the
 way onto the other image. This copies the image from
 the first file to the top of the other file — watch for
 the cursor to change and the edges of the second
 photo to highlight, which tells you that you are mak-
 ing a copy, as seen in figure 12-10. You have to hold
 the Shift key down to keep the two photos aligned,
 and you have to drag the photo *all the way* onto the
 other image — if you don't, an error message like the
 one shown in figure 12-11 appears.

12-10

12-11

4. Prep your workspace. You can leave both original images open if you like, but my preference is to close the single image and move the layered photo into the prime working area of the interface as shown in figure 12-12. Note that the layers have been renamed. Renaming the Background layer requires you to make it a layer. That is pretty simple — just double click the word Background and you will get a New Layer dialog box. Type in a new name in that dialog box, click OK, and you're done.

5. Add a layer mask to the top layer, as shown in figure 12-13.

6. Remove the bad part of the top photo. You can use any or all of the techniques described earlier in Chapters 6 through 10 to paint in black in the layer mask to remove that part of the top photo. It is very important that you are in the layer mask or you will paint black on the actual photo.

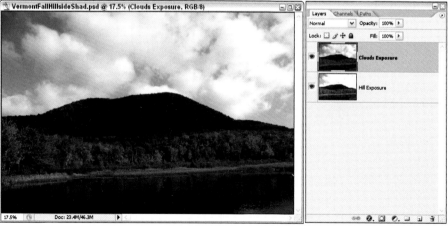

12-12

12-13

I did this example in two steps:

> I used the Gradient tool to do a rough removal as seen in figure 12-14. This actually looks quite good, but it can be improved.

> I refined the removal of the top image by using a black brush over the hill and a white brush over the lower clouds as shown in figure 12-15. Using the Gradient tool demonstrates a great advantage of using this technique over a graduated filter for a scene like this — you can match the actual curves of the landscape.

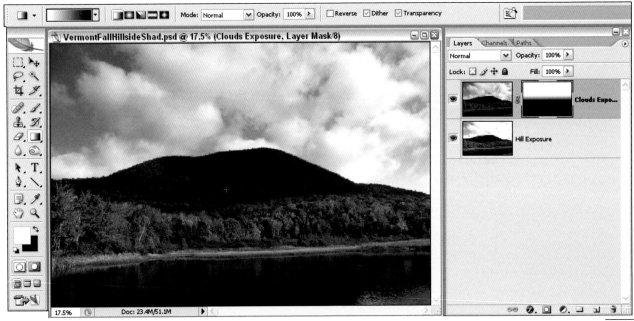

12-14

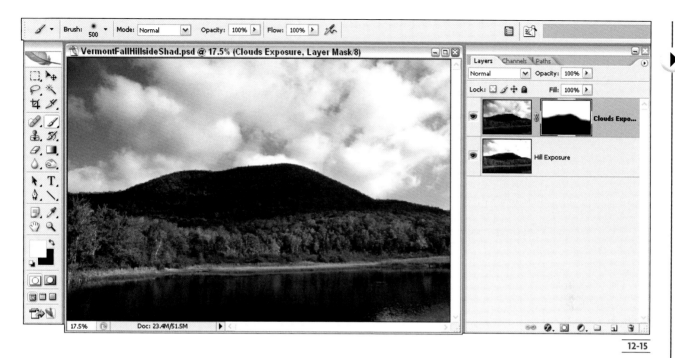

12-15

7. Refine the photo. Now that the photo looks much more like the real scene, you may need to do some refinements of tonalities. In this photo, I felt the fall colors could be lifted a bit in tone, plus those to the right were not in balance with those on the left. I added a Curves layer and tweaked these tones (which also affected the color), limiting where these effects occurred with the layer mask, as shown in figure 12-16 (note that the mask is gray on the left where the trees are brighter — this is done by turning down the opacity of the brush).

Now look at figure 12-17. What a difference from the single shots coming directly from the camera! This, believe it or not, is not a new technique unique to the computer. In the 1850s, a photographer by the name of Gustave Le Gray dealt with severe tonal limitations of the film of the time. It could not register clouds in the sky and proper exposure on the ground at the same time, so he took two exposures — one for the sky and one for the ground. He put them together in the darkroom. He did this many times and was considered brilliant for his innovative way of dealing with the challenge of technology of his time.

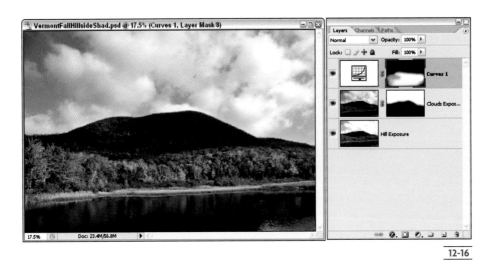

As I've stated throughout this text, photography is by its nature interpretation. Just selecting something to photograph out of a natural scene starts the interpretation process. The lens used, light captured, filters or flash employed, exposure chosen, color balance selected (whether by film choice or white balance settings); all these technologically influenced decisions are personal to any photographer (even if they aren't all chosen deliberately) and lead to an interpretation of the subject.

The work you do in Photoshop is also interpretation. What is the best tonality and contrast for your subject? Is the color faithful to the subject overall and in specific places?

What truthfully and accurately interprets this scene for the viewer to best see and understand the subject?

WHEN THE TONALITIES ARE NOT EASILY SEPARATED

Often you face conditions where the transition from shadows to highlights is not as well defined as in the Vermont fall scene used in the previous example. Look at the exposure for the greens surrounding a small stream in the Great Smoky Mountains National Park shown in figure 12-18. This area can offer an amazing display of green in the spring, along with wonderful streams and an abundance of wildflowers. The problem here is that a good exposure for the moss in the foreground results in overexposed whitewater in the stream. There is no easy photography technique that can be used to bring these into correct balance at the time of exposure.

I took two exposures of the scene; however, the footing for me and my tripod was not as good as it could have been (note the rocks at the bottom and lower right of the scene), so the two shots do not match up the way they should. This example provides a good explanation of how to deal with matching up non-identically framed images, as well as the problem of the overexposed, detail-less whitewater.

12-18

The next set of steps builds on the detail in the previous example's steps. Here's how these two obstacles can be overcome:

1. Open the two exposures in Photoshop as shown in figure 12-19.

2. Move one image on top of the other. Follow the procedure outlined in Step 3 of the previous set of steps. In this case, I moved the image that looked good overall but had the lost whitewater detail to the top, as seen in figure 12-20. But now it gets tricky because the two shots do not line up properly.

3. Reveal the mismatch. To do this, decrease the opacity setting of the top layer as seen in figure 12-21. You can see how chattery the image now looks because things are not lining up. How much you turn the opacity down depends entirely on the scene. You just need to be able to see parts of both photos so you can line them up.

12-19

12-20

12-21

4. Roughly line up the layers. Select the Move tool. Click and drag the top layer to bring the picture elements into rough alignment. As you can see in figure 12-22, things are sort of lined up, but you can see a circular pattern due to the misalignment. This is because the two images are slightly rotated in relation to each other. You can also see in the Layers palette that the top layer is showing transparency around the edges because of this movement.

5. Refine the lining up of the layers. Use the arrow keys for slight movements. In this example, the top photo needs rotation first.

6. Rotate the layer with the Move Tool. In preparation, click the Show Transform Controls check box in the Options bar. A bounding box immediately appears and some additional control points are added to the top layer's edges. In addition, there is a little cross-hair sort

of point in the center of the photo. This is the rotation point so that any rotation of the image is centered on it. In this photo, I clicked and dragged this point to the upper right of the image where the center of the circular pattern seemed to be, then enlarged the work area (by dragging the corners of the photo window) outside of the photo itself as seen in figure 12-23.

7. Rotate the layer. When you move your cursor outside the bounding box, it turns into a curved cursor (see figure 12-23). This lets you rotate the layer. I rotated and nudged the layer by using the arrow keys until it looked good through the water area as seen in figure 12-24. Press Enter/Return (you have to remember that last step or Photoshop acts like it is frozen).

12-22

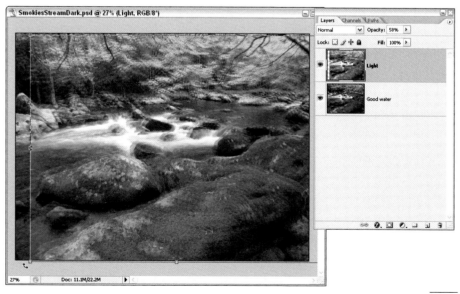

12-23

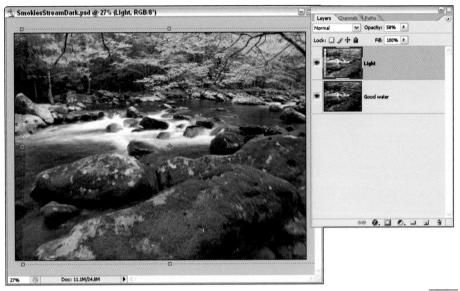

12-24

It is not perfect, but it is close enough for what I want to do with the photo.

8. Bring the top photo back to 100 percent opacity and add a layer mask as shown in figure 12-25.

9. Paint out the offending part of the top layer to reveal the good part underneath. I enlarged the photo

to better see the area and painted black in the layer mask over the whitewater in order to bring in the details of the water, as seen in figure 12-26. You may need to do some additional movement of either the top or bottom layer if you find things are not lining up enough.

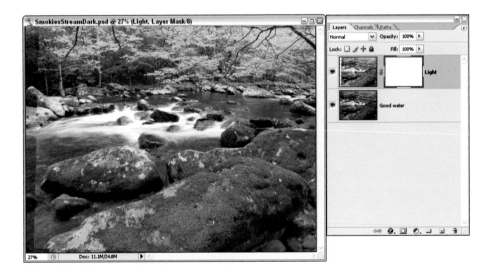

12-25

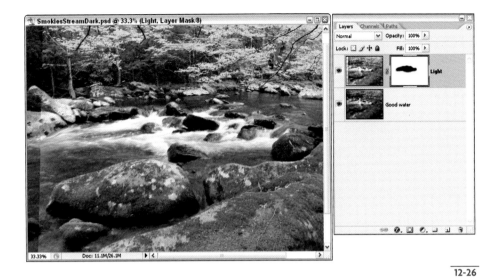

10. Crop out problems along the edges. When the two photos do not line up, there will be gaps along the edges that need to be cropped out as shown in figure 12-27, the final image.

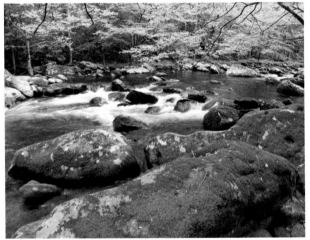

12-27

TWICE-PROCESSED RAW FILES

In figure 12-28, you see a photograph of a bristlecone pine from the Ancient Bristlecone Forest east of Bishop, California. This is an incredible specimen of a tree thousands of years old. The breaking light and clouds made the experience dramatic and exciting, but much of that is lost in this photo. The light is too harsh for the sensor, especially in the highlights (which are way too bright), yet the image has some core qualities that make it worth working on.

The photo needs a way of dealing with the highlights and shadows so the drama can be revealed. While the Shadow/Highlight control can be useful in situations that have such strong contrast, I find that dramatic scenes like this are not helped by this adjustment, as shown in Figure 12-29. The photo deals with the contrast "better" in an arbitrary way, but the tonalities don't quite work to give the image the life and drama needed.

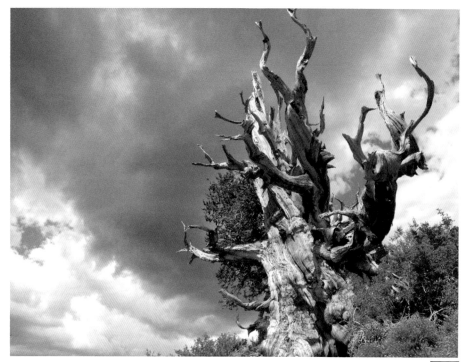

12-28

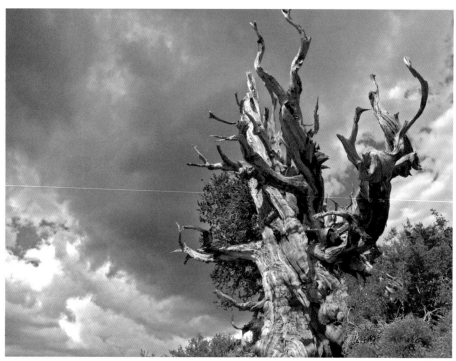

12-29

X-REF

For more details about working with Adobe Camera Raw, go back and check out Chapter 5.

There is a better way in this situation. Adobe Camera Raw is really quite powerful in accessing detail in light and dark areas of an image as long as the exposure has not pushed them way past the capabilities of the sensor. This means you can process the same image file twice in Camera Raw — once to optimize the highlights and once for the shadows.

With the Camera Raw program that comes with CS2, you can easily do this double processing. Here's how:

1. Process the image file in Camera Raw first to favor the highlights as seen in figure 12-30. Open this high-light-enhanced photo in Photoshop.

2. Go back to Camera Raw, reopen the same photo and process it this time for the darker parts of the photo as seen in figure 12-31. Open this shadow-enhanced image in Photoshop again. The neat thing is that Camera Raw remembers the previous processing of this image, so you take that basic adjustment and now tweak it for the dark areas. I went for drama in the clouds, even though the tree got a little harsh. This interpretation isn't bad, but it could be better. (Earlier versions of Photoshop will not let you process and open an image twice unless you save the first opened image with a new name.)

3. Combine the two processed photos into one file. These photos are exact, so there should be no problems in dragging and dropping one on top of the other (remember to press and hold the Shift key). I put the darker photo on top, as shown in figure 12-32, because I liked its drama.

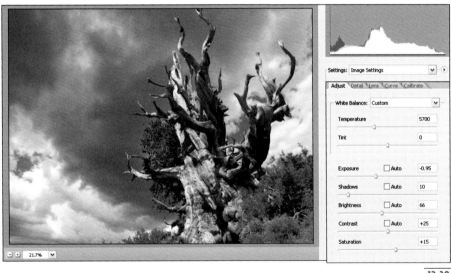

12-30

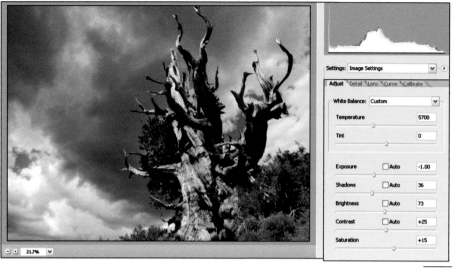

12-31

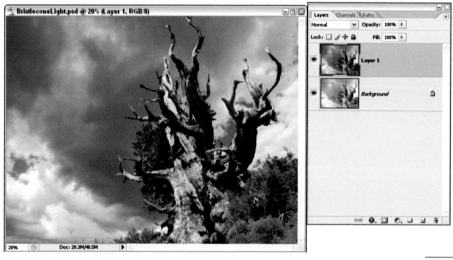

12-32

4. You now need to be able to blend important parts of the two photos together, merging the good highlights of the highlight-processed file with the good shadows of the shadow-processed file. In this case, the bright areas look good. I wanted to bring out the shadows and midtones, especially in the tree. To select the highlights, go back to a tool with which you should be fairly familiar now, Color Range. When it opens, go to the drop-down menu for the Select box at the top,

choose Highlights and click OK. Highlights and bright midtones are now selected as seen in figure 12-33. Add a layer mask, and it uses the selection to automatically keep those tones (they stay white and light gray in the mask) while the dark areas fill with black, turning them off. That brings in the dark parts of the photo from the lighter image below as seen in figure 12-34. This does the job for dark areas, but the photo doesn't look right yet.

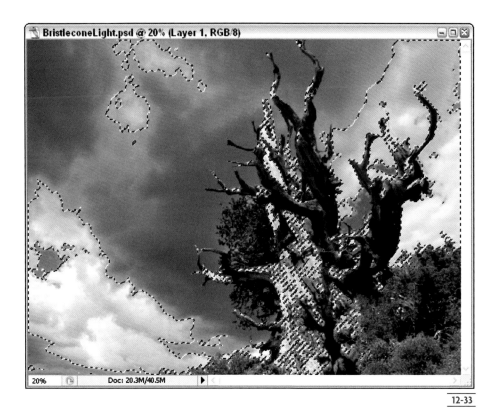

12-33

5. Adjust the blend. By painting the upper layer in and out with the layer mask, you can customize the blending to control the photo as needed. In this case, I wanted to bring back more of the darkness that was in the top, darker photo. So I used a white brush to paint it back in. As you can see in figure 12-35, this

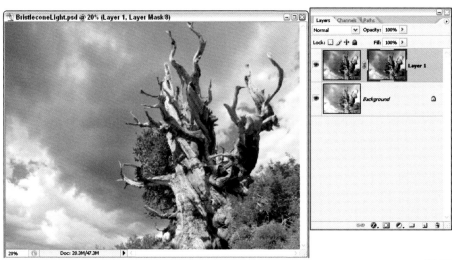

12-34

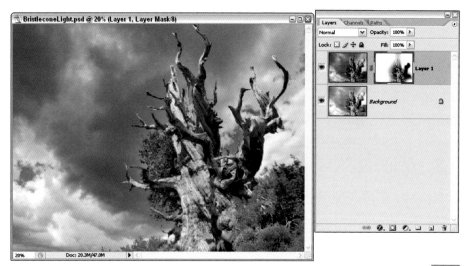

12-35

photo has come to life. There is drama in the sky, yet the tree is lively without harshness to the shadows.

6. Do an initial reevaluation of the photo. Once the two layers have been combined, it is worth reevaluating the image, because it really is different than anything you've processed before. For example, when I was evaluating the example image after these first

changes, I felt the light on the tree could look a little more golden. So, I added a Color Balance adjustment layer and increased yellow and red color in the midtones as seen in figure 12-36. This made the sky ugly, so I filled the layer mask with black to turn off the effect and painted in the tree with white on the mask as seen in figure 12-37.

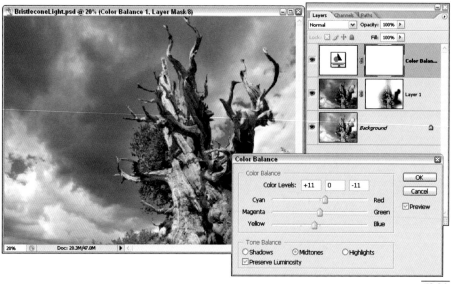

12-36

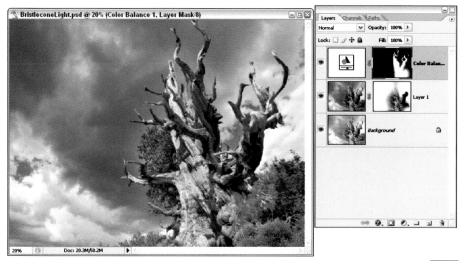

12-37

7. Now, after a few more changes, reevaluate the photo again. I felt the clouds could be a little richer. The day was one of sun and storm clouds. About an hour after this photo was taken, it was pouring rain. I added a Brightness/Contrast layer, darkened everything, filled the layer mask with black to turn it off, and then painted the effect back in with white over the darker clouds as seen in figure 12-38. I kept the effect off the tree and the light clouds at the lower left. This image, fully revealed in figure 12-39, is much closer to the experience of actually photographing this amazing tree under the changing weather conditions of that day. Compare it with figure 12-28 or figure 12-29.

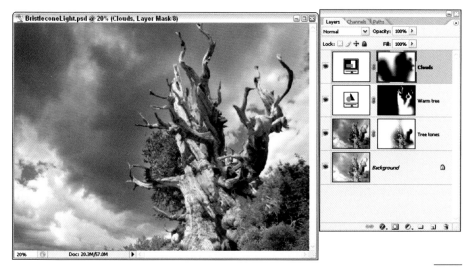

12-38

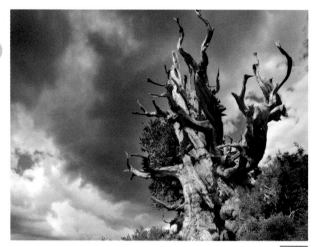

12-39

PRO TIP

You may also have noticed that the layers are now named. I don't always name every layer when I only have a couple, as they are usually easy to figure out. But as soon as the layer count reaches three, I name them. I highly recommend including layer naming as part of your workflow.

HIGH DYNAMIC RANGE ADJUSTMENT

By taking multiple photos of a scene and changing the exposure on each one so you get a series of shots from very dark to very light, you can capture a huge range of tonalities that could not normally be recorded on film or by a sensor. If you were a glutton for punishment, you could probably combine all of these images into one photo using the techniques described above and get an amazing tonal range in your photograph. But that's not worth doing.

Photoshop CS2 introduced a brand-new tool, the High Dynamic Range (HDR) adjustment found in the Automate menu. Technologically, this is an amazing use of computer power. It takes all those differently exposed photos of the same scene and merges them into one image file with a very large dynamic range (this refers to the range of tones from light to dark). Typically, it seems to work its best with from five to seven images, though it works with as few as three.

I say seems to work its best because this is still a relatively new tool for most photographers, including me. It provides amazing tonal ranges, but the resulting photos often don't look quite right. To me, it is too often an effect used for its own sake rather than for interpretive or creative landscape and nature photography. It has potential, and I will be the first to admit I have not pushed it to its full potential, but you'd have to really need this extreme tonal range and be able to control it so that it looks good aesthetically.

From my perspective, there are two major disadvantages to this control:

> **It is an overall adjustment.** This means that you have no control to bias its conversion of images to favor certain exposures and therefore, tonalities.

> **It has some severe restrictions in shooting.** To use this tool, all of the photos must match so that it can work its best (meaning no movement of the subject, no change of depth of field, and so on). In addition, I have seen too many uses of this that really fit the "gee-whiz" factor — photographers are using it because the technology is impressive and they are not always considering the aesthetics of the photograph that comes from it.

Still, the HDR tool is an admirable attempt by Adobe engineers to build a high tonal range — more than the camera can capture alone — into a scene. You may find it worth spending some time trying it out, but to use it, you have to shoot multiple images with big changes in exposure between them. Photoshop engineers actually scold you, as I have discovered, with an error message if you try to do this with multiple images that don't have the tonal range that they think you must have.

Here's how to use HDR:

1. Shoot three to nine photos of a scene, changing each by one or two f-stops of exposure. You must lock your camera to a tripod — moving objects are a problem. Figure 12-40 shows a collection of six photos shot with a big change in exposure from shot to shot in order to capture all the detail from the charcoal black of the tree trunk to the whites in the clouds. This burned area in Southern California has a huge range of tonalities in real life.

2. Choose File ➪ Automate ➪ Merge to HDR to open the Merge to HDR dialog box (see figure 12-41). Use this dialog box to import your photos. Click File or Folder in the Use drop-down menu, and then browse to your photos. They appear as a list in this box. You need to identify your photos before you start this process because there is no visual browser.

3. Click OK. If you think the photos are out of alignment, select the Attempt to Automatically Align Source Images check box. Photoshop goes to work. This can take some time because your computer is dealing with a lot of files with much data to crunch, especially if you selected the align sources check box. It opens all the images, compares them, and then creates a unique, 32-bit file that includes all of the images. Your combined image appears in a new interface seen in figure 12-42.

4. Set the HDR control. The HDR interface seen in figure 12-42 has a number of important controls. It tells you how much exposure difference you have from photo to photo and lets you turn on or off the use of individual photos. You can choose bit depth — this is an output bit depth and at the moment, you can't do a lot

with 32 Bit/Channel. I suggest using 16 Bit/Channel option at this point in this tool's evolution. HDR does its actual work in a very unique 32-bit space that holds a huge amount of information, which gives it its flexibility, but you can't do much with that space outside of HDR. Set White Point Preview gives an idea of how the overall photo will look when it goes into Photoshop as seen in figure 12-43. Set it so that you have detail in the right places for your image. (Hopefully as this evolves, you will be able to set more than one point.)

12-40

NOTE

Be careful that you don't select Photomerge by mistake. It is located directly above Merge to HDR in the Automate menu.

12-41

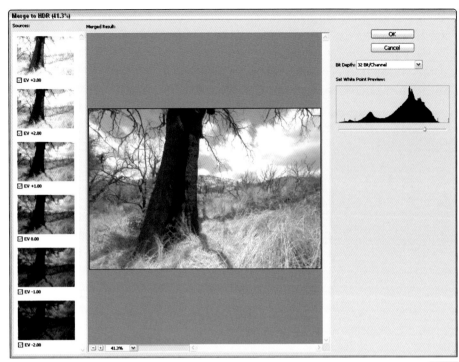

12-42

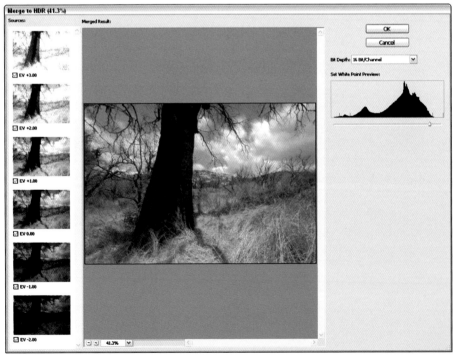

12-43

5. Click OK. Merge to HDR then merges tonal information from all of your files into one image as seen in figure 12-44. This process can also take some time because your computer is dealing with a lot of files to complete its work based on your choices, and there is still much data to crunch. But you and the computer are not done. The HDR Conversion dialog box (see figure 12-44) provides additional choices that you can make to convert the 32-bit file to 16 bit. Unless you really want to spend a lot of time exploring this new tool, I recommend you stick to the Exposure and Gamma method (it is the most intuitive of the bunch). You'll also see a Toning Curve and Histogram, but you can only use it with the very unintuitive Local Adaptation selection for Method. Exposure is basically brightness and Gamma contrast.

Looking at the tonalities of the completed photo (see figure 12-45) is quite awe-inspiring. You can actually see detail from the black, burned, charcoal tree trunk (in the shade, no less!) to the white clouds. You can also see problems in the clouds at the upper right, the grass against the tree trunk and some branches — these are all due to movement during the exposures. They can be fixed by cloning or by going back to one of the original exposures and cloning correct picture elements over the problems.

Yet, I am not so inspired by the way the tonalities have settled out visually. It is a bit gray in certain mid-tone tonalities. It does not have the strength, I believe, that you get from an image by hand-working multiple exposures yourself as described earlier in this chapter. Still, to be fair, this photo is not really done.

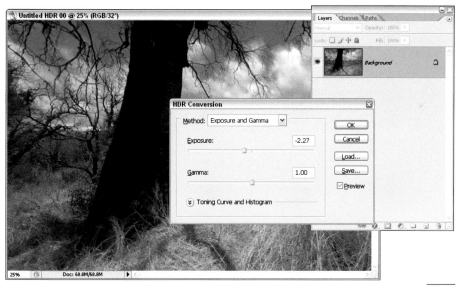

12-44

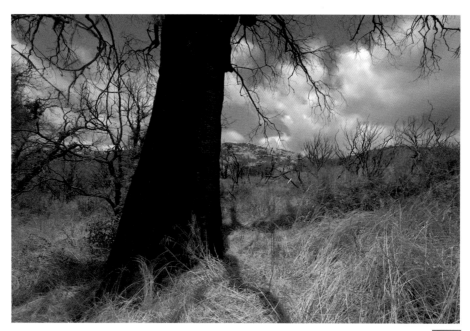

12-45

PRO TIP

You can always go back to original photos when you are doing any Photoshop work to grab elements to fix something in a later incarnation of the image. You can open two photos, for example, the original and the processed image, set a clone point in the original, move to the processed image, and then clone from the original to the later photo. This is the same process that is described in Chapter 11 for general cloning, but in this case, you are cloning from one photograph to another instead of cloning from one point to another in the same photo.

6. Make further adjustments. For this photo, I added adjustment layers: Levels to deal with blacks (mainly), Curves for midtones, and Hue/Saturation for what was a weak bit of color, as seen in figure 12-46.

In the final photo, figure 12-47, tonalities and color look good. HDR is certainly a worthy tool to add to your arsenal of Photoshop tools when you need to deal with something that has an extreme tonal range. I would expect talented and creative photographers to discover new ways of photographing scenes using this technology as it evolves.

12-46

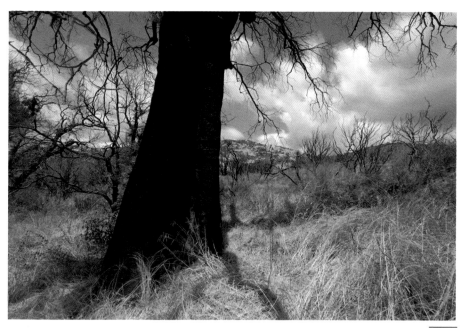

12-47

■ **I can understand how digital cameras can work for the two-exposure technique. I still shoot some medium-format film. Can film really be used for this technique?**

Film is harder to use than digital, but it is still possible. I used to experiment with expanding tonal range in this way many years ago before digital cameras were affordable.

The challenge comes from the fact that film moves through the camera and scanner. It is very difficult to take two photographs that are exactly lined up on film in the camera and again precisely lined up in the scanner. So you always have to do some alignment work on the photos when they are in layers in Photoshop. The method used in this chapter for working with the Great Smokies stream will also work for film.

You can also use a variation of the process twice RAW file technique. For film, you can scan the image twice, working the scanner controls to get the best from the highlights first, and then changing the controls to optimize the scan of the shadow areas. This can sometimes get you better results from a difficult image. In this case, the two scans should line up exactly because the film doesn't move between them.

It seems to me that the 32-bit file of HDR offers some amazing capabilities. Do you think this will become common for future versions of Photoshop?

Because of my connection with *Outdoor Photographer* and *PCPhoto* magazines, I often get asked to predict the future like this. The honest answer is that I have no idea. The question is interesting, however, because it challenges one to look at what 32 bit really does mean to the photographer.

One thing to realize is that, visually, a 32-bit file doesn't look much different than a 16-bit file or even an 8-bit file. Humans need at least the data in an 8-bit file for accurate and realistic color in a photograph. When just looking at a photo, your eyes can't tell the difference between 8, 16, or 32 bit because 8 bit has passed this threshold. The difference, however, is that 8 bit just passes and the others go way past with additional information. That means that adjustments to an 8-bit file can cause loss of tonality and color that will show up as a quality issue in the photograph. On the other hand, you can adjust a 16-bit file quite strongly and not have problems occurring from that adjustment, simply because there is so much data available for adjustment. With 32 bit, this reaches a range that is beyond my understanding — you have the capacity for severe change without that change damaging image quality.

The question is, though, is it needed? I don't know. There is much that can be done, and done well, with 8-bit files (which were the standard for image processing until a few years ago) and certainly with 16-bit images. 32 bit increases the data available, but also increases the pressure on the computer — these become very big files that can quickly stress a processor and RAM. Perhaps as HDR processing becomes common and gains better controls, photographers will discover new possibilities for photography when using 32 bit. Or perhaps photographers will say the work and results aren't worth it. It will be interesting to see this part of image processing evolve.

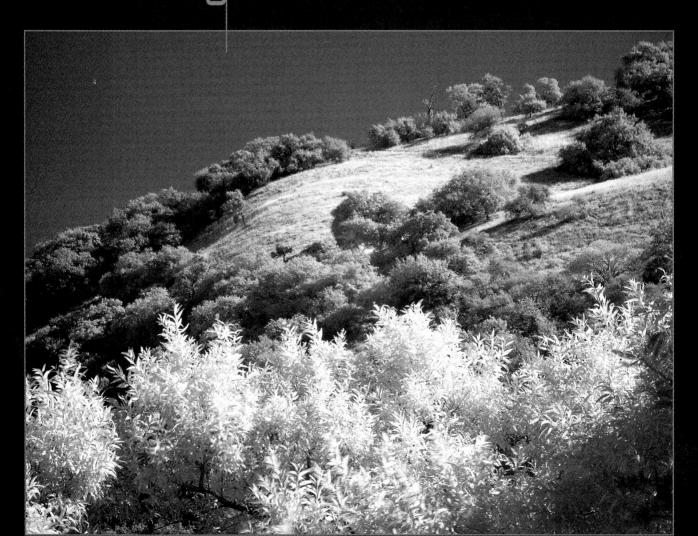

CLASSIC BLACK AND WHITE

Black and white has made a tremendous comeback in photography. It was all anyone used years ago, but once color gained quality and became widely available, photographers from beginners to pro abandoned black and white. It still was used by a few dedicated photographers, but as a whole, most people shot color. Once the darkroom was a common part of photographers' homes; you could even find them for public use in camera stores, libraries, apartment buildings, and schools. Then they disappeared.

Black and white has always been a very beautiful medium when used right. Black and white takes you out of the direct color connection to the subject and brings a strong graphic element to the photographs. It is very powerful in its ability to portray mood and atmosphere in an image.

It also has a great deal of flexibility built into it because there is no such thing as a standard way of translating color into black and white, meaning that the photographer has a lot of creative control.

In recent years, many photographers, including young people who had never seen a darkroom before, began to come back to black and white photography. At first, digital photography manufacturers didn't recognize this, but today, you have many possibilities for doing beautiful work in black and white (as seen in figure 13-1) with the computer, or digital darkroom. You can still shoot black and white film, you can shoot color film or digital and convert it to black and white, and now, you can even shoot black and white directly in the camera.

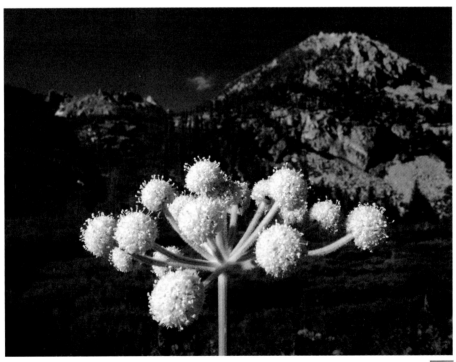

13-1

SEEING BLACK AND WHITE

Black and white is not a matter of simply removing color from a picture, whether that is post shooting in the computer or during shooting by using black and white film or digital cameras that shoot black and white. Good black and white photography recognizes that colors change to tones and must be dealt with as tonalities on their own. Red flowers in a green field, for example, look great in color, but a direct translation to black and white can look terrible. The Texas paintbrush flowers look lively and colorful in figure 13-2, but a simple change to black and white (see figure 13-3) is a poor version of the color.

The front flower looks okay (though not great) because the light on it contrasts with the shadows behind it. However, the nice flowers directly above and behind have disappeared. In this chapter, you'll learn how to avoid this problem of translating colors to black and white tonalities, as shown in figure 13-4, but it is still a challenge for the black and white shooter.

Understanding the prime importance of tonalities helps you take better photographs directly to black and white, plus it influences how you look at color images that you think might look good in black and white. Most of the photos in this chapter come from images originally shot in color.

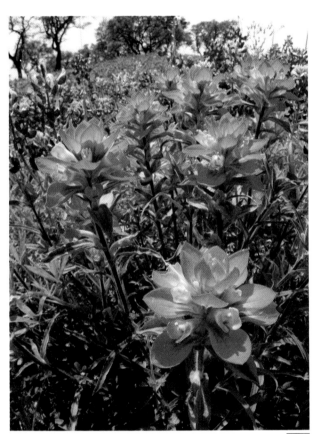

13-2

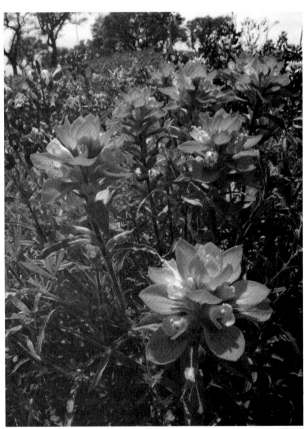

13-3

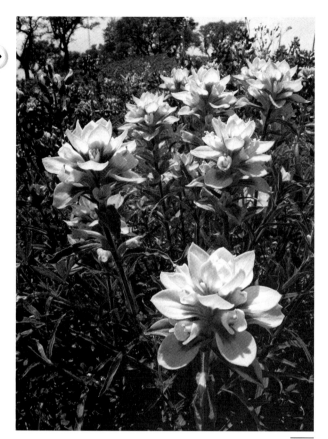
13-4

PHOTOGRAPHING IN BLACK AND WHITE

You can photograph directly to black and white by using black and white film or by using the black and white settings offered now by many digital cameras. If shooting film interests you, I strongly recommend you shoot black and white chromogenic film that can be processed at any one-hour mini-lab. Both of these let you see photos quickly — this is important because the experience of black and white is so different than color. You need to quickly see how your subjects change into black and white tonalities as shown in figures 13-5 and 13-6. If you wait a while for processing and scanning, you learn a lot less.

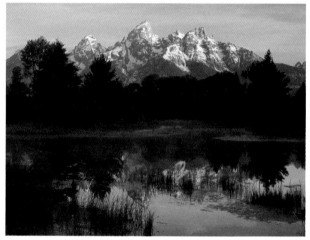
13-5

This does not mean, however, that you can simply convert any color photo and make a good black and white image. Not all color photos translate well to black and white — in fact, some nature subjects are so dependent on color that black and white photos never portray them well. On the flip side, some great black and white shots come from scenes that photograph poorly in color.

Even if I know a particular image will make a great black and white shot, I usually shoot it in color because of some advantages to converting black and white from color in Photoshop. However, because seeing black and white is so important to working in black and white in Photoshop, I recommend that anyone who has not photographed directly to black and white do exactly that. It is an important step in the learning process of getting a great black and white photograph in Photoshop.

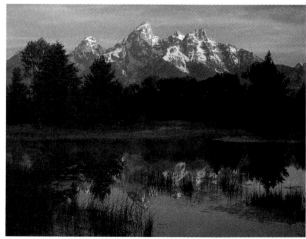
13-6

I have also found that working for a while in black and white teaches you to see light better (because you are not distracted by the color). Light has a huge influence on brightness and contrast, which ultimately translates as tonalities in a black and white photo as seen in figure 13-7.

Colors also change into tones and often in surprising ways, though this can be controlled. You cannot, however, determine colors from a black and white photo unless you recognize the subject. One of the great possibilities with black and white is that you can translate colors differently both when you take the picture and when using Photoshop. Figures 13-8 and 13-9 show two black and white versions of the same subject. You cannot tell what

the original colors are (these are fall leaves with mostly red color in them) though the black and white translations are wildly different.

PRO TIP

Chromogenic black and white film is really color film designed for processing in color chemicals, but ends up as a black and white negative that you can scan for the computer. The advantage is that you can take this film to any color film mini-lab and have it processed with the standard C-41 color print film processor. Be careful though, that lab workers don't try to sell you different and more expensive processing; they may not understand the film. If you can find it, try Ilford XP-2 or Kodak's Professional BW400CN.

13-7

13-8

13-9

Black and white is not complicated. Most of the things you know about color photography, from exposure to composition, still relate to this medium. But there are a few key ways of looking at a scene that can help you get better black and white images that can be processed in Photoshop:

> **Look for tonalities.** Look for elements in your scene and composition that offer tonal, not color, differences. In other words, really observe the brightness differences in a scene, as this strongly influences the black and white result.

> **Search for graphics.** Without color, scenes need something to make them work as a photograph. Strong graphic elements are a great help.

> **Work shape over color.** Shapes are always good possibilities for a black and white photograph. Don't be distracted by great color.

> **Find contrasts.** Black and white is a medium of tonal contrasts. Look for ways to contrast your subject and its surroundings based on the brightness or darkness of all picture elements.

> **Beware of strong color contrasts.** Strong color contrasts can create great compositions in color, but they can totally mislead you if the photo is going to be black and white. Good examples of this are the way that green and red translate — they have a very strong color difference, yet have very little difference in black and white.

FILTERS FOR BLACK AND WHITE

Filters or digital-camera equivalents are a huge benefit for shooting black and white directly and will make your images far easier to work with in Photoshop. Colors translate quite flexibly into different tonalities through the use of special color filters, such as red, green, yellow, and so forth.

TIPS FOR PHOTOGRAPHING IN BLACK AND WHITE

As I always stress in my books and workshops, it is important to get the best image possible when actually taking the photograph. Photoshop can do a lot, but it does not do its best if the original doesn't have what is needed. In the case of black and white photography, this is especially critical. If you don't separate the tones while shooting, through the use of either light or filtrations, you will not be satisfied with your final black and white Photoshop work.

Using filters for black and white is beyond the scope of this book, but keep this in mind: Colors in the scene that are the same or similar to the filter color remain bright in tonality, while opposite colors go darker. Many digital cameras now offer black and white controls that simulate black and white filters.

Figures 13-10 through 13-12 show a range of possibilities from filters. Figure 13-10 demonstrates the use of a yellow filter, figure 13-11 the use of green, and figure 13-12 the use of red. Notice the distinct differences in the tones of the sky, rock, and trees.

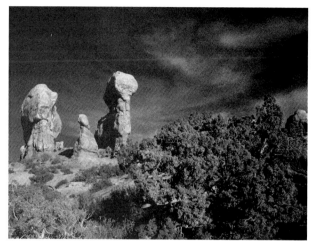

13-12

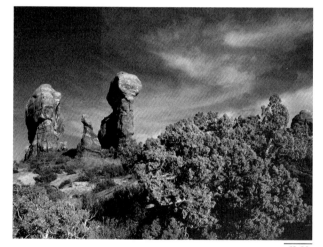

13-10

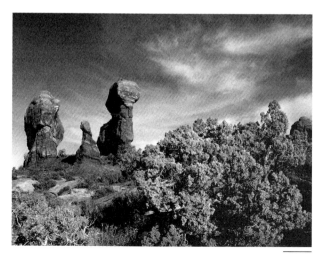

13-11

SHOOTING BLACK AND WHITE VERSUS CONVERTING FROM COLOR

Years ago, I shot a great deal of black and white directly for two good reasons: First, it was not easy to convert from color film to black and white prints; second, the quality of the conversion never matched what you got from black and white film. So for anyone interested in good black and white film, you shot black and white in the first place.

That has all changed today. Photoshop offers some very good ways of converting color to black and white, plus there are excellent plug-ins for Photoshop (covered in Appendix A) that make black and white conversion very easy to do. You can get very high-quality black and white images by shooting color in the first place.

But you can get very high-quality black and white by shooting black and white in the first place, too. So why shoot color for black and white? There are three very good reasons:

> **More tonal choices.** If you shoot in black and white, the tonal relationships you have in the image are pretty much locked in with the shot. Once a red flower is turned into a shade of gray, as seen in figure 13-13, for example, it is a lot of work to make it some other shade. However, if you convert from color (see figure 13-14), you can change and adjust how colors translate into tones as needed while making the conversion as shown in figures 13-15 and 13-16.

> **Multiple "filters" for one photo.** If you shoot directly in black and white, you can filter the scene for specific black and white results, but you can only use one filter at a time. When converting from color, you can select different parts of the photo and convert them differently. In effect, using what would be different filters for the same image.

> **You can still use the photo in color if needed.**

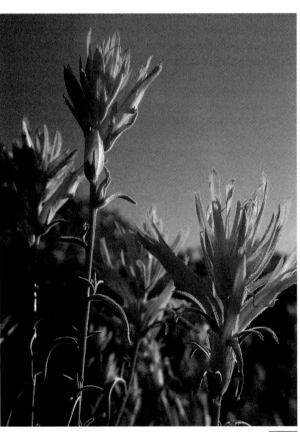

13-13

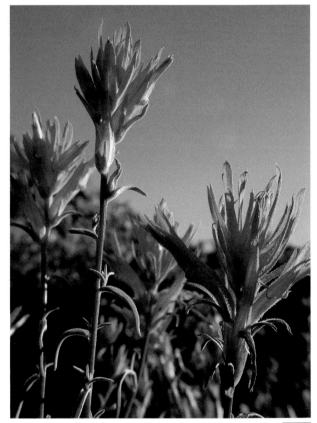

13-14

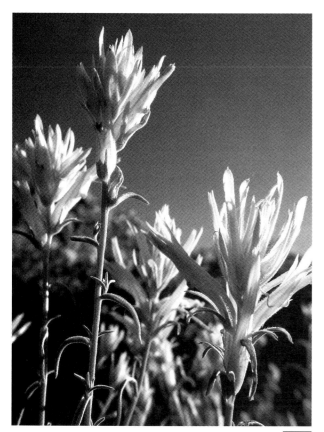

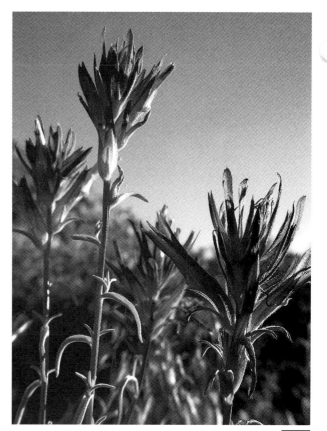

13-15　　　　　13-16

CONVERSION TECHNIQUES

You can get started seeing what a color image might look like in black and white by choosing Image ⇨ Adjustments ⇨ Desaturate, or Image ⇨ Mode ⇨ Grayscale. You may or may not get a good black and white image with either of these menu items, though. Processing your image in such a way as to create a strong and compelling black and white photograph is a bit more of a challenge.

I can tell you from personal experience how poorly black and white conversions are often done. I have always cared very much about good black and white. I used to spend a lot of time making black and white prints, and I have shot

it professionally. Over the years in doing many articles and books, I used to figure that art directors and printers knew what they were doing in converting color to black and white. Mostly I was wrong about that. I think this is because these people are not photographers and do not look at the image in the same way as a photographer. To them, black and white is simply color without the color. That way of thinking will always get you into trouble.

Simply using the Desaturate or Grayscale commands without any other processing rarely gives you good black and white results. That doesn't mean they won't work — you just need to do some further adjustments such as checking blacks and whites. A consistent problem that I

see with black and white done in Photoshop is poor con-
trast, as seen in figure 13-17, which resulted from a sim-
ple color conversion.

There are a lot of different ways of converting color to
black and white. I show you several that I find work very
well for nature photography. I also finish each example,
going beyond the simple color version so you can see
how the photograph should be worked to get the best
black and white image as shown in figure 13-18.

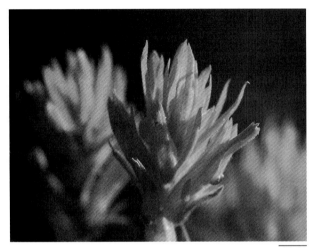

13-17

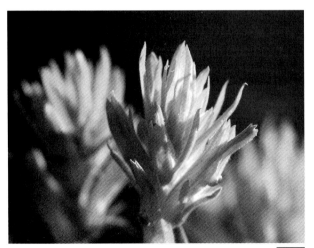

13-18

GRAYSCALE OR DESATURATE

I tend not to use either Grayscale or Desaturate much for
converting color to black and white. For a lot of nature
photography, neither one offers enough control over
color-to-tone interpretation. However, for down-and-dirty
conversions of images that don't rely on color for compo-
sition or impact (water flowing over rocks might be a
good example of that), they can be a quick way of getting
to black and white.

Grayscale is found in the Image menu (choose Image ➪
Mode ➪ Grayscale). It not only changes everything to
black and white, but it also removes any color information
in the file. When you tell Photoshop to use this control, it
asks you if you want to flatten your photo or not. The rea-
son for this is that not all color layers work properly in
this conversion. I find it best to save the color file, flatten
the image, do the conversion, and save as a new file.

Desaturate only works on pixels, so you have to have
pixels to work with. You can either flatten your photo
or add a layer that combines all of your work (you
may remember this is done by pressing and holding
Alt/Option+Ctrl/⌘+Shift, and then pressing E).

You can Desaturate the layer you create by using the com-
mand in the Image menu (choose Image ➪ Adjustments
➪ Desaturate). This, by the way, is the same thing as
going to Hue/Saturation and moving the Saturation slider
all the way to the left.

Grayscale and Desaturate use slightly different interpreta-
tions of the color in an image in order to create black and
white tonalities. But because they are really very easy to
use, you don't lose much by trying them, seeing how they
translate your photo, and then deciding if they are appro-
priate or not.

X-REF

For more details about flattening a layered file, go
back and check out Chapter 6.

There is a significant difference in these two conversion controls, however, that is not obvious on the surface. Grayscale changes the color content of the file, removing all color capability (and in the process, creating a much smaller file). Desaturate changes color to black and white, but does not remove color capability of the file. If you start with an RGB file, for example, you end up with an RGB file, which can be important for certain black and white effects such as adding a color tint to the photo.

Other than trying these for down-and-dirty, quick conversions, I can't recommend them for most black and white conversions for landscape and nature photographers. They are just too limited. But you need to know about them because so many people use them for black and white conversion with very mediocre results.

CHANNELS FOR BLACK AND WHITE

A quick way of evaluating your photo for black and white (and even converting) is to check the channels for your image. You are most likely working in an RGB color space, so you will have a set of color channels giving you red, green, and blue information about the photograph. These are actually seen as black and white versions of your photo when you go to the Channels palette as seen in figure 13-19 (Channels by default sits with Layers, but if it is not open, you can get it by choosing Window ➪ Channels).

You can now see these channels as black and white images by clicking on them one at a time, as seen in figures 13-20 through 13-22 (click the RGB channel to get back to normal). As you can see, even from an image that is largely green, you get quite a range of color/tone interpretations. You may also notice that certain channels hold more noise than others, even to the extent of making them unusable.

13-19

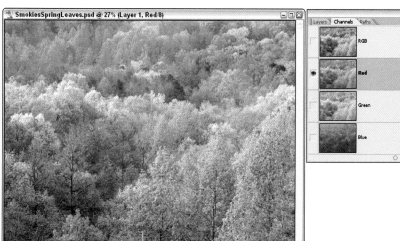

13-20

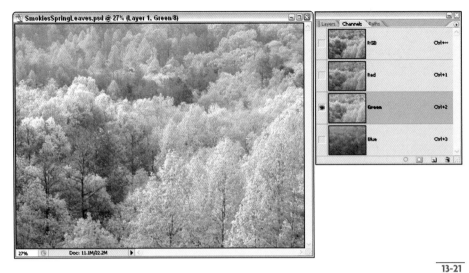

13-21

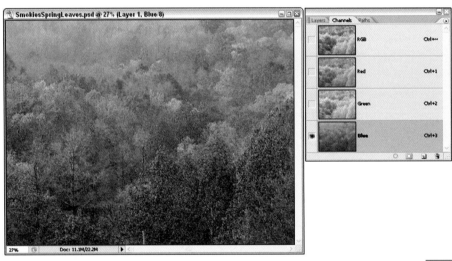

13-22

Here's how to make a complete black and white image using channels:

1. Pick the channel that gives the best tonalities for your photo. In this example, the green channel looks best (see figure 13-21).

2. Convert the image to Grayscale (choose Image ⇨ Mode ⇨ Grayscale). Photoshop asks you if you want to flatten layers. Your layers do little good beyond this point, so flatten. It also asks if you want to discard other channels as seen in figure 13-23. You end up with one channel, Gray, that is based on the color channel you originally selected.

3. Fix blacks and whites. Sometimes you get lucky and the conversion gives you good blacks and whites in the image. In most cases, I find stronger blacks are needed, at the minimum, to make the photo look its best in black and white. In this example of spring

trees in the Smokies, a feeling of lightness is certainly appropriate, but the photo in figure 13-24 is too gray for my taste. Adding a Levels layer, as seen in figure 13-25, confirms the blacks (the left side of the histogram) are weak. At this point, you can adjust using the Alt/Option threshold technique used throughout the book or simply move the left slider over to the right until the blacks look good (I actually did both in figure 13-26). This immediately gives the photo more life.

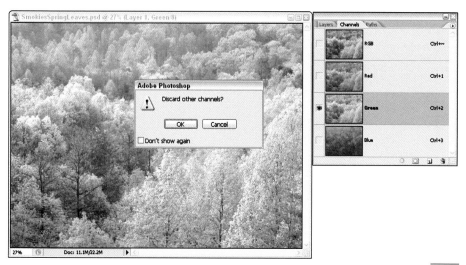

13-23

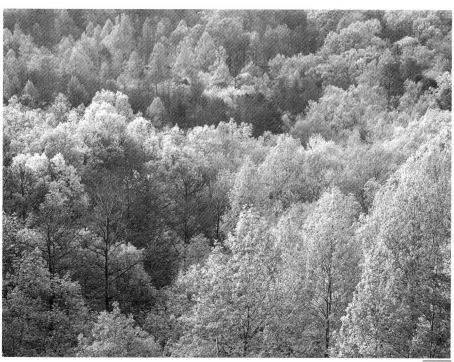

13-24

4. Check the midtones. A black and white image looks very harsh if nothing is done with midtones. Figure 13-26 shows Curves being applied to the Smokies photo. The curve is going down, but a Grayscale photo acts differently than RGB. That down curve lightens the midtones.

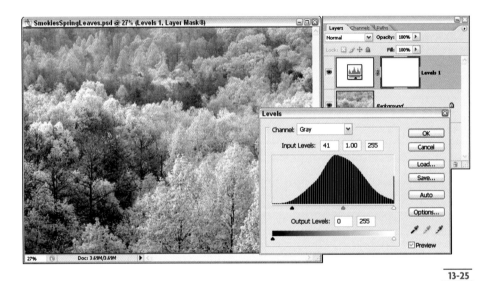

13-25

13-26

5. Lighten or darken local areas (dodge and burn). In figure 5-27, I added a Brightness/Contrast layer to subtly tone down local areas of brightness to balance and bring out the overall tonality of the photo.

Now the image has a richness and tonality that a straight conversion cannot give, as seen in figure 13-28. Every black and white image is an interpretation of a scene.

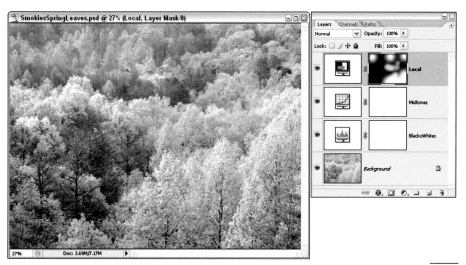

13-27

13-28

Tonal Gradations and Histograms

You'll notice in figure 13-25 that the histogram is not solid. I briefly touch on this in Chapter 6, but there are some new things to consider with black and white. Basically, a tight comb pattern in a histogram has little effect except to annoy computer purists who pay more attention to graphs than photographs.

But it does represent some missing data in the tonalities and colors of a photograph. If the gaps get too big, you may find problems with tonal gradations in the photograph. They may tear or have banding.

In black and white, this can be more serious because tonalities are all you have.

Tonal gradations are really very important to good black and white work. Some photographers have found that they don't like working with digital camera files for black and white because the tonal gradations are not always as good as what you can get from black and white film.

For the pure black and white art photographer, that can be very important. Most photographers find, however, that you can get truly wonderful black and white images using the methods described in this chapter with digital camera image files. All of the photos you see reproduced here came from digital cameras.

You might go for a brighter or darker version of this scene, or one that has more or less contrast. One thing that is important to me as a nature photographer is to have an interpretation that keeps the mood and feeling of the original scene.

CHANNEL MIXER WORK

My favorite Photoshop control for converting a photo to black and white is the Channel Mixer. This can be hard to use at first because its variations are literally infinite, but with a little practice, you can direct it to give you a great amount of control over how colors change to black and white tones in your photograph.

Channel Mixer is best used as an adjustment layer and you find this option in Adjustment Layer choices. It allows you to mix different percentages of the channels that make up your photo into a new image. It can be used to change a color image, but for nature photographers, the main use is for black and white. Here's how to do it:

1. Open and correct your color photo. The shot in figure 13-29 has some interesting elements in it, but as a color photo, it doesn't work for me. The light isn't quite right. But if you look at it in terms of its tonalities and graphic elements, there is a black and white photo there.

13-29

2. Add a Channel Mixer layer. The easiest way to do that is by clicking the adjustment layer icon to open the menu seen in figure 13-30. Select Channel Mixer to open the Channel Mixer dialog box and its adjustments as seen in figure 13-31. The default is Red at 100 percent, and Green and Blue at 0. These numbers are important, because in most cases, the three Source Channel percentages combined must add up to 100 to keep the image at the same overall brightness. If they are more, the photo gets brighter; if less, the image darkens. Photoshop offers an out here with the Constant slider — it allows you to make an overall change to balance adjustments that are more or less than 100 percent. For black and white photos, select the Monochrome check box at the bottom.

3. Evaluate your black and white image. In figure 13-32, you can see the effect of selecting the Monochrome option. The image looks okay, but the strong graphic that I want does not appear as strong as I would like for this scene of red rock formations in the Mojave Desert in Nevada. The secret to using Channel Mixer is to consider that as you increase the amount of a

13-30

13-31

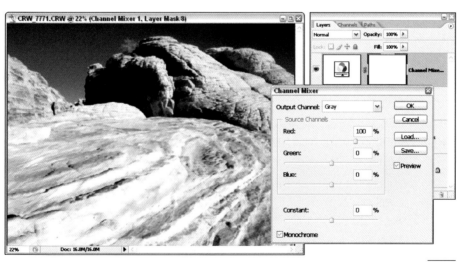

13-32

particular channel, colors related to the channel (for example, red and orange for the red channel) get lighter, while unrelated colors (for example, blue and green when the red channel is high) get darker. That is why the sky is so dark and why the graphic pattern is not as strong as it could be. The red rock has been lightened, making it closer to the lighter rock lines.

4. Adjust the channels. I need the rocks to be darker and the sky to be a little lighter. Green darkens the red, while blue can lighten the sky. So I adjust the Red to a very low amount, Green high, and Blue to a moderate amount. Now the graphic elements of the scene are revealed as seen in figure 13-33. Notice, however, that the Source Channel percentage total is much higher than 100! That's because there is no real green in the image that can be lightened (the green channel doesn't have much in it), but there is much red that can be darkened. So in this case, the 100 percent rule does not apply.

5. Make your final adjustments. In this photo, I add a Curves layer to increase the contrast of the midtones

slightly, then add a Brightness/Contrast layer to tone down some areas around the edges, all revealed in the photo and the layers seen in figure 13-34.

The final photo, figure 13-35, is a far more dramatic and dynamic image than the original color shot. This is really a much better black and white than color subject. But it only works as a black and white photo when the color-to-tone conversion helps the photo. The Channel Mixer is a huge help in ensuring that the tones truly represent and highlight the key elements of the composition that originally caught my eye for this scene.

PRO TIP

This technique is using adjustment layers, so always keep in mind that you can go back and readjust lower layers to tweak the Channel Mixer-converted black and white photo. You can, for example, go to the Levels layer and bring back blacks or whites that were lost in the Channel Mixer layer. Or you can do this with a new adjustment layer. The advantage of going back and readjusting earlier layers rather than adding new layers is that your layer stack stays simpler and more manageable.

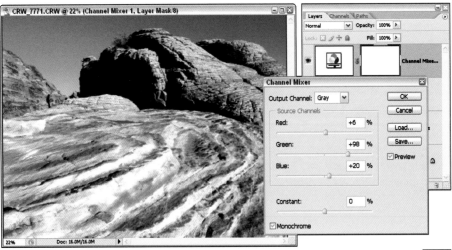

13-33

13-34

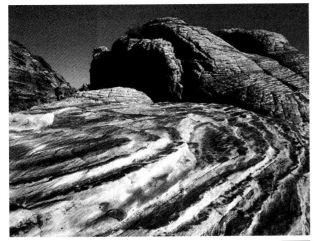

13-35

You might have noticed that the name of the photo indicates this came from a RAW file. I did not rename and resave this particular file to offer you another possibility. Because you cannot damage your original RAW file by saving over it, you don't have to always do a Save As

immediately when opening your RAW file. It is still a good idea to do a Save As just so you have an appropriate name for the file. I also left it as is because I like doing black and white conversions to a converted RAW file using Channel Mixer, rather than doing the conversion in Camera Raw. That usually offers more control in dealing with color-to-gray tonality conversion. But Camera Raw conversions can also give very good results, and some photographers prefer it. It is especially helpful when you need the maximum tonality possible for black and white from digital files.

BLACK AND WHITE FROM CAMERA RAW

One of the big advantages of using Camera Raw for black and white work is the 16 bits per channel and the conversion of tonalities closer to the original data coming from the digital camera sensor. These don't always outweigh the fewer controls available for black and white, but in some situations, they can be important.

Here's how to work an image to get good black and white from Camera Raw:

1. Make the image look good in Camera Raw (see figure 13-36). You may notice that I consistently suggest working the color photo to get it looking good before making the jump to black and white. This is not an absolute by any means. If you want to turn the photo into black and white then make the key tonal adjustments (blacks/whites, midtones), you can certainly do that. I like the workflow of seeing my image in good color first. I also find that having good, clean color helps me make the translation to black and white better.

2. Desaturate the color. Move the Saturation slider all the way to the left as seen in figure 13-37. This gives a black and white image, but it is not an optimum photo yet.

3. Adjust color relationships. If you look at figure 13-37, you notice that the image brightness and contrast can be adjusted. I don't want to do that yet. In figure 13-38, you can see the Calibrate tab has been accessed and many of the sliders changed. To me, this tab is a necessity for converting color to black and white in Camera Raw. It is here that the color-to-tone relationships can be changed. This does much more for black and white than any other adjustments in Camera Raw conversion. Though the controls are different, you can approach Calibrate like using the Channel Mixer. You adjust the red, green, and blue controls to affect how those colors are changed into gray tones. There is no simple way to describe their use. You have to get in and move the sliders around and watch what happens to the image. Try big changes and see what occurs. You use the red controls to affect more of the change of red-related colors to grays, the green controls for green-related colors, and blue controls for blue-related colors. However, you can see in figure 13-38 what a difference using Calibrate makes compared to figure 13-37.

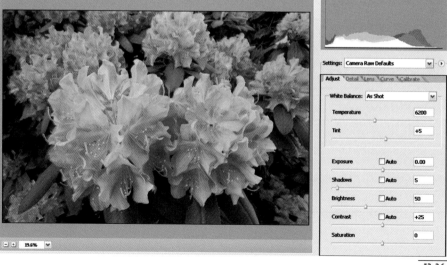

13-36

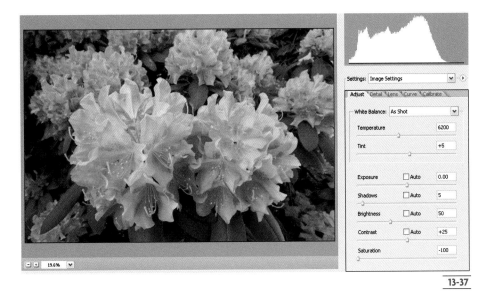

13-37

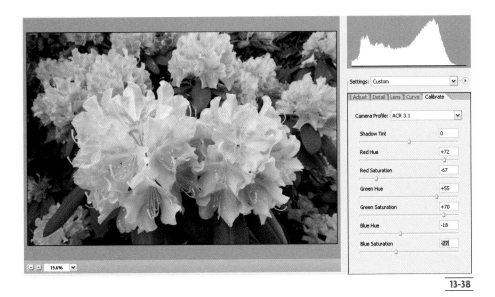

13-38

4. Readjust brightness and contrast in Camera Raw. Color brightness is not the same as black and white brightness. Sometimes no additional correction is needed at this point, but usually, some adjustment is necessary, as seen in figure 13-39. I use the threshold screens with Exposure and Shadows (press

Alt/Option) to see where the whites and blacks are after changing to black and white. I often tweak the Tone Curve to realign tonalities now that they are no longer in color (Chapter 6 covers the Tone Curve in detail).

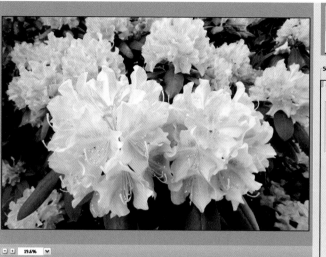
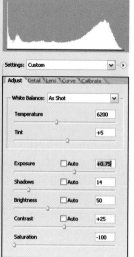

13-39

5. Finish the photo in Photoshop. Camera Raw does not allow local adjustments, so you have to do them in Photoshop. In this photo, the lower parts of the rhododendron flower heads need some work. You can see from figure 13-40 that adjustment layers are added and I paint in layer masks to mainly affect the lower flowers. I first add a Levels layer to check whites and

blacks, brightening the lower flowers, and then I work the flower midtones, darken bright areas above them, make the detail of the lower flowers richer, and make a final tweak of those flowers. I decided to keep this image in 16-bit because I wanted to be sure the subtle details were held in the bright parts of the flowers. The finished photo is seen in figure 13-41.

13-40

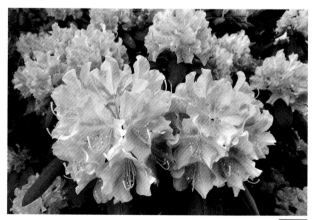

13-41

MULTIPLE CONVERSIONS IN THE SAME IMAGE

Photoshop's layers let you go even further with black and white conversion. As hinted earlier in this chapter, you can perform more than one conversion on the same photo, acting in effect like you shot the scene with two or more black and white filters on your lens, something that is impossible in traditional black and white work.

The most obvious need for this is in a landscape with flowers and grass in the lower part of the photo and blue sky and clouds in the upper part — both areas require a different conversion to get the most from both. Figure 13-42 is a good example. It is a photo of Mules Ear flowers in the Grand Teton National Park. This finished photo has great color contrasts, but look at a straightforward Desaturate conversion of the image in figure 13-43. That is not at all something useful in black and white. Any straight, one-style conversion is going to give this photo less than the best results because the colors in the bottom of the photo are so different than the top.

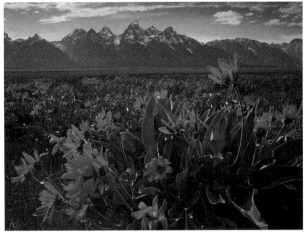

13-43

The answer to this challenge is to convert the image twice in the same file, once for the lower part, and once for the mountains and sky. To do that, follow these steps:

1. Add a Channel Mixer layer. In figure 13-44, you can see the red channel looks great for converting the sky and mountains. However, it makes the flowers and leaves below way too contrasty for my taste. Still, I keep the adjustment for the sky. There is no reason to try to make a compromise adjustment for everything.

2. Restrict the conversion. Figure 13-45 shows a partly gray and partly colored image (which should also give you an idea of how to do special effects color and black and white photo — use a Channel Mixer layer and its layer mask to control what is black and white and what is color). I use the Gradient tool to keep the black and white conversion that favors the skies limited to the top of the photo.

13-42

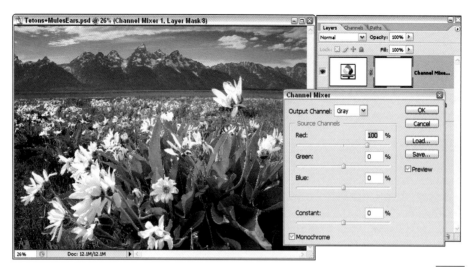

13-44

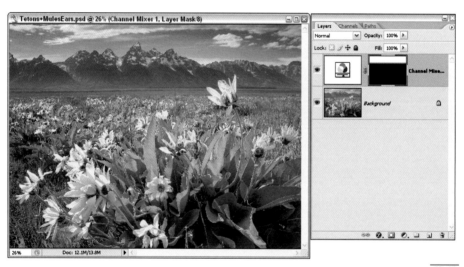

13-45

3. Add a new Channel Mixer layer for a new conversion. Figure 13-46 shows quite different Channel Mixer settings than seen in figure 13-44. Now the flowers look more normal. They still look light, but now they have a more realistic appearance.

PRO TIP

Black and white conversion is art and interpretation. Every photographer translates his or her images differently, sometimes with subtle differences, sometimes extreme. Work an image the way you like it and remember that there is no one "right" way for black and white conversion.

4. Restrict the conversion. You can always paint the Channel Mixer layer in and out by using the layer mask. In this example, the easiest way to restrict the conversion is to copy the Sky layer's layer mask and invert it, which is what I do for figure 13-47.

Press Alt/Option then click on the Sky layer mask and drag it onto the Flwrs/Ground layer mask. Photoshop asks if I want to replace the layer mask. I say yes, then invert it using the keyboard shortcut Ctrl/⌘+I.

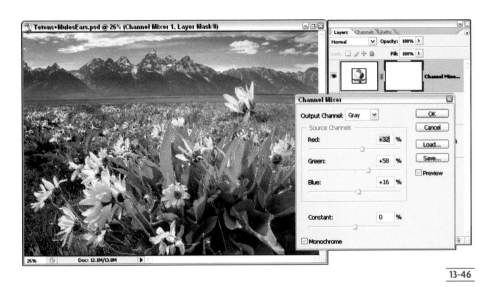

13-46

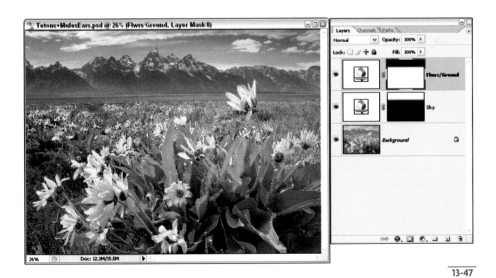

13-47

5. Fix the blend between conversions. If you look carefully at figure 13-47, you can see a little bit of color creeping through across the blend area at the base of the mountains. This is normal. You can get rid of it by flattening the image and using Desaturate. I use a Hue/Saturation adjustment layer with the Saturation slider moved all the way to the left, as shown in figure 13-48.

6. Finish the photo adjustments. For this photo, I don't see any big needs for changes. You can see in figure 13-49 that I add a Levels layer to tweak the blacks and whites, plus a Brightness/Contrast layer to do a little balancing to the overall image.

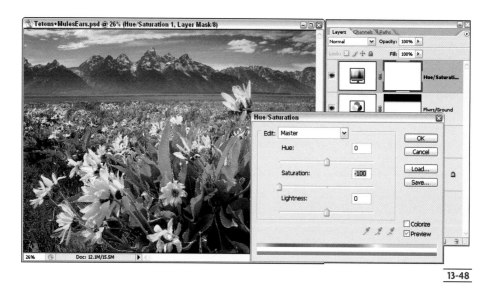

13-48

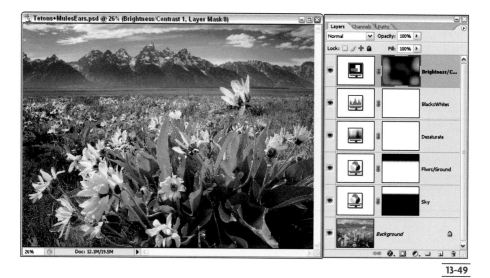

13-49

TONING BLACK-AND-WHITE IMAGES

If you have ever seen an exhibit of classic black and white images like those from Ansel Adams or Edward Weston, you quickly notice that the prints usually have a slight color to them. In the darkroom, this was called toning, and prints were typically given a warm tone (sepia) or cool tone (selenium), though many colors are possible.

Toning an image can add a richness to it that the plain black and white photo doesn't have. In addition, it can make it easier to print with a color inkjet printer. Photoshop offers a number of excellent ways of making a toned or colored black and white photo. I show you two easy techniques that are quite effective. Before I start, however, it is important to understand that your black and white photo must be in a color space and not Grayscale in order to do any of this. An RGB color space is fine. If your photo is in Grayscale, choose Image ⇨ Mode and change it to RGB.

I use the Teton flower photo just converted in the previous section for this example. To start, I show you another layers management tool — the group. By selecting all the black and white conversion layers, I can use the Layers palette drop-down menu to group them. I name the group as shown in figure 13-50. The result is a simplified Layers palette shown in figure 13-51. All of the layers are still there, inside the BW Conversion group folder. You can see them by clicking on the arrow at the left side of the group layer.

13-51

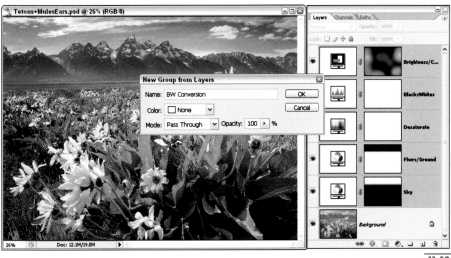

13-50

The first way I like to do toning is through the use of a Hue/Saturation layer. When the dialog box seen in figure 13-52 appears, you see something new. I select the Colorize check box at the lower right. Now Hue is shifted from the center point, and Saturation is reduced.

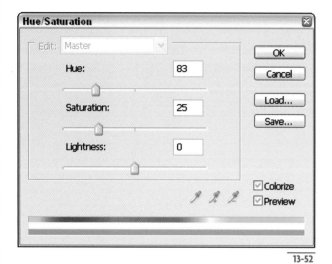

13-52

The image is now colored with the color seen in the bottom stripe. This green is not particularly good for toning (though graphic artists like lots of color effects, including this color, for design effects in a publication).

By adjusting the Hue and Saturation sliders, you quickly see a whole range of colors (hue) and intensity of the effect (saturation). For example, in figure 13-53, you see a sepia-like effect, while figure 13-54 shows a cool-tone effect.

Another good, easy way of adding color toning to a black and white image is to use a Color Balance adjustment layer as seen in figure 13-55. You simply add color by moving the color sliders. You get sepia tones by using the red and yellow adjustments seen in figure 13-55.

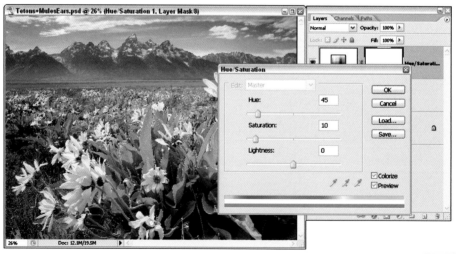

13-53

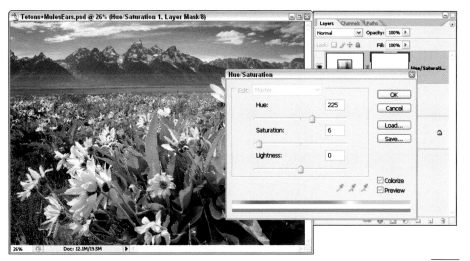

13-54

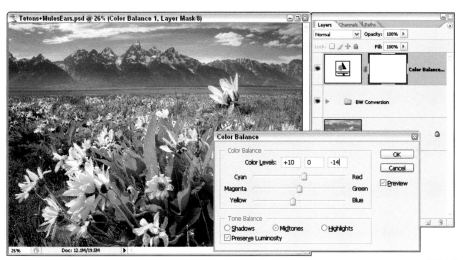

13-55

You get cooler tones by using blue and cyan. You can use whatever colors you like.

Basic adjustments are made by keeping the changes to the midtones. You can, however, get some rich effects by giving different adjustments to the different tones (in the Tone Balance section at the bottom). In figure 13-56 you see the Color Balance dialog boxes for adding some yellow to the Highlights and blue in the Shadows. Figure 13-57 shows the final image with all the adjustments.

NOTE

This method is sort of a poor man's duotone. A duotone is a very rich way of giving color to a black and white image that is often used in the publishing industry. Though Photoshop has some excellent duotone capabilities, this work is a bit involved and beyond the scope of this book.

13-56

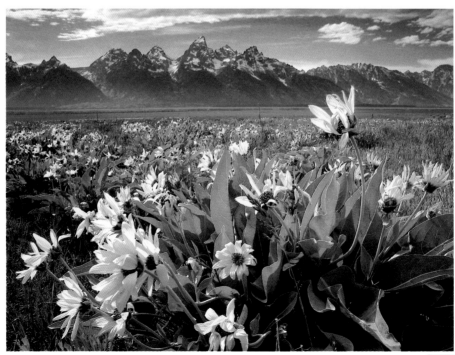

13-57

Q & A

Okay, I understand the possibilities. Tell me honestly what is the best way to convert to black and white?

I get questions like this all the time. There is the belief that surely there must be a best way to do this, and if I learn that method, I can ignore all the rest of this stuff. I really don't mean to be as facetious as this sounds, but the best way of converting your photos to black and white is the way that works best for you and yields the best image.

Black and white is such a subjective thing. With color, you can make an argument that you are going to try to get closer to reality or to a certain traditional film, such as Velvia. There is some sort of standard or goal. Black and white has nothing of the sort. Should green be light or dark? It depends on the photo. Should yellow look white or have some gray tone to it? That's really up to the photographer.

This subjectivity affects how any photographer approaches a color image with the goal of changing it to black and white. Consequently, it affects the choice of method or technique as well. I believe you learn as you go, making conversions to black and white in different ways and comparing the results. You will discover what works best for you.

I've heard that the best and easiest black and white conversions come from Photoshop plug-ins. Is that true?

There are some truly outstanding plug-ins on the market that offer excellent black and white capabilities in very easy-to-use interfaces. I discuss plug-ins in more detail in Appendix A.

Do they work better than Photoshop? Not really. Do they offer more efficient and easier-to-use choices? Absolutely, and that is the advantage of plug-ins. There are two that I have found work quite well for black and white conversions: nik Color Efex and 55mm (there are others available on the market — I do not have experience with them). Color Efex 2.0 offers a lot of color adjustment capabilities along with three different ways of converting color to black and white. They all use a sliding color scale that changes how colors are translated into different black and white tones — in a way, it is like having an infinite variety of black and white filters available to affect your photo.

55mm also offers a good variety of color adjustment capabilities along with a handy and very easy black and white conversion. It is simply a set of choices based on black and white filters, including yellow, orange, red, green, and blue. Each gives a very different interpretation to the scene, plus you get some brightness and contrast slider controls as well. You get less control options with 55mm compared to Color Efex, but that is what makes it easier to work with.

FINISHING THE IMAGE

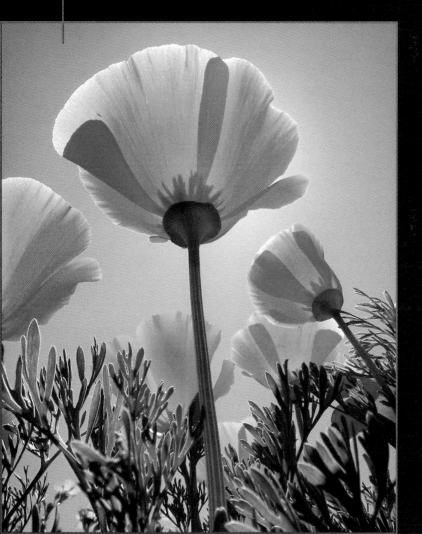

Once you make your adjustments to a photo, you can make a print such as the one in figure 14-1. However, before you make final prints, you need to perform a couple of finishing steps: sizing and sharpening. In this chapter, I cover key elements of sizing an image and sharpening for nature photography.

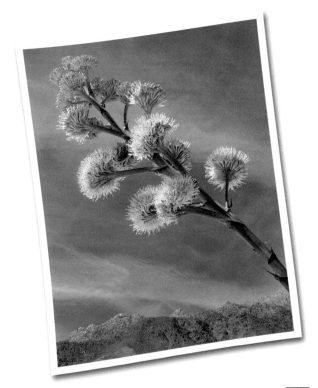

14-1

SIZING AND SHARPENING — WHY LAST IN THE PROCESS?

You certainly can size and sharpen an image at any point described in this book so far. However, there are some very important reasons for leaving sizing and sharpening of an image until last:

> Images are sharpened best to a specific size and for a specific output (from inkjet prints to reproduction in a publication).

> A number of adjustments can affect the appearance of sharpness. Sharpening too soon can lead to a poor decision on the amount of sharpening needed.

> Photos print best when they have a specific image size that is directly related to the desired print size and sharpened for that size, so having an unchanged master image makes it much easier to size to a specific printing need. Figures 14-2 and 14-3 are of the same image, but reproduced at different sizes on the page. They have two very different pixel dimensions.

> Sizing in Photoshop CS2 is different when done to make an image larger than when making one smaller.

> Sharpening too early can overenhance certain color effects, such as Hue/Saturation, and it can affect noise adversely.

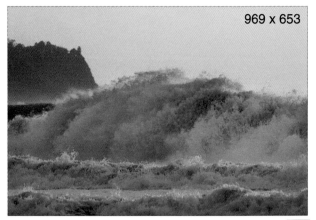

969 x 653

14-2

483 x 325

14-3

If you do much work in Camera Raw, or even if you just read Chapter 5, you know that you can size an image in that program. Consider that your master size. You may often make images larger or smaller than the finished image in Photoshop (there is little point in going through the trouble of sizing in Camera Raw and redoing your imaging work in Photoshop just to get a different size).

SIZING SURPRISES

Image size and resolution are something that can be terribly confusing to the photographer. Resolution in the computer world is entirely different from the resolution of a lens or resolution capabilities of film. More is not automatically better, and it changes!

Luckily, Photoshop offers a great sizing tool that shows exactly what is going on. You don't have to be a computer scientist or a math whiz in order to size your images properly. That said, it is very important to understand that you must size your images. Pixels exist independently of the size of a photo — you can have a lot of pixels in a small photo and very few in a large photo, and you can have the opposite.

Sizing also affects film and digital images differently. The process is the same, but as a whole, film images do not enlarge very well by increasing their resolution, yet digital images do. This has caused some confusion (and a lot of nonsense going around the industry) because of the old tendency to mathematically compare sizes of film and digital. Years ago, some smart folks figured out that it would take about 18 to 22 megapixels to equal 35mm film.

The math was good, but the real world stepped in. You can easily match 35mm with a 6- to 8-megapixel camera. Actually, I have shown people prints from both media, and even when the prints are as large as 24 x 30 inches, the average person generally picks the print from the digital camera over the film print as being the better one. Sure, if you look closely, you can see differences between a 6-megapixel camera and 35mm film, but if you've never had this experience, you might find the comparison quite interesting because the digital looks so good.

SIZING IN PHOTOSHOP

Sizing an image is all based around the Image Size dialog box seen in figure 14-4. You get to this from the Image menu (choose Image ➪ Image Size). It is important to understand how this dialog box is set up to help you resize an image. Again, if you use Camera Raw, you have an initial size that can be used as a master to be resized for specific purposes.

The Image Size dialog box has three distinct sections. Understanding what each section does gives you a good start on understanding sizing. The three sections are Pixel Dimensions, Document Size, and an unnamed bottom section with instructions to Photoshop on how to do the sizing.

14-4

> **Pixel Dimensions:** The Pixel Dimensions section of the Image Size dialog box can be seen in figure 14-5. It shows you the core size of the image based on file size (22.0M in this example means the file is 22 megabytes in size) and actual pixel dimensions of width and height. This is the number of pixels that reside in this file regardless of the actual resolution of the image as seen in the next part of this dialog box. It also has the OK and Cancel buttons. Auto is for publications and sets resolution based on halftone printing — you only need that if you are a graphic designer.

14-5

> **Document Size:** The Document size section, shown in figure 14-6, shows how big the image is when printed or used at the specified resolution. It shows it in a specific width and height as well as a resolution. Each of these has drop-down menus so you can change how they are measured, but I recommend sticking to inches and pixels/inch (pixels per inch, or ppi). In this example, the photo will make a 12-x-16-inch print at 200 ppi.

14-6

The bottom part of the Image Size dialog box (seen in figure 14-7) includes several options:

> Scale Styles

> Constrain Proportions

> Resample Image

Each affects how the pixels in the image are interpreted when the photo is resized.

Sizing can be done on flattened or layered images.

14-7

SIZE BASED ON THE NATIVE RESOLUTION FIRST

I am a strong believer in sizing first based on what you have from your image, which is the native size. This is the area resolution, the pixel dimensions of your photo as it comes from the camera, scanner, or Camera Raw. I often do sizing based on the native size only to the master, layered file, save that, and then flatten it for special crop needs or other sizes (which I save as separate files). Figure 14-8 shows a photo ready for resizing. Its native resolution (or pixel dimensions) is 2400 x 3200. I want to make this image ready for printing first without changing those dimensions. Here's how:

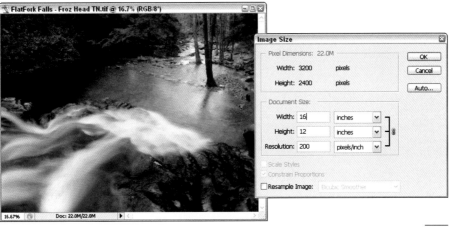

14-8

1. Be sure the Resample Image option is not checked, as seen in figure 14-8. This locks the top Pixel Dimensions so they cannot be changed. The only thing that can be changed is the width and height in inches of the photo.

2. Check to see how big or small your photo will be. You want to plug in some numbers in the Resolution box and see how the inches end up. I give you some numbers that are better explained in the printing part of this chapter, but some people vigorously disagree with them. I only suggest that you try them and see if any viewer sees a significant difference in the prints. With modern printers, few will see a difference. Type **200** for Resolution; that gives you a good maximum print size for your image. Figures 14-6 and 14-8 use that number, and you can see the photo print at 12 × 16 inches. Type **300** in the resolution field, and you see in figure 14-9 that the size drops to approximately 8 × 10. These are both very printable sizes. If those sizes work for you, you are done.

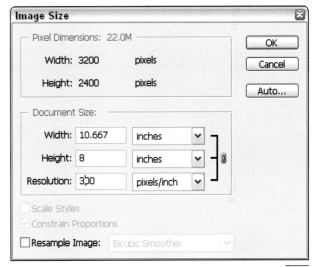

14-9

PRO TIP

Don't be shocked or dismayed if you open a JPEG from your camera and see that it has huge width and height inch dimensions. This is because of an outdated, but still blindly used, convention in the industry of making JPEGs read at 72 ppi. Such a resolution is used for the Web, not for printing photos. You have to change this to a printable resolution such as 200 or 300 in order to see a real print size for your photo.

3. Size the image to your needs. As long as you can get an image width and height in inches that matches those needs and has a resolution between 200 and 360 ppi (meaning a range of printable ppi that works great on the majority of inkjet printers), you can quickly get to a printing size. Just type the number you need for at least one dimension, and because these dimensions follow the proportions of your photo, the other dimension and resolution are filled in automatically. For figure 14-10, I use 11 inches for the height because I wanted an 11-x-14-inch print. The width is larger than 14 inches because the original proportions of the photo don't match (the little chain with lines going to the different boxes means they are all linked together). You do not want to change those proportions or you will warp the scene. You get to your final size in the next step, although at this point, I highly recommend saving a master, uncropped image at the desired size.

4. Crop to size. Use the Crop tool to crop the photo to a specific size. Type the desired numbers in the Options bar for the Crop Tool as seen in figure 14-11. Click and drag the crop area around until you get the image you want, as seen in figure 14-12.

If Resample remains deselected, you can change the Document Size boxes as much as you want and the photo will not have any quality change. These changes to Document Size affect only the way the computer spreads the pixels out — it does not actually change any pixels.

14-11

14-12

14-10

PRO TIP

If you are preparing an image for a publication, you will usually choose 300 ppi for the Resolution box. This means no more changes in this part of the process. You now have an image size based on the native pixels of the photo. You may have heard that this is the only size at which an image can be published (and I have heard many an art director say this). In years of experience with *Outdoor Photographer* and *PCPhoto* magazines, as well as working on multiple books, I can tell you that it is an unfortunate myth and only says that such people have not really tried to get the most from digital images.

BIGGER OR SMALLER PHOTOS

When you need an image that is larger or smaller than what the native size provides, you need to have Photoshop use its advanced algorithms to make more or less pixels in the image. This is what interpolation, or resampling as Photoshop calls it, is about — the analysis of existing image pixels and the smart addition of new pixels or the careful removal of pixels in order to create a new photo size.

If you are working with film, it is best to scan it at the very highest resolution that you might possibly need. Film does not interpolate up in size well and that interpolation never matches an image scanned at the larger size in the first place.

Digital camera files interpolate up in size quite well. There are a number of reasons for this, including the fact that the noise of a digital image shot at low ISO settings is usually quite a bit less than the grain in film. This is fortunate, because digital files need to be interpolated up in order to match film.

Reducing the size of a photo is also not as simple as it might seem. Why not just print a larger image at a smaller size? In order to do that, data must be thrown out somewhere in the process, whether in the printer driver or in the Print dialog box for Photoshop, but neither does the job as smartly as doing the sizing specifically for the need in the Image Size dialog box. When done properly, the

photo resized in the Image Size dialog box typically shows more important detail (and looks sharper) than when done in other ways.

ENLARGING IMAGE FILES

Adding data to an image so that it can be used at a larger size is done quite easily in Photoshop. You use the Image Size dialog box controls. The technique I use is easy and is designed to get the most from the original or native pixels of the image. It is a little different than what some Photoshop users do, but it is based on a lot of prints coming out of a great variety of printers. I guarantee you that it works.

To enlarge your images, follow these steps:

1. Set your maximum native size for the photo. With Resample Image still unchecked, type **200** in the Resolution box.

2. Select the Resample Image check box. This activates the top and bottom sections of the Image Size dialog box, as shown in figure 14-13. In the top of the box, you can type a specific pixel amount (this is useful for Web or e-mail needs). At the bottom, drop-down menu choices are now active for the Resample Image. You can also select the check boxes for Constrain Proportions and Scale Styles. For landscape and nature photography, it is very rare to use any option other than Constrain Proportions, which means that when one dimension in a photo is changed, the other is proportionally changed automatically. This keeps everything in correct proportions. When you select Constrain Proportions, a link appears beside width and height in both upper sections of the Image Size dialog box to remind you that the dimensions are linked. Scale Styles refers to styles, a unique way of dealing with layers that are beyond the scope of this book. If you have them, you usually need to scale them. If not, it doesn't matter.

3. From the Resample Image drop-down menu, select Bicubic Smoother. Click the drop-down arrow and the menu seen in figure 14-14 appears. It offers a series

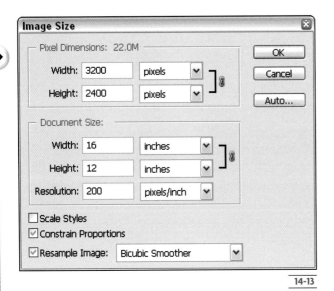

14-13

of choices. The two options in this menu that are important for nature photographers are Bicubic Smoother (used for enlarging photos) and Bicubic Sharper (used for reducing the size of photos).

4. Set your photo size. Leave Resolution set at 200, and type a height or width that you need. In figure 14-15, the height is set at 16 inches so that the photo can be used for a 16 × 20-inch print. Notice that the top part of the Image Size box changes. The width and height show new amounts, and there is a new number to the right of the heading, Pixel Dimensions. Photoshop tells you the new image file size along with the old one. This is a big jump in size, though Photoshop is capable of doing a very good job with it from the original image file. It does not do as well with a file that is already sized or sharpened. Click OK and let Photoshop do its work.

14-14

14-15

Before going to image reduction, I want to show you why I use the numbers I do for this. Some Photoshop users suggest only using 300 or even 360 ppi. Look at what 300 ppi does to the example I just showed you (see figure 14-16). The file size increases to nearly 90 megabytes! That's a lot of pixel interpolation. If you do this with 360 ppi, the file increases to 126.6 megabytes in size! That's a huge file that takes up unnecessary space in RAM and on your hard drive.

I have seen the claims that this is necessary, and I have seen the results that purport to support this. But in doing blind tests using prints with sophisticated photographers, photo editors, and art designers, I have never found anyone who can consistently tell the difference in prints from images using from 200 to 360 ppi. Maybe there is a difference if you put the print to your nose or you use a magnifier, but what real-world displays of photo prints encourages viewers to evaluate a photo by sticking their nose close to it? And when was the last time anyone offered magnifiers at a photo exhibition so you could check print quality?

14-16

REDUCING IMAGE FILES

Now, on to reducing an image file size. This requires a different procedure and algorithm (courtesy of Adobe) in order to retain detail as information is removed to shrink a picture. Here's how:

1. Set your minimum native file size for the photo. With Resample Image deselected, type **360** into the Resolution box. In this case, 360 works to reduce the file size without changing pixels. If you try something like 500 or 600, the image gets small, but the resolution is too high to be used smartly by most inkjet printers. So the printer driver throws out data, and image quality can be reduced. In figure 14-17, you see that 360 brings the image down to under 7 × 9 inches.

2. Select the Resample Image check box.

3. Click the Resample Image down arrow and choose Bicubic Sharper (see figure 14-18). The algorithm for Bicubic Sharper is designed specifically for reducing image size so that details are retained as much as possible.

4. Set your photo size. Leave Resolution set at 360, and type a height or width that you need. In figure 14-19, I set the image at 1.5 × 2 inches so that I can use it for a letterhead. Notice the new image file size along with the old one. Imagine putting the original 22MB file into a simple letter! 1.11MB is much more manageable. Click OK and let Photoshop do its work.

E-MAIL SIZING

E-mail is a special case of sizing and worth a mention here because it seems to be a consistent problem. Photos used for e-mail need to be sized appropriately. Large photos are a pain for most people to deal with in their e-mail systems. A small photo goes quickly to the recipient, opens easily, and doesn't cause computer problems. It is possible that in the future e-mailing large images will be a fast and easy process, but for now, good e-mail etiquette means not sending huge image files.

14-17

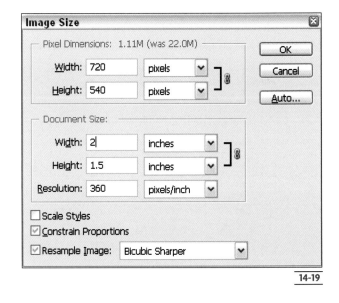

14-18

14-19

I give you two approaches to sizing for e-mail. The first, seen in figure 14-20, is a small file that is designed purely for viewing. Most people have monitors that offer just under 100 ppi (not the old 72 ppi), so to make the process easier to follow, I use 100 ppi because any math is so much simpler and more understandable. Because most monitors easily accommodate a photo 8 inches wide by 6 inches tall, I use those numbers in the Document Size. The result is a manageable 1.37 MB file that usually shrinks to less than 100KB when saved as a JPEG file at a medium compression. That is a very polite size to send someone.

The second approach, seen in figure 14-21, is done a little differently to give a printable file. Here, I make approximately a 4-x-6-inch photo for printing at 150 ppi resolution. The file size is larger, but it still reduces to less than 200 to 300KB with moderately high JPEG compression (I recommend keeping e-mailed photos under 300KB unless you know your recipient can handle something bigger). While 150 ppi isn't ideal as a printing resolution, it is still very useable as a print.

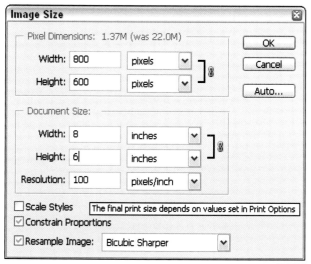

14-20

14-21

SHARPENING TOOLS

Sharpening in Photoshop is not to make blurry or unsharp images sharp (even though Unsharp Mask is an important sharpening tool). Sharpening tools look at tiny areas of contrast between light and dark wherever there is an edge of detail throughout an image and enhance that contrast. They are designed to bring out the sharpness in the image based on what is sharp in the photo. In scanning and digital camera processes, there are certain factors that keep the file from initially appearing at its sharpest. In addition, having some things too sharp during Photoshop work (such as noise) can adversely affect the final appearance of the photo.

Once an image is processed and sized for a final use, it is time to sharpen it. There are several sharpening tools available in Photoshop, but there are only two that are key for photographers: Unsharp Mask and Smart Sharpen. Both are found in the Filter menu (choose Filter ➪ Sharpen ➪ Unsharp Mask or Smart Sharpen).

Unsharp Mask is named after a real sharpening process from the commercial printing industry in which a blurred copy of the photo is used as a mask (unsharp mask) with the original in order to create a sharper image. Photoshop's Unsharp Mask uses some complex algorithms to do something similar.

Smart Sharpen is a new sharpening tool introduced with Photoshop CS2. It is quite good and effectively brings out detail that might not show up clearly otherwise. It does have a serious flaw, however, that can limit its use — it can overenhance noise or grain in a photo and it has no controls to reduce that effect.

Before I go in detail about sharpening, it is important to understand two things:

> **Sharpening needs pixels.** You cannot arbitrarily sharpen a layered file. You either need to flatten the image and sharpen to a specific size, then save that file as a separate image, or you need to sharpen a specific sharpening layer that holds all the work done from the complete layered file.

PRO TIP

Remember that you can get a single layer of pixels based on all the other layers combined by pressing and holding Alt/Option+Ctrl/⌘+Shift, and then pressing E. This is only true for Photoshop CS2 — earlier versions require you to press the N key before E.

> **Sharpening is very subjective.** It is not the same thing for everyone, every subject, or even every use of a photograph. Photographers give widely varied formulas and approaches for using Unsharp Mask (or USM as it is also called); perhaps the surprising thing to know about them is that they are all probably right! I have some formulas for you as well, and I guarantee they work. Try them and see how they work for you. If you prefer another formula, go for it. The important thing is to do some sharpening and understand how it works.

UNSHARP MASK UNMASKED

Figure 14-22 shows Unsharp Mask being used for a photograph of rocky bluffs at sunrise in Arches National Park in Utah. Using the Unsharp Mask controls is pretty straightforward — it is the choices you make for the controls that make the difference.

You can see the sharpening effect in progress in several ways. First, there is the 100% view inside the Unsharp Mask dialog box itself. The magnification can be changed by clicking the +/- buttons below the image, but I recommend keeping it at 100 percent. You can adjust its position by moving your cursor onto this small image; the cursor changes to a hand as seen in figure 14-23 so you can click and drag the area around. Something else important happens when you click right on the small preview — the sharpening effect is removed from the small preview only. You can see what the sharpening is doing by clicking on and off this image. You can also see what is happening to the whole image by checking and unchecking the Preview check box.

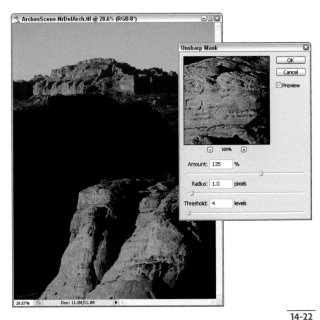

14-22

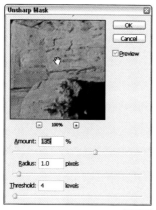

14-23

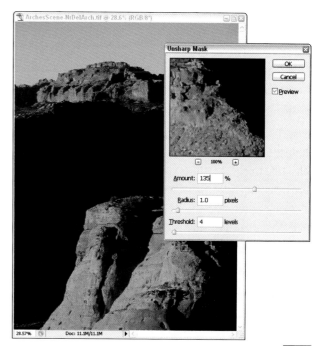

14-24

Many photographers like to enlarge the actual image to 100 percent. I don't because I like to see what is happening to it overall — select and unselect the Preview check box and the sharpening of the full photo turns on and off. Because I keep the small preview at 100 percent, I can quickly see any part of the photo at 100 percent by moving the cursor onto the actual photo, where it turns into a box as seen in figure 14-24. Click on a new location and that spot instantly appears in the small preview at 100 percent.

Figure 14-25 is a detail of the Unsharp Mask showing the three key controls:

14-25

> **Amount:** This is the intensity of the sharpening. This tells Photoshop how strongly to enhance edge contrast to bring out sharpness.

> **Radius:** This is how far in pixels Photoshop looks for edge contrast to make the enhancement. This tells Photoshop where to look for bringing out sharpness.

> **Threshold:** This is at what level of difference between light and dark edges Photoshop starts processing differences. This has a very strong effect on noise.

When sharpening an image using any technique, it is important not to oversharpen the photo. Figure 14-26 shows an oversharpened photo with an enlarged detail in

figure 14-27. The photo looks harsh, with contrasty and mottled details. There are unnatural white lines or halos around details, especially at the edge of the sky. This figure is purposefully way oversharpened so you can better see details in the book. Still, the problems caused by oversharpening are things you want to avoid.

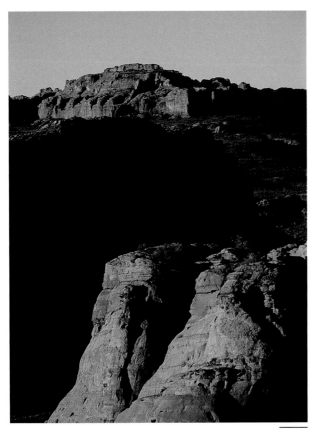

14-26

14-27

FORMULAS

Here are some numbers to try for Amount, Radius, and Threshold. I find these formulas work very well for landscape and nature photography, but I would not necessarily use them for portraits.

> **Amount:** For digital camera photos, try 130 to 160 percent. For scanned images, a little stronger amount works well; try 150 to 200 percent.

> **Radius:** This is very dependent on image size. For smaller files of about 10MB, try 1.0 to 1.3 pixels. For larger files of about 20MB, try 1.0 to 1.5. For very large files, you can go up to 2.0, but don't go higher. For all settings, check strongly contrasting edges for problem halos (they are not always bad — sometimes a slight halo will help edges, but you must be careful with it).

> **Threshold:** Keep this low. If you can get away with 0, it can make an image look quite sharp with less overall sharpening (which may give the photo a better look). However, most photos have at least some noise or grain requiring some amount for Threshold. I typically find most digital cameras need something between 2 and 4, while scanned images are variable, sometimes needing more. Compare figures 14-28 and 14-29 and look at the granularity of the Unsharp Mask small preview. You are seeing a piece of sky, which is a very good place to look for noise or grain (any smooth-toned area will show noise or grain most). Stop at 10 to 12. At that point, you are beginning to miss small details in the sharpening. If you need numbers between 6 and 12, increase the Amount number, too.

Don't try to completely eliminate grain or noise in the sharpening. You only want to reduce the effect of the sharpening on these image artifacts. It is normal for a photo to have some noise or grain at a subtle level.

14-28

14-29

highlights as tiny bright highlights (the light does not spread around them) and the overall image looks very crisp from that. A higher Radius with lower Amount intensifies tiny bright highlights in a photo, making the image more brilliant and crisp. But don't overdo this or harsh halos may result that hurt the photo.

There is a unique way of using Unsharp Mask that uses a special formula for the numbers that is totally different, which I find very helpful in many nature images. This unique use is not so much a sharpening tool as a way of making an image look a little livelier with some brightening at the local level. I first saw this technique in, believe it or not, a book about wedding photography by Kevin Kubota — he calls it clarifying an image. I tried it for nature photos and found it worked for them also.

This technique is used before you sharpen your image. It won't help every photo (some look too harsh, the highlights are adversely affected, or not much happens at all), but this tends to work well for detailed photos in soft light. Using Unsharp Mask, set the Amount low at 20, the Radius high at 60, and Threshold at 4, as seen in figure 14-30.

SHARPENING AND IMAGE BRILLIANCE

I need to explain a little about the Amount and Radius numbers I suggest here. I tend to sharpen a little more aggressively with Radius than many other photographers and keep Amount lower. I know that this increases the risk of halos. For that reason, a number of photographers use a much lower Radius, such as 0.5, and a high Amount, such as 225.

But my numbers do something I like for an image — they intensify the brilliance of an image. Brilliance is related to, but not the same as, sharpness. High-quality lenses have high image brilliance, which means they keep tiny bright

14-30

This method works well on a scene like the one shown in figure 14-31 (Texas bluebonnets at sunset near Burnet, Texas), shown adjusted, but before using this special USM technique. Figure 14-32 is the same image with the technique applied. You can see how it brightens the highlights and livens the image. (Both figure 14-31 and 14-32 were sharpened afterward for publication purposes, too.) Applying this effect to a separate layer, then adjusting the layer's opacity, can help you refine this technique.

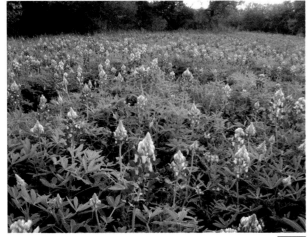

14-31

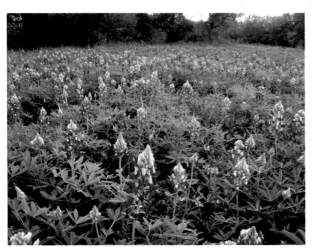

14-32

SMART SHARPEN

Smart Sharpen is a new sharpening tool introduced in Photoshop CS2 (choose Filter ⇨ Sharpen ⇨ Smart Sharpen), seen in figure 14-33. It can do a remarkable job in bringing out detail in a photo, especially photos from digital cameras. Its controls are similar to Unsharp Mask with Amount and Radius, but it applies sharpening with more advanced algorithms. The More Accurate check box does an especially good job, so most of the time, use it. The Preview check box and small preview image work similarly to Unsharp Mask.

A new control, Remove, seen in figure 14-34, has a drop-down menu that includes three choices that change how Smart Sharpen deals with the image.

> **Gaussian Blur:** This option is probably the most useful for nature photography and does a great job of sharpening an image overall.

> **Lens Blur:** This option works to sharpen images that are not focused as well as you want.

> **Motion Blur:** This option works to remove blur caused by camera movement (to use it, click on the clock-like button and drag the line in it to an angle that counteracts the angle of the movement of the camera during the exposure).

Settings also has a drop-down menu that allows you to access saved Smart Sharpen settings. You save and delete them with the Save and Delete icons to the right of Settings.

Theoretically, Smart Sharpen allows sharpening without increasing the appearance of noise, but in this, I believe it is a work in progress. In my experience, it overenhances noise because you cannot set Threshold, especially when you use More Accurate. The answer to this is supposed to be in the Advanced settings. Select the Advanced option and the area below the Settings menu changes. Three tabs appear: Sharpen, Shadow, and Highlight (see figure 14-35).

14-33

14-34

14-35

Sharpen has become a tab, but the settings are the same as are available with the Basic settings. Both the Shadow and Highlight tabs have the same controls in them (see figure 14-36).

> **Fade Amount:** This setting changes how much sharpening occurs for the shadows or highlights.

> **Tonal Width:** This setting determines the range of tones that are affected — a higher number increases

the range of shadows or highlights; a lower number decreases the range.

> **Radius:** You can usually leave Radius set to the default of 1.

If you reduce the sharpening in the shadows and the highlights, you end up sharpening the midtones, which may or may not be appropriate.

If it sounds like I am not enamored of the Advanced part of Smart Sharpen, you are right. While I have seen it help in some situations, I have seen it cause problems in others. Consider this: Shadows are dark and include the blacks of an image. I do not like having the blacks not sharpened (the image never looks quite right to me). While use of the Shadow tab controls can reduce noise sharpening in the shadows, it can also make dark details that are true to the image look muddy (or even disappear because they are not being sharpened).

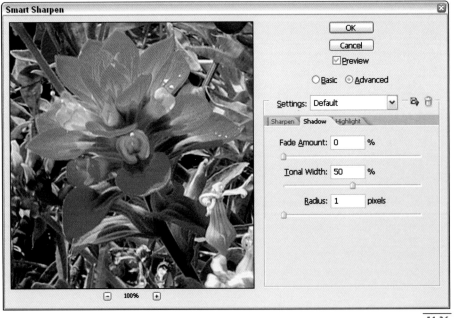

14-36

Another thing to consider: Highlights rarely have much noise, so reducing the sharpening there has little effect on noise. There are some artifacts of digital capture that can be found in highlights (such as sharp tonal cutoffs that aren't seen in film) that can look better with less sharpening, however. My feeling is that the Advanced tabs offer a lot of controls without a lot of benefit to the nature photographer.

So why not use Smart Sharpen all the time? I have to go back to noise as a reason. For the image shown fully sharpened in figure 14-37, Smart Sharpen was perfect. It did a great job on the image, but then there is a lot of detail that needs sharpening. If there was a lot of sky, a large area of one tone, or out-of-focus areas, I would probably not use Smart Sharpen because it overenhances noise in those areas.

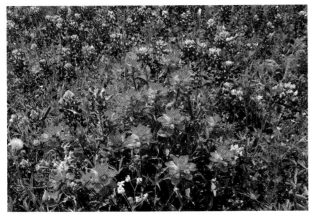

14-37

SHARPENING WITH LAYERS

I often sharpen a specific layer rather than flattening an image and sharpening the entire image. One reason for sharpening in a layer is to have a specific layer in your master Photoshop layered file that is sharpened at the native size of the master. Use the layer combination technique described in this book to create a single layer based on the combination of all the visible layers. You then sharpen that layer.

A very important reason for using a layer for sharpening is it allows you to selectively sharpen parts of your photo. In nature photography, you often use selective focus to make your subject sharp and the background out of focus — there is little point in using Unsharp Mask or Smart Sharpen on the background. Also, skies, smooth water, and dark areas that are greatly brightened may show too much noise if sharpened.

The photo of Mexican clover (which is not a true clover) in this example, a common plant of open, disturbed areas in Florida, is a good example of a sharp subject that needs sharpening, along with a blurry background that should not be sharpened. Here's how:

1. Duplicate your photo on a layer as seen in figure 14-38. Press Ctrl/⌘+J to quickly duplicate a layer. Name it Sharpen.

2. Open the Unsharp Mask dialog box (you can also use Smart Sharpen if appropriate for your image) and sharpen the Sharpen layer. As seen in figure 14-39, you want to pay the most attention to how the sharp part of the image is sharpened. In figures 14-40 and 14-41, you can see a detail of the same image where it is out of focus. Notice the noise that becomes more obvious because it is sharpened in figure 14-40 compared to what it looks like without sharpening in figure 14-41. In addition, out-of-focus flowers gain a sharpening that does not help them.

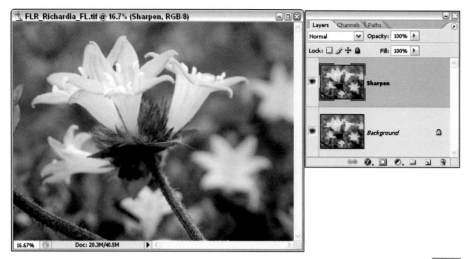

14-38

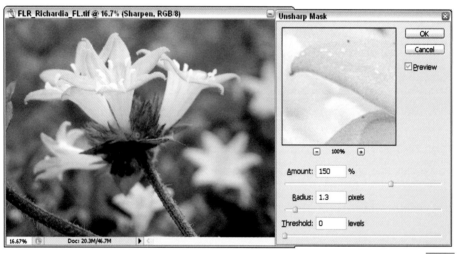

14-39

14-40

14-41

3. Use a layer mask to control the sharpening. There is a trick you can use here. Press Alt/Option as you click on the Layer Mask icon in the Layers palette. That creates a black layer mask, turning off the effect of the layer. Paint white over the sharp parts of the photo as seen in the Layers palette shown in figure 14-42. Change your brush size as appropriate so you go over only the parts of the image that really need to be sharp. Also, change back and forth between white and black (pressing X does this from the keyboard) to refine the mask. It doesn't hurt if some of this has more noise or grain than the rest of the photo as that actually increases the impression of sharpness. Also, if you compare the mask in figure 14-42 back to figure 14-38, you notice no white has been painted in the lower left in the image where there is a sharp stem. It doesn't need to be sharpened.

Now you can flatten the photo for use. You can, however, go further on photos like this and remove sharpness from distractions, which I show you next.

14-42

BLURRING DISTRACTIONS

Sharp elements not part of the subject are one problem that you consistently face when dealing with close-ups that use limited depth of field for effect, such as can be seen in this Mexican clover example. These are distractions and have nothing to do with the sharp subject. You can reduce their effect by blurring them slightly. This simply mimics the natural effect that comes from shooting a narrow depth of field and is no more real or less real than the exposure made by the camera. Out-of-focus areas are photographic artifacts and do not exist in nature; however, you can use them to control how a viewer sees your subject.

Here's how to blur distractions:

1. Copy the unneeded sharp area to a new layer. Figure 14-43 shows this in the layer named Blur. I used the Lasso tool to circle around the sharp stem and some sharp leaves above it. Then I pressed Ctrl/⌘+J to copy this selection to a new layer. It is important to understand that I made this selection on the unaffected Background layer and then had the copied layer appear above the Background, but below the Sharpen layer. That ensures that anything sharpened is not affected by the Blur layer (remember that layer stacks always work from the top down).

2. Blur the Blur layer. Using Gaussian Blur (choose Filter ⇨ Blur ⇨ Gaussian Blur), adjust the Radius until you like the blur effect as seen in figure 14-44. The small preview in the dialog box works like the small preview in Unsharp Mask — clicking on it removes the effect and you can set it to a specific part of your photo by moving your cursor to that area and clicking.

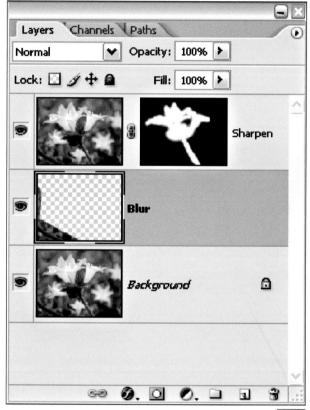

14-43

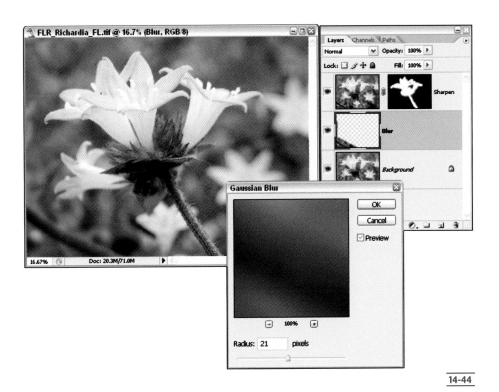

14-44

Now you can flatten or save your photo as needed. Sometimes you need to do more than one blur layer because distinct distractions that need blurring may not look right if all blurred the same amount. The final photo of the Mexican clover is shown in figure 14-45 so you can see the results of sharpening and blurring on layers.

PRO TIP

Adobe has introduced other types of blurs in recent versions of Photoshop that you can try, including a group of them in CS2. The blurring technique described here needs a variable control, like that in Gaussian Blur, so some blur filters can't be used. Lens Blur is quite effective, though more than a bit complicated. You don't need it for the technique described here, though it can help if you need to blur out a background completely. Box Blur gives a different blur look that some photographers prefer.

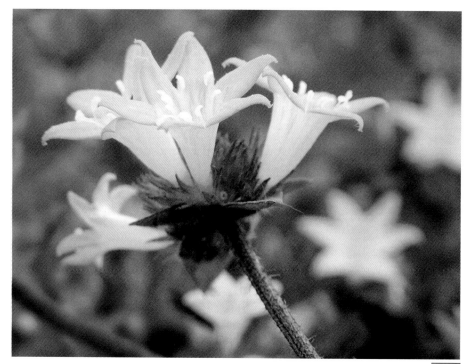

14-45

You can take this technique of blurring layers further by careful planning when you take the picture of your subject in the first place. Shoot with a smaller f-stop to get more sharpness in depth for the subject; this also makes the rest of the photo too sharp. But you then blur the rest of the photo to give a contrast in sharpness like shooting the overall image with less depth of field. The advantage, of course, is that you can see more of your subject sharply. The easiest way to do this is to duplicate the image, blur that layer, then paint out the blur with black over the desired sharp areas on a layer mask.

Q & A

I have a close-up image that mostly sharpens up okay, but there is a flower closer to the camera that could be sharper. Increasing the sharpening on the whole sharp subject makes it look too harsh. What should I do?

You can sharpen these areas in a two-step process that often works quite well. First, do the sharpening process described in this chapter, either an overall sharpening or selective sharpening with a layer.

Next, duplicate your sharpened layer. Sharpen it again until either your problem area looks sharp or just before it looks too harsh. Ignore the other parts of the sharpened photo as they will look bad at this point. Smart Sharpen at low settings can be very effective here.

Finally, add a black layer mask to the duplicated and twice-sharpened layer to turn off its effects. Then paint in the problem area with white on the mask to reveal it in this layer. You can further tweak this by changing the opacity of the layer.

If blurring can affect distractions in the photo, how about using it to get rid of noise?

You can do that, but I do not recommend it as a general practice. To remove overall problem noise in an image, I recommend using specific noise-reduction programs such as Kodak Digital GEM or nik Dfine. They give better, more controllable results.

However, you may find a specific problem area of noise in your photo. This can come because you had to do some strong processing to bring out something in the photo that also brings out undesirable noise. You can also find a problem of banding or tearing of tonalities due to extreme adjustments that go beyond the capacity of the bit depth of the image.

Both of these conditions can be affected by selecting that problem area, copying it to a layer, then blurring until the problem is reduced (eliminating it may cause other problems). You can then use the Opacity of the layer and a layer mask to tweak the effect.

THE BETTER PRINT

One chapter is not enough to give you everything you need to know about making a print that you can put on your wall like the one pictured in figure 15-1. There are many books on the market that devote much more space to this topic. However, in this chapter, I highlight specific issues related to printing that can help create better landscape and nature prints from your photos, and I give you some additional ideas not commonly offered in Photoshop or printing books.

Note that this chapter is not called, "The Good Print," but instead, "The Better Print." That is very deliberate. With the latest inkjet printers and Photoshop CS2, it is possible to get a good print fairly quickly and relatively easily (I hesitate saying easy as I know that not everyone finds printing easy). Getting a better print, an image that goes beyond the obvious good print, is something different.

15-1

MONITOR VERSUS PRINT

Many photographers suggest that a print is best when it matches the monitor. Keep in mind that a print can never perfectly match the monitor because they are two completely different media, the first with opaque colors on paper, the other with glowing colors in a monitor. However, if the monitor is calibrated and the printing process is done deliberately, you can have a reasonable facsimile of the monitor in a print that could be said to match.

I am suggesting a different idea than what you may usually hear: A print that matches the monitor can be a good print, but is rarely the best print. I also suggest that trying too hard to make a print look like the monitor may actually result in a worse print. Prints must stand on their own.

In addition, why should a print look exactly like the monitor? People look at prints as prints, so a print must look good as a print, not in reference to a monitor. The monitor only helps you get to a good print; it does not automatically give you the better print.

Finally, there is one thing that is always a huge factor in prints that cannot be seen in a monitor — size. There is no question that prints look different when printed at different sizes. A great 4-x-6-inch print may be a poor print at 12 x 18 inches. The larger size reveals tonalities, image balance, and more that cannot be seen at the small size. That usually means additional adjustment is needed for the larger print.

WORK PRINTS

The idea of a work print has long been part of the traditional darkroom process. Ansel Adams devoted a good bit of space in his books to the work print in the darkroom. John Sexton, Adams's last assistant and a superb black-and-white photographer in his own right, has told me that he believes the biggest problem digital photographers have is not making work prints early enough in the process.

A work print is simply a print you make based on your best idea of what would make a good print. You make your adjustments to the photo, and then make a print to see what it looks like as a print, not as a photo on a monitor. That then influences changes you may make to get a better print. This is not about correcting a print that does not match the monitor. It is about going beyond what is seen on the monitor.

Going beyond the monitor version is illustrated in figures 15-2 and 15-3. There is absolutely nothing wrong with figure 15-2, and it looks great on the monitor. A print made from this image would be considered a work print. After examining such a print, I felt it needed more drama in order to be a better print, and the result is seen in figure 15-3. The difference is quite dramatic even in an 8-x-10-inch print (the printed page changes an image, so I can only show you an approximation of what the prints look like).

It is worth saving your master file separately from your printing files beyond simply to have files sized and sharpened to specific sizes. This way you have an image that you feel looks its best on the monitor and a place to start for your work prints. Then as you adjust the printing file for printing, you are not affecting your master.

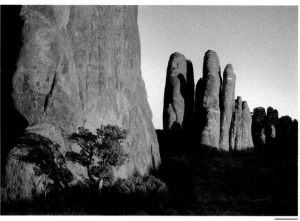
15-3

I know this means making more prints, which goes against the common idea that if you do everything right in Photoshop and do color management right, you should be able to make one print and be done with it. If you can get a good print that satisfies you that way, then go for it and enjoy your prints. A great print is one that satisfies you, not one that you think I would like or of which any other Photoshop expert would approve.

I often find an image that works great on-screen and that even works well printed in *Outdoor Photographer* or one of my books, but that simply needs more work to make it print its best. I am interested in the better print, one that fully expresses the photo in a way that pleases me *as a print*. That means first making prints that I consider work prints to evaluate for final work on making the better print.

BASIC PRINTING

To get to your work print, you need to follow a workflow in Photoshop to make a print. There are two ways of getting a good print: a simple way and a more controlled way. Both methods word with modern inkjet printers, but the second, more controlled way is worth learning, as it gives more consistent results.

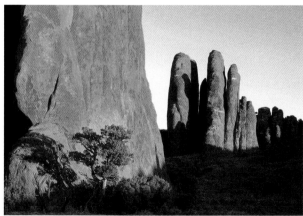
15-2

QUICK PRINTING

Here's how to print quickly and easily (this works especially well for me when working with sRGB files (also, many of the steps here are just listed so you know what they are and you don't need to actually do anything with them):

1. Use Print with Preview (choose File ➪ Print with Preview or press Alt/Option+Ctrl/⌘+P). The Print dialog box appears. If you don't see the full dialog box, as seen in figure 15-4, click More Options. The photo does not match the vertical frame in the print preview at the top left. I show this purposefully to show how easily you can make changes to set up the page at this point. While you can choose File ➪ Page Setup before going here, that is just an extra step to me. Whenever you need Page Setup, however (and I do for this image), it is available in this dialog box.

NOTE

At the bottom of the Photoshop Print dialog box is an area called Description (seen in figure 15-4, but cropped off of other screens to more efficiently use space in the book). If you position your cursor over words in the bottom half of this box, a description of that control appears in Description to help you.

2. Set up the page if needed. Click Page Setup to open the Page Setup dialog box seen in figure 15-5. This is where you select the size paper you want to use (click the Size drop-down arrow to see the menu), the Orientation (Landscape in this case), and the printer if you have more than one connected to your computer. Clicking OK gives the image the correct orientation for the paper, as seen in figure 15-6 (it also fits the preview because it was sized for this size print).

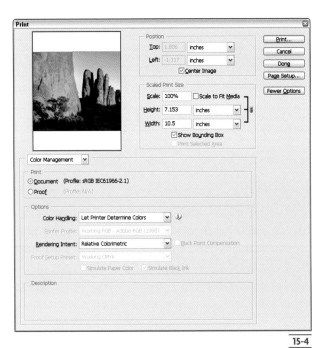

15-4

15-5

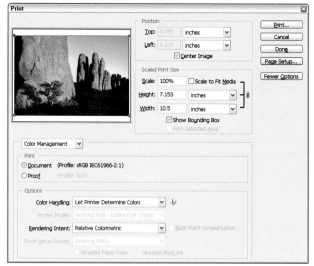

15-6

3. Confirm the Position and Print Size settings. At the top of the Print dialog box is the Position section. The Center Image check box is selected in figure 15-6, which you will want to use in most of your work. When Center Image is not checked, the photo in the small preview is no longer locked to the center of the printing area. You can then click on the image and move it in the printing area if you need the image high or low on the printed page. In the Scaled Print Size section, the normal Scale percentage is 100 percent if you size and sharpen your photo properly for the print size. If the size you see is incorrect for the print you want to make (for example, it is 8 x 10 when you are making an 11-x-14-inch print), I recommend going back to the photo and changing the size with the Resample Image option not selected so that you are only changing pixel spacing. Making the change with this dialog box can reduce quality. If the size is only a little off, you can select the Scale to Fit Media check box or change the Scale, Height, or Width numbers (they are all linked).

NOTE

If you select this option and your printer does not print a centered image, check the printer driver (if you don't know what this is, you'll learn it later in this chapter) to be sure there is not another Center Image check box there.

4. Be sure Color Management is visible. This is also seen in figure 15-6, just below the small preview. The drop-down menu that has Color Management selected also has another choice, Output. Few photographers ever use Output, as it is mainly for commercial printing purposes.

5. In the Print section, the Document radio button should be selected (the Proof option is for folks like graphic designers who are proofing an image for commercial printing).

6. Set the Options. For the quick and easy method, choose Let Printer Determine Colors from the Color Handling drop-down menu. Leave Relative Colorimetric selected in the Rendering Intent drop-down menu, and you're done.

7. Click Print, and then set your Printer driver correctly for the paper used as seen in figure 15-7. This is a Windows printer driver; Mac drivers have the same information in a different form. A *printer driver* is simply the program that controls or drives the printing by your printer. It tells the printer that you are making a photo print and what kind of paper you are using so that it lays ink down properly on the paper. The printer driver comes up directly after the Photoshop Print dialog box in Mac OS. However, in Windows, an intermediate Print dialog box (that every Windows user sees when printing from any program, from Word to

NOTE

Mac users have the same choices as Windows users, but in a different format found under Print Settings. In the Mac Print (printer driver) dialog box, choose Print Settings from the third drop-down menu from the top and choose the paper under Media Type, then Automatic for Mode. Set the Quality/Speed slider to Quality.

Outlook to Photoshop) appears. In that box, you see the word "Properties." Click that to access the printer driver. The example printer driver dialog box in figure 15-7 is for an Epson Stylus. Every printer driver dialog box has a different look. Click OK to exit the printer driver, and then OK again to exit the Windows Print dialog box.

8. Click OK in the Print dialog box.

PRINTING WITH MORE CONTROL

Here's how to print with a little more control (you may find it is the only way to get consistent results with certain printers). I'm using a different image so the boxes look different and have some different choices. Also, I am not going to repeat everything noted in the printing method just described, so to understand everything that follows you will need to know some of the details from the previous section:

1. Use Print with Preview (choose File ⇨ Print with Preview or press Alt/Option+Ctrl/⌘+P) to open the Print dialog box seen in figure 15-8. This example shows the photo coming in wrong again as a vertical on a horizontal page to emphasize the point that you need to check this and then go to Page Setup if it is incorrect. If the photo is a horizontal image (Landscape), it appears in this dialog box small preview properly because Print with Preview bases its choice on what you were just doing. By the way, the small preview is for size only, not color or tonality.

15-7

15-8

2. Set up the page if needed. Clicking Page Setup, I changed the Orientation to Portrait. Clicking OK gives the image the correct orientation for the paper as seen in figure 15-9, but there is a problem that can give you less than optimum results if you are not careful. The Scale to Fit Media option appears checked because Photoshop recognizes that the photo is bigger than the paper size on at least one dimension. I sized it to a large enough paper size, but because I did not choose the right paper size for this wrong orientation in Page Setup, Photoshop automatically resized it, which I do not want it to do. By selecting the correct paper size in Page Setup, along with the right orientation, the problem is fixed (see figure 15-10).

3. Confirm the Position and Print Size settings. In Scaled Print Size, the correct size for the image appears in figure 15-11.

4. Be sure Color Management is visible.

15-9

15-11

15-10

5. The Document option is selected by default in the Print section. Proof, as noted above, is not what photographers would use.

6. In the Options section, select a Color Handling setting. This is the point when the process changes from the simpler technique first described. For Color Handling, use the drop-down menu to select Let Photoshop Determine Colors as seen in figure 15-12. This is an important step, as you are now telling Photoshop to define colors for printing rather than letting the printer do it.

7. In the Options section, set the Printer Profile. This new choice is now available. When you click the drop-down menu, many choices are available, as seen in figure 15-13. These are printer profiles that come with your printer (or can be downloaded from your printer

or paper manufacturer's Web site). Don't be confused by the variety. Look for something related to your printer with a paper type. (It may or may not have the manufacturer's name listed, but it should have the model number at least, as seen with the SP2200 choices here that are for the Epson Stylus Photo 2200.) Choose the profile appropriate to the paper you are using. If you can't find your paper, you can try finding a match to your color space (for example, Adobe RGB) or the manufacturer's interpretation of the color space (for example, Epson Adobe RGB).

8. Leave Rendering Intent at Relative Colorimetric and be sure the Black Point Compensation check box is selected. Black Point Compensation must be checked for proper blacks in the image.

15-12

15-13

9. Click Print to go to the Windows Print dialog box; this goes directly to printer driver choices in the Mac. In Windows, click Properties in the Print dialog box to get to your printer driver. For both platforms, you need to set your printer driver for the paper used, as seen in figure 15-14. Tell the printer you are making a photo print and what kind of paper you are using so that it lays ink down properly on the paper. In this case, the type of paper must match what you chose in Printer Profile in the Photoshop Print dialog box. But you aren't done.

10. Click Advanced to get the options seen in figure 15-15. Under Color Management, select the ICM radio button, and under ICC Profile, select No Color Adjustment.

Mac has the same Color Management choice in the third drop-down menu from the top — choose No Color Adjustment. This is very important because Photoshop is already managing color for the print and you don't want the printer driver doing it again.

11. Click OK in the Print dialog box.

PRO TIP

In the Photoshop Print dialog box, there is a Done button (refer to Figure 15-12). This allows you to set up a print for printing but not actually print it. This can be used to do a print later, for example. The Print controls are saved with the image file when you save the file.

15-14

15-15

Image and Printer Resolution

One thing that is very confusing about printing is that the term resolution is used in two completely different ways: one way for the image file and something completely different for the printer. If you don't understand what is going on, you may use the wrong resolution.

Image resolution refers to the pixels in the photo, whether by area (for example, 3200 × 2400) or linear distance (for example, 300 ppi). Printer resolution refers to the way the printer puts ink droplets down on the paper and is always a much higher number along with dpi or dots per inch (for example, 1440 dpi).

There is a pervasive belief among many photographers that these two numbers are related and that you need to use an image resolution in ppi that can be directly multiplied to equal the printer dpi. That may have been true at one time, but there is a serious problem with that idea today.

Inkjet printers lay down ink in very distinct patterns using highly protected, secret algorithms that vary the dpi of the ink

being printed! That is important in order to gain the range of colors and tones that these printers provide. That being the case, then what ppi of an image can be used to match a variable number? Obviously, there is none that can match.

Modern inkjet printers examine the image they get from the computer and interpret it to make the best print possible (assuming the printer driver is set correctly for photo and paper type). As long as the ppi of the image is within its acceptable range (and 200 to 300 is always in that range), the printer makes a good print.

Will you see differences with certain images printed at specific ppi settings? Maybe. I have seen highly magnified images from some photographers purporting to show these differences, but as I said earlier, who takes a magnifying glass to look at a print? If a print is so dull that someone needs to do that, then maybe the whole process of photography, from subject selection to Photoshop work to print, needs some reevaluation.

EVALUATING THE PRINT: WHERE

Once you make a print and consider it a work print on the way to a better print, you need to evaluate it thoughtfully. However, one challenge you face immediately is where do you evaluate this print and in what light? The answer is not simple.

It is important that you view the print in a neutral environment. Strong colors or contrasts near the print influence how you see color and contrast in the print

itself. You can see how color affects the appearance of an image in the illustrations seen in figures 15-16 and 15-17. The two photos are identical in every way, from color to contrast, but they look different. You don't have to have pure gray for your surroundings in order to judge a photo well (though that doesn't hurt), but you do need to avoid strong colors of any kind.

A trickier issue is the light used to view the print. The color of light, from incandescent to fluorescent to sunlight, changes the colors and appearance of a print.

15-16

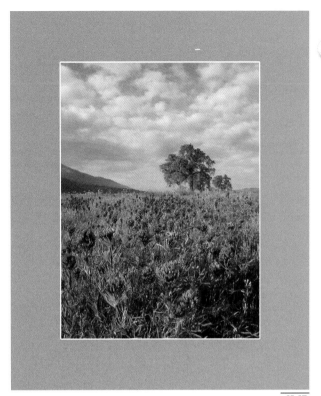

15-17

Many pros who sell images use a consistent, daylight-balanced light to view images because they cannot predict where the print will be displayed.

Having a consistent light to evaluate a print is important because it helps you see differences that are due to printing rather than changes in the light. But do you need a daylight-balanced viewing light? Some folks say this is critical, and they have a good argument for it, saying that our eyes are adapted best to this light, so if you can't predict where your print will end up, it is best.

On the other hand, most photographers know their prints will be displayed in their homes or businesses and with friends and relatives. In most of these locations, viewing of

the prints is rarely done in daylight conditions. In most home situations, the prints are seen under incandescent lights. In business locations, the prints are often seen under fluorescent lighting. So there is a good argument for evaluating your prints under the specific sort of lighting that will illuminate the location where your prints will end up.

No matter where you evaluate your print, you may discover that it does not look the way you expect it to look in its final location. I will remake a print specifically for a location because of this. This is one reason why I recommend you temporarily put a print up in a location you are not sure about before having that print framed for permanent display in that location.

EVALUATING THE PRINT: HOW

How do you evaluate your work print? What do you look for? I can give you some tips, but always remember, as a photographer, you started with an idea of what you wanted from the scene, so first off, it must satisfy you. More than once I made a print that was truly faithful to what I saw on the monitor, and I liked what I saw on the monitor, but I did not like the print because it did not satisfy what I wanted from a print of the scene. So I went back and adjusted the image until I got a print that I really did like.

I strongly suggest in evaluating an image that you try to look at the photo quickly and decide what you like or dislike without studying it too long. If you make this evaluation a search for "what's wrong with this picture," you will find things wrong that really aren't. Step back from the photo (literally — give yourself some distance), and see how it works as a print without getting caught up in minutiae that viewers of your photo will never see.

Here are some things to look for in evaluating your print. These are all related to issues that have been discussed throughout this book, but now you are using them to specifically look at your photo as it lives in a print:

> **Balance:** Does the print look balanced visually? Are there bright areas that fight with the composition? Are there strong colors that take the eye away from the subject?

> **Colorcasts:** Does the print seem to have a colorcast inappropriate to the scene? Or a cast that you don't like?

> **Noise:** Are there noise issues in the print that you did not see on the monitor? Are they distracting when the print is seen at a normal viewing distance?

> **Sharpness:** Is the print appropriately sharp when viewed at a normal distance? Are there sharpening

artifacts such as halos or odd edges that are distracting?

> **Local areas:** Are there small areas in the print that have poor color or tonality, even though the overall image looks good? This can especially be a problem with a large print that shows things that were not easily seen on the monitor (while you can enlarge parts of the photo on the monitor, you can never see those parts in relation to the whole image the way you do in a print).

ADJUSTING FOR THE PRINT

The best way to adjust an image for a better print after evaluating your work print is to use adjustment layers for colors and tonalities, which were discussed in detail in Part II of this book. For sharpness and noise issues, you may also need new layers.

You can go back into your master and readjust the layers you made for it. I don't recommend that for tone and color changes for printing (for sharpness and noise, you may have to go back and correct things in the master). Because a print is a different sort of beast than what you see in the monitor, and especially because different sizes of prints can change the impression of an image, I recommend making your printing adjustments as new adjustment layers specific to your printing file as illustrated by figure 15-18 (and this is purely meant to illustrate — you rarely need this many adjustments for most prints!).

Use adjustment layers one at a time for specific issues; for example, one for colorcast, one for local contrast, one for sky color, and so forth. Use the layer masks to control where the adjustment does its job. Then make a new print as a work print to see how these changes affect the appearance of the print. With practice, you can make these changes quickly and not have to make a lot of new prints.

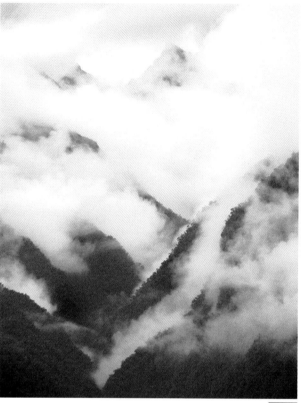

MAKING AN ELEGANT BORDER

Putting a small border around an image is an elegant way to complete a print. For some photos, a border is a necessity in order to clearly define the edge of the image, which may be very light and can blend with the white base of the printing paper.

There are many types of borders that can be used, and a lot of them can be created in Photoshop. They come and go as fads. But there is one border that has had a long life and likely will continue to be used a long time — the simple black line around the photo. This gives a very elegant and refined look to the image, and Photoshop can create it for you by using Layer Styles. For the example, I have chosen an image from Peru near Machu Pichu that almost demands a border because of all the light clouds as seen in figure 15-19. Here's how to apply it:

1. Create a layer for the border. With this technique, you can't apply a border to the Background in your layer stack. It can only be applied to a layer. You can use the Stamp Visible technique used so often through this book for this layer (press and hold Alt/Option+Ctrl/⌘+Shift, and then press E) if you are working from a layered file. The image in figure 15-20 is a final image prepared for printing and has

no layers. To turn the Background in a flattened file into a layer, double-click on the layer as described in Chapter 14 to open the New Layer dialog box seen in figure 15-20. Click OK.

2. Open the Add a Layer Style control for Stroke. Click the Add a Layer Style button at the bottom of the Layers palette (it looks like a small *f* in a dark circle). The drop-down menu seen in figure 15-21 appears. Select Stroke and the Layer Style dialog box, seen in figure 15-22, appears.

3. Make a black border. When the Layer Style dialog box is opened for Stroke, it will give you a red border but you won't see it yet on your image. Change two things: Color and Position. Click the red Color rectangle to open the Color Picker, seen in figure 15-23. Click at the very lower left to make a pure black as seen in figure 15-23 (you can also type in **0**, **0**, and **0** for R, G, and B). Click OK.

15-20

15-21

15-22

15-23

4. Back on the Layer Style dialog box, open the Position drop-down menu, select Inside as seen in figure 15-24, and a border appears. In the figure, you can also see a small icon added to the right side of the layer that indicates there is a layer style applied to the layer.

5. Adjust the size of your border. There is no absolute for this black border size in pixels, as it depends on the size of the photo (bigger photos need larger borders) and personal taste. On average-size prints that are 8-x-10- or even 12-x-18-inch prints, a size of 4 to 8 pixels usually works (see figure 15-25). Now you are ready to print.

15-24

15-25

The finished photo is seen in figure 15-26. Compare it to figure 15-19. You can change the black border at any time because it is applied as a layer style. Simply double-click the Layer Style icon on the layer to get to the Layer Style controls, go to Stroke and change whatever you want, including turning it off. You can save this file with the layer and its associated style as a Photoshop PSD file or you can flatten it to make changes permanent and save any way you want.

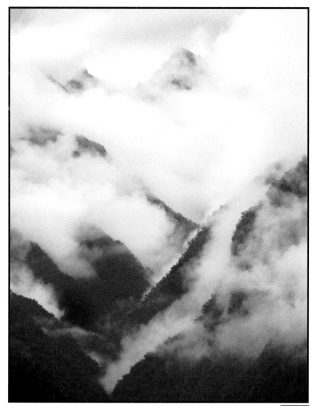

15-26

MAKING MULTIPLE PRINTS ON ONE SHEET OF PAPER

Sooner or later, you will need to make multiple prints of the same photo on a single sheet of printing paper. You may want to make a number of 4-x-6-inch postcards. You want to make a couple of 8 x 10s for family, or maybe you want to do both the 8 x 10s and the postcards at once.

Photoshop offers a convenient and very handy way of creating multiple prints, even at different sizes, on the same sheet of printing paper.

Here's how to do that for a photo that you have open (other variations in a moment):

1. Open Picture Package by choosing File ⇨ Automate ⇨ Picture Package. The Picture Package dialog box, similar to that seen in figure 15-27, appears. If your photo does not appear, be sure that it is the front, open file and that Frontmost Document is selected in the Use field in the Source Images section, as seen here.

2. In the Document section, start by doing the following:

 • Be sure Page Size is set large enough for your needs.

 • Set Resolution to a printable resolution (200 to 300 ppi).

 • Set Mode to RGB color.

15-27

3. Now, select a multi-image page from the Layout drop-down menu (see figure 15-28). Find a choice that works for your print size needs. I chose (4)4x5, which results in four images up to 4 × 5 inches in size. I say up to, because if your crop is not exactly proportional to 4 × 5, Photoshop puts the exact proportions of your original image into the 4 × 5 box but only up to the width or length of the original (whichever hits the sides first).

4. Finish with Picture Package. You only need to do a few more things to complete your picture package, which is a group of images made for a single sheet of printing paper. You can either check or not check the Flatten All Layers option. In figure 15-29, it is checked. The choice changes how the group of photos is organized on the page — as separate layers for each or one layer for all. A curious thing about Picture Package is that when Flatten All Layers is checked, it flattens the image layers onto one layer, but does not actually flatten all layers. The image layer sits above a white background layer. I usually flatten the whole thing then because if I really want separate layers, I would not select the Flatten All Layers check box.

5. Click OK. Stand back as Photoshop puts together this page (it is quite amazing to watch Photoshop resize and position these images onto a page). The result is what you see in figure 15-30 (which has been rotated for convenience).

15-28

15-29

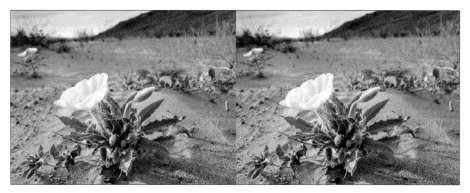

15-30

You have several options that you can use for Picture Package that can help you more easily get the multi-print you want. These include:

> **Don't flatten the images.** That allows you to do a number of things. You can move the photos around on the layers if needed, you can add a border to one or more of them, or you can remove any of the photos to give you space for something else, such as text.

> **Go to a specific file.** Choose an option from the Use drop-down menu for this. When you choose a specific file and specific folder (seen next), the Browse button becomes active, which allows you to browse your hard drive for the needed image or folder.

> **Go to a specific folder.** Choose an option from the Use drop-down menu for this, too. This can be a very convenient way to deal with a lot of prints (for example, making photos to send to people who are expecting prints from you because you promised them photos). Put copies of the photos into a new folder just for that purpose, then tell Picture Package to use the photos in that folder.

> **Change the photos.** You can put different photos into each image area by double-clicking on an image and choosing something else. You do that with the Select an Image File dialog box, seen in figure 15-31, that appears. Navigate it like any file open box. Do this for each image area and something that looks like figure 15-32 appears.

15-31

15-32

Q & A

I have seen printers advertised with very high printing resolutions, something like 5800 dpi. What does that do to the print?

It wastes your time. Seriously, the high resolutions of printers started as a marketing war that had little to do with image quality. Tests have shown that the human eye has difficulty seeing any difference in a print that is made at a printer resolution higher than 1440 dpi. There is some evidence that 2880 dpi (or similar) may offer slightly better gradations in an image, but truthfully, the size of the ink droplet along with the algorithms used for placing it have a far greater effect.

The very high resolutions, such as the ones around 5800 dpi, are not optimized for the best prints because there are just too many ink droplets to deal with. If you look at a Hewlett-Packard inkjet printer driver, for example, you can see that its highly touted (and quite good) algorithms for color called PhotoRET are not even an option for the high resolution.

Do your own tests. Mostly, I think you will find the high resolutions do little beyond slow your printer down.

In this book, everything is in the RGB color space (either sRGB or Adobe RGB). If you pay close attention to the inks used in a printer, you can see they are not RGB, but CMYK or cyan, magenta, yellow, and black. Why wouldn't you want to print from a CMYK file?

That would seem to make a lot of sense. Why not go directly from a color space that mimics the actual printer colors?

I suppose that printer manufacturers could have made printers that work well with the CMYK color space, but actually, inkjet printers are optimized to print from RGB. This actually makes sense because RGB is a much larger color space with which to work.

Printer manufacturers use advanced, highly technical (and closely guarded) algorithms to look at the large space of RGB colors and very smartly interpret them specifically to work with the ink colors of the printer. This, in a sense, gives the printer more to work from in order to give you the best print possible.

Special Techniques for the Nature Photographer

PHOTOSHOP PLUG-INS
FOR NATURE PHOTOGRAPHERS

Plug-ins are special software programs that "plug in" to a host program and either do something that the host program can't do (expanding its capabilities) or use the host program's power in unique ways to make the host program work more easily, more effectively, or both. They usually consist of a set of filters and reside at the bottom of the Filters menu in Photoshop.

There are a lot of plug-in programs available for Photoshop, though many of them are more appropriate to graphic artists' work than that of landscape and nature photographers. Those types of plug-ins create things such as text effects or alter a photograph in unique, though unnatural, ways. Many plug-ins can be fun to play with, but they don't do much for true nature photography.

A common question among photographers is why bother with plug-ins when Photoshop does so much already. Some photographers never use a plug-in and do not miss them. On the other hand, many photographers who try these programs discover they do some wonderful things for their work in Photoshop. If a plug-in does something that is not possible in Photoshop or does it better (such as noise reduction plug-ins), then the reason for using it is obvious.

There are also plug-ins that do things that are possible in Photoshop only they do them faster, more easily, and more intuitively. From a workflow standpoint, that can make a plug-in well worth the cost. In addition, plug-ins often do things possible in Photoshop, but that would require an advanced understanding and long-term experience with Photoshop. So there are some plug-ins that get you doing advanced processing without the learning curve.

PRO TIP

I have tried out many — though far from all — plug-ins on the market. I am careful to always use them on a layer (they need pixels to work on) so I can control an effect easily with a layer mask or by changing layer opacity.

This appendix offers a select list of programs that I think offer a lot for nature photographers.

NIK SOFTWARE

nik Software makes a number of plug-ins that are very photographer friendly. To be direct, Photoshop and a lot of other imaging programs are not particularly photographer friendly. And they are definitely not intuitive or graphically inviting to the photographer. nik Software plug-ins are obviously made by people who understand and appreciate photographers' needs.

The first time I used a plug-in from nik Software, I was impressed with the interface and the choices of adjustments because they actually meant something for photographers.

Find nik Software on the Internet at www.niksoftware.com. There were three programs available at the time of this writing, though I understand some new ones may be introduced in the near future.

NIK COLOR EFEX

nik Color Efex Pro 2.0 comes in four different packages, each holding a different set of filters. The complete set has 75 different filters in two groups: stylizing and traditional. For landscape and nature photographers, the traditional group is most significant. I use filters there quite often and find some of them an absolute necessity for my work. Here is a sampling of those I find quite helpful:

> **B/W Conversion.** As mentioned in Chapter 13, nik Color Efex has three different black-and-white conversion filters. These are well thought out and give the photographer interested in black-and-white a set of quick and easy ways of converting color. If black-and-white is important to you, these are well worth looking into.

> **Brilliance/Warmth.** I actually use this filter a lot when I need to increase the overall saturation of a photo. Brilliance is the same as saturation and seems to have a better set of algorithms than Photoshop does for

saturation control. Warmth is a slider that adds an attractive warm color to an image as needed.

> **Contrast: Color Range.** This filter is one of my favorites, and I find it nearly indispensable for a lot of nature work with flowers. One problem with a lot of landscape photography with flowers is that the flowers don't stand out as well they did when you saw them. There are things you can do in Photoshop that help, but it can require a lot of work. With this filter, you set a color slider to the color of your flowers (or other unique color) and Color Efex creates a contrast in the photo that makes that color more visible. Figure A-1 shows the Contrast: Color Range interface.

A-1

> **Graduated filters.** Color Efex has a whole set of filters that darken part of the photo and leave the rest alone, both neutral density and in color.

> **Polarization.** You cannot truly polarize an image after it is shot, but this filter helps to liven up the color of an image and bring out clouds in a blue sky.

> **Sunshine.** While nik claims this makes scenes look like they were shot in sunshine when they weren't, I don't find that particularly useful. However, I do find this is an excellent tool to use on images shot on cloudy, low-contrast days to improve contrast and color.

While the stylizing filters are not generally as useful (they mostly add very strong, obvious effects to a photo, including some really odd effects, including one called Weird Dreams), there are some worth checking out even for the most traditional nature photographer:

> **Foliage.** This is quite a remarkable filter. Very often, I find that digital cameras do not capture greens the way I see them. This filter looks specifically for the greens of foliage and enriches them in some very specific ways.

> **Midnight series.** These create some very interesting, moody effects in a photograph for a very artistic look. As you might expect from the name, things do look dark. Try increasing the Brightness and Blur sliders for some great effects.

> **Monday Morning series.** This is also a moody effect, though this series adds grain, increases contrast, and smears tones in very graphic ways. Try increasing the Grain and Smear sliders.

NIK SHARPENER

Sharpening is one of those nonintuitive parts of Photoshop. It is also less controllable than one might like, though the tips given in Chapter 14 help. nik has given photographers an excellent sharpening plug-in in nik Sharpener Pro 2.0 that is far more intuitive than sharpening in Photoshop; it offers some remarkable control that is very, very helpful. It comes in Complete and Inkjet versions. The Complete version is almost twice as expensive as the Inkjet version and has added controls for publication, design, and commercial printing businesses that few landscape and nature photographers need.

Here are some things that nik Sharpener offers the photographer:

> Sharpening optimized for specific printers.

> Automatic scanning of image to give optimum sharpening for the size of the photo.

> Sharpening that changes based on the type of paper selected and printer resolution.

> Sharpening that can be controlled based on colors in the image so you do not oversharpen noise or out-of-focus areas (see figure A-2). This is my favorite part of this program. Very often, areas that show noise or out-of-focus areas are quite different in color than the rest of the photo. You can tell Sharpener Pro 2.0 how much to sharpen up to five specified colors that helps sharpen an image very smartly.

A-2

NIK DFINE

Dfine is a very comprehensive noise reduction program. It offers a great deal of control over the image, more than any other noise program that I have used, while offering excellent noise reduction. You can specify more or less noise reduction according to specific colors in a photo, just like Sharpener Pro 2.0. This program has way more in it than simple noise reduction, which gives it both more power and makes it more complex and harder to use. For the power computer user, this is a great program. For photographers looking for simple noise reduction, this program is not for them.

DIGITAL FILM TOOLS

Digital Film Tools is a Hollywood-based company that produces plug-ins for Photoshop and film/video production software that is designed to speed up work on images. For this company and its customers, high-quality correction and adjustment of images are critical, but these tasks must also be done fast to meet the deadlines of movie production where a film must be in the theaters by a certain date. You can find this company at www.digitalfilmtools.com.

55MM

55mm is a plug-in that includes 48 very photographic filters. They are similar in some ways to nik Color Efex, though there are quite a few filters here that are not in the nik set. I also like these filters quite a lot and find that they are easy and fast to use and apply. Here is a sampling of some that are quite useful for nature photographers:

> **Color Correction.** This is like Photoshop's Color Balance control on steroids. This is very powerful for adjusting overall color.

> **Color Grad and ND Grad.** These two filters are a very quick and easy way of darkening (and coloring) a part of an image that needs to be brought in balance with the rest of the photo. The grad's edges are set quickly by clicking and dragging control points along the edge of the preview image.

> **Color Temperature.** A fast and effective way of correcting overall color.

> **Lens Distortion.** A quick and easy way of dealing with pincushion and barrel distortion in lenses.

> **Low Contrast.** A very different way of dealing with contrast in an image than anything available in Photoshop.

> **Ozone.** This is one filter in this package, but it is worth a bunch of them. It is inspired by Ansel Adams's Zone System and allows you to very pre-

cisely and quickly adjust 11 different zones of brightness in a photograph (zones 0-10) in ways that I suppose you could do in Photoshop, but it would take forever if you did. I find this very useful for photographs that just need a specific tonality or color adjusted, and you can't get at either easily in Photoshop. Its interface is seen in figure A-3, with the mask used to limit the adjustment visible in figure A-4 (the mask is generated automatically).

> **Selective Color.** Like Photoshop's Hue/Saturation on steroids, this filter has a lot of power.

> **Selective Saturation.** This filter is very interesting; you can control the saturation of different tones and colors in the photograph very quickly with Range and Position sliders.

> **Ultra Contrast.** This filter is like the Shadow/Highlight control in Photoshop, but has more intuitive sliders.

A-3

A-4

KODAK ASF

Kodak purchased a small software development company, Applied Science Fiction, a few years ago for its very innovative and highly useful photography programs (and a proprietary film processing system that never really went anywhere). It is now called Kodak ASF group and can be found at www.asf.com or by searching the Kodak site at www.kodak.com.

DIGITAL GEM

If I could have only one plug-in, this one from Kodak ASF might be it. This is one of the easiest-to-use and most effective noise-reduction filters available. It makes Photoshop's noise-reduction filter look very ineffective. I use it all the time. Dfine and Noise Ninja are more comprehensive and offer more controls over noise, but GEM is so quick and easy to use that I find it far more attractive. And it works!

Like all noise-reduction software, however, you need to use it with care. If you increase the settings too high, you lose more than noise in your photograph. Tonalities and colors start to look plastic. In addition, slight noise in a photograph can make it look sharper.

Digital Gem comes in two versions: regular and Pro. I recommend the Pro version seen in figure A-5 because it works with 16-bit files, it has a noise-preview screen (very

useful), and according to Kodak, has better noise-reduction algorithms (I have not had the opportunity to try these head to head, but my impression of the Pro version is that it does its noise reduction job quite well).

DIGITAL SHO

This is another program from Kodak ASF group. It basically only does one thing, but it does it very well, and that is to bring out details in very dark areas in a photograph. The Pro version reveals details in highlights and supports 16-bit. It is like Photoshop's Shadow/Highlight control but a lot simpler to use, as seen in figure A-6, and in my experience, it does a nicer job (that's subjective, I know, but the transitions from shadow to midtones to highlight look better).

One thing to be aware of is that in the process of revealing amazing detail in very dark shadows, SHO also reveals a lot of noise. That is not SHO's fault. The noise is there in areas with minimal exposure because of the way sensors deal with low exposure. SHO simply makes it brighter along with other detail. On the other hand, it truly brings out detail quickly and easily when you need it.

DIGITAL ROC

Digital ROC is a very unique plug-in that won't be for all nature photographers, but for those that need it, it can truly be a lifesaver. This software looks deeply at the color

A-5

A-6

Special Techniques for the Nature Photographer

363

data in an image, and then works to bring out optimum color. For photos that already have optimum color, it doesn't do much. But for those that have weak color due to fading or flare, it can do an amazing job.

It was originally developed to bring back color into old, faded photos that were scanned into the computer. If you have old photos that need to be restored to their original color, this is definitely a plug-in you need. I know of no other software that does this so well, yet so easily. I restored a whole set of photos from my childhood, one of which is shown in figure A-7, that I got from my dad when my parents moved to a seniors complex. Digital ROC made the work so much easier and faster than I could have done with Photoshop alone. The Pro version adds 16-bit capability and a little more control, though frankly, I am not sure most photographers need it unless they are doing a lot of restoration work.

A-7

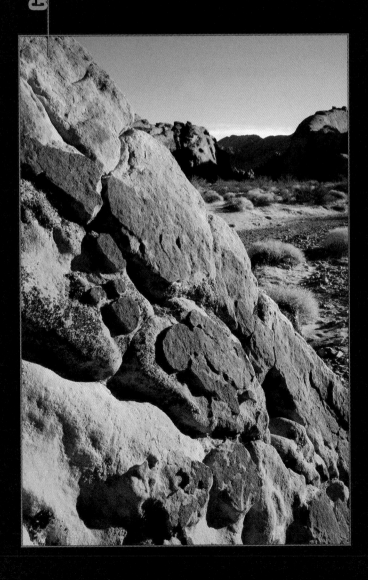

PRO GLOSSARY

Glossary

Adjustment layer: a layer without pixels that carries instructions to affect what is seen on any layer under it; it allows adjustments to be changed at any time because the original changes are not permanent.

Adobe RGB: a working color space based on the standard computer RGB colors created by Adobe Systems. It includes a wide gamut of colors that makes it a very flexible color space for using in Photoshop.

Algorithm: the computations, formulas, and procedures – the software-based steps or instructions used in digital devices and programs to process data.

Anti-Aliasing: using software to soften and blend rough edges (called aliased).

Archival Storage: using external, nonmagnetic media such as CDs to store information long term.

Artifact: A defect in an image or other recorded data created by the tool used to record or output; something in an image that did not exist in the original scene but was inadvertently added to the photo by the technology.

Background color: one of two colors that are always available for use and appear at the bottom of the Tools palette (Toolbox); the background color is the one at the bottom, "behind" the other; it can be changed by double-clicking to bring up the Color Picker. See also *Foreground color*.

Batch processing: a way of making one or more changes, such as new file type or image size, to a group or "batch" of image files all at once.

Bit: the smallest unit of data in a computer.

Bit depth: this refers to the number of bits required to represent the color in a pixel. With more bit depth, more colors are available. This increases exponentially. True photo color starts at 8-bit.

Browser: 1) a program that's used for examining sites on the World Wide Web; 2) a software program designed to show small, thumbnail images of digital files.

Brush tool: This tool is used for brushing on color or tone in precise ways by controlling the size, the softness, and the opacity (or intensity) of the brush. The basic use of the Brush tool applies to all tools that are brush based.

Burn tool: a brush-based tool that darkens areas that you click and drag your cursor over; works best when used at low levels of exposure.

CCD (charge-coupled device): a common type of image sensor used in digital cameras. The CCD actually sees only black-and-white images and must have red, green, and blue filters built into it in order to capture color.

CD-ROM (Compact Disc-Read-Only Memory): a compact disc that contains information that can only be read. It cannot be updated or recorded over.

Channels: Photoshop builds an image from information based on each segment of a color space, such as RGB, giving a red, green, and blue channel. Each channel has its own photographic information and contributes to the final, full-color image.

Chip: common term for a computer integrated circuit; the place where the data in a computer is processed.

Chroma: the color component of an image; it includes the hue and saturation information of color.

Clone Stamp tool: the "cloning" tool; this brush-based tool lets you copy small areas from one spot and clone them (paste them) over other places in the image; often used to cover up or fix problems or defects in the photo.

CMOS (complementary metal-oxide semiconductor): a common type of image sensor used in digital cameras. Like the CCD, a CMOS sensor typically sees only black-and-white images and must have red, green, and blue filters built into it in order to capture color. CMOS sensors use less energy than CCD chips.

CMYK (cyan, magenta, yellow, black): these are the subtractive primary colors and the basis for the CMYK color space. They're used in so-called four-color printing processes used in books and magazines because they produce the most photo-like look for publications.

Color noise: noise in a digital image that has a strong color component to it; commonly found in dark areas in long exposures. Also known as chromatic noise.

Color Picker: a color palette that allows you to pick colors based on hue (the actual color), saturation (the intensity), and tonal value (from black to white); it appears when you double click on the foreground or background colors.

Color range: a unique selection tool that resides in the Selection menu. It uses a special interface to allow you to make a selection based on specific colors and tones.

Color space: colors in digital cameras, the computer, and other digital devices are described by a set of numbers and these numbers can be interpreted differently by different devices. Models of color are based on a range of colors that can be described by a particular digital device. This is its color space. There are many color spaces, though the two main ones used for photography are RGB and CMYK. Within those spaces are subsets of spaces such as Adobe RGB 1998 (larger) and sRGB (smaller).

Compression: the use of algorithms to reduce the amount of data needed to reconstruct a file.

Continuous tone: the appearance of smooth color or black-and-white gradations, as in a photograph.

Copy: This copies whatever is selected (such as a layer or a selection of it), leaves the original, and makes a new copy on a separate layer. This is the same command in all software that allows you to copy things. See also *Cut*.

Copyright: a legal term that denotes rights of ownership and, thus, control over usage of written or other creative material. Unless otherwise noted, assume all images are copyrighted and can't be used by anyone without permission of the photographer.

Cut: This copies whatever is selected (such as a layer or a selection of it), but removes or cuts the original and places this removed segment on a separate layer. Like copy, it is the same command in all software that does this process. See also *Copy*.

Dodge tool: this brush-based tool acts like the traditional dodging tool in a darkroom — it lightens whatever it moves over. Highly sensitive, it is usually used at low settings, and like all brush tools, needs to have a size selected.

DPI (dots per inch): resolution of a peripheral as a measurement of the number of horizontal or vertical dots it's able to resolve in input or output. This is confusing because dpi for a scanner is the same as ppi of an image, yet both are different than the dpi of a printer. Dpi for a printer refers to the way ink droplets are laid down on paper.

Dye-sublimation: printing technology that results in continuous-tone images by passing gaseous color dyes through a semipermeable membrane on the media surface.

Dynamic range: the difference between the highest and the lowest values, as in the brightest highlights and the darkest shadows in an image.

Elliptical Marquee tool: a shaped selection tool that allows you to create a selection based on an ellipse or a circle (press and hold Shift for circle).

Eraser tool: this tool removes pixels from the image, so it takes out pieces of an image permanently; a brush-based tool, it can be set to varied sizes and opacities (strengths).

EVF: electronic viewfinder.

Exposure: 1) the combination of shutter speed and f-stop used in a camera to control the light hitting the sensor or film; 2) a specific control in Camera Raw that affects highlights.

Eyedropper: an image sampler tool; alone, it samples colors and selects them for the foreground color; it is also part of several adjustment windows, such as Levels, and is used for specific image sampling purposes ranging from black or white levels to colors.

Feather: a blending of a selection edge so a selection is "feathered" or blended into the areas around it.

File format: how the data that makes up an image is defined and organized for storage on a disk or other media. Standard image formats include JPEG, RAW, and TIFF.

Filter: 1) a special adjustment built into the program that makes a unique change to the image ranging from sharpening to special effects such as a water color painting look; 2) in traditional photography, this refers to colored optical glass or a plastic sheet that goes in front of the lens and affects how the image is captured.

FireWire: a very fast connection (meaning lots of data transmitted quickly) for linking peripherals to the computer; also called IEEE 1394 and i.Link.

Foreground color: one of two colors that are always available for use and show up at the bottom of the Tools palette; the foreground color is the one at the top, "in front of" the other; it can be changed by using the Eyedropper tool to select a color in the photo or double-clicking to bring up the Color Picker. See also *Background color*.

Gradient tool: a tool that blends the foreground and background colors together across an image, a selected area, or in a layer mask.

Graphics tablet and pen: a way of controlling your cursor's movement and actions by using an electronic tablet that senses where its graphic pen is moving; an alternative to the mouse.

Gray scale (or Grayscale): a black-and-white image composed of a range of gray levels from black to white.

HDR: this stands for high dynamic range and is a way for Photoshop to deal with a very large range of tones in a scene using multiple exposures and a specialized 32-bit file.

Histogram: a very important tool for adjusting a photo that is a graph of pixels at different brightness levels in the photo, with black represented at the left, white at the right, and gray in between.

History palette: an interactive chart of the actions taken on your photo, its history, that allows you to see what you've done and back up to earlier actions.

Hue: the actual color of a color.

Inkjet: a digital printing technology where tiny droplets of ink are placed on the paper to form characters or images.

Interpolation: a way of increasing or decreasing the apparent resolution of an image by using algorithms to create additional pixels in an image by smartly filling in the gaps between the original pixels or by smartly replacing them in order to get to a smaller file size.

JPEG (Joint Photographic Experts Group): a file format that smartly compresses image information to create smaller files; the files are reconstructed later. JPEG files lose quality as compression increases. Technically, JPEG is a compression standard rather than a file format (the term JPEG really refers to the standards committee), but through common use it has come to mean a file format.

JPEG artifacts: image defects due to file size compression that look like tiny rectangles or squarish grain.

Lasso tool: a freehand selection tool that follows exactly where your cursor goes.

Layer blending modes: special instructions that Photoshop uses to combine layers in unique ways, such as "multiply" to intensify tones and "screen" to reduce them.

Layer mask: a special part of an adjustment layer that allows you to turn the layer effects on and off by painting in white or black, respectively.

Layer styles: unique adjustments added to a layer from the Styles and Effects palette; very useful for text and shapes, doing such things as embossing them or adding a drop shadow or border.

Layers: separated elements of a Photoshop digital photo in which each part has its own isolated plane or level.

LCD (liquid crystal display): a display technology used for small monitors that act as viewfinders and playback display for digital cameras.

Lens aberration: a defect in the optical path of a lens that creates optical artifacts such as color fringing that can affect color definition and sharpness of a lens.

Levels: key tonal adjustment tool in Photoshop; this uses a histogram and three sliders under it to affect the image: the left is for dark areas, the middle for middle tones, and the right for bright areas.

Lossless compression: any form of file size reduction where no loss of data occurs.

Lossy compression: any form of file size reduction technique where some loss of data occurs.

Luminance noise: a special type of noise in a digital image that looks like a dark/light sand-like texture or pattern without colors in it (other than the original subject colors).

Magic wand: an automated selection tool that allows you to click on an area and everything around that point is selected depending on the sensitivity setting (tolerance); checking Contiguous selects areas connected to each other, while unchecking Contiguous selects everything in the photo within the defined tolerance of the tool.

Magnetic Lasso tool: an "automated" freehand selection tool; this tool finds an edge to select along for you, but it needs some contrast to an edge to be able to do this (you can also set its sensitivity in edge contrast and width).

Marquee tool: a shaped selection tool that allows you to create a selection based on a specific shape, such as a rectangle or ellipse.

Metadata: this means information about information; for photos, it refers to data stored with an image that describes exposure, camera type, copyright, and so on.

Noise: an artifact of the digital technologies, largely the sensor, that shows up in the photograph as a fine pattern that looks like grain or sand texture.

Paste: This places or "pastes" whatever is in memory that was cut or copied onto a new place on the image, onto a separate layer. Pastes into places or pastes the cut or copied pixels into a selection. It is the same command in all software that uses it. See also *Copy* and *Cut*.

Photomerge: a unique panoramic tool in Photoshop that allows you to take multiple images across a scene, then automatically stitch them together into a single panoramic shot.

Photosite: the individual, actual photosensitive area on a sensor that captures the brightness for a single pixel in the image. There is one photosite for every pixel in the original image.

Picture Package: an automated menu selection that allows you to print more than one photo per page.

Pixel: short for picture element (pix/picture, el/element). The smallest element of a picture that can be controlled by the computer.

Plug-in: a specialized piece of software that sits inside Photoshop and uses Photoshop's power to provide unique adjustments and enhancements to a photo; Plug-ins usually appear in the Filter menu.

Polygonal Lasso tool: a highly controllable freehand selection tool that follows your cursor but only sets down selection points when you click on a spot in the photo.

PPI (pixels per inch): a way of measuring linear resolution of an image and refers to how the pixels are spaced, meaning the number of pixels per inch in an image, often used interchangeably with dpi.

PSD file: the native file format for Photoshop and Photoshop Elements. It allows the saving of layers, layer masks, and more.

RAM (Random Access Memory): the computer's memory that's actually active for use in programs; comes on special chips. Anything in it is temporary and disappears when a program is closed or the computer is shut down.

RAW file: an image file that is minimally processed after it comes from the sensor in a camera. Data comes from the sensor and is translated to digital in the A/D converter; that data is then packaged for the RAW file. A RAW file is not generic for all cameras; there are actually proprietary files made by each camera manufacturer.

Resample: a command used for resizing an image that interpolates pixels, either increasing or decreasing their number from the original.

Resolution: the density of pixels in an image or the number of pixels or dots per inch in an image or that a device, such as a scanner, can capture.

RGB: the primary color system of a computer based on red, green, and blue, the additive primary colors. Computer monitors (CRT and LCD) display RGB-based screen images.

Ringing: white, ring-like border at distinct edges in a photo when that photo has been oversharpened.

Saturation: the amount of brilliance or intensity of a color; how colorful or dull a color is.

Selection: a way of isolating part of an image so it can be adjusted, changed, copied, or otherwise changed without affecting any other part of the image.

Sensor: the light-capturing part of a digital camera, usually a CCD or CMOS chip.

Smart Sharpen: a new sharpening tool for Photoshop CS2 that uses better algorithms than Unsharp Mask in order to create more accurate sharpening.

sRGB: a common color space in the RGB color system that is more restricted than others.

Thumbnail: a small, low-resolution version of an image that is useful for browsing many images at a time.

TIFF (Tagged Image File Format): an important, high-quality image format common to most image-processing programs.

Tonal range: the difference in brightness from the brightest to the darkest tones in an image.

Tone Curve: an adjustment for tonal values in an image that offers a great deal of flexibility. It appears first as a 45-degree angle line running up to the right in a graph. When that line is clicked on and moved, it changes tones in the image. The upper part of the curve is light, the bottom dark. Moving the curve up lightens tones; moving it down darkens tones. It is possible to move parts of the curve in different directions.

Unsharp Mask (USM): the name is misleading because it is based on an old commercial printing term; it is a highly controllable adjustment used for sharpening an image and includes three settings: amount, radius, and threshold.

USB: a standard computer connection for linking peripherals to the computer; Hi-Speed USB 2.0 is very fast, comparable to FireWire.

Vignetting: the darkening or lightening of the outer part of an image due to the way the photograph was shot (either the lens used or special vignetting techniques employed).

White Balance: a special digital control that tells digital still and video cameras how to correctly represent color based on the color temperatures of different light sources. All digital cameras have automatic white balance; most also let photographers adjust it manually.

Zoom tool: this tool looks like a magnifier because that is exactly what it does — magnify the image; click on the photo and it enlarges from that point; press and hold Alt or Option while clicking and the tool causes the photo to get smaller, zooming out from the image.

index

Index